Adolescents
and Literacies
in a Digital World

new
literacies
¶

AND DIGITAL EPISTEMOLOGIES

Colin Lankshear, Michele Knobel,
Chris Bigum, and Michael Peters
General Editors

Vol. 7

PETER LANG
New York • Washington, D.C./Baltimore • Bern
Frankfurt am Main • Berlin • Brussels • Vienna • Oxford

Adolescents and Literacies in a Digital World

EDITED BY
Donna E. Alvermann

PETER LANG
New York • Washington, D.C./Baltimore • Bern
Frankfurt am Main • Berlin • Brussels • Vienna • Oxford

Library of Congress Cataloging-in-Publication Data

Adolescents and literacies in a digital world / edited by Donna E. Alvermann.
p. cm. (New literacies and digital epistemologies; vol. 7)
Includes bibliographical references and index.
1. Communication in education. 2. Media literacy. 3. Mass media in education.
4. Popular culture. I. Alvermann, Donna E. II. Series.
LB1033.5 .A36 373.133—dc21 2001038812
ISBN 0-8204-5573-3
ISSN 1523-9543

Die Deutsche Bibliothek-CIP-Einheitsaufnahme

Adolescents and literacies in a digital world / ed. by: Donna E. Alvermann.
–New York; Washington, D.C./Baltimore; Bern;
Frankfurt am Main; Berlin; Brussels; Vienna; Oxford: Lang.
(New literacies and digital epistemologies; Vol. 7)
ISBN 0-8204-5573-3

Cover design by Dutton & Sherman Design

The paper in this book meets the guidelines for permanence and durability
of the Committee on Production Guidelines for Book Longevity
of the Council of Library Resources.

Printed in the United States of America

CONTENTS

Preface vii
 DONNA E. ALVERMANN

Acknowledgments xiii

CHAPTER 1
 Diversity and Critical Social Engagement: How Changing Technologies
 Enable New Modes of Literacy in Changing Circumstances 1
 BERTRAM C. BRUCE

CHAPTER 2
 Do We Have Your Attention? New Literacies, Digital Technologies,
 and the Education of Adolescents 19
 COLIN LANKSHEAR AND MICHELE KNOBEL

CHAPTER 3
 Adolescents' Multiliteracies and Their Teachers' Needs to Know:
 Toward a Digital Détente 40
 JAMES R. KING AND DAVID G. O'BRIEN

CHAPTER 4
 Millennials and Bobos, *Blue's Clues* and *Sesame Street*: A Story for Our Times 51
 JAMES PAUL GEE

CHAPTER 5
 What Do *THEY* Have to Teach *US*? Talkin' 'Cross Generations! 68
 MARGARET C. HAGOOD, LISA PATEL STEVENS, AND
 DAVID REINKING

CHAPTER 6
 Imagining Literacy Teacher Education in Changing Times:
 Considering the Views of Adult and Adolescent Collaborators 84
 KATHLEEN A. HINCHMAN AND ROSARY LALIK

CHAPTER 7
 Implied Adolescents and Implied Teachers: A Generation Gap for New Times 101
 CYNTHIA LEWIS AND MARGARET FINDERS

CHAPTER 8
 Shape-Shifting Portfolios: Millennial Youth, Literacies, and the Game of Life 114
 JOSEPHINE PEYTON YOUNG, DEBORAH R. DILLON,
 AND ELIZABETH BIRR MOJE

CHAPTER 9
 Re-crafting Media and ICT Literacies 132
 CARMEN LUKE

CHAPTER 10
 Using Digital Tools to Foster Critical Inquiry 147
 RICHARD BEACH AND BERTRAM C. BRUCE

CHAPTER 11
 Cut, Paste, Publish: The Production and Consumption of Zines 164
 MICHELE KNOBEL AND COLIN LANKSHEAR

CHAPTER 12
 What Happens to Literacies Old and New When They're Turned into Policy 186
 ALLAN LUKE

References 205

Contributors 223

Index 227

Donna E. Alvermann

PREFACE

Adolescence is a troubled term. As a categorical term for marking the space and time of being an adolescent—someone who is "not yet" an adult—the term comes under criticism on at least two fronts. First, there is the problem of biological determinism and its claim that adolescents are trapped within bodies destined to fall prey to the so-called physical, sexual, and emotional "excesses" of youth. Critics of this claim dispute a literature in psychology replete with accounts of adolescence as a period in young people's lives when turmoil, fueled by intrapersonal and interpersonal problems, is thought to consume most of youth's waking moments. Although this literature has met with strong criticism by those who view it as developmentally deterministic and age-biased, nonetheless its presence remains, most notably as a force behind some of the current rhetoric on family values and school violence.

A second critique of adolescence as an isolatable category—and adolescents as "not yet" adults—draws from the literature in social constructionism, which focuses on the centrality of people's use of language to construct a negotiated understanding about their lived experiences and the experiences of others. Although a social constructionist perspective offers warranted interpretations of various race, class, and gender differences among adolescents that members of a particular community have constructed together and tacitly agreed upon, it fails to address the underlying assumption that adolescents, themselves, are basically different as a group due to developmental, age-driven factors. Scholars who view a social constructionist perspective as inadequate for addressing these age-related factors are beginning to use sociohistorically informed practices in order to understand better how age categorization is achieved by adults and adolescents in interaction.

The authors in *Adolescents and Literacies in a Digital World* draw from a theory of youth culture that is critical of the notion that adolescents are incomplete adults. Rather than view them as "not yet" adults and thus less competent and less knowledgeable than their elders, the authors in this volume write about adolescents, who, like adults, know things that have to do with their particular situations

and the particular places and spaces they occupy. This situated perspective on youth culture argues as well for exploring how people (adolescents and adults alike) act provisionally at particular times given particular circumstances within various discourses. Working from a sociohistorical perspective, the authors in this volume focus on the multiple and complex ways that adolescent and adult discourses interanimate each other, thus avoiding to some extent the romanticizing and/or privileging of either discourse.

The literacies described and accounted for in this book are no less discursively (and historically) situated. They reflect the sociocultural, economic, and political struggles that come with reading the world, not just the word—in effect, they are the literacies that adolescents need presently as citizens of a fast-changing world filled with numerous complexities and challenges not yet comprehended. Specifically, the authors in this volume offer interesting insights into the digital world as we now know it, while simultaneously providing glimpses of that which is to come. Looking through their eyes and the case study data they have amassed on adolescents' use of literacies and new technologies, it is easy to imagine a widening gap between youth who have ready access to digital technologies and those who must struggle to get a foot in the door.

But *Adolescents and Literacies in a Digital World* is about more than access. It is about broadening the term *literacies* to include the performative, visual, aural, and semiotic understandings necessary for constructing and reconstructing print- and nonprint-based texts. It is also about surviving in an attention economy, communicating across generations, creating "shape-shifting" portfolios, reinventing literacy teacher education, and using digital tools to foster critical inquiry. Providing background for these multiple literacies are the myths and realities of neoliberal educational policy, teacher knowledge, information communication technologies, media studies, and zine culture. In short, the chapters in this book are about the use of new literacies and technologies and how they blur distinctions once thought to be inviolable.

These distinctions, as David O'Brien reminded me in a recent email, have been blurring for some time now. As David noted, before kids' lives in the mediasphere were singled out for study or juxtaposed in stark contrast to their school lives, the students in the Literacy Lab at Jefferson High in the early to mid-'90s routinely studied every topic they selected by using online and CD-ROM resources. They also represented their ideas with digital photos, video clips, and animations. Even though these so-called at-risk kids had failed for years at reading print on paper, they thrived in an environment in which they could create their own texts using Hyperstudio and Multimedia Director. The adolescents in the Literacy Lab at Jeff High encountered few challenges with digital media that they couldn't solve, and they were savvy enough to know that they needed to get their teachers up to speed so that the teachers could appreciate the work they were doing.

By embracing a rapidly changing digital world, the so-called millennial adolescent is proving quite adept at breaking down century-old distinctions between age groups, among disciplines, between high- and low-brow media culture, and within

print and digitized text types. But such embracing is not done uncritically; neither is it done for the sole purpose of compartmentalizing digital technologies as tools for learning, entertaining, or knowledge production. Rather, as Emily and Stephen Bruce, two teenagers with whom I've recently been in correspondence, clearly demonstrate, new technologies are part and parcel of their everyday lives. Emily, for instance, says she can't recall a single research project in the past three years for which she hasn't used the Internet. She emails her friends daily and also writes a weekly column for the local newspaper that traditionally employs only adults—a teen page called "Hit Return." In addition, this past summer, Emily did volunteer work at the University of Illinois's Center for Children's Books, updating its online journal files. Stephen emailed me that his experiences on the Internet were similar to those of his sister. He described how he spent his summer doing volunteer work to improve a university-based web site's navigation bars and images—work that will affect how users of all ages who visit the site will interact and find their way around the site. He also reported that he updates his home page, which he designed, whenever he can find time.

Adolescents and Literacies in a Digital World explores the significance of youth's engagements with digital technologies, such as those David, Emily, and Stephen describe, and more. At the same time, it takes into account how adolescents use information and communication technologies to negotiate meaning within a broad array of globally defined and self-defined literacy practices. In both instances, the volume succeeds in moving the discussion beyond a technocratic view of literacy practices toward an understanding of how digital culture locates adolescents in new ways—ways that necessarily challenge earlier views on what counts as literacy, for whom, and when.

Overview of the Chapters

In Chapter 1, Bertram (Chip) Bruce takes a historical perspective on the notion of "new literacies," asking how literacies, technologies, and social circumstances co-evolve and what changes in literacy practices mean for adolescents today. He argues that literacy becomes inextricable from community, from the ways that communities and society change, and from the material means by which knowledge is negotiated, synthesized, and used.

Chapter 2, co-authored by Colin Lankshear and Michele Knobel, focuses on the idea that a new kind of economy—an *attention* economy—is currently emerging, and that it will become increasingly dominant in the future. This idea is explored in relation to new literacies and digital technologies from the standpoint of formal (school-based) learning opportunities available (or not available) to adolescents being educated in contemporary classrooms

In Chapter 3, James King and David O'Brien build on notions from the preceding two chapters to argue, among other things, that teachers of so-called at-risk adolescents, whom they've studied, often position technology and media work as

"play" to distinguish it from school-sanctioned work. Claiming that within the classroom economy, technology work is often viewed as distracting students from engaging in "real" work, the two co-authors suggest the need for metaphorically lifting one's gaze above the immediate problem to gain an additional view.

In Chapter 4, James Gee describes and analyzes a story with important implications for how we think about the current state and future trajectory of schools and schooling in a digital world, especially as these relate to adolescents growing up in a media-rich environment. The story, rooted in both academic and popular texts, focuses among other things on Shape-Shifting Portfolio People—a notion that helps capture new ways in which class functions in the New Capitalism.

Chapter 5, co-authored by Margaret Hagood, Lisa Patel Stevens, and David Reinking, explores the notion of generational literacies. Using case study data, the authors portray the literacies in the lives of several individuals defined as millennial adolescents and as adults. From these individuals' own words, the authors examine how parallels and disjunctures open up and close off conceptualizations about literacies across and between generations.

In Chapter 6, Kathleen Hinchman and Rosary Lalik initiate a conversation with colleagues in literacy teacher education using a collaborative planning process called scenario-building. Their purpose is to consider possible issues and outcomes that would result if they were to change their pedagogies to reflect the impact of digital technologies on adolescents' lives. They also invite a group of adolescents to respond to the literacy educators' conversation.

In Chapter 7, Cynthia Lewis and Margaret Finders use the tropes of "implied adolescent" and "implied teacher" to show that what some may see as a generation gap—a simple case of divide between teachers and the "new media" adolescents they teach—is complicated by constructions of identity that come with material consequences related to access and authority. Using data from two case studies, the authors illustrate particular adolescents' and adults' identity performances as viewed within youth's extracurricular digital literacy practices and preservice teachers' attempts to infuse media literacies into their literacy lessons.

Chapter 8, co-authored by Josephine Young, Deborah Dillon, and Elizabeth Moje, extends and illustrates Gee's notion of Shape-Shifting Portfolio People. They present three case narratives in which they describe three youths' portfolios and explore how family income, race and ethnicity, native language, social class, gender, popular culture, digital technologies, globalization, and/or geographic and social space are part of these portfolios and influence adolescents' shape-shifting practices to attain future life goals.

In Chapter 9, Carmen Luke argues that media studies must contend with new information technologies and computer education, especially given the fervor with which computer education has been embraced, and the relatively modest incursions media and cultural studies have made into mainstream curricula. She suggests that the blending of media/cultural studies with computer, information, and communication technology studies can inject new life, as it were, into both fields of study.

Chapter 10, co-authored by Richard Beach and Bertram (Chip) Bruce, illustrates how, despite popular images of adolescents using media to construct themselves according to the values of a consumerist society, there is emerging evidence to suggest that their participation in digital technologies offers alternative ways of constructing identities. The authors provide numerous examples of how adolescents are using digital tools to engage in literacy practices that are part of the cycle of critical inquiry.

Chapter 11, co-authored by Michele Knobel and Colin Lankshear, provides a redress of the silence with respect to hard copy and electronic zines within literacy studies generally and the New Literacy Studies in particular. The authors argue that anyone interested in the nature, role, and significance of adolescents' literacy practices under contemporary conditions has much to learn from zines—especially in thinking about such texts from a sociocultural perspective.

In Chapter 12, Allan Luke focuses on new multiliteracies as an object of state educational policy. He describes a first cut at state policy that included some of the available discourses on both print and new literacies among particular generational cohorts of teachers, and finally, the implications of current patterns of neoliberal educational policy for the appropriation and remediation of new literacies.

In sum, the chapters in this book call attention to the relationships between adolescents and adults as they engage in multiple forms of literacy within and against the backdrop of a digital world. How such relationships develop, change, or sustain themselves over time as part of this world is key to understanding adolescents and their literacies from a sociohistorical perspective. For it is in emphasizing the *how* of these relationships—as the relationships shift and change—that we stand to gain insights into youth's literacy practices and their engagement in and with digital and media texts.

September 30, 2001 Donna E. Alvermann
Athens, Georgia

ACKNOWLEDGMENTS

I would like to thank the following people and offices for their generous support in making this volume possible: Rex Forehand, George Hynd, Steven Beach, Martha Carr, Sandra Gary, Joy Fulmer, Kristiina Montero, George Hruby, the Office of Vice President for Research, and the Department of Reading Education at the University of Georgia. I would also like to thank Daniel Martin, a 14-year-old, for his time and talents in creating original artwork that inspired the cover design, though it does not quite match his original computer graphic. Finally, a special thanks to the series editors and to Lisa Dillon for giving this project their careful attention and providing expert advice at every turn.

Bertram C. Bruce

DIVERSITY AND CRITICAL SOCIAL ENGAGEMENT: HOW CHANGING TECHNOLOGIES ENABLE NEW MODES OF LITERACY IN CHANGING CIRCUMSTANCES

Every other year, my children's high school hosts an event called "lock-in." Students are allowed to spend the entire night in the school talking, eating, dancing, playing games and music, watching videos, meditating, and doing some service activities, such as packing meals for a local shelter. The lock-in is presented primarily as a time for recreation that stretches the usual rules about staying up late and playing in the school, but with teachers and parent chaperones not letting the rules stretch too far. Being there provides a brief glimpse into adolescent life today.

Even in the somewhat artificial setting of the lock-in one can see some of the diversity of roles and activities that young people engage in as we begin the 21st century. Much of what they do reminds me of times when I was their age, but one key difference is the mediation of activities through electronic technologies. This year, in one room, I saw about a dozen students dancing to a music video, all facing toward a video monitor. In another, an even larger group were absorbed viewing Men in Black, one of a continuous series of videos shown that night. These movies relied on production technologies unknown in my high school days, in many cases realizing the possibilities of what were science-fiction notions a generation earlier. Their content likewise embraced a world of computers, gadgets, and high-tech weapons. Many students could be found alone, or in pairs. Some were talking or sleeping, but many were plugged into CD players, listening to music they had purchased, copied from their friends' CDs, or in some cases, downloaded from the Internet.

I spent some extended time as chaperone in the computer lab. A key assignment was to keep the food out. Food is normally forbidden in computer labs, but with the bending of the rules that night, a number of students thought they could bend the eating rule as well. Another normal rule for the lab is that students are supposed to do only school-related tasks; that is, activities such as word processing, reading email, searching for information on the web, and running simulation programs, but not using chat rooms or playing games. On this special night, that rule was lifted: Students could play games and visit web sites that were normally banned. I got an idea of how special the lock-in time was and how well that rule was enforced when one boy came in saying for my benefit, "Oh, yea! Computer games! It's not like we ever play computer games in the lab when we're not allowed to."

For a good part of my time in the lab there were two main groups. One was a group of boys playing computer action games, such as *Warcraft* or *Quake*. Although only one boy was typing at a given time, another might be controlling the mouse. About six others—the number varied as some would move in or out of the group—contributed suggestions and commentary: "Oh, great! You just killed one of the hostages. Back up and do it again."

Meanwhile, another group, this time all girls, were engaged in a quieter, but equally intense activity. When I wandered near, one quickly switched to another site so I wouldn't see what they had entered. It turns out they were at the "Emode" web site, which has scores of self-discovery tests ("from fun and wacky to downright serious"). Users fill out a multiple-choice questionnaire and receive an evaluation on questions such as "What's Your Celebrity Look?," "Are You High Maintenance?," "Who's Your Inner Rock Star?," "Who's Your Type?," "What's Your Movie Mood Tonight?," and "Are You a Workaholic?" Later, the same girl who had hidden her responses before gave me a tour of the site and shared some of the ratings she and others had received. Emode users can use the site to "link up with friends, share and compare . . . test results, and send personalized email invitations," with the implication that through the site one can find a soulmate.

The computer lab was a popular venue throughout the night of the lock-in, even though many of the students had access to computers at other times. As were the other digital technologies in evidence that night, the lab was worthy of the attention of adolescents (Lankshear & Knobel, this volume). Several other observations stood out for me: One was how much the use of the computers constituted a social activity. In many ways there was more talk, shared laughter, and physical closeness in the computer lab than in other activities in the school that night. Another was of course the stereotypical gender divide, both in terms of the particular computer applications being used and in the ways that students interacted with them. It was also striking how much there seemed to be a shared micro-culture around the computers and the specific applications, a millennial culture only partly accessible to the older generation (see Gee, this volume). There was a shared understanding regarding how to use programs or web sites, as well as opinions about which ones were worth using. There was also a common sense of how a group activity was organized, even though this was banned in the normal use of the lab.

A characterization that applies to the computer lab applies to many of the other activities that night as well: Young people were engaged in technology-mediated social interaction. These technologies included CDs and CD players, MP3 files, audio headsets, stand-alone computer games, interactive web sites, email and e-chat, DVDs, tape cassette videos, video players, and monitors. Rather than isolating them, these technologies served as media for interaction among the adolescents. They were boundary objects (Star, 1989) allowing them to connect with each other by means of and through shared artifacts (see the discussion of e-zines in Knobel & Lankshear, this volume). These *boundary objects* are now integral to the ways that these young people make meaning, communicate, and construct their social lives.

As social life moves into a wired, and now wireless, world, many educators ask whether traditional ways of teaching and learning, which had been developed in an industrial age, are still adequate for a time defined by video, the world wide web, cell phones, wearable computers, and instant messaging. The new technologies thus challenge the educational system, but at the same time support an expanded view of learning, which welcomes change, responds to new media, and extends the classroom to connect with the larger society. In this context, learning based on inquiry seems more needed than ever (see Beach & Bruce, this volume).

If we conceive literacy practices as a set of activities around texts, including understanding and composing, but also the whole complex of social relations and actions related to making and communicating meaning, then literacy becomes inextricable from community, and from the ways in which communities and society change. It is likewise inseparable from the material means by which knowledge is negotiated, synthesized, and used. This chapter takes a historical perspective on the notion of new literacies (Bruce, 1998), raising the question of how literacies, technologies, and social circumstances co-evolve and what changes in literacy practices mean for adolescents today. It presents first the case that a fundamental transformation is visible already in the literacy practices of young people, but follows that with questions about what this change really means. It then considers a framework for a critical examination of literacy and technology and its implications for research and teaching.

Are New Literacy Technologies Harbingers of a Radically New Literacy?

When asked to say what source they relied on for the last big report they wrote for school, 71% of teens in the United States with Internet access reported that the Internet was their major source, compared to 24% who cited library sources (Lenhart, Simon, & Graziano, 2001). More than half of these teens had used school or class web sites; a third had downloaded study aids, and a sixth had created web pages. Even their parents were getting involved: 28% have used email to communicate with their children's teachers. Today nearly every school in the United States has Internet access and many students have access at home, in

libraries, or in community centers as well. Various studies are showing substantial and growing use. For example, a survey by Statistics Canada (2001) found that 61% of households there had a member who spent 20 hours or more a month on the Internet in 2000, compared to 47% in 1999.

One consequence of the growing access to the Internet is that students are increasingly using email, instant messaging, web resource sites, essay sites, online reference tools, online tutoring, and ask-an-expert sites as an integral part of their school work. This for-school use merges with the out-of-school uses such as game playing and chatting with friends, so that a major chunk of adolescents' time each day is now mediated through the Internet.

The life of adolescents is thus already changing as a consequence of the affordances of new media: Using new communication and information technologies, teachers and students are discovering more ways to learn about the world, to express themselves, and to communicate with others. Stories of their classrooms are beginning to appear in books (e.g., Bruce & Rubin, 1993; Garner & Gillingham, 1996; Reinking, Mckenna, Labbo, & Kieffer, 1998), as well as, not surprisingly, on the web. These stories show that dedicated teachers can accomplish extraordinary things with good tools. Research in these classrooms has shown how important it is to understand the new ways of writing in the context of what we know about how people learn, as well as to examine what is needed to achieve the potential of the new media and learning resources. At homes and in after-school programs, these media provide new opportunities for creative expression and community (Garner, Zhao, & Gillingham, in press).

The previous examples provide only hints of what could be fundamental changes in literacy derived in whole or in part from the effects of new communication and information technologies. I discuss these changes below in terms of digital texts, new literate communities, and cultural transformations.

Digital Texts

Only a short time ago, but long enough that I cannot easily envision it, I wrote using a machine much noisier than the one I use today, one without a screen or a mouse. Each key clicked as it impacted the paper and required correspondingly greater pressure to imprint a letter. Today, I am surprised to come across a typewriter in use, even though such machines were the norm for writing just a short while ago. Before the typewriter, I wrote by hand. These have not disappeared, but their functions have changed. For example, longhand still serves well for personal notes and is a hallmark of personal attention in a way that it had not been in the era before mechanical typing.

One is tempted to say that the basic issues of writing have not changed: discussing, planning, organizing, thinking of audience and purpose, and revising are as pertinent as ever. And yet it is already not exactly the same; each new tool subtly changes the practice. For example, I recently wanted to find a citation for Paul Saffo's idea about short-term versus long-term change. In the past, I might have

turned to a manila folder containing scraps of paper, or a box of coded index cards. Today, I suspected that a quick check of the world wide web would help me out. I searched for "Paul Saffo" and "short term"; a Google search found 219 documents matching my query. A quick check of the first located an interview (Public Broadcasting System: Frontline, 1995; see also Saffo, 1996), with the following quote, which I could, of course, cut and paste directly into this article:

> . . . collectively as a society and as individuals we all suffer from what I call macromyopia. A pattern where our hopes and our expectations or our fears about the threatened impact of some new technology causes us to overestimate its short term impacts and reality always fails to meet those inflated expectations. And as a result our disappointment then leads us to turn around and underestimate the long term implications and I can guarantee you this time will be no different. The short term impact of this stuff will be less than the hype would suggest but the long term implications will be vastly larger than we can possibly imagine today.

Saffo's point applies well to writing. Initial expectations about word processing or the world wide web were often inflated. Only after these tools became integrated into daily practice did we find that we were no longer reading and writing in the same way. The merging of web browsing with writing, and writing with easy editing, to take just one example, has begun to change the writing process in substantial ways for many people. And now, there are new problems: A format checker might have difficulty with my Saffo citation: What is the page number for a quote from a video whose transcript is now posted in a web page? What are the consequences of coming to rely on the ease of searching the web? Is the citation of a web source meaningless for the reader who has no access to the web?

More and more texts are becoming accessible in digital form, with all that implies for rapid dissemination, duplication, indexing, storage, and searching both for and within the text (Burbules & Bruce, 1995). Many texts are now available not just additionally, but primarily, in digital form. This may constitute what Burbules calls "an epochal shift, in the ways we write and the ways we think about the importance of writing" (p. 107).

Thus, changes in writing technologies accompany changes in larger sociocultural contexts. Not only must the teaching of writing change to accommodate these shifts, but so must teaching and learning in general, inextricable as these are from the available forms of writing. This position is articulated in the introduction to the online journal, *Kairos:*

> In hypertextual environments, writers are not only learning to strike forcefully in the traditional sense of presenting the correct words in the proper manner, but are also learning to weave a writing space that is more personal than the standard sheet of paper. We are writing differently; we are reading differently; we are learning differently; we are teaching differently. *Kairos* is a journal that addresses these facts individually and syllogistically. [http://english.ttu.edu/kairos/]

Text is no longer a sequence of alphabetic characters on a piece of paper. Various writers (Barthes, 1985; Foucault, 1980; Kennedy, 1993; Latour, 1998; Lincoln, 1989; Selfe & Selfe, 1994) have shown us that social arrangements, clothing, buildings, new technologies, sports, and so on, can all be read as texts. We are just beginning to see the full implications of this perspective for visual literacy. Moreover, new technologies are making photographs and video images as manipulable, searchable, and writable as alphabetic text. Writing is now seen more clearly as assemblage, rather than creation *de novo:*

> The modern subject proceeds through life by selecting from numerous menus and catalogs of items be it assembling an outfit, decorating the apartment, choosing dishes from a restaurant menu, choosing which interest groups to join. With electronic and digital media, art making similarly entails choosing from ready-made elements: textures and icons supplied by a paint program; 3D models which come with a 3D modeling program; melodies and rhythms built into a music program. (Manovich, 1996)

The process of assemblage is aided by the *convergence* of communication technologies through the Internet (see C. Luke, this volume). Print, images, databases, instant messaging, conferencing, email, fax, radio, video, interactive programs, and virtual reality are now available through a web browser and becoming increasingly interoperable. Access to these tools is becoming possible in the most remote regions (Bruce, in press), not only for readers (one-way transmission), but for writers as well (two-way communication). The new technologies allow anyone to become a producer as well as a consumer. For example, *Live365* alone offers over 40,000 radio stations from around the world through the web. Users can create their own radio programs and deliver them through the site.

New Literate Communities

A university student sent the email message below to her class listing various web sites she had found on the subject of writing. Here is part of that message:

> 14.) http://www.venus/net/~emery2/writing.html[1]
> This is a site that describes the ideal Writers Workshop from the same elementary school as the previous site. There are tips for success in a workshop and suggestions for organization. It follows very closely with the philosophy of Donald Graves. There are also some links to sample writing from some of the children at the elementary school. If you are thinking about starting Writers Workshop in the classroom, this is a good place to look.

This message fragment is not all that remarkable on the surface, but as we look more closely, it is clear that we are seeing new forms of writing. For one thing, the code on the first line is an address on the world wide web. Using my email program I can click on that address and fairly quickly access the text she is describing.

Thus, her email message is a hypertext; its content is only partially contained in the few lines we see here. If we follow the hyperlink, we find ourselves in Madison, Indiana, at the E. O. Muncie Elementary School. We can read there about the approach to writing taken by a class in that school, and even see an example of writing by the student, Polly B.:

Bunny the Dog
Bunny is my dog and I had to give her away because we were moving. Now I couldn't hate my life more.
My dog's name is Bunny because she jumps a lot and she thinks that if she wiggles her bottom she can stay in the air.
But know I am lucky cause my grandma took her cause if she didn't, Bunny would have to go to the pound.
By Polly B.

Thus, a student, who might otherwise have published her writing on a cork bulletin board within the classroom, is publishing instead to the global community. Her story can be read anywhere in the world. Polly's story thus enriches the university student's message, and in turn adds to my understanding of what the E. O. Muncie School is doing. This could all be done without computers or the world wide web, but the ease of linking these texts makes possible a remarkable sharing of writing, and consequently, enlarged communities of learning.

Today, I feel a sense of immediacy and a much closer connection between research and writing than I remember from my high school or college days. It feels more natural to write reflecting on my own process of writing. Through the web, I also feel a greater connection to the writing of others. I know that if this text were on the web instead of in a book, there could be a hot link to Saffo's article, even his photo, email address, or the video session of the interview with him. The notion of a community of writers thus seems more real and present than ever before, making Barrett's idea (1989) of a "society of text" more tangible than metaphorical.

Complex projects that call for interdisciplinary collaboration, as well as collaborative support systems known as groupware, are increasingly pointing to professional writing as a collaborative process (see Kouzes, Myers, & Wulf, 1996; Lunsford & Bruce, 2001). The case of the solitary writer in the garret, or more pertinently, the student "doing his/her own work" may soon be seen as the anomalous case for writing. The Emode community is one such new literate community, one in which the social interactions around and by means of the computer represent heightened modes of co-construction of texts and meaning. Even my example of the Saffo quote is a new form of collaboration, in which writers make their texts more accessible and helpful to one another.

Collaboration becomes more salient in the work world as well, when demands for knowledge workers (Drucker, 1994) or symbolic analysts (Reich, 1991) situate workers within communities of practice that support lifelong learning. Proponents of the new economy argue that the new worker needs to understand the

work process and see it as inseparable from continual learning, un-learning, and re-learning. In the new digital economy, work will supposedly be more meaningful than in previous economies based on manufacturing or agriculture. This is certainly occurring to some extent, but Gee, Hull, and Lankshear (1996) have critiqued these claims, questioning the extent to which it happens for the majority of workers.

The new communities have much in common with communities as far back as we can see, but they also exhibit new forms of organization and new practices. Commentators have remarked on the lack of sustained engagement as people move from one place to another and switch jobs frequently. The connections through the web can be meaningful, leading even to marriages, but they also may substitute weak ties for strong ties, time divided into ever finer fragments among more and more people. All of this occurs as many feel an accelerated pace to life, with increased stress. The volume increases, but as McKibben (1993) argues, the apparent deluge of information may obscure the loss of more vital information about nature and human relationships.

Cultural Transformations

Technological developments greatly facilitate the operations of multinational cor-porations. Online databases, audio and video conferencing, automatic translation systems, and other new media enhance the global reach and local adaptation of world soft drinks, cars, and clothing. Work that was once tied to a particular locale and culture can now be redirected overnight to sites around the world. The growth of these companies leads them to act as supra-governments, controlling the movement of labor and making decisions affecting the environment, health, housing, and job security. The protests at WTO and G8 meetings reflect the pow-erlessness that many feel as these supra-governments replace more familiar and (possibly) accessible institutions.

To meet the needs of a multinational environment, many multinational corpo-rations move employees around specifically so that they and their families will de-velop a "cross-cultural glue" enabling them to acquire "global personalities" (Ka-plan, 1997, p. 72). They promote *umbrella cultures,* intended to transcend local and national boundaries. Whereas political conservatives question multiculturalism, their natural allies in large corporations have become among the major promoters in order to expand markets and establish the complete interchangeability of labor.

Literacy today cannot be understood separately from the increasingly inter-connected world in which we live and work. Globalization implies the need to understand the world through the eyes of others as well as through our own situ-ated perspectives. What will be the consequences of a world of "global personal-ities"? Will it lead to greater peace? To more global understanding? Or do its threats to the cultural strengths and diversities of the world challenge democratic societies? Is democracy, as Kaplan (1997) asks, just a moment in history that will be replaced by other political formations through continuing globalization? If

literacy is an expression of culture, what does it mean to create hybrid, umbrella, and technologized varieties?

Meanwhile, the nature of the languages in the world is changing rapidly. Hundreds of languages spoken today may die out over the next century (see *Ethnologue*, 2001; *Terralingua*, 2001). At the same time new languages, including many world Englishes and dialects for technical communication, are proliferating. It is not obvious how the new writing technologies will interact with these changes. Will they help preserve minority languages? Will they hasten the acceptance of English as the world's lingua franca? What will happen to the diverse writing systems now in use around the world, especially the nonalphabetic forms? Will greater international communication lead to more learning of other languages, or will automatic translation systems allow people to remain in their linguistic enclaves, yet still communicate?

Has It All Happened Before?

It seems inescapable that we live in a time of momentous change, with new social roles, massive immigration leading to a multicultural society, globalization, questions about political structures, and new literacy technologies. It is tempting to see our own era as a unique historical moment leading to radically new forms of literacy and even new kinds of people. But a very different stance toward the new technologies (Bruce, 1997) emerges from historical considerations. A century ago, technological change transformed American life much as it is doing today, with each change supplying the conditions for further changes (Malone & Crowston, 1994). The industrial revolution brought factories to the cities and mechanized agriculture to the farms. As workers moved from partially automated farms to run the new factories, urban areas grew rapidly. Railroads, and later the automobile, brought distant points together and changed the social order. Advances in printing and the telephone expanded communication practices.

The Turn of the Century

A consideration of U.S. society at the start of the previous century does not support the view that we are in an unprecedented time of globalization, technological change, and societal disruption. On the contrary, the changes of today all have precursors. Whether we think in terms of literacy technologies, immigration, dependence on foreign trade, social change, or consequences for education and literacy, the evidence favors the early period as being more tumultuous (see Bruce, in press).

On a list of the greatest engineering achievements of the 20th century (National Academy of Engineering, 2000), the computer ranks number 8 and the Internet number 13. Other technologies, most of which emerged in the early part

of the century, were judged more significant in terms of "impact on the quality of life." Electrification ranked number one, largely because it enabled most of the other achievements on the list. The automobile, airplane, water distribution, electronics, radio and television, and mechanization of agriculture all ranked ahead of computers. The telephone, which ranked ahead of the Internet, made nearly instant voice communication possible across long distances and directly affects most people today on a daily basis. Radio, television, and motion pictures have likewise had an enormous impact on society.

Technologies most directly related to literacy also saw significant changes in the early 20th century. Lithography, mechanical paper making, and cloth binding along with improved transportation enabled the mass production and distribution of books (Lewis, 1998). Color illustrations made reading more attractive and low cost made it more accessible to a mass audience. Even the mundane tools—such as dependable, low-cost pencils and pens—have been crucial to changes in literacy practices. It remains to be seen whether computers and the Internet will have a greater, or even comparable, impact.

Along with these technological changes the United States saw a rate of immigration more than double that of recent years. This arguably led to more significant changes in the cultural and linguistic fabric of American life. All of this occurred when globalization was a fact of life. As Smoler (1998) says,

> It is a great and misunderstood fact that globalization is a return to normal for the American economy. Between 1890 or so and 1914, America was the world's biggest trading economy except for Britain. A very large proportion of the economy was either imports or exports. There were massive direct investments, which dwarf the level of foreign investment you see now. (pp. 65–66)

Throughout the period of a century ago there was rapid social change accompanying the technological. Schooling was transformed through the introduction of compulsory education for most children, and the reduction of some class barriers. Struggles for the rights of women, immigrants, Native Americans, and African Americans were at very different stages, but all saw progress during this time.

Implications for Schooling

The combination of new literacy technologies, changes in the workplace, shifting demographics and social relations, and awareness of the international context led to demands for new forms of education. More people began to spend more time in school. Educators recognized the need for learning that was more responsive to new conceptions of knowledge and more attuned to the changing society (Dewey, 1938). Newly industrialized countries that were immersed in a global economy adopted mass literacy as a goal, seeing schools and public libraries (Minow, 1997) as vital to economic development.

During this time, pragmatism supplied a theoretical basis to account for a world in which what we knew changed from day to day. Thus, knowing, more a process than a static object, must grow out of reflection on experience, not simply be imported from some pre-existing structure. The progressive movement in education was built on these ideas, especially Dewey's articulation of the need to build a more inclusive society with methods appropriate to the new contexts for learning. Basing education on ordinary experience opened possibilities for learners and laid the basis for engaged citizenship.

Another force driving these changes was the need to assimilate immigrant and rural workers into an increasingly mechanized and urbanized economy. Libraries and advanced education helped inculcate political and social values seen as needed in a manufacturing-based economy. They shored up the class system as well by delineating the educated elites from the workers. Thus, although new libraries and extended education for the masses created expanded learning opportunities and promoted a democratic society, they also had the crucial function of fashioning "civilized" production workers who could function within a hierarchical system (Bowles & Gintis, 1976). Politicians today focus on education for many of the same reasons they did then. There are calls for restoring fundamental values in schooling and for increased accountability of students, teachers, and schools. Despite the hopes of many educators that new media will open up learning, the major effect may be instead to reinforce the normalizing function of schooling through online learning, computerized testing, and control of publication.

Constancy in the Midst of Chaos

Many of the purported changes of today are less obvious when one examines the evidence more closely. Despite the Internet, or rather because of it, over one billion books were sold in 1999 (Dembeck, 2000). The sales of books and magazines are at all-time highs and are growing, as are sales of academic journals (Leslie, 1994). There are also many indications that more people use more reading and writing in their work and leisure than ever before and that the rates are rising despite television (Newman, 1991), the "inadequate" schools, and the breakdown of the social order. Publishers of e-books are trying to figure out why they have not lived up to expectations.

The idea of "crisis" has been a recurring theme in writings about American education (Berliner & Biddle, 1996). This dismal view is conveyed by commentators across the political spectrum and persists whether economic times are good or bad. However, major long-term measures indicate gradual improvement in schooling generation by generation, across genders, and across major ethnic and racial categories (cf., Anderson, 1988). For example, high school graduation rates in the United States at the turn of the 20th century were around 6–8%; by the 1920s they had reached 17–29%; and by the 1940s had climbed to 51–59%. For the last 25 years they have remained steady at or above 80%, and at 88% for young adults (ages 25–29). These are now among the highest graduation rates in the

world (Marable, 1993; U.S. Census Bureau, 2000; White, 1987). College completion rates are now around 29% for young women and men (ages 25–29), the highest anywhere (U.S. Census Bureau, 2000). Achievement test scores, IQ scores, and other achievement measures also show steady, long-term improvement for every group (Berliner & Biddle, 1996).

Nearly all large-scale measures indicate that the level of literacy is higher than ever before. More people spend more time reading and writing. Even in de-skilled jobs, reading and writing are now assumed components of normal workplace abilities. As we look to the future, indications are that writing will become even more a part of ordinary life. Whatever else new technologies have done, it is difficult to make the case that they diminish literate practices or fully replace old forms of meaning-making with new ones. Instead, as they are assimilated they simply enrich a growing matrix of multiple genres and media.

How Can We Assess Change?

Literacy is implicated in all human activity, and as such, is a process of language, culture, economics, politics, history, and education. It is a set of social practices through which readers and writers make meaning together, but whether we think of writing with a word processor, chalk on a slate board, quill pen, crayon, or stylus on clay, the act of writing is a material act, one that is embodied in time and place. It involves technologies, both tangible devices and sets of practices that serve as tools for the literate person. New technologies are thus neither determinate nor irrelevant to the changes in literacy. If we are to make sense of changes in literacy, we need to develop better ways of conceptualizing technologies in relation to epistemological and social processes. Such a conception helps us move beyond the new/not-new, good/bad, and tool/media dichotomies that characterize the current discourse around new technologies.

These considerations suggest a four-part framework for assessing the new literacies. This framework calls for viewing literacy as a material activity, identifying realizations in practice, understanding technologies as representations of knowledge, and seeing how technological literacy is part of social literacy.

Literacy as a Material Activity

As I write, I see words appear instantly on a screen in front of me, silently—except for the click of the keys and hum of the fan cooling the computer underneath. More than usual, I am aware of the room, the furniture, my body, the artifacts, and the tools that define the material setting of my act of writing. These things do not determine what I write, but they participate in the act; they are part of what it means to me to write and in many subtle ways they undoubtedly shape the content.

Important though it may be, the physicality of writing, as revealed through the objects in the room around me, is by no means an independent force. The very fact that I have a computer to use derives from holding a particular kind of job in a society with a capitalist economic system that supports higher education. My position cannot be separated from my history, including all the circumstances of gender, race, and class that permit me to lead the life I do. Similarly, I write in a language that for a variety of economic and political reasons is rapidly becoming the lingua franca of the world. Thus, I know my writing has at least the chance of being noticed, without the requirement of first being translated into English.

I know that what I write cannot be extracted from a complex matrix of language, economics, social relations, technologies, and embodiment situated in activities and histories. I begin to see that the immediate materiality of my writing must be construed within a larger conception of its sociohistorical circumstances. If we are to understand the future of literacy, we need to see its physical manifestations as well as its social significance over time. This raises important questions: What is the sociohistorical moment at which we examine writing?

Writing was present when the first teacher encountered the first student. The student's questions led to pointing, gestures, marks in the sand, arrangements of sticks, and other ways of representing meaning, perhaps long before speech. And viewed in the context of today's multimedia representation systems, speech itself begins to look like simply another writing system. Writing is thus the first educational technology, and the many tools and forms of writing define a series of educational technologies:

Early communities with primitive symbol systems

> → complex oral language
>> → early writing/inscribing
>>> → manuscripts
>>>> → printing, typewriting
>>>>> → video
>>>>>> → word processing, email, groupware
>>>>>>> → digital/multimedia/hypertext; the web
>>>>>>>> → interactive systems, virtual reality

Figure 1–1. Stages in the development of writing technologies (adapted from Bruce, 1998).

These transformations gloss over many intermediate stages and side branches, but they are enough to suggest a pattern of relations between writing and its technologies. Each transformation offers at first merely new ways of doing old things.

For example, mechanical printing was faster than writing by hand, especially if one desired multiple copies. After that initial substitution stage, there is an enlargement of what people can do, and ultimately a reconfiguration of the social meaning and practices, not just their physical realization (Contractor & Seibold, 1993). There is room for debate about the direction and mechanism of the causalities, but the spread of printing certainly had implications in the West for the move toward widespread literacy, the growth of a merchant class, European imperialism, the Protestant Reformation, and other great social changes. The recent digital technologies are notable in that they not only portend similar changes, but that the linear process implied in the figure is clearly inadequate to account for the explosion of developments in diverse directions.

Realizations in Practice

One clear result of research on new forms of reading and writing has been to show clearly how technologies rarely produce simple, one-step changes. Instead, changes occur over long periods, as people develop enlarged understandings of what the technologies can do and how they enable new ways of relating to one another (Bruce & Easley, 2000). In her decade-long study of businesses struggling through the changes necessary for automating either production or office systems processes, Zuboff (1988) found changes in working conditions to be of historical significance; but people required time to integrate the new tools into their existing practices. As they integrated the new tools, their practices changed, which in turn made other new tools relevant in ways they had not been before.

A related result is that the realizations of a technologically based innovation vary widely (Bruce & Rubin, 1993). In a classroom, these depend on the teachers' goals, students' previous experiences with technologies, the available support, and the school's policies with respect to assessment and curriculum. One teacher may use a word processor to create practice lessons on punctuation while another may develop a year-long theme study that relies on extensive student writing and revision for publication. These differences reveal that the teacher's creative role is vital to the successful use of new technologies. As Allan Luke (this volume) shows, change depends on participants at all levels within the educational system coming "to grips with new cultures, identities, and technologies."

Technologies as Knowledge

Larry Hickman (1990) makes two remarkable claims about John Dewey's theory of technology. One is that Dewey's *pragmatic technology* is the most productive account of how technologies are developed and used, and how they operate within social systems. The second is that his theory of technology is a key to understanding Dewey's whole enterprise. Simply put, technology is characterized as the means for resolving a problematic situation. The method devised to solve one problem becomes knowledge that prepares us for enlarged experiences later.

For example, if we need to provide structure for student learning and we devise a curriculum unit in the course of solving that problem, then that unit we construct is a technology, and the concept of a curriculum unit is a technology that we may now use in future situations. A technology can thus be conceived as the thing we get when we engage with a present situation and "extract . . . the full meaning of each present experience" (Dewey, 1938, p. 49). As communities develop through shared literacies, they construct technologies that reflect their collective extraction of meaning from experience. Thus, community technologies are not only a means to enable or foster literacy, but the product of a community's literacy practices.

As individuals or communities construct new technologies, they too change. According to this view, adoption of new tools is always a constructive process. The technology represents an understanding of how a need within the community can be addressed. Because it is an understanding, and not an inert artifact, the technology does not merely mediate changes in practices, but also catalyzes changes in social interactions, values, and power relations. As Zuboff (1988) found, it was not simply that new processes were adopted, but that in order to make new technologies succeed, organizations had to change as well, often in major ways:

> The material alterations in their means of production were [transforming their] assumptions about knowledge and power, their beliefs about work and the meaning they derived from it, the content and rhythm of their social exchanges, and the ordinary mental and physical disciplines to which they accommodated in their daily lives. (p. xiii)

This is another reason why Saffo's long-term changes are unexpected. It is not merely that "our disappointment" with "unfulfilled expectations" leads us to underestimate long-term effects, but that we fail to see how we will change. We are quite good at measuring the speed, size, or power of a new tool, but we have trouble conceiving that we could become something other that what we are today. We cannot easily accept that the meaning of our work, the nature of our knowledge, the "content and rhythm of [our] social exchanges," the power relations in our communities, our language, or the way that we live our lives could be much different from what they are now.

Social Literacy

The term *new literacies* has been used to refer to various hyphenated literacies: information-, media-, Internet-, visual-, computer-, consumer-, and scientific-, to name just a few. They all relate to new means for representing knowledge and communicating. These terms usually imply access, as well as the acquisition of appropriate skills and knowledge (Bruce & Hogan, 1998; Nardi & O'Day, 1999). As members of diverse communities using these technologies, we must also develop our social literacy (Bishop, in press; Bishop, Bazzell, Mehra, & Smith,

2001), including learning how to read each other and how to grant respect and va-
lidity to diverse funds of knowledge and social capital (Smith, 1989). We need new
social content in the form of artifacts and structures both online and offline that
embody constructive social change. As Dewey (1966) shows, the path of individ-
ual development is inseparable from the processes of societal growth and change.

The richness of the new technologies, the access to vast resources on the world
wide web, new media, and interactivity can sometimes lead to a focus on procedures
over critique, thus exemplifying the split between computer literacy and media lit-
eracy discussed by Carmen Luke (this volume). This can lead to emphasizing con-
tent or methods in teaching, with less attention to individual learners. When we
design a web site we think of its wonderful graphics or how much information it
contains. Slowly, our focus shifts from the student to the materials. The teacher-
centered classroom begins to dominate. Students, too, risk alienation rather than
connection. Being guided by technology alone, we engage in what the French phi-
losopher and social critic Jacques Ellul (1973, 1980) calls La Technique, the modern
drive to organize living in terms of procedures that operate with mechanical preci-
sion to the exclusion of deeper human values. In essence it means elevating proce-
dures over people, machines over humanity.

Research Questions

Literacy is embedded within a complex matrix of language, economics, social rela-
tions, technologies, and physicality. If this is so, and if these relations are multifac-
eted, interactive, dynamic, and even contradictory, then how do we conduct useful
research that will lead to greater understandings of the processes of writing or the
teaching of writing? Can we generate specific, meaningful findings that respect the
complexities and the dynamics of change? Some key questions are these:

In what ways will we think about literacy differently when our potential audi-
ence has immediacy and global reach?

To what extent will the writing of students in schools around the world exhibit
the global popular culture, as opposed to historically-defined local cultures?

In what ways will our concepts of published writing change through elec-
tronic media, and how will those changes in turn affect what we expect of stu-
dents in school?

What will be the languages for writing in the next generation?

Can we develop a framework for studying literacy that recognizes its material
conditions without reducing it to a technocentric account?

Is multimedia a mode or extension of writing as we currently conceive it? To the
extent that this is so, how does that change the way we should teach writing?
How will our notions of collaboration, ownership, and plagiarism change as
new tools make the finding, sharing, and intermingling of texts and writers so
much easier?

How will new modes of gathering information, reading, and writing relate to the existing educational disparities along lines of race, class, nationality, language, gender, and physical ability? Will the new media lead to a blurring of these lines of social conflict, or will they heighten them as never before?

What really happens in the classroom when new approaches to literacy are introduced? How do students perceive their reading, their writing, and themselves in relation to new media?

What do teachers need to know to cope with all these changes and to support literacy development in the new century?

Questions such as these position both literacy and literacy education within a matrix of historical, institutional, cultural, social, and technological relations. They remind us that literacy is not just a procedural act, but a way of being in the world.

Conclusion

Simply using computers or connecting to the network does not ensure that teaching is easier and more effective or that adolescents will be automatically well prepared to read, write, and live in the 21st century. Instead, making good use of new technologies increases the demands on teachers, at least initially. Educators face major challenges to use these technologies to expand the possibilities for learning.

Recognizing the importance of new technologies for future writing, and knowing about the good effects they can have, many people feel that there is no question about the desirability of the world wide web, electronic mail, CD-ROMs, and other new technologies, but only about their availability. Most Americans would willingly pay higher taxes to meet school technology needs and nearly all think that well-equipped schools have major advantages in information access and in preparing adolescents for the workplace. Some go so far as to equate good teaching with the use of new technologies, implying that the presence of computers in the classroom means the teacher in that classroom is up to date, innovative, and successful. Unfortunately, new technologies are no panacea for problems in education and by themselves they at most enable, rather than create, change. It is ironic that the research showing how powerful computers can be ultimately brings us back to the familiar idea that it is teachers who make the difference (Cuban, 1993; Goodlad, 1990; Jackson, 1986).

The present conditions also call for an expanded view of learning, one attendant to diversity and critical social engagement (Dewey, 1956; Mitchell, 1961). Adolescents need to learn how to integrate knowledge from multiple sources, including music, video, online databases, and other media. They need to think critically about information that can be found nearly instantaneously throughout the world. They need to participate in the kinds of collaboration that new communication and information technologies enable, but also increasingly demand. Considerations of

globalization lead us toward the importance of understanding the perspective of others, developing an historical grounding, and seeing the interconnectedness of economic and ecological systems. Rather than learning to solve well-structured problems of the kind seen in textbooks, there is a need to know how to engage with a complex situation and turn it into a problem that can be solved; thus, to find problems rather than just to solve them. Learning how to learn becomes ever more relevant in a rapidly changing technological and cultural environment. These *soft skills* (Murnane & Levy, 1996) are increasingly important in today's Internet world.

The reality for adolescents is that they already live within the technologized world that the advertisers promise us and Ellul warns us about. Our task is not to prepare them to be components of the global machine, nor to shrink from it, but rather to help them engage that world as informed participants and critics. Beyond any specific imperatives, the new literacies highlight the central role that language and cultural values have always had in education. Thus, as we move into the fast-paced, multimedia, internationalized 21st century, the needs in literacy education direct us to earlier conceptions of learning grounded in ordinary experience and social concerns.

Notes

1. Unfortunately, that link no longer works. As any user of the web soon discovers, the half-life of web links is very short, perhaps less than a year. Contrary to some initial hopes, it now appears that it is a greater challenge to preserve digital documents than to preserve those written on paper or clay.

Colin Lankshear and Michele Knobel

DO WE HAVE YOUR ATTENTION?
NEW LITERACIES, DIGITAL
TECHNOLOGIES, AND THE EDUCATION
OF ADOLESCENTS

What information consumes is rather obvious. It consumes the atten-
tion of its recipients. Hence a wealth of information creates a poverty
of attention and a need to allocate attention efficiently among the
overabundance of information sources that might consume it.

—SIMON, 1971, pp. 40–41

If one is looking for a glimpse of what literacy will look like in the fu-
ture, the fighter cockpit is a good place to look . . . The most interesting
conversation I have had about literacy at the end of the twentieth
century was with a fellow who designed avionic displays for fighters.
He knew all the basic questions and a good many of the answers.

—LANHAM, 1994, n.p.

 This chapter is based on the idea that a new kind of economy—an *atten-*
tion economy—is currently emerging, which will become increasingly
dominant in the future (Goldhaber, 1997). We will explore this idea in re-
lation to new literacies and digital technologies from the standpoint of formal—
school-based—learning opportunities available (or not available) to adolescents

being educated in contemporary classrooms. After introducing the concept of an attention economy in some of its main variations, and considering some of its surrounding theory, we will address three key questions about the relationship between education and the attention economy:

1. What significance do digital technologies have for paying, attracting, and maintaining attention?
2. What significance do new literacies have for effective participation in an attention economy?
3. What do findings from 1 and 2 above imply for formal education?

Conceptions and Theory of an Emerging Attention Economy

While there is growing agreement that an attention economy is emerging, we nonetheless find significant differences in substance and perspective among those who employ and support the idea. These differences will result in varying implications for formal education if we decide that education should indeed attend to the nature and demands of an attention economy. To help clear the terrain, then, we will describe what seem to us to be three significantly different "takes"—albeit with broad "family resemblances"—on the concept and theory of an emerging attention economy. These are associated with work by Michael Goldhaber (1997, 1998a, 1998b), Richard Lanham (1994), the Aspen Institute (Adler, 1997), and the NCR Knowledge Lab (MacLeod, 2000). We will take these briefly in turn.

Michael Goldhaber on the "Attention Economy"

Goldhaber links the superabundance of information to the hypothesis of an emerging attention economy. He believes the fact that information is in oversaturated supply is fatal to the coherence of the idea of an information economy—since "economics are governed by what is scarce" (Goldhaber, 1997). In other words, economies are based on "what is both most desirable and ultimately most scarce" (Goldhaber, 1998b, n.p.). Yet, if people in postindustrial societies will increasingly live their lives in the spaces of the Internet, these lives will fall more and more under economic laws organic to this new space. Goldhaber (1997, 1998a) argues that the basis of the coming new economy will be attention and *not* information.

Attention, unlike information, is inherently scarce. This, says Goldhaber (1998b), is because "each of us has only so much of it to give, and [attention] can only come from us—not machines, computers or anywhere else" (n.p.). But like information, attention moves through the Net. Goldhaber identifies cyberspace as the being where the attention economy will come into its own.

The idea of an attention economy is premised on the fact that the human capacity

to produce material things outstrips the net capacity to consume the things that are produced—such are the irrational contingencies of distribution. In this context, "material needs at the level of creature comfort are fairly well satisfied for those in a position to demand them" (Goldhaber, 1997, n.p.), the great *minority* of living human beings, it should noted. Nonetheless, for this powerful minority, the need for attention becomes increasingly important, and increasingly the focus of their productive activity.

Goldhaber (1998a) argues that when our material desires are more or less satisfied, such that we do not feel pressures of scarcity (such as being afraid of hunger or lack of shelter), we are driven increasingly by "desires of a less strictly material kind" (n.p.). Several such desires, he believes, converge toward a desire for attention. These include, for example, a desire for meaning in our lives—which is no longer a "luxury" once material needs are assured. Goldhaber links the search for meaning to gaining attention. "Why are we here, and how do we know that we are somehow worthwhile? If a person feels utterly ignored by those around her, she is unlikely to feel that her life has much meaning to them. Since all meaning is ultimately conferred by society, one must have the attention of others if there is to be any chance that one's life is meaningful" (Goldhaber, 1998a, n.p.). Hence, the attention economy:

> [T]he energies set free by the successes of . . . the money-industrial economy go more and more in the direction of obtaining attention. And that leads to growing competition for what is increasingly scarce, which is of course attention. It sets up an unending scramble, a scramble that also increases the demands on each of us to pay what scarce attention we can. (Goldhaber, 1997, n.p.)

Goldhaber makes six points of particular relevance to our concerns here. First, in economically advanced societies young people during recent decades have spent a huge proportion of their waking hours within two key contexts: either in school, or engrossed in media—especially television and recordings. The experiences of these contexts involve paying great amounts of attention and, moreover, focusing attention on "a relative few" (Goldhaber, 1998a, n.p): TV personalities; stars in different fields (music, sport, films, etc.) whom we attend to via television, audio media, or contemporary multimedia; teachers; selected members of our peer group, and so on. Goldhaber notes that

> everyone who is seen on television models one common role, as do all teachers in schools, and that role is to be the object of a good deal of attention. Thus, without planning or intention, there has been a kind of cultural revolution, telling us that getting attention is a fine thing. And for many of us, having the attention of others turns out to feel very good, something we often want more of. (Goldhaber, 1998a, n.p.)

Second, Goldhaber envisages two "classes" within the attention economy. These are "stars," who have large amounts of attention paid to them, and "fans,"

who pay their attention to the stars. Because paying attention requires effort, fans supply most of the effort in the attention economy. Unlike most workers in the industrial economy who had/have only one boss, fans will typically devote their attention-paying effort to multiple stars. While stars are the great winners in the attention economy, the losers are not necessarily the fans—who may receive sufficient "illusory attention" to meet their attention needs. The losers, says Goldhaber, are those who don't get any attention, who are simply ignored. This entails having "less of a clear identity and place in the community" (Goldhaber, 1998a, n.p.). The extreme case is a homeless person who dies in the street but is ignored for days—as happened in L.A. (Goldhaber, 1998a). "Losers" may be people who do not stand out sufficiently to attract attention, or individuals who do not effectively reward attention paid to them, or else individuals who repel others by demanding too much attention.

Third, being able to participate in the attention economy involves knowing how to pay and receive attention. A distinction between real attention and illusory attention is involved here. This is because in order to get attention one has to pay attention. Goldhaber (1997) argues that in a full-fledged attention economy the goal is simply to get enough attention, or to get as much as possible. Clearly, accumulating more than one's "share" of attention involves receiving more than one puts out. On the other hand, if one is to get attention one has to pay attention. The conundrum, so far as the attention rich are concerned, is resolved by the distinction between real and illusory attention. Stars and performers pay "illusory attention" to fans and audiences. They create the illusion that they are paying attention to each fan, to each member of their audience. Attention involves an exchange. People will withhold attention if they have no interest in the exchange. When readers lose interest in a chapter, they put the book down. To maintain interest they have to believe that the author is attending to them and their needs or desires. Creating illusory attention may be done by "pretending to flatter" the audience, "creating questions in their minds which you then 'obligingly' answer," claiming you will "help them with some real problem they have," making eye contact, gesturing, and so on (Goldhaber, 1997, n.p.). Methods of creating illusions of attention may lose worth (effect) if they become too common or well recognized.

Fourth, the emerging attention economy is creating large markets for attention technologies—technologies that allow us to get attention, or that make it possible for us to go after it. The Internet is a classic example (see below). But old technologies, such as stages where entertainers perform, are also important. The recent invention of digitized wearable display jackets (Kahney, 2000) is a new trend in generating attention (see below). This may involve gaining attention directly, for example, by advertising oneself. It may, however, involve a form of "three-way attention transaction" (Goldhaber, 1998a, n.p.). This is where one has attention passed to one by somebody else—as when advertisers use stars to pass attention to clients and their products, or show hosts pass attention to guests (but in turn also receive attention from fans of the stars who watch the shows). Hence, someone wearing a display jacket may screen clips of a popular star.

Fifth, the attention economy necessarily entails a new kind of privacy from the familiar kind of having private space away from the public gaze. Those who would accumulate attention have to be "out there." Attention wealth accrues from expressing oneself fully, living one's life "as openly as possible," and expressing oneself "as publicly as possible as early as possible"—e g., putting drafts on the web, rather than keeping them under wraps until publication (Goldhaber, 1998b, n.p.). The quest for privacy under these conditions becomes one of avoiding being constrained by "would-be attention payers" and avoiding having to pay them too much attention (Goldhaber, 1998a). Whereas the old privacy was about not being seen, the new privacy will be about "not [having] to look at or see anyone else" (Goldhaber, 1998b, n.p.).

Finally, gaining attention is indexical to originality. It is difficult, says Goldhaber (1997, n.p.), to get new attention "by repeating exactly what you or someone else has done before." Consequently, the attention economy is based on "endless originality, or at least attempts at originality" (Goldhaber, 1997, n.p.). Attention is a function of "everything that makes you distinctly you and not somebody else" (Goldhaber, 1998b, n.p.).

Richard Lanham on the Attention Economy

In *The Economics of Attention* (1994), Lanham's focus is on the changing world of the library and, especially, on the changing role of librarians in the age of digitized information and communications technologies. According to Lanham, in order to address questions like, "How are libraries and librarians to negotiate the changing terrain of information?"; "What kind of changes are involved?"; and "Where should one look for clues to handling the changes?," it is important to understand the new economy of attention.

Lanham shares some common bases with Goldhaber. He begins by observing that we currently seem to be moving from "the goods economy" to "the information economy" (Lanham, 1994). Within the so-called information economy, however, information is not the scarce resource. On the contrary, "we are drowning in it" (Lanham, 1994, n.p.). At least, to put it more accurately, we are drowning in a particular order or kind of information—information as raw data.

Lanham argues that we use different terms for information, depending on how much attention—"the action that turns raw data into something humans can use"—has been given to it. No attention gives you "raw data." Some attention gives you "massaged data." Lots of attention gives you "useful information." Maximal attention gives you "wisdom." And so on (Lanham, 1994, n.p.). For simplicity's sake, Lanham reduces these to data, information, and wisdom, and claims that of these wisdom and information are in shortest supply. In the face of the volumes of data coming at us "we do not have time [and] do not know how to construct the human-attention structures that would make data useful to us both for . . . private life and public life, domestic economy and political economy" (Lanham, 1994, n.p.). The scarce resource in the information economy, according to Lanham, is attention.

Like Goldhaber, Lanham claims that the key resource of the new economy is non-material (or what he calls "immaterial"). But when the most precious resource is non-material, "the economic doctrines, social structures, and political systems that evolved in a world devoted to the service of matter become rapidly ill-suited to cope with the new situation" (Wriston, 1997, pp. 19–20). Similar to Goldhaber, and along with growing numbers of others (e.g., John Perry Barlow, cited in Tunbridge, 1995), Lanham insists that we cannot continue to apply concepts, laws, practices, and the like that were developed to deal with the economic world of goods to the emerging economic world of information. Entertaining and exploring the notion of an emerging economy of attention looks like a step in the right direction.

From these similar starting points, however, Lanham's thought develops in a different direction from Goldhaber's. Rather than focusing on how to gain and maintain attention, Lanham is concerned with how to facilitate or enable attention to data by developing new human attention structures for attending to the flood of information-as-data that we face constantly. He notes that banks have been early starters here, out of necessity since the banks' traditional role of safeguarding clients' money and lending it out has largely been taken over by other institutions. "To survive, banks are now creating from the digital stuff of instantaneous global data new attention structures for savers and borrowers, new investment instruments [which banks call] 'securitization'" (Lanham, 1994, n.p.). These provide people with new frames for attending to the [financial part of their] world.

Lanham elucidates the concept of human-attention structures by reference to examples from contemporary conceptual art and pop art. In an environmental art exhibit which involved erecting many large umbrellas in two very different kinds of location—a rainy valley in Japan and a desert mountain pass in southern California—the artist, Christo, created "temporary attention structures to make us pause and ponder how we engage in large-scale collective human effort." The "product" was attention structures rather than objects. "The center of the project . . . became the contrast in how each culture went about its work, both social and geographic" (Lanham, 1994, n.p.).

Some decades earlier Roy Lichtenstein had taken popular attention structures like the comic strip as his subject matter. Andy Warhol, as much as conceptual artists in the mould of Christo, Rauschenberg, and Robert Irwin, along with today's leaders in the aesthetics of digital expression, recognized that organizing human attention was "the fundamental locus of art, not making physical objects" (Lanham, 1994, n.p.). Lanham notes that many of Warhol's best remembered observations indicate how far the Pop Art explosion comprised an "Arts of Attention Management": compare, "we weren't just *at* the exhibit, we *were* the art incarnate and the sixties were really about people, not about what they did," and "Fashion wasn't what you wore somewhere anymore, it was the whole reason for going" (Lanham, 1994, n.p.).

Within the information economy the scarce commodity is "how human attention sorts out an overpowering flow of information" (Lanham, 1994, n.p.). Exam-

ples from the worlds of conceptual and pop art reveal the macroeconomics of attention. From the perspective of the microeconomics of attention, Lanham asks how the overload of information carried by "the rich signal" which is the heart of the digital revolution can be managed. This signal can be manifested as alphabetic text, as image and as sound, and "creates its own internal economy of attention" (Lanham, 1994, n.p.). Lanham illustrates this with his example of fighter-jet cockpit displays, where digital data arrives at quantum rates in alphabetical and numerical information, in iconic displays, and as audio signals. A design was needed to mix all this data-information into "a single functioning information structure" that, as in the rest of contemporary life, allows our minds to make sense of data coming at us "thick and fast" (Lanham, 1994, n.p.). This is a technical instance of the larger questions of how to develop structures—frames and organizers—that facilitate paying attention to data so that we can turn it into something useful, and who will develop these structures. To the extent that the world of information at large is becoming like the fighter cockpit displays as it falls increasingly under the logic of digital expression, the key questions for literacy and the answers to those questions will increasingly concern how to develop attention structures and to organize and manage attention.

As a new dominant metaphor for thinking about our world, as matter and energy were previously, the model of information directs us to attend to what lies behind or beneath "stuff"—the world of objects—and to see "hidden forces and forms . . . which those objects allegorize" (Lanham, 1994, n.p.). Similarly, a theory of communication based on stuff presupposes a model of simple exchange whereby a package of thought and feeling is transferred from one body and place to another or others. The same communication model, says Lanham, employs a "Clarity-Brevity-Sincerity" style of prose and expression (n.p.).

Lanham argues that this model no longer applies. In terms of style and expression, the transaction within an attention economy is no longer "simply the rational market . . . beloved by the economists of stuff." Rather, people bring with them to the free market of ideas "a complex calculus of pleasure" and "make all kinds of purchases" in the attention economy. Lanham suggests that our efforts to learn and understand how to handle the new conditions of "seeing" and thinking about the world, and of style and expression—in short, how to develop appropriate attention structures—may be usefully informed by earlier and long-standing arts and habits. These include the Western tradition of rhetoric and the medieval allegorical habit of life and thought that saw "the immanence of God as informing all things" (Lanham, 1994, n.p.).

In spatial terms, the information model is revolutionizing practices of literacy and thinking, which Lanham illustrates by reference to the library. No longer, says Lanham, can librarians see their role as one of "facilitating thinking done elsewhere," as was the case in the age of lending out books. Under that regime, the role of the librarian was a matter of librarians "maintaining the signifiers, and leaving the decryption of the signifieds to the readers" (Lanham, 1994, n.p. The quotation is from a librarian named Atkinson, who corresponded with Lanham on

this theme, arguing that the role of the librarian remained the same in the information age as it had been before. Lanham repudiates this position). Instead, in the world of superabundant information, thinking involves constructing attention structures, and libraries and librarians are in the middle of this—as schools and teachers and academics should be (although Lanham holds out little short term hope for universities and does not mention schools).

The point, finally, is that gateways will need to be developed to facilitate attention to information, to turn it into something useful for users and to enable users to use it usefully in terms of their wants and goals. Lanham believes, however, that this involves much more than the current development of intelligent software agents like search engines, specialized bots, and the like. Rather, he says, there is a frame issue involved. Building attention structures is more than a software or "technical" issue alone. It calls for an architecture that incorporates frames, and for a "new kind of human architect" who will mediate the economics of attention. This will be far from a technical task and will comprise the highest order and most powerful, sought-after and rewarded literacy.

Advertising and the Attention Economy: The Aspen Institute and National Cash Register's Knowledge Lab

Not surprisingly, the notion of an economics of attention, and the theme of how to gain attention as an increasingly scarce resource in proportion to the sources competing for it, have entered advertising discourse during recent years. Advertising is a domain of human practice with a strong stake in the economics of attention: "The first challenge for every advertiser is to capture and hold the attention of the intended audience" (Adler, 1997, p. 5). Indeed, advertisers have to create attention to products in which the targets of advertising typically have no inherent interest. Despite the massive and increasing amount of time citizens in countries like the United States spend using or consuming media of one kind or another—projected to reach 60.5% of the waking hours of the average U.S. person in 2000—advertising faces ever-increasing competition for attention. More is involved in this competition than the success of advertisers and products alone. The very fortunes of the media used for advertising—from TV (whether public broadcast or cable) to the world wide web, via newspapers, magazines, and radio—fluctuate with and depend upon levels and constancy of advertising revenue.

In 1996 the Aspen Institute hosted a seminar to assess the current state of and prospect for the field of advertising and to identify perspectives on how individuals choose to allocate their attention. The seminar made particular reference to the context of emerging new media, notably the Internet and world wide web, which have the potential to challenge established media as advertising channels. As Internet use has continued to grow rapidly in recent years, the Net has been transformed "from a non-profit medium for academic and personal communication into a dynamic commercial medium" in which most major corporations and many small companies have established an online presence (Adler, 1997, p. 20). Although

Internet advertising accounts for only a tiny proportion of total current advertising expenditure, it is growing rapidly and a hot search has been mounted by marketers and advertisers to create ever new and more effective means for gaining attention.

The Internet, however, presents advertisers with differences in both degree and kind from other media. The Web, for example, produces a *massive* "fragmentation of channels" (Adler, 1997, p. 21). As the original situation of a very small core of television networks became dozens and then literally "hundreds of different cable- and satellite-delivered channels," advertisers had to switch from broadcast to narrowcast strategies. With the advent of the Net, however, "there are now potentially millions of channels available, with the conceivable end point being a separate, customized channel for each individual" (Adler, 1997, pp. 21–22). The growth of new interactive media creates the possibility for one-to-one marketing. This involves a strategy which focuses less on building advertising market share than on "investigating a company's *best* customers and building a one-to-one relationship with them" in order to get more purchasing or consuming per customer by "treating them as individuals . . . [to] build loyalty" (Adler, 1997, p. 24).

This is a context where there is much to play for and where old kinds of intermediaries and partnerships change and new ones are invented. For example, given that distribution expenses may account for 50–80% of the end cost of consumer products, if producers can bypass conventional marketing and distribution intermediaries and sell direct to the consumer via the Internet, this has potentially huge advantages for the latter in terms of cost and ease. At the same time, however, Internet users have greater potential than users of other media to actively control the information they receive. In Net advertising, the relative balance of power shifts from producers to consumers of advertising, since on the world wide web customers do not face the choice of sitting through intrusive ads (Adler, 1997, p. 37). The logic that has to operate in Net advertising is less one of how media users can opt out of advertisements to one of how advertisers can get users to opt in to marketing information.

This has seen the emergence of new kinds of intermediaries, like search engines, bots, the active creation of interest-based online communities with potential for commercial exploitation, collaborative filtering technology for sharing views and interests online, and so on. For example, marketers quickly saw and acted on the potential of creating and exploiting online communities concerned with specific topics that would attract key groups or niches of customers. Once these audiences are created and identified, marketers can interact with them to "sell and support products, provide customer service [and] conduct continuous market research" (Adler, 1997, p. 25). Ingenious devices and processes — as well as some utterly gross forms — have been developed to capture audience attention on the Internet. Gross forms include "spam" and "push" strategies, as well as successive generations of eye-catching "gizmos" (animation, flashing signals, etc.). Subtler means include companies hiring marketers to create "ad bots" that inhabit chat rooms and similar spaces on the Net. These respond to trigger words and can engage potential customers in private conversation that has commercial relevance (Adler, 1997).

High-profile research work, backed by serious budgets, aimed at developing approaches to advertising grounded in the economics of attention are under way. Perhaps the current leader in the field is the NCR Knowledge Lab. The lab's work in this area begins from the idea that consumers are saturated with potential information sources for practically any requirement and simply cannot use all the available options without eating heavily into time. For producers and vendors operating in the emerging network economy, this creates the challenge of how to get the attention of those consumers they want to attract and/or keep, and how to make their product or brand stand out amidst increasing competition for customer attention. According to the Knowledge Lab, as the network economy continues to grow, attention will become increasingly scarce. In an early statement, now superseded in the latest information contained on its site, the lab claimed that firms now "think of themselves as operating both in an Attention Market as well as their core market" (http://www.knowledgelab.ncr.com, sourced 20 July 1999). The lab's introduction to its research focus claimed that:

> Attention will be hard to earn, but if it is viewed as a reciprocal flow, firms can use information about consumers and customers to stand out in a sea of content to increase profitability: pay attention to them and they pay attention to you. Relationships are likely to encompass attention transactions. As customers realize the value of their attention and their information needed to get it, we show that they may require payment of some kind for both.
>
> The Knowledge Lab is looking into how we can quantify, measure and track flows of attention in the Network Economy (http://www.knowledgelab.ncr.com sourced 20 July 1999).

To this end, the Knowledge Lab has established consumer research as one of its five research foci. The program comprises research into a web of intersecting themes. These include (among others) the nature and role of online branding, the use of interfaces for interactions and relationships with customers, the adoption and diffusion of new technology, online communities and relationships, "connecting with kids" and "cashless kids," together with research on the attention economy. The lab has also developed and trademarked the concept of "relationship technologies" and settled on a view of attention as "engagement with information." The key to successful business in the future, says the lab, will be the capacity to generate and maintain personal attention to new and existing customers. Advertising can create *opportunities* to gain attention, but it cannot actually secure, let alone maintain and build, ongoing attention (MacLeod, 2000). Early work by lab researchers suggests the importance of using personal information to gain initial attention, and "harnessing [this] attention" to create successful "real relationships" with customers (MacLeod, 2000, p. 3) with the assistance of "relationship technologies." Successful relationships of all kinds "contain the elements of attraction, communication, 'being there' for the other party, and understanding." The lab's

idea is that in business as well as in other areas of life, relationship technologies will serve to "enable, support and enhance these key elements of real relationships" (MacLeod, 2000, p. 3).

This will be achieved through attention transactions in which information flows back and forward between content providers (the business or commercial interest) and content users (potential and actual customers). Since attention is "engagement with information," both-way information flows grounded in reciprocal interest are, in effect, attention transactions that create and sustain relationships (MacLeod, 2000, p. 7). The lab puts its faith in the capacity of *paying* attention to gain and maintain attention. Its early research documents various mechanisms used to try and elicit customer attention (such as paying people to view content, providing free computers which come with content, offering free email via portals which bombard users with advertising and other commercial information, and so on). Without dismissing these outright, the lab stresses the importance of attention transactions based on personal information. This requires customers to appreciate the advantages that can come from providing personal information that permits companies to pay personal attention to them in the course of creating and developing successful relationships (MacLeod, 2000). Reciprocally, it presupposes that companies will use this information fruitfully: "Acquiring personal information about a potential customer is useful only insofar as it can be translated into more personal attention" (MacLeod, 2000, p. 19).

MacLeod (2000) identifies key strategic implications for businesses operating in the Network Economy. These include:

- Participation in the Network Economy presupposes participating in the Attention Market, since to develop relationships with customers it is necessary first to have their attention.

- To gain the attention of network users, companies must transform initial contacts (e.g., as obtained by advertising) into an attention transaction from which to develop relationships.

- At the beginning of a relationship it may be necessary to purchase information, and some consumers may be able to ask more for it than others. Hence, companies must be prepared to negotiate.

- Consumer information costs should be seen as investments that have value to be unlocked rather than as costs to be avoided.

- The "epitome of an attention-based relationship is to move from mass customisation to engaging customers in the design of products for themselves."

- As pressure increases on people's time, companies best able to provide "intelligent agents or intermediaries" will get "first call on [a] consumer's attention."

- Companies will have to identify technologies best suited to capture consumers' attention, "and 'own' the newly emerging personal access points." (pp. 19–20)

Overlaps and Differences: Multifaceted Attention

While there is much more to be said than is possible here, there seems to be significant overlap as well as significant differences among these positions. In terms of differences, the three perspectives pursue attention on behalf of quite different purposes and beneficiaries. Goldhaber's account focuses on individuals pursuing attention for their own purposes in terms of finding meaning for their lives under "post materialist" conditions. Lanham addresses the pursuit of attention structures that will enable other people to use information effectively in relation to what they are interested in. The work of the Aspen Institute and the NCR Knowledge Lab seeks in different ways to help companies mobilize attention in the interests of selling consumer items to customers who believe their purposes are served by purchasing them.

The main point of overlap seems to be the creation of effective attention structures, even though Lanham is the only one of the three to identify this construct explicitly. Managing attention is clearly where the action is for each perspective. The point of advertisers, producers, and vendors entering relationships with consumers and obtaining information on them directly or via research is to be able better to mobilize and organize their attention to what is available commercially as goods and services. Goldhaber's reference to the pursuit of endless originality seems also, albeit tacitly, to entail a search for frames that will draw or focus the attention of potential fans on would-be stars.

Digital Technologies and the Economics of Attention

Goldhaber (1997) highlights the distinctive significance of new information and communications technologies—especially, but by no means solely, the world wide web. He sees the capacity to send out multimedia or virtual reality signals via the web as a particularly effective and efficient means for attracting attention and paying illusory attention.

> Say you are primarily a writer of mere words, i.e., text; still, on the Web you [are] able to supplement your writings with your picture, with video images, with recordings of your voice, with interviews or pieces of autobiography. The advantages of doing that is that by offering potential readers a more vivid and rounded sense of who you are, you can both increase their sense of who it is who is offering them illusory attention, and have them have a clearer and more definite feeling than otherwise of what it is like to pay attention to you, rather than to some other writer of similar sounding words. Both these effects can help you hold their attention better. (Goldhaber, 1997, n.p.)

In this way the web is an ideal means for "transmitting and circulating attention" and is getting better for this all the time: a precondition, says Goldha-

ber, for a full-fledged attention economy to emerge. He contrasts the circumstances of Plato with those of any number of people today. Over the past two millennia, says Goldhaber, millions of people have read and studied (paid attention to) Plato. But apart from "contributing to his 'immortality,'" the vast majority of that attention did him little personal good." It came after he was dead! Whilst very few of today's "attention getters" could aspire to be remembered for thousands of years, they are able to pursue the benefits of attention from many—maybe millions—of people via the web throughout their lives (Goldhaber, 1997, n.p.). This, says Goldhaber, is what will constitute living very well (on a sliding scale) in the new economy.

At the level of employing digital technologies, working the attention economy can take on very different forms. Two cases must suffice here. They will serve to make wider points as well.

Early in 2000, a number of online magazines (e.g., Salon, http://www.salon.com) described one young man's special mission and encouraged readers to help him meet his goal. Walter, a 16-year-old high school student, described his special mission on his web site, which was located within the Geocities community (http://www.geocities.com/Walters_Mission). According to Walter's web site, two girls from his school had told him that one would have sex with him if his web site received a designated (massive) number of hits within a given period. Pictures of Walter were published alongside the articles featuring his mission. They showed him to have an almost-shaved head, braces on his teeth, features that would conventionally be described as ungainly, and what would generally pass for an "unattractive air."

The articles urged readers to visit Walter's web site to help him complete his mission before his time ran out. The response was overwhelming. Some of these sources also stated that while Walter's special mission might be a hoax, people should visit his web site anyway, in case the endeavor was for real (cf., Suck, http://www.suck.com). On the day we visited Walter's web site—well before the deadline set by his female peers—the only page that could be accessed told in huge letters that the mission had been accomplished. It also stated that due to still-heavy traffic to his web site, Walter had been forced to remove it from the Internet.

In the second case, Steven Fitch, a graduate of MIT's Media Lab, developed a leather jacket containing in its back panel a complete Windows computer with a "233-MHz Pentium III processor, a 1 Gigabyte IBM micro hard drive, and a broadband wireless Internet connection" (Kahney, 2000, p. 1). The jacket is being marketed as "wearable advertising" and even comes with "a built-in infrared motion detector that can tell how many people have seen it close up by sensing their body heat" (Kahney, 2000, p. 2). According to Fitch (cited in Kahney, 2000), the jacket "allows people to use video as a form of self-expression" (p. 1).

The jacket could be used in diverse ways as a medium for initiating or mediating attention flows and transactions. Some uses might essentially serve the owner's own attention-seeking interests simply by attracting the gaze of passersby and engaging them in information (however briefly or superficially). Alternatively, the

owner might use the display as an initial point of contact with potential customers for her or his own goods and services. Likewise companies, advertisers, and "stars" might hire "jacket space" as part of their contact-making and attention-attracting strategies. Many uses of the jacket display might serve multiple attention interests conjointly. For example, if the wearer were running a video for a popular band or an upcoming movie (that is, for "stars"), she or he would simultaneously be paying illusory attention to fans of the band or movie star, transferring attention to the star, giving the star an opportunity for paying illusory attention to the fans, and generating attention for herself or himself.

Fitch has formed a company called Hardwear International (http://www.hardwearcorp.com/) to market the video jacket. His main company tagline is "The revolution will be televised." Hollywood has already shown keen interest, planning to display trailers for upcoming movies on people's clothing. Fitch is currently also working on a range of video jackets for children, as well as lunchboxes, handbags, and hats, all of which incorporate his video technology. Fitch (cited in Kahney, 2000) says, "I believe display technology will be incorporated into our lives as a form of personal expression" (p. 2).

New Literacies and the Economics of Attention

On the basis of the ideas sketched above, it is reasonably easy to identify a range of typical "new" literacies that might become increasingly significant within an emerging economy of attention. We will outline several such literacies here in embryonic ways that will provide a base for potential further exploration and development.

"Contact Displaying": Jackets (and Similar Gadgets) That Work

This is the idea of using highly customizable, mobile, public media—like the video display jacket—to catch the eye and establish a basis for gaining attention. Not every jacket will "work" in an attention economy. Not every jacket owner/-wearer will be able to use it successfully as a means to gain and sustain real attention. Moreover, the jacket itself (or any similar device) cannot be the medium for sustained attention unless its wearer can claim a "space" to which others "return" in order to see what she or he is up to today. More likely, a successful display will create an *opportunity* to gain attention in the manner described by MacLeod—by establishing initial contacts that may create the possibility to develop relationships via attention transactions. This could take diverse forms, ranging from broadcasting arresting or entertaining "display bytes" that achieve their task of establishing a sense of identity and presence instantaneously—in the moment of a passing by—to simply announcing a product or service that can be "taken down now" (e.g., a URL, phone contact, email address) or memorized for following up later. Part of displaying successfully is likely to be a matter of

"immediate effects" (rhetorical, quirky, stunning), but much will likely be predicated on having something to say that is worth hearing, something to sell that is worth buying, and so on.

Meme-ing

In his MEME email newsletter (see http://memex.org/), David Bennahum defines "meme" thus:

> meme: (pron. "meem") A contagious idea that replicates like a virus, passed on from mind to mind. Memes function the same way genes and viruses do, propagating through communication networks and face-to-face contact between people. Root of the word "memetics," a field of study which postulates that the meme is the basic unit of cultural evolution. Examples of memes include melodies, icons, fashion statements and phrases.

We have extended this definition to suggest a kind of literacy that may prove very effective in gaining attention as well as in constructing attention structures along the lines described by Lanham (1994). Meme-ing may be seen as a meta-level literacy whereby "writers" (e.g., displayers, conventional authors, advertisers, changemakers, publicizers, and so on) try to project into cultural evolution by imitating the behavioral logic (replication) of genes and viruses. This involves generating and transmitting a successful meme, or becoming a high-profile "carrier" of a successful meme. Meme-ing presupposes the existence or establishment of two necessary conditions: "susceptibility" (for contagion), and suitable conditions for replication to occur.

Susceptibility is tackled by way of "hooks" and "catches"—by conceiving something that is likely to catch on or that gets behind early warning systems and immunity (for example, even well-honed critical perspectives can be infiltrated by textual creations like Coca Cola's white swirl on red, or by the Nike swoosh). Networks— for example, communities of scholars, electronic networks—provide ideal conditions for replication. Examples of successful memes and their respective "cloners," "high profile carriers," or "taggers" include "cyberspace" (Gibson, 1984), "screenagers" (Rushkoff, 1996), "GenX" and "Microserfs" (Coupland, 1991, 1995), "the information superhighway" (Al Gore, as referred to in Gromov, 1995–2000), "global village" (McLuhan and Powers, 1989), "cyborgs" (Haraway, 1985), "clock of the long now" (Stewart Brand and colleagues, as referred to in Brand, 1999), "complexity" (the Santa Fe Group, as described by Waldrop, 1992), D/discourse (Gee, 1996b), and so on. Obviously, for a meme to be a way both of gaining attention and of bringing attention to a particular individual or group, its cloners or key carriers must somehow or other lay claim to it or otherwise publicly establish their association with it.

"Scenariating"

Building or narrating scenarios is a good way of coming up with original or fresh ideas of the kind needed to attract and sustain attention. We think of it as a literacy because it is a way of reading and writing the world (of the future). Scenarios are catchy narratives that describe possible futures and alternative paths toward the future, based on plausible hypotheses and assumptions grounded in the present. Scenarios are *not* predictions. Rather, building scenarios is a way of asking important "what if?" questions: a means of helping groups of people change the way they think about a problem (Rowan & Bigum, 1998, p. 73). Scenarios aim to perceive possible futures in the present, encourage us to question "conventional predictions of the future," help us to recognize "signs of change" when they occur, and establish standards for evaluating "continued use of different strategies under different conditions" (Rowan & Bigum, 1998, p. 73).

Scenarios must narrate particular and credible possible future worlds in the light of forces and influences that are apparent or inchoate in the present, and which are likely to steer the future in one direction or another if they get to play out. A typical approach to generating scenarios is to bring a group of participants together around a shared issue or concern and have them frame a focusing question or theme within this area. Once the question is framed, participants try to identify "driving forces" they see as operating and as being important in terms of their question or theme. When these have been thought through, participants identify those forces or influences that seem more or less "pre-determined," that will play out in more or less known ways. Participants then identify less predictable influences or uncertainties: key variables in shaping the future that could be influenced or influence others in quite different ways, but where we genuinely can't be confident about how they will play out. From this latter set, one or two are selected as "critical uncertainties" (Rowan & Bigum 1998, p. 81). These are forces or influences that seem especially important in terms of the focusing question or theme but which are genuinely up for grabs and unpredictable. The "critical uncertainties" are then dimensionalised by plotting credible poles: between possibilities that, at one pole are not too unimaginative and, at the other, not too far-fetched as to be completely impossible. These become raw materials for building scenarios.

In relation to the economics of attention, "scenariating" is a potentially significant new literacy because it provides a basis not only for coming up with innovative, original, and interesting information, but also because it addresses a topic in which almost everybody has a keen interest: what the future might be like and how to prepare for it. Scenarios can work very well as attention structures, providing frames within which people can work on information in ways that make it useful. There are many reasons for engaging adolescent students in activities of building and narrating scenarios besides the potential value of such activities for helping prepare adolescents to participate effectively in an attention economy. The latter, however, would be sufficient reason on its own because of its fruitfulness as a way of balancing originality and freshness with sheer usefulness for human beings in most areas of everyday life.

"Attention Transacting"

This is based on MacLeod's (2000) idea of both-way information flows grounded in reciprocal interest that create and sustain relationships. "Attention transacting" need not be grounded in commercial or business motives. It is about knowing how to elicit information from others, encouraging them to provide it (with appropriate assurances), and knowing how to work with that information so that it becomes an instrument for meeting what the other party believes to be its needs or interests. These may be in terms of goods, services, or more interpersonal concerns. To a large extent there is nothing particularly *new* involved here. It is similar to the kind of thing talk-back radio hosts, psychoanalysts, therapists, market researchers, and diverse kinds of consultants have had to learn to do in the past using different media. What *is* new is largely the use of new information technologies to obtain, interpret, share, and act on information of a private nature, knowing how to build and honor trust in online settings, knowing how to divulge and interpret information obtained electronically in appropriate ways, and so on. So far as formal education is concerned, of course, this is an entirely new literacy because it projects into modes and domains of life with which schools have not typically been concerned—even in subject areas like business and commercial practice. Interestingly, various "meta" approaches to language and literacy education, such as "genre theory," have access to theories and concepts of direct relevance to developing such a new literacy. Conventional curriculum and syllabus foci, however, have rarely encouraged serious movement into the kinds of "reading" and "writing" implicit in attention transacting. Many of these will have to be invented "on the fly" and by trial and error—as with so much that is important to know in any period of transition.

"Culture Jamming"

Culture jamming refers to counter-cultural practices that critique, spoof, and otherwise confront elements of mainstream or dominant culture. It relies on making incisive or telling "strikes" that manage to turn elements of mainstream culture against themselves in a manner reminiscent of Michel de Certeau's (1984) notion of "tactics." The logic of culture jamming tactics is of gaining maximum attention with minimum resources or inputs.

A good example of culture jamming is provided by Adbusters (see Adbusters Culture Jamming Headquarters at http://www.adbusters.org/). A sequence of highly polished web pages comprising slick and clean designs present information about Adbusters and its purposes. They describe an array of culture jamming campaigns, subject-worthy media events and advertising, cultural practices, and overbloated corporate globalization to knife-sharp critiques in the form of parodies or exposés of corporate wheelings and dealings, and undertake online information tours that focus on social issues. The following graphic (Figure 2–1), which depicts the true colors of Benetton, is a typical example of culture jamming as literacy. It

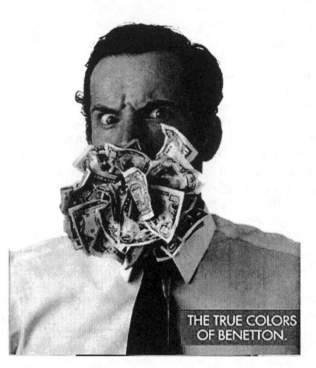

THE TRUE COLORS
OF BENETTON.

Figure 2–1. Source:
http://adbusters.org/spoofads/fashion/benetton

shows how the act of "tweaking" readily available resources available as images
and texts can produce direct and bitingly honest social commentaries. These are
commentaries that everyone everywhere is able to read—a form of global literacy
which has the potential to catch the attention of almost any population, whether
or not they share the text's inherent values.

"Transferring" (or "Trickle Across")

The principle of transferring is apparent each time one uses a search engine to lo-
cate information on a well-recognized expert or authority and turns up a student as-
signment, or reads a journal article that takes the form of an interview with a well-
known person conducted (and published) by a much less (or un)known person, or
when one happens upon web pages and zines lovingly assembled by fans. Transfer-
ring is based on the principle that "you have to be in to win." If one has something
to say or offer that might otherwise remain unrecognized and unknown, one has
nothing to lose by hitching it to or bundling it up with a personality or theme that
enjoys a good deal of attention. This literacy may involve nothing more than insert-

ing references or hyperlinks into a text published on the world wide web. At a more complex level, it may involve negotiating aon interview, conducting, editing, and "thematising" the interview, and then getting it placed for publication.

"Framing" and "Encapsulating": Beyond Keywords

Lanham (1994) makes an important and interesting point in his comment on the "hot search for software intelligence agents that will create 'gateways' of one sort or another without further human intervention" (n.p.). This endeavour has developed in conjunction with attempts to define "information literacy" and identify the kinds of skills—e.g., locating maximally efficient keywords—integral to being informationally literate. The other side to this literacy, which relates more directly to attention, was evident in the discourse of "tricks" one can use when registering one's web site to try and ensure that it comes near the top of the list for keyword searches—or, at any rate, finds a place as often as possible within the kinds of searches people are likely to do about the things one has to offer.

This is useful so far as it goes. But Lanham (1994) is pitching for higher and richer stakes in his focus on attention structures: in short, ways of *framing* information that hook us into organizing our interests within an area in this way rather than that; or in ways of *encapsulating* information that stand out because they are especially attractive or interesting. This involves the kind of analytical and theoretical work that puts someone sufficiently "on top of" a subject or area to allow them to find "angles" that attract and compel. Notions like "a brief history of time," or of "Pythagoras" trousers, of "a language instinct" or of "things biting back" are reasonably familiar (if high end) examples. The point here is that reading and writing the world (of information) is very different from the kind of approach evident in key words and the like. The same kind of difference is evident in titles for works: some (like the examples listed above) are frames and (en)capsules; others are more like keywords (accurate, functional, but short on inspiration). The best, of course, are both. Their production encapsulates the kind of literacy we have in mind here.

A Challenge for Schools

There are many other new literacies we have neither time nor space to think about and sketch here. For example, literacies that go to "smarts" in design, that get the mix right within "multimediated" productions, and so on. Hopefully, the examples sketched here will be sufficient to indicate and illustrate the nature and extent of the challenge facing formal education if we believe schools ought to be paying more attention to attention. It is worth noting that all the "new" literacies identified here are "higher order" and/or "meta literacies." Some are good for creating opportunities to gain attention, others for facilitating and structuring attention, and others for getting and maintaining attention. Some are good for a combination of these. Few are closely related to most of what passes for literacy in schools today.

Indeed, prior to even addressing the more specific issues of literacy in relation to preparing students for effective participation in an attention economy, it is important to note that attention is currently constituted mainly as a *problem* for schools. On the one hand, "attention seeking" is closely associated with—and often cited as a cause of—behavioural problems. On the other hand, learning difficulties are often attributed to "short attention spans" or "attention deficiency syndrome." Thus, schools are simultaneously caught between trying to reduce and increase attention.

Interestingly, the postmodern world of the web, channel surfing, and "playing the future" (Rushkoff, 1996) and the postmaterialist world of the attention economy openly embrace tendencies that currently constitute problems for schools. Perhaps it is time for us in formal education to rethink the issue of attention, and quite possibly the interface between digital technologies and new literacies provides a good place to start.

For many of us this will almost certainly involve a challenge to existing mindsets. Cathie Walker, self-styled queen of the Internet, creator of the Centre for the Easily Amused and co-founder of forkinthehead.com, offers an early warning of what that challenge might involve. In "Short attention spans on the web" (reprinted at http://www.sitelaunch.net/attention.htm), she confesses to having once read in a magazine that if you don't grab the average web surfer's attention within 10 seconds, they'll be out of your site. She immediately qualifies that claim by admitting that she doesn't remember whether the exact figure was 10 seconds because her attention span "isn't that great either" (http://www.sitelaunch.net/attention.htm, n.p.)

If we can "hack" that kind of entree, and accept her celebration of the short attention span as a basic assumption for effective web site design, the five short paragraphs that follow in Walker's statement provide an engaging perspective on literacy in relation to attention. It is a perspective that may well offer more to adolescent and young adult students than much that is to be found in our most venerated and most-cited tomes. If nothing else, it would provide a class with serious grist for problematising "attention" and evaluating literacies that pitch for attention. Our own web site observes none of her recommendations, but it doubtless receives almost infinitely fewer visitors as well.

At the opposite extreme, we note that the sources we have cited on the economics of the attention economy point to the importance of having a good grasp of theory and analysis. This is not necessarily an explicit grasp of highbrow theory and analysis. The ideas surveyed owe as much to the tradition of "Geek" philosophers as to the tradition of Greek philosophers. They uniformly assume that an emphasis on content and lower-order skills is not enough. The kinds of competencies associated with successfully engaging the economics of attention are those that come with the capacity to *research* aspects of the world as opposed to merely looking at them or receiving them as content.

Once again, this does not imply a highbrow or academic approach to research, although these will be advantageous if other things are in place—such as an interest in "angles," an interest in originality, willingness to take risks, and so on.

Rather, the generic sense of "research" that we have in mind is inherent in the very kinds of new literacies we have begun to identify here, and which we think it is now time for us to explore, develop, and encourage as the core of the high school literacy curriculum. Although imaginative and expansive use of new digital technologies is not a *necessary* facet of such literacies (c.f., scenariating, transferring, meme-ing, framing, encapsulating), they certainly enhance and enrich their scope and possibilities.

If we continue to believe that formal education has something to do with helping prepare (young) people for the world they will enter, it will be worth exploring further conceptions and implications of the economics of attention, and relating them to our conceptions and practices of literacy education within formal settings.

ADOLESCENTS' MULTILITERACIES AND THEIR TEACHERS' NEEDS TO KNOW: TOWARD A DIGITAL DÉTENTE

Adolescent learners are caught in a literacy Catch-22. They are the likely beneficiaries of a new world of information. At the same time, schools, rooted in a tradition that privileges print, may devalue or even prohibit the use of their students' newfound expertise with language and literacy of information technologies (C. Luke, this volume). Like the rest of us, these young learners live in a world saturated with information, a fact that has profound consequences. Rushkoff (1996), acknowledging the overwhelming effects of ever-increasing and persistent data, as well as an expanding media space, referred to this *datasphere* as the new "electronic social hall." In a similar fashion, O'Brien (2001) has extended this metaphor to *mediasphere,* which includes a diversity of input such as images, audio bites, and video streaming that acknowledges the day-to-day immersion in the sphere where the mediation of our experiences is inescapable. When one considers the interplay that such diverse input allows, the typical textual notion of intertextuality gives way to intermediality (Semali & Pailliot, 1999)—where print and visual media meet to create textuality that bridges home, classroom, and community contexts.

The demands of the mediasphere culture are now well known. Consumers adapt with increasing efficiency to a variety of (often) simultaneous and/or juxtaposed information sources. Thus, they are immersed in a world of images, sound bites, texts and icons, as well as countless other signs that flash, pulse, and fade in and out. Efficient consumers sample these simultaneous data streams for the most significant signs at a given point in time and media space. This has led Lankshear and Knobel (this volume) to suggest that we live in an "attention economy." In

contrast to an "information age," where access to limitless data would seem to promote a potentially democratic learning context, Lankshear and Knobel's notion of an attention economy designates users' *attention* to ubiquitous information as the most precious commodity. Our students, predisposed to simultaneous multiple sources of information, may be especially well suited to "gaining attention" in this market arena. In many ways, gaining a larger share of the available attention will, in theory, also provide our students the material benefits that come with the attention.

There is, of course, another side to this dilemma. Students also live within the culture of schools. In this culture, information is best understood as a limited commodity. Curriculum coordinators and teachers select, define, delimit, shape, and package the most important information for the moment, for the semester, for the academic year, and for "learning" tracks that span years. In schools, print predominates. The canonical texts are situated alongside limited forms of alternative print texts, supplemented with a limited cycling of visual media, and used to anchor the curriculum. In addition to this tightly controlled representation of the available information, teachers regulate not only the kinds of content but the kinds of thinking about that content that are acceptable. The differences between outside-of-school and inside-of-school media literacies are apparent. In addition, time, as it is configured in school culture, happens in large, intact, and "thematically organized" segments. In school, we typically conceptualize attention spaces in terms of disciplined cognition—"on task" time, and prolonged student engagement with teachers' agendas (both topic and task). This focus on disciplined cognition within the typical school culture of structure and control still implies to youth that disciplined attention is good for them. In contrast, their daily experiences outside of school may suggest that narrow, prolonged focus effectively removes them from the data stream that drives the mediasphere.

This dichotomy suggests that students in the mediasphere, savvy in its multimedia and multiliteracies, apprehend mixed media in flashes, bits, and bites. These selective information consumers also integrate seemingly disparate information into coherent, integrated wholes. The other side of the dichotomy is that these students' teachers, as agents of the school culture, may recognize only a narrow band of literate enactments, sanctioned topics, and texts in print media. Allan Luke (this volume) suggests that a school bias favoring print has caused teachers to make choices that reveal their grounding in a preference for "the textual." It starts early on. School and cultural valuing for print literacy prior to other media literacies is analogous to the fundamentalist early literacy argument that letters and words must precede whole text reading. To the contrary, early literates learn letters and sounds *while* they solve problems in reading and writing whole texts. Either way, early literacy practices in school are print bound.

In later school years, preference for print may preclude teachers from even noticing their students' competence with multi- and digital literacies. Hence, according to Allan Luke's interpretation (this volume), in both developmental theorizing and in teaching approaches, print literacy is assumed to precede multiliteracies. To

extend the early literacy analogy, a fundamentalist perspective in adolescent literacy would maintain that the conventions of print media must be learned prior to productive learning experiences with other media literacies. Actually, it is clear that students can learn the conventions of print media as part of the complexity of intermediality (Semali & Pailliotet, 1999). As they gain competence with diverse symbol systems, receiving, reconstructing, producing, and critiquing the media, its meaning, and its power, they also gain proficiency with its conventions. Yet the teachers in the Luke study who were asked to respond to the new literacies (required in the mediasphere) were observed by Luke as fixing very strongly on verbal, intellectual, and social deficit explanations of student failure. They tended to view students' engagement with new technologies as a cause of difficulty in reading typographic print media. According to Luke, this is "a misrepresentation and misrecognition of competence, where competence and engagement with new technologies is read off as individual deficit in old technologies" (p. 196).

Teachers often use the term "play" as a metaphor for students' multiliteracy efforts. Students are told that they can play with computers when they are done with their real work. The students in the Jefferson High School Literacy Lab (O'Brien, 1998) referred to "playing" with scanners and cameras while surfing the web. We believe that teachers position technology and media work as "play" to dismiss it in comparison with school-sanctioned work. In contrast, students' use of "play" is anchored in their relationship with the task. From teachers' perspectives, all of these presumably pleasurable experiences with multimedia detract from students' engagement with their real work. Within the classroom economy technology work is time off task; it is classified as a sort of leisure recreational activity. Here is the basis for the deficit/displacement understanding of the computer threat to learning. But it seems that there must be some deeper concern, some digitally enhanced urgency in teachers' reservations.

Walkerdine (1996) argues convincingly about the pervasive influence of the incursion of popular culture into more traditional discourses; in this case, classroom discourses. The flood of digital information into the classroom may threaten teachers' security in "knowing." The use of popular culture, represented by multimedia, may undermine the traditional control teachers enjoy when enacting prescribed curricula. The contention that engagement with technologies detracts from traditional print literacy is, therefore, a ploy. Rather, the blaming of technology for traditional print "deficits" intends to neutralize the lure of the mediasphere and reinstate print literacy and its accompanying control. Paradoxically, the use of the play metaphor has conceded the contest to the student learners. The result is that intermediality, while overlooked by teachers ostensibly because it detracts from print literacy, is consequently enhanced in its subversive use by students. But more fundamentally, students' competence with digitized multiliteracies must be delegitimated because it has the potential to destabilize teachers' control. Print is categorical, history to math. Print is linear, chapter to chapter. Print is the guts of the textbook, the primary artifact of "legitimate" knowledge in school (Apple, 1988, 1998). In this way, print represents the essence of control in the classroom.

We do not intend to "solve" such a dilemma. In fact, proposing "solutions" would be an instrumental approach that would have the effect of telling others what is best for their particular set of circumstances; in effect, we would own the problem for those involved, and close down the conversation on what might be underlying the dilemma as we have understood it. Therefore, we present a limited set of perspectives that intend to view the dilemma again. Consider the metaphor of lifting your gaze above the immediate problem to gain an additional view. We "review" the notions of at-risk adolescents, school-based literacy tasks and curricula, as well as teaching approaches intended to help remedial adolescents. Finally, we suggest that teachers and their students collaboratively learn the "new literacies."

Reconceptualizing the Term "At-Risk"

James Paul Gee (this volume) makes the point that current educational and social contracts have opted for certification as the goal of public schooling. Gee draws a useful distinction between certification and education. Settling for certification means that minimal levels of thinking, reading, and writing are now acceptable and responsible to standardized, high-stakes testing. This compliance with a single standard for every student at a grade level or within a subject area course has "dumbed-down" what happens and what is expected to happen in schools. In effect, we have accepted certification for all in preference for education for some. As a result, education—that is, competencies, identities, the cultural capital necessary for high levels of success in the outside world—is largely not available inside the school. Therefore, children with financial means, or students from upper middle class families, gain this learning in experiences outside of school. This, in effect, leaves the less privileged students with the basic curriculum of the schools, and with experiences that will get them low-paying, service-economy jobs. Since jobs are now seen as more temporary, serial, and situated, workers who are credentialed and successful (academic track students in their later years) have learned to reconfigure their portfolios of personal expertise to correspond with new jobs. On one level, this kind of shape shifting requires that the shifter has a sense of self-efficacy and possibilities—a recognition that other framings for a given experience, situation, text, or conflict are possible. Problem solving with regard to one's own life circumstances is a high-stakes test of learning. Yet if schooling has not engaged in these shape-shifting exercises as part of curriculum, the learning will be costly at the point of need, when students have become workers.

Gee's argument is not far from the traditional dichotomy of academic versus vocational track curricula. Implicit since at least the late 1940s, curriculum tracks have routed some students on a path that leads to blue-collar trade jobs rationalized with the argument that these "nonacademic" youth would have something tangible, "a place in the company for life." A different curriculum routes other students into colleges where they have the brains, money, and tenacity to go to school longer, so they will make more money. In effect, the academically successful shape

shifters have always been the students in the academic track. They learned early from their parents that they needed to build their portfolios. What is different now are the resources (kind, not amount) that affluent parents dedicate to make sure that their kids participate in a range of activities and construct those activities for their shape-shifting portfolios. The technological experiences that these resources make possible are either not available in the "new schools," or their deployment is not valued as a school activity in literacy. This reasoning results in at least two related issues: perpetuating differential education for different social classes, and avoiding any school responsibility for whole groups of students' systematic failure in school literacies.

First, schools may be seen as perpetuating the historically grounded, classed system that continues to privilege young people with clear goals supported by the more extensive resources of their parents, if those goals are compatible with higher education following high school. Schools also perpetuate this classed system by offering "vocational" programs, by directing students who are not academically tracked into these programs, and, most recently, by offering "school-to-work" programs that target blue-collar, working class people. Lankshear (1987) calls this differential access to reading and writing competency "inappropriate literacy," signaling the intentional role of schools and naming them in the process. An implicit goal for the first group, the academics, is that you need to build your "shape shiftable" portfolio around the core credentials provided by the school—a substantial GPA in academic track courses. You are told by peers, teachers, and guidance counselors that you need to augment this with various experiences and community service to indicate generally that you are a smart, well-balanced person who cares about others and is willing to work hard. In this group, you are prepared to reinvent yourself for almost any contingency. In the second group—vocational education—the at-risk kids are taught to exclude college as a possibility. A "more attainable goal" is to focus on trades and jobs in the new service sector. This shifting entails seeing themselves in a job, or more likely a series of jobs, with relatively low pay. In contrast, those who have engaged in reinventing themselves for a variety of social circumstances (a leader in a community group, a tourist in Europe, a volunteer in a homeless shelter, an observer in a daughter-to-work day, a web master for a fan group) will be better positioned to reconfigure themselves for new, more prestigious opportunities as young adults.

Second, schools may also be seen absolving themselves of responsibility for their "classed instruction" (O'Brien, Springs, & Stith, 2001; Waxman, de Felix, Anderson, & Baptiste, Jr., 1992). Allington (1994) traces the instruction provided for marginalized students in what he calls the "second system." Historically, schools have provided a "less than" curriculum predicated on basics for students who have been perceived as non-elite. Allington's critique is launched to undermine the second system, and it calls for the integration of all students into the richer, more privileged experiences that will prepare them for later lives of leadership and control. The irony here is that, according to Gee (this volume), schools are now gearing up (down) to offer only the basic curriculum, with enriching

real-life learning activities taking place in private, pay-as-you-go spaces and opportunities. So, it seems that schools have responded to the needed critique offered by Allington, though not in the direction he would have wished. Another outcome of Allington's critique is the immunity schools enjoy as a result of the categorical labeling that the second systems proffers. The very terms "educationally handicapped," "educationally disadvantaged," "at-risk," "struggling"—subtly but effectively grant immunity to schools with regard to blame for their students' failures (King, 1993; O'Brien, 2001; Waxman, 1992). Clearly, there are real and observable differences in literacy practices among our classes of students. The ways in which we have understood and acted upon our notions of their differences have much to teach us. We will also speculate on how we have constructed learning tasks that tap into our notions of literacy and how it is acquired by "different" learners.

Releasing the Tasks

If school practices are understood as constraining literacy, how can we release our control? The interpretive democracy that is possible through multiliteracies may be short-circuited if our interpretive practices with any kind of text (typographical, visual, digital) rely on the accuracy of "true," or essentialist accounts. We consider two examples that raise cautions regarding our hopes for interpretive democracy based on digital multiliteracy: one based on literature; the other with expository texts. First, we will discuss literature.

In our use of text of all kinds, interpretation of literature remains a stronghold of classroom tasks. Teachers' control of interpretation is largely based on the "correct response." Yet Probst (1998) argues:

> [Print] text, as immutable and permanent as it is, offers us only an illusory sense of security. Unchanging as it may be, once it enters the diverse minds of its many readers and is transformed by the transaction into a poem or a story it becomes many different things. The single text, in our class of 30 students, is suddenly 30 poems, each unique, all tied in some way to that single text but also to those 30 different lives. (p. 132)

So, teachers' efforts directed toward controlling students' interpretations are likely unproductive. How can a transactional theory for multiliteracy be crafted to allow for the lives of our students in our classrooms? Willinsky (1991) points to the missing half of Rosenblatt's (1995) transactional theory, arguing that current conceptualizations of Rosenblatt's reader response theory capture the role of readers' personal interpretations. Yet the social and political uses of literature in classrooms are often overlooked. It is as if once freed from the domination of New Criticism's textual authority, we failed to take the next step and use individuals' interpretations (with their incipient diversity of response) to engender the necessary political shifting in classroom literacy work. Only by contesting the taken-for-granted assumptions embedded in the culture can we hope to capture the attention of our

middle-grade students in their accommodations to the emerging mediasphere. Kutz and Roskelly (1991) also ruminate on the failed promises in Rosenblatt's (1995) *Literature as Exploration*. While independent readers (both teachers and their students) may experience the subjectivities made possible through reader-text transactions, students continue to endure the authority-based "readings" of the last century's New Critics. Multimedia perspectives on literature, imminently possible through classroom Internet searches and multimedia reading and authoring, are likely to be devalued if authority-based interpretations are the goal.

Analogously with expository texts, Applebee's (1996) *Curriculum as Conversation* recommends a textual diversity that may promote increased student ownership of classroom learning. This approach ensures the negotiation of multiple perspectives by starting from multiple source texts on a given topic of inquiry. In our case, "texts" can be broadened to include digital sources, including print and nonprint media. Digitally based texts, as part of classroom discourses, would necessitate discussion and debate on veracity or the impact of text strategies such as propaganda or authors' viewpoint as students unpack the spin on various information sources. Of course, such criticism includes textbooks (as a type of text). Since information is ubiquitous, the learning goal becomes the transferable strategies that students use to critique and compare different information sources.

What is common to both of these approaches is the necessity of divergent points of view that are shared, contested, and challenged in negotiated meaning production. What is also common between these two approaches is the non-authoritative role of the teacher who must become a facilitator to blend meaning from multiple sources. This is a significant role change for many teachers. When individuals' divergent responses to a text are joined in discussion, it is reasonable that underlying values, ethics, and politics will emerge as part of the discussion. This part, according to Willinsky (1991), has not generally been an aspect of response pedagogies presumably based on Rosenblatt's transactional theory. This pedagogic shortfall is even more important when one considers the possibilities for multiple interpretations in Internet and multimedia contexts. But first, there must be multiple texts. And one variety of text that must be taken into account is the lives that our students live.

Neilsen (1998) moves the argument to the individual student in her case study of two adolescents:

> [T]heir ongoing curriculum is the lives they lead; that they make real texts for themselves; that they teach one another and can teach their teachers; and that they will explore learning, grow in their literacy, and dream their dreams in settings much more influential than school settings. (p. 22)

The implication for us as teachers is that the tasks we assign or even sanction must be isomorphic with the lives of our students, *as they perceive them*. Similarly, with reference to assignments in the media-rich project-based curriculum in the Jefferson High School Literacy Lab, O'Brien (1998) recommends "assignments that are

challenging enough to be interesting, yet flexible enough to provide students considerable leverage in controlling the level of difficulty" (p. 46). For those tasks to work, however, he recommends that teachers "know students as individuals" (p. 46), rather than through the labels schools assign them.

We can choose to contour our classroom work in the direction of our students' lives. Yet even that intention may not win the day. From Gee and Crawford (1998) we learn that language and self-positioning/self-presentation within a linguistic frame are mutually entailed phenomena. In a comparison of two students, Gee and Crawford reveal that how these students (and others) will take up, react to, interpret, and talk about texts will also be different, regardless of the assigned text or task. In this example, the students' responses to literature texts, as another kind of text, join the classroom intermediality. The language forms (the ways in which students structure their responses) is highly personalized and related to students' backgrounds. These individualistic aspects of language use become part of our students' unique responses, even with the same onset task. This means that who our students are as individuals and how they represent themselves with language impacts the student whose presence may be found lurking in the written products for our learning tasks. Shifting our perspectives from learning tasks to a student-centered perspective is hard work, with some inherent risks. Alvermann (1998) contends that it is schooled literacy that counts. This happens via the absence of non-schooled literacies and by "devaluing nonacademic literacies by positioning them as 'other' [the exotic, the prohibited] to the discourse of schooled literacy" (p. 357).

Un-teaching

Reconceptualizing literacy tasks is but part of the journey. It is also crucial that we examine the ways we understand our own position within the "violence of literacy" (Stuckey, 1991). Stuckey's metaphor calls attention to the involvement of literacy professionals in the production of illiteracy. Part of "the problem," according to Stuckey, is how we conceptualize literacy when we intend to "teach it":

> The unwillingness to either relinquish or expand notions of literacy is riveted in American economic and educational structures . . . Few of the present advocates, however, escape the silent mandate to keep the status quo where it is . . . The first advocacy group is . . . English teachers and teachers of English teachers. (pp. 33–34)

Kutz and Roskelly (1991) point out the necessity of teacher change in the context of working with students who are perceived as at risk. The authors narrate the writings of Shaughnessy (1977) and Conroy (1987) to recommend that successful teachers revision their perspectives and beliefs on literate competence in order to enhance their practices with older, developing students. One such shift is a reversal of commonplace understandings regarding restricted linguistic codes. For Kutz and Roskelly, school discourses, both oral and written, become the impoverished

or restricted linguistic codes. Schooled literacy (Barton, 1994; Barton & Hamilton, 2000), the dominant discourse of learning, which includes print bias, recitation as performance, essays and their structure, textbooks and scanning for short answers to textbook questions, functions to privilege a particular kind of knowing. By virtue of their regulative intent, these school discourse practices disadvantage students who have historically been ill served by traditional schooling because they have not been permitted to use the richness, nuance, and particularities of non-school linguistic competencies.

From a perspective of one accurate academic discourse and considering the narrow range of opportunities that exist in school literacies, the possible competence that will be exercised or demonstrated by some students is delimited. In three ways, classroom practices may limit literacy. First, a limited range of acceptable cognitive tasks may manifest literacy in print-based contexts and on canonical texts. Second, certain participation structures organize what can count as school literacy. Third, the execution of sanctioned tasks that must be completed within specified social contexts may limit students' performance and teachers' view of their competence. The wider the acceptable range for these options becomes, the greater the possibility that meaningful multiliteracies may occur.

A second shift, or reversal, is one away from fixation on content mastery and toward Vygotskian tenets of learning. Instead of relying on content and its acquisition (which may then be realized as static school products), Kutz and Roskelly (1991) urge us to "re-view" students in their developmental acquisition of learning processes. Understanding individuals' strategic learning processes during content experiences may provide teacher and students with a deeper knowledge of the strategic qualities of learning—in this case the manipulation and productive use of information, knowledge we believe to have greater transfer potential.

A final reversal asks us to reconsider our investments in accuracy as a goal, and error as its fetishized delimiter. Barksdale and King (2000) speculate that teachers' fetishized relations with accuracy may impede students' literacy learning processes. The connection here is that a focus on content and its "correct" deployment sets up teachers as monitors. Yet learning to be literate, especially in the mediasphere, cannot only be about accuracy. Jacob Bronowski (cited in Kutz & Roskelly, 1991) noted that "every act of imagination is the discovery of likenesses between two things which were thought unlike" and "all imaginative inventions are, to some extent, errors with respect to the norm" (p. 225). Following Bronowski's reasoning, we should expect our students' real growth in literacy, both print and intermedial, to be punctuated by error. Kutz and Roskelly agree, concluding:

> [W]hether the existing system is a bureaucratic structure, a format for lessons, a poetic form, or a scientific problem, coming to new understandings involves moving outside of the existing system, reconceiving it and seeing it in new ways. And to make the change, learners must recast what they know in new terms. (p. 225)

This is true of adolescents' learning of new literacy and no less true for their teachers.

Of course, changing our everyday practice is difficult. First, what one *does* daily must be objectified as "practice." Next, that familiar practice must be regarded as "strange" (Spindler & Spindler, 1982) so that we can critically examine it. Kutz and Roskelly offer teachers three strategies that may decenter the familiar: juxtaposition, metaphor, and repetition. Similar to their use in figurative language, these strategies allow users to embed their language use with extra meaning, to create new meanings, and to form new structures of understanding. These strategies (juxtaposition, metaphor, and repetition) are not unlike those proposed by Lankshear and Knobel (this volume). Their list includes "meme-ing" (personalized, attention-gaining icons); scenariating (recasting current circumstances into new, imagined situations and allowing for "play-out"); culture jamming (reusing media icons and images in a countercultural way); and transfer (arranging for links to "hot properties" so that your work will be accessed).

The purposeful use of these literacy strategies by both teachers and students has the potential to resent the vestigial boundaries of print literacy. Should these multimedia strategies be included in what we count as adolescents' literacy, and if so, how? It is really a moot point because the students already control many of the strategies mentioned. Lankshear and Knobel (this volume) include vignettes that illustrate younger users' proficiency with them. As teachers of literacy, our challenge is how will *we* react to students' use of innovative transformations of data and language in our classroom spaces. Does such strategy use count as literacy? Or will we penalize students' creative use of the new literacy because it is thought to short-circuit "real" (textual) literacy?

Toward Détente

The ways in which teachers take up this new challenge may predetermine its outcome. The "multimedia challenge" to literacy and its outcome will play out in adolescents' classes within relationships with their teachers. Literacy, as a sociocultural product and process, will be imbricated with these relationships. According to Collins (1998), "People become as literate as they need to be to participate meaningfully in the cultures in which they hold membership" (p. 209). Teachers can productively shift to thinking strategically so that they can co-construct strategic interventions on the fly, or at the point of need (Nelson, 1991). Like other types of scaffolded instruction, this "strategic habit of mind" (Collins, p. 210) balances student independence, strategy acquisition, and task completion with teacher-as-mediator or scaffold. In contrast, many of our students have already developed some of the expertise we will require. And even with our best intentions, our shifts in teacherly thinking may meet with our students' resistance toward teachers and our thinking. Student resistance is a discourse co-production. School success and failure are constituted through face-to-face interactions, inside relationships. The full exclusion of a resistant student is only accomplished

through cooperation between a "resistant" student and his or her teacher. According to Collins:

> [R]esistance is socially constructed by the discourse in classroom communities. Resistant students are not resistant all by themselves. Resistance is constituted through discourse . . . Resistance in this view has a history; it begins with playfulness and boredom and only later turns to anger and frustration and the apparent formation of identity as a resistant student. (p. 202)

Our youth, who are increasingly inattentive and disinterested in school, are increasingly developing an unsanctioned, articulate and even masterful digitally literate, critically literate, and intermedial competence that schools are slow to recognize or adapt to. Schools are slow or loath to reconfigure the curriculum and its intermedial representation in the attention economy. Ironically, a lot of what kids want to read and write intermedially is jamming directed not at popular culture but at school culture's rigidity, demands for compliance, and insistence on print literacy. The better they get at this institutional culture jamming, the harder it will be for schools to get their attention. The less schools get their attention, the more they will jam. In light of students' relative competence with the mediasphere, the frustration and resistance in classrooms must now be shared by students *and* their teachers. It is time for détente. We cannot know the answers to the dilemmas and paradoxes that must be part of teaching the new literacies. Therefore, it seems productive to go to our students for some answers. How we understand literacy, multiliteracies, our students, and our position in teaching them will soundly determine what occurs in the name of literacy learning in our respective classrooms. How can we come to know multiliteracies from the playful perspectives of our savvy students?

Our tentative response has been the purpose for this chapter. In our efforts to cope with the dilemma of "new," "digital," and "multimedia" literacies as they emerge in our classrooms, we have suggested three general perspectives. First, review students and their expertise with the mediasphere. How can their wisdom become part of what counts as literacy? Second, release the classroom tasks that limit the students' participation. How can the digitized cyberlives of our students become part of the literacy work in our classes? Third, reconsider the value we place on accuracy in language. How can we learn about our students through their divergent responses?

MILLENNIALS AND BOBOS,
BLUE'S CLUES AND *SESAME STREET:*
A STORY FOR OUR TIMES

In this chapter, I want to describe and analyze a story with important implications for how we think about the current state and future trajectory of schools and society. The story is rooted in both academic and popular texts, some of which are what I have elsewhere called "enactive texts" (Gee, Hull, & Lankshear, 1996), that is, texts written by authors (often activists, consultants, or political figures) who attempt to tell a story that they claim is true, but which they are also trying to make true by the very telling of the story and their other activities connected to the story. Thus, the story I deal with here is partially true and partially a vision of the way certain (powerful) people would like the world to be. Throughout the chapter I have capitalized terms that are core elements in the story, at least as I tell it, terms such as the Great Disruption, the Transition, the Restoration, the Old Capitalism, the New Capitalism, Winner-Take-All, Baby Boomers, Bobos, Gen-Xers, New Baby Boom, Millennials, Children of the Restoration, Overclass, the Tale of Two Millennial Cities, Shape-Shifting Portfolio People, and Affinity Groups.

I start with the basic story, the story of the Great Disruption and its repair. I then turn to a discussion of the so-called Millennials (the children of the New Baby Boom, living amidst the Restoration) and an analysis that contrasts *Sesame Street* (a Baby Boomer show) with *Barney & Friends* and *Blue's Clues* (formative shows for Millennials' souls and minds). After generalizing some of the contrasts I draw between these shows as indicative of wider contrasts between Baby Boomers and Millennials, I turn to Shape-Shifting Portfolio People (a notion that helps to capture new ways in which class functions in the New Capitalism). Then I turn to

a discussion of how and why the story I deal with here applies, not just to white, well-off children (as it may at first appear), but to young people who are neither. I close with a brief discussion of schools and schooling.

The Great Disruption Story

In April 1984 the report *A Nation at Risk* was all the rage in the press (National Commission on Excellence in Education, 1983). With precious little empirical evidence, the report announced a crisis in America's schools. This crisis was not really about schools, but about society. By 1984, from the point of many political leaders, the United States had suffered more than two decades of "decline." Indeed, 1984 has now become a pivotal year in what is fast becoming a standard story about crucial changes in our society: the Story of the Great Disruption (e.g., Fukuyama, 1999; Howe & Strauss, 2000, both of whom cite many other academic and popular sources).

The story goes like this: In the two decades before 1984, the United States experienced a Great Disruption. By the early 1980s, "social ills" like divorce, single-parent families, abortion, child poverty, violent crime, teen suicide, and drug abuse, long on the increase, peaked. In 1984 the tide turned and a New Civic Order began to emerge (see data in Fukuyama, 1999; Howe & Strauss, 2000). Three significant trends started in 1984: the above "social ills" began a steady decline; a new "kinderpolitics" (Howe & Strauss, 2000) emerged as the center of American political life, a politics in which children's issues became the only ones around which increasingly fragmented and hostile political and social forces could converge; and the United States started on its longest economic expansion in history, giving rise to a generation of children who had experienced only unbroken "good times."

It is easy to see the Great Disruption Story in the following terms: the Great Disruption represents the chaotic Transition between the Old Capitalism (industrial capitalism, based on producing commodities for a large middle class) and the New Capitalism (high-tech global capitalism, based on networks and knowledge in a world of increasing returns in which the rich get richer, the poor poorer, and the middle class shrinks; see e.g., Rifkin, 2000; Thurow, 1999).

The most powerful people in the emerging New Civic Order today were born in the heyday of the Old Capitalism, but spent their formative years in the Age of Transition. These are the so-called Baby-Boomers (Thau & Heflin, 1997). Those Baby-Boomers who survived the great down-scaling of the middle class in the Age of Transition to end up in the upper middle class of the emerging New Civic Order went through two stages on their way to their current third stage.

In Stage One, they were Hippies or fellow travelers. In the 1960s and 1970s (good times in the Old Capitalism, but its last days), they found society's institutions too rigid and powerful and their parents too materialistic. In turn, they championed non-conformism, anti-materialism, and individuality. After a significant

U.S. economic downturn and the short life of the "Asian Tigers," the "New Economy" emerged, stepchild of Thatcher and Reagan (its real parents were various neoliberal economists and businesspeople). In Stage Two, the non-conformist individualist turned into the Yuppie, the business- and market-oriented individualist who saw wealth and status as the litmus test of success and human worth. Baby-Boomer Yuppies were eventually joined and even trumped at this game by the Gen-X e-entrepreneurs, as millions of people left middle management and big businesses for more entrepreneurial lifestyles inside and outside the Internet (Lewis, 1999).

Today, in Stage Three, these successful Baby Boomers have become the new elite class, what David Brooks (2000) calls "bobos" (see also Rifkin, 2000). Having "made it," Bobos want more in life than money and possessions. They want spirituality and values. They attempt now to combine bohemianism (a version of which they experienced in "the '60s") and the bourgeois values they enacted and championed in the Reagan '80s. However, non-conformism today is a matter of style, not politics; a set of lifestyle values meant to leaven the harsh realities of bourgeois materialism.

The Bobos want lifestyles with meaning, individuality, and aesthetics, but filled with money and status as well. These are the people who drive hefty four-wheel-drive all-terrain vehicles to expensive malls, all the while dressing down in rustic but nonetheless expensive and stylish clothes. They are the people, as well, who have new Volkswagen bugs (with a flower in the holder) parked at health clubs that look like four-star hotels. Their wealth is tied up in stocks; in other investments; and in their cultural, professional, and/or entrepreneurial skills and knowledge.

Earlier in their lives, Bobos, before they were Bobos, when they were riding the Reagan frontier, downplayed family and children in favor of self-development and success (Putnam, 1995). Indeed, this is part of why, the Great Disruption story has it, values connected to children and families deteriorated (only part of the reason, of course: the rest of the story is that Welfare ruined poor people's family values). The Bobos' early children were Gen-Xers (an important part of this story is that many of the Bobos now have later and *better* children, as well).

Gen-Xers divided into two camps, both of which were reactions to the Boomers in their Yuppie stage (Craig & Bennett, 1997; Holtz, 1995). Some Gen-Xers (the latch-key children of the Yuppies left too much to their own devices) became Slackers: apolitical, cynical, detached, and the consumers of edgy in-your-face uncivil popular culture (much of it, ironically, produced for them by the Boomers). Some Gen-Xers hypercorrected the Yuppies and became E-Cowboys, reveling in their economic free agency and their mastery of digital technologies, unabashed and unashamed of wealth and customized luxury.

As they came into middle life, Bobos, in their newfound search for values, have come to foreground children and family. A great many of them have had children later in life or a second batch later in life (often a batch of one). In this they have been joined by a segment of the Gen-X population, some of whom value children and families just because their Boomer parents emotionally deserted them in favor

of wealth and success. These Bobos and Gen-Xers have taken part in the production of a new Baby Boom, often called a Boomlet, but, in reality, bigger than the Baby Boomers' Boom (Howe & Strauss, 2000; O'Reilly, 2000). The New Baby Boom has been greatly increased by large numbers of immigrants bringing their children to the United States and/or having children here. Many of these immigrants are, of course, not themselves Bobos, but busy working for the Bobos in service jobs (and herein lies another story), which is not to say they don't aspire to be Bobos (or have their children become Bobos).

For Bobos and many Gen-Xers participating in the New Baby Boom, children are valued in a very specific way. They are seen as vulnerable "resources" which one must assiduously protect and in which one must heavily invest in order, in the long run, to have any significant chance for a successful result. "Successful result" here means children who, as adults, will be well off, heavily credentialed by elite educational institutions, professionals living in elite neighborhoods, but invested in their own families and able to pass on their success to their own children. Thus, today, well-off parents spend on ("invest in") a single child what parents use to spend on four. And money is only part of the investment. Elite parents today devote more time, attention, and supervision to their children, and control their activities more, than did parents in the heyday of the Reagan Yuppies (and, of course, sometimes we are talking about the same parents with earlier and later children).

Millennials

The children of the New Baby Boom are a generation that have been called by many names—for example, Generation Y, Generation ", Echo Boom, Generation Next, the Bridger Generation, Generation 2K, Millennials, and so forth (*Barna, 1997; Howe & Strauss, 2000; *McAllister & Springle, 1999; O'Reilly, 2000; *Rainer, 1997; *Zoba, 1999). Many sources on the New Generation are Christian books (see asterisked citations in preceding list) intended to help ministers and others "reach" them. This is not surprising, given the coalition among neoliberals, neoconservatives, and moderate and conservative religious forces that stands at the heart of the politics of the Restoration (see Apple, 1996). See also *"Millennials Rising: The Next Great Generation,"* available at http://www.millenialsrising.com; WWW. Millenials.Com: *A publication of Generational Inquiry Group,* available at http://www.millennials.com/ltm/main.html; and *Generation Y,* available at http://www.generation-y.com/. I will call the children of the New Baby Boom the Millennials, though Children of the Restoration would be a good name, too.

Millennials were born and have always lived in the New Capitalism amidst the Restoration from the Great Disruption. At the earliest they were born in 1982—and this only for the United States where the trends that gave rise to Millennials happened earlier than elsewhere; in other parts of the world they are not yet in their teens (Howe & Strauss, 2000). In fact, 1982 was used as a political device (in

the political initiations involved in the Restoration, especially in the first Bush presidency) to convince the Class of 2000 that they were different and should eschew the "bad" values of Children of the Disruption (e.g., Slacker Gen-Xers and poor kids shooting each other).

The world in which Millennials have been socialized (the Restoration) is massively different from the world in which the Bobos were socialized (the final years of the Old Capitalism). The world of the Millennials is of course currently analyzed, for the most part, by academics and popular writers who are themselves Bobos, wannabe Bobos, or Baby-Boomer anti-Bobo critics of the Bobos (sore losers from the point of view of the Bobos).

Above I mentioned that "Children of the Restoration" would be a good name for the Millennials. So, too, would "the Barney Generation" or, better yet, "the Blues Clue's Generation." Most Baby Boomers can't stand shows like *Barney & Friends* and *Blue's Clues,* but they rather like *Sesame Street*. Young Millennials like *Sesame Street,* especially the Muppets, but they also like *Barney* and *Blue's Clues,* often more than *Sesame Street*. *Sesame Street* is a grand Baby Boom gesture (it first aired in 1969) to save the world from the problems of race, poverty, and a lack of equity. Maturing Millennials, as I will point out below, don't care as much about civil rights as they do about civic duties. They don't care as much about difference as they do about commonality and community.

Sesame Street, Barney & Friends, and Blue's Clues

Let me take a moment to contrast *Sesame Street* (first aired in 1969) with *Barney & Friends* (first aired in 1991) and *Blue's Clues* (which within months of first airing in 1996 was trouncing *Sesame Street* in the ratings; see Gladwell, 2000). The themes that emerge from this analysis by and large replicate themes that emerge from a contrast between the Baby Boom generation and the Millennial generation, a topic to which I will turn later. Below, I reprint material from the shows' web sites about their respective philosophies. I have underlined words that I believe are particularly important for the discussion that follows.

Sesame Street. Designed to use the medium of television to reach and teach preschoolers, and give them *skills* that would provide a *successful transition from home to school*. The show gave children *a head start* and provided them with enough *confidence* to begin learning the *alphabet, numbers, and pro-social skills*. . . .Everything about the series was a departure from previous children's television programming—from its format to its *focus on disadvantaged inner city children,* to the way it *combined education and entertainment. (Sesameworkshop,* available at http://www.sesameworkshop.org/faq/answers/0,6113,0,00.html)

Barney & Friends. The programs are designed to *enhance the development of the whole child*—the cognitive, social, emotional, and physical domains. . . .A strong em-

phasis is put on *prosocial skills* such as making friends, sharing, cooperating, and using good manners. (Available at http://www.pbs.org/barney/html/Philosophy.html)

Blue's Clues. Play-to-learn is the essence of *Blue's Clues. Blue's Clues* was created to *celebrate the life of a preschooler*—who they are, what they know, and how they experience and learn from everything that they do. . . .Every episode is developed to fulfill the mission of the show: to *empower, challenge,* and *build the self-esteem* of preschoolers all the while making them laugh. (*Nick Jr.com,* available at http://www.nickjr.com/grownups/home/shows/blue/blues_play_to_learn. jhtml)

Sesame Street is devoted to the transition from home to school, especially in respect to disadvantaged children and particularly in regard to "disadvantaged inner city children" (Baby Boomer code for poor African American children living in urban ghettos). Note that "prosocial skills" for *Sesame Street* are part of a list of school-based things like literacy (the alphabet) and numeracy (numbers). "Prosocial" here appears to mean "knowing how to behave in school." *Sesame Street* is, in many respects, a quite overt form of early schooling, a kind of Head Start program all of its own.

Sesame Street combines real people and Muppets in an urban-looking three-dimensional space. It believes (like almost all Baby Boomers do) that children's attention spans are short (and getting shorter) and, thus, it cuts quickly between episodes that often have little to do with each other (there have been some not completely successful attempts to change this in later years). It is replete with an often wryly humorous subtext directed at adults (e.g., Monsterpiece Theater) and uses a good deal of metaphorical language and language play that only adults can understand. In regard to its subtext for adults as well as to its direct engagement with its child viewers, *Sesame Street* is far more focused on language than either *Barney* or *Blue's Clues. Sesame Street* displays, foregrounds, and celebrates social and cultural differences. In fact, the celebration of difference is one of its major themes (though *The Puzzle Place* became the high-water mark of the celebration of difference).

Barney & Friends is not primarily about making the transition from home to school, though it embeds in its shows things like counting or learning shapes. It is primarily about the "whole child" and "prosocial skills" in the sense of cooperation and community, not in the sense of knowing how to behave in school *per se*. It contains a good deal of play, song, dance, and other sorts of movement of the body, less school-type language, and less diversity of language, than *Sesame Street*. Like *Sesame Street,* it combines real people and fantasy figures, but in a suburban, or even rural, context, not an urban one. In fact, the show is often set in what looks like a suburban or rural school yard, but after school is over. It is almost as if children become really alive (or "lively") only after school is over or outside of school.

Like *Sesame Street, Barney & Friends* cuts between short episodes, but the episodes are often tied to a single theme such as learning to count, identifying colors or shapes, or making friends. It has little or no sub-text directed at adults and engages

in little or no metaphorical language of the sort only an adult could understand. While *Barney & Friends* displays children of different ethnic groups, it does not foreground social or cultural differences. Rather, one of its major themes is commonality and what makes children the same.

Blue's Clues (in which children solve a puzzle using three clues in each episode) takes *Barney & Friends* one step further. It is overtly about "playing to learn," much like *Barney*, which often seems to be about "singing and dancing around to learn," and thus, in a sense, overtly contrasts itself with school (which is not to say it is anti-school). It celebrates the life of a preschooler and what preschoolers are and know as they are now, not as they will become in the future. It is about "empowerment," where "empowerment" means feeling smart and being willing to take on intellectual challenges.

Blue's Clues combines one real person ("Steve," who is about as close to not being a real person as a real person can get) with fantasy figures (there are some, though not many, brief appearances by real children). Like *Barney*, it is filmed in a setting that looks suburban or even rural, but the setting is two-dimensional. It looks like a child's magazine or book in bright primary colors, not like the real world (e.g., the dog "Blue" looks like a cutout of a child's drawing of a blue dog).

Blue's Clues does not believe children have short attention spans. It believes their attention spans last as long as things make lucid sense to them, which is why the show is so literal (Gladwell, 2000), and thus, each half-hour episode is devoted not only to a single theme but to a single cognitive problem that the child viewer must solve. Unlike other shows, *Blue's Clues* runs each episode five times before running the next one, so that children can solve the problems completely and feel a sense of total mastery.

Blue's Clues entirely eschews adult-directed subtext and metaphorical language. Characters are named quite literally (e.g., "Blue," a dog that is blue, "Shovel," a shovel, "Pail," a pail). Steve often directly faces the camera and interacts with the show's child viewers, giving them ample time to answer his queries and comments. While *Blue's Clues* very occasionally shows culturally diverse children (it does not show many people for very long beside Steve, a white man who always wears the same clothes), it has next to nothing to do with difference, diversity, or commonality. It is primarily focused on the socially situated cognitive growth of children in interaction with an adult (Steve) and his cognitive "mediating devices," characters like Blue, Shovel, Pail, and Soap, as well as tools like a notebook in which to keep a record of the clues, all of which help the child solve the problems (Nick Jr.com, available at http://www.nickjr.com/grownups/home/shows/blue/inside /alice_wilder_interview.jhtml).

Sesame Street is designed to entice the parent to watch with the child, assuming the parent (perhaps a poor disadvantaged urban mother) might not. *Sesame Street* assumes (certain) kids need a head start for school, a head start they may not get in their homes (perhaps poor disadvantaged urban homes). *Barney* and *Blue's Clues* do nothing to entice the parent to watch (in fact, many adults hate both shows), but their web sites make it clear that they absolutely assume a parent is watching

with the child, and in an interactive way. Unlike *Sesame Street, Barney* and *Blue's Clues* assume parents are so devoted to their children's interests and development that they do not need a subtext to keep them attending with their child (remember, Baby Boomers in their Bobo guise like children and are now willing to subordinate their own interests to their children's development). *Barney* and *Blue's Clues* do not assume that children need a head start for school. Rather, they assume children are already smart, will develop through play, and have homes that will enhance their smartness and add value to their play.

Sesame Street assumes that what children really need they will or ought to get in school or through schooling. It does not compete with school; rather, it prepares children for school. *Barney & Friends* takes place alongside of school and is a space that enhances school and schooling. When *Barney* shows a classroom, it always seems so inert—the displays and activities left over from the school day only really come alive when Barney and the gang enact them into communal song and dance after school. *Blue's Clues* is in a space (Steve's two-dimensional home) completely away from school and, in sense, it is in competition with school. In many respects it is better than school. Steve's home, like many of the homes of the children watching *Blue's Clues,* seems to assume that it has a truer sense of who children are and what they know and need than does school.

Sesame Street, on the one hand, and *Barney & Friends* and *Blue's Clues,* on the other, orient quite differently towards literacy. *Sesame Street* overtly stresses and showcases language, literacy, and school skills. *Barney & Friends* does not stress these things, but rather stresses the body, play, the whole child, sharing, and commonality. *Blue's Clues* also does not stress language, literacy, or schooling, but rather stresses thinking, problem solving, and empowerment. In *Barney & Friends* and *Blue's Clues* children become literate and smart by being and celebrating themselves. In *Sesame Street,* they become literate and smart by learning school-based skills. The "model" child viewer (the "assumed reader" in literary critical terms) of *Sesame Street* is a poor child (whose assumed shaky sense of confidence needs building up). The model child viewer of *Barney & Friends* and *Blue's Clues* is a Millennial child from a Boboesque home (whose assumed strong sense of self is being further empowered).

Blue's Clues is, in my view, the ultimate Millennial show for small children. Its practices and values are fully aligned with rhetoric about New Capitalist workplaces (Drucker, 1999; Gee, Hull, & Lankshear, 1996). New Capitalist workplaces (according to this rhetoric) require empowered employees who can think for themselves and who think of themselves as smart and creative people. They require employees who are good at problem solving and who can use various tools and technologies to solve problems. In turn, *Barney & Friends* celebrates the cooperative learning and working together (think of work teams and quality circles) and the stress on commonality and community (think of corporate cultures and communities of practice) so commonly stressed in the literature on New Capitalist workplaces.

Barney & Friends and *Blue's Clues* are also well aligned with the current practices and views of Bobo homes. Such homes see school as only one site—and, perhaps,

not the most important one—for enriching and accelerating their children (Gee, 2000c; Gee & Crawford, 1998; Gee, Allen, & Clinton, 2001). Such homes offer their children a plethora of out-of-school tools, technologies, experiences, activities, and sites for the formation of intellectual and social skills that will equip them for elite higher education and success in the New Capitalist world. In line with current neoliberal philosophy, homes that cannot leverage such advantages for their children in the free marketplace are entitled only to the basic skills that "accountable" public schools have to offer "off market" (D'Souza, 2000).

Boomers Versus Millennials

Let me now turn to what popular sources have had to say—based partly on surveys and other sorts of empirical evidence—about the contrasts between Baby Boomers (when they were younger) and Millennials (18 at the oldest, but with the heart of their generation younger). These contrasts will supplement the discussion above of children's television shows. Below, I list a large number of contrasts between Baby Boomers and Millennials, gathered from a variety of sources (especially, Howe & Strauss, 2000; O'Reilly, 2000; Millennial Surveys, available at: http://millennial-srising.com/survey.shtml):

Boomers	*Millennials*
institutions felt too strong	institutions feel too weak
key problem: institutional repression	key problem: fragmentation of society
individuals seemed too weak	individuals seem too strong
distrusting of institutions and government	more trusting of institutions and government
stressed independent study in school	stress collaboration in school
liked school, but behaved badly	dislike (high) school, but behave well
saw the world as black-white	see the world as browning
sought integration	accept segregation
stressed civil rights	want to stress civic duties
race is viewed as main divide	class is viewed as main divide
worry about an underclass	accept an overclass
as children time was unstructured	as children, time is structured and controlled
took recreational drugs	take therapeutic drugs
when young, wanted to be unconventional	want to be conventional
into language	into action and activities
stressed social studies and arts	stress science, math, and technology
focused on difference	desire commonality/community
boys led	girls lead
gender neutrality was developing	gender distinctions are widening

I cannot elaborate on all these contrasts here. Suffice it to say that the "big picture" is something like the following. Millennials regret the societal fragmentation and extreme individualism to which the Boomers' earlier assault on social and governmental institutions gave rise. However, Millennials live in a New Capitalist world in which, while poverty has declined, the gap between the poor and the rich has increased. This growing gap has been caused by the very logic of the New Capitalism, a logic of increasing returns or a "Winner Take All" system (Frank & Cook, 1995). By and large, the Millennials appear to find this logic acceptable, natural, and inevitable (Gee, 2000c; Gee, Allen, & Clinton, 2001; Rifkin, 2000).

In the New Capitalism, the increase of technological and scientific innovations, the rise of immigration, increases in global trade, and the ability of businesses to get workers at the lowest price across the globe have widened the market-determined difference between high and low wages (Greider, 1997; Thurow, 1999). Over the Millennial childhood, Millennials have seen workers with high educational credentials gain more and more income, while they have seen poor people and immigrants fill unskilled labor positions and the massive supply of service jobs.

All this has created something of a paradox for the Millennials. Millennials want to stress commonality, community, conformity, responsibility, and civic duties, while they also want to accept as natural large disparities between the rich and the poor, even to the point of accepting as natural the existence, power, and status of an Overclass. Of course, this paradox exists in large part because Millennials have seen Baby Boomers in their Yuppie and Bobo guises come to accept and even celebrate this Overclass themselves:

> One intriguing generational aspect of the Millennial child era has been first the tolerance, then the defense, and eventually the exuberant celebration of a new "overclass" of mid-life Boomers who long ago once accused their own GI parents of materialism. (Howe & Strauss, 2000, p. 109)

The acceptance and importance of this Overclass is perhaps one reason Bobo parents (and Gen-X parents who follow these trends) seek to control their children's time and attention so tightly. Millennials show a significant decline in the amount of time they spend in unstructured activity compared to Gen-Xers as children (Howe & Strauss, 2000). As I mentioned above, such parents feel they must heavily invest in their children if they are to end up successful in an hourglass social structure.

It is interesting that polls show even the well-off Millennials like school less with each passing year, but accept it as necessary for their future (Farkas, 1997; Howe & Strauss, 2000). They tend to like school less well than the Baby Boomers did, but they behave better in school (in part, Millennials behave well because so many aging Baby Boomers have pushed zero tolerance policies in schools and society). Many Millennials see success in school as necessary for the future precisely because they (and their parents) are aware of the role that educational credentials,

especially from elite institutions, play in the New Capitalist world. At the same time, they are well aware that many of the core credentials, skills, experiences, and identities necessary for success in that world are not gained in school, but rather outside school at home, in activities, camps, travel, and on the Net.

Diversity functions quite differently for the Millennials than it did for the Baby Boomers (Howe & Strauss, 2000). The Baby Boomers lived in a world in which the Great Divide was between black and white, and race was the key social issue. Indeed, even today, for many Baby Boomer academics, "cultural diversity" is still a code word for "race" defined in terms of black and white. In the world in which Millennials live, diversity doesn't mean black or white; it means a great many shades of white, brown, and black: Chinese, Vietnamese, Koreans, Japanese, Malaysians, Asian Americans, Mexicans, Mexican Americans, Indians, Guatemalans, El Salvadorians, Colombians, Peruvians, and so forth through a very long list, indeed (and each of these groups comes in many types, income levels, and colors).

In the Millennials' world, segregation is increasing, both in communities and schools (and on television, where blacks and whites now watch quite different shows). But, for the Millennials, segregation is defined more by income than race (Howe & Strauss, 2000, p. 220). Boomer and Gen-X parents appear to have less and less interest in raising their children in multicultural settings, in part because, while they tend to accept cultural diversity as a value and still care about civil rights, they do not want their children mixing with poor children of any sort.

Gender works differently for Millennials, as well (Gilbert & Gilbert, 1998; Howe & Strauss, 2000). In schools, girls, in nearly every area, are showing more progress than boys. In fact, some colleges are beginning to see fewer applications from boys, less good ones, and more boys dropping out. Even in areas like math and science where boys are still ahead of girls, the girls are catching up fast. Girls appear to be the cultural leading edge of the Millennials, with many Millennial boys caught between following the lead of the girls or retaining the pre-Restoration behaviors of Gen-Xers.

Shape-Shifting Portfolio People

It is often thought that the growth of the Net and a plethora of media outlets lead to fragmentation and the defeat of standardization. In fact, the situation is the reverse. Thanks to the Internet and ever more global media outlets, teens almost anywhere in the United States and the world can gain the sorts of information to which only teens in bigger and more central places once had access. Today, nearly anyone can find out where the cutting edge of fashion is and can order it over the Net (Kaplan, 2000).

Furthermore, a Darwinian principle of increasing returns operates on the Net, as it does elsewhere in the New Capitalism. Small advantages (e.g., a good Net name, being early into the market, easy access, being well linked to other sites, and so one)—some of which money can buy—quickly ramp up to big ones, small

disadvantages quickly build up to large ones. The rich become richer and the poor get poorer (e.g., a site gets more hits in one cycle of activity because it got slightly more in the last, then it gets even more in the next, and so on until it has taken most of the space available). As the New Capitalism is stabilizing, businesses are getting bigger, fewer businesses are taking more and more share of each market, and mass fads and big brands are making a comeback (Greider, 1997).

These processes are part of what make well-off Millennials so important, even though they represent a minority of the population of young people. Thanks to the reach of the Net and global media, and the ways in which certain sites gain hegemony through the processes of increasing returns, young people from many places and many economic niches can see, share in, and be influenced by these well-off Millennials and the powerful sites that cater to them (and are made powerful by catering to them). Paradoxically, then, the Net can allow Millennial fashions and viewpoints to become something of a standard or "attractor."

For example, Claire's is a popular store that sells accessories to Millennial girls. The business reported a five-year growth rate of 23.79% (Claire's, available at http://www.clairestores.com/pages/financials). No Claire's store may exist in a rural part of Wisconsin, say, but any Wisconsin teen can easily purchase the company's products, join its club and enter its chat rooms, or enter sites to which they link, and so be influenced by Claire's sense of fashion and its perspectives on society and culture. Further, they can easily find Claire's by the number of teen sites that link to Claire's site, some of which are paid to link to it.

Of course, though I have stressed neostandardization, modern technologies allow consumers to customize what they buy, whether it is a thing, experience, or activity. However, this customization is often not actually at the individual level so much as at the class level—it is determined by what one can afford and how one defines one's lifestyle in class terms (Rifkin, 2000). It is important to see, though, that today class is defined not primarily and directly in terms of income or level of education, but rather in terms of one's affiliations with certain sorts of people, objects, technologies, practices, and the status of one's educational credentials and professional achievements (Brooks, 2000; Heilbroner, 1994; Rifkin, 2000). Thus, what one finds in the New Capitalism is a process of *class-based customized standardization,* where class is defined in distinctive terms.

Class-based customized standardization applies to people, as well, in the New Capitalism. New Capitalist literature calls for what I have elsewhere referred to as Shape-Shifting Portfolio People (1999b, 2000c). Shape-Shifting Portfolio People are people who see themselves in entrepreneurial terms. That is, they see themselves as free agents in charge of their own selves as if those selves were projects or businesses. They believe they must manage their own risky trajectories through building up a variety of skills, experiences, and achievements in terms of which they can define themselves as successful now and worthy of more success later. Their set of skills, experiences, and achievements at any one time constitutes their Portfolio. However, they must also stand ready and able to rearrange these skills,

experiences, and achievements creatively (that is, to Shape-Shift into different identities) in order to define themselves anew (as competent and worthy) for changed circumstances. If I am now an "X," and the economy no longer needs "Xs," or "Xs" are no longer the right thing to be in society, but now "Ys" are called for, then I have to be able to Shape-Shift quickly into a Y.

In earlier work I have argued that well-off teens today see home, community, school, and society in just such terms (Gee, 1999b, 2000c; Gee, Allen & Clinton, 2001). They seek to pick up a variety of experiences (e.g., the "right" sort of summer camps, travel, and special activities), skills (not just school-based skills, but a wide variety of interactional, aesthetic, and technological skills), and achievements (honors, awards, projects) in terms of which they can define themselves as worthy of admission to elite educational institutions and worthy of professional success later in life. They think and act, from quite early in life, in terms of their resumé. Note that school (or at least the classroom at school) is not the only, perhaps not even the central, site for filling up one's resumé.

Crucially, the sorts of experiences, skills, and achievements that are important for higher-level success in the Millennials' world are heavily class based and shared by teens based on their access to financial, social, and cultural resources (e.g., how Boboesque their home is). Such teens can customize themselves, indeed they must if they are to stand out on their applications to elite schools, but within a range defined by and standardized within their class. Thus, Shape-Shifting Portfolio People are themselves an example of *class-based customized standardization*.

I want to stress, again, that class means something different in the New Capitalism than it did in the Old. In the Old Capitalism there was a broad and massive "middle class" defined by one's ability to consume standardized commodities. Many blue-collar workers, thanks to unions and high wages, were in this middle class. In the New Capitalism, class is defined by the nature of one's Portfolio, the sorts of experiences, skills, and achievements one has accrued (which one shares, by and large, with the "right" sorts of people), and one's ability to manage these in a Shape-Shifting way. One's Portfolio surely correlates with one's parents' income (though by no means perfectly), but what matters is the Portfolio and the way in which it is viewed and managed. If you have no Portfolio or don't view yourself in Portfolio terms, then you are surely in the "lower class."

Returning for a moment to *Barney & Friends* and *Blue's Clues,* note how the philosophical statement reprinted from *Barney & Friends'* web site talks about "enhanc[ing] the development of the whole child" and even more how *Blue's Clues* web site talks about celebrating "who [preschoolers] are, what they know, and how they experience and learn from everything that they do," and how the show's mission is "to empower, challenge, and build the self-esteem of preschoolers." Unlike *Sesame Street,* where the focus is on skills and school, here the focus is on the formation of empowered people who can build on (and build up) their experiences. *Blue's Clues,* in many respects, is a perfect first show for up-and-coming Shape-Shifting Portfolio People.

Diverse Millennials

To many it may seem as if my discussion of Millennials only applies to well-off young people, perhaps even only to well-off white young people. It is important to note that this is not necessarily the case. As I pointed out earlier, well-off Millennials, thanks to the Net and global media, can serve as an "attractor" for other young people. However that may be, lots and lots of young people today who are not well-off or white display Millennial viewpoints and aspirations.

For example, Wan Shun Eva Lam (2000), in her excellent article "L2 Literacy and the Design of the Self," discusses a case that is not at all atypical in the Millennial generation, where 35% are non-white or Latino (Howe & Strauss, 2000). Lam's focal student, whom she calls "Almon," emigrated from Hong Kong to the United States in 1992 at the age of 12. His family rented a small apartment on the outer fringes of the Chinatown community. When Lam first met Almon, he expressed frustration over the fact that his English skills were insufficient even though he had been in the country for five years. School only offered him ESL, bilingual, or remedial courses, courses that stigmatized him as a "low-achieving student" (Lam, 2000, p. 466). Almon felt that it was going to be hard for him to develop his "career" (his word, p. 467) in the United States because of his English skills.

However, when Lam returned to her field site six months later, she found that Almon's English writing skills had markedly improved. In the interim he had gotten involved with the Internet, created his own personal home page on a Japanese pop singer, "compiled a long list of names of online chat mates in several countries around the world, and was starting to write regularly to a few e-mail 'pen pals'" (p. 467). Almon felt it was easier to express himself in writing, and his Internet writing eventually improved his writing in school significantly. In addition, he was planning to take a public speaking class to improve his oral delivery skills.

After his experiences with and on the Net, here is how Almon talked about himself and his future:

> I'm not as fearful, or afraid of the future, that I won't have a future. . . . I didn't feel I belonged to this world. . . . But now I feel there's nothing to be afraid of. It really depends on how you go about it. It's not like the world always has power over you. It was [names of a few chat mates and e-mail pen pals omitted] who helped me to change and encouraged me. If I hadn't known them, perhaps I wouldn't have changed so much. . . . Yeah, maybe the *Internet* has changed me. (Lam, 2000, p. 468)

Almon had chosen to settle his home page in the "Tokyo" section of *Geocities* (an international server), where a global community of Asians gathers around Japanese pop culture. Almon's online chat mates were located in a wide variety of places, including Canada, Hong Kong, Japan, Malaysia, and the United States.

Almon's story is one variety of a typical Millennial story. He thinks in terms of his career and future and evaluates his current skills and experiences in that light. He gains his most important skills, experiences, and identities, including even

school-based skills, outside of school (indeed, school stigmatizes and deskills him). Though I have not discussed the matter above, Lam makes it clear that Almon's pen pal relationships are mainly with girls, who he believes "are more able to foster self-knowledge and confidence" (p. 472), and that his remarks take on some of the values and perspectives that these girls enact on the Net. Finally, Almon forms his new identities as part and parcel of what I have elsewhere called an "Affinity Group" (Gee, 2001).

An Affinity Group is a group wherein people form affiliations with each other, often at a distance (that is, not necessarily face-to-face), primarily through shared practices or a common endeavor (which entails shared practices), and only secondarily through shared culture, gender, ethnicity, or face-to-face relationships. Almon's Affinity Group is global and Asian-based, but here "Asian" covers a truly huge amount of diversity (native and non-native speakers, immigrants and non-immigrants, many countries and languages). Here, "Asian" itself names a massive and higher-level Affinity Group.

Lam (2000) argues that the genre of electronic dialogue, as a form of communication that relies heavily on writing, "constitutes a highly visible medium for the scripting of social roles" (p. 474). She points out that many of Almon's postings to his female interlocutors "sound both very personal and very much like role play" (p. 474). Almon not only gains new skills and develops new identities on the Net; he also learns to Shape-Shift, to enact different social roles by designing representations of meaning and self through language and other symbol systems such as music, graphics, and emoticons (New London Group, 1996).

There is no doubt that Almon, regardless of his economically based social class, is building a Portfolio and learning to think of himself in entrepreneurial terms (both in the creation of his own web site and in his sense of free agency and control over his own destiny) and in Shape-Shifting terms. Connected as he is in an Affinity Group way to a young Asian Diaspora, many of whom are, rich or poor, core Millennials, Almon is not at the margins (except in the eyes of the school), but instead is at the center of the New Capitalist Restoration.

School

We return from whence we began (remember *A Nation at Risk*), to schools and schooling. The first response to *A Nation at Risk,* much like the post-Sputnik response in the late 1950s and early 1960s, was to stress pedagogies and curricula that would get children thinking conceptually and deeply, rather than only in terms of basic skills and rote facts. Inspired by work in cognitive science, various "higher-order thinking" ("HOTS") curricula were developed and put into practice in classrooms that stressed technology, collaborative learning, and communities of learners (Brown, 1994; Bruer, 1993; Perkins, 1992). In fact, this was the initial inspiration behind the standards movement, which originally meant "high standards" and understanding of the conceptual bases of areas like math, science, so-

cial studies, history, and literature. In a variety of pieces of work in the past (1996a, 1999b; Gee, Hull, & Lankshear, 1996), I have argued that these pedagogies and curricula fit well with New Capitalist workplaces, which themselves stress collaboration, critical thinking (in the sense of deep understanding and thinking about complex systems), and communities of practice.

Of course, thanks to the current neoliberal hegemony, the canonical response to the Great Disruption, at least vis-à-vis schools, has come to be a stress on basic skills, passing standardized tests of basic knowledge, and traditional, often fairly scripted, instruction (McNeil, 2000; Perkins, 1992). This is a paradox. Why would political leaders push such forms of schooling in a New Capitalist world where success requires self-empowered learners capable of learning new, especially technical, things quickly and well, and where Millennials seek multiple, diverse, and distinctive experiences and achievements for their Portfolios?

Part of the answer is, I believe, this: in neoliberal philosophy everything should be on a (free) market and people ought to get what (and only what) they can pay for (Hayek, 1996; Sowell, 1996; von Mises, 1997). Of course, in the New Capitalism people don't always pay with money; sometimes they pay with their attention (see Lankshear & Knobel, this volume) or with information they have to offer. If, for humane reasons, there has to be, within a given area, something "off market" (i.e., free or subsidized), then it must be "basic," otherwise it will encourage people to withdraw from the market and, thus, disrupt the market. The current "accountability" movement is meant to guarantee that all children—not least, poor children—will get the basics in school, no more, no less.

This, of course, allows children to begin to fill up their Portfolios only if they can draw on family, community, or Internet resources, resources from various sorts of private sites and institutions, and school resources at the margins of the neoliberal "basic skills" curriculum (e.g., in special enrichment programs). In turn, it leaves children without such resources to fill the huge number of service jobs created by the New Capitalism and its distinctive workings of class defined in terms of the consumption of status and lifestyle. In the end, we get the Tale of Two Millennial Cities (Howe & Strauss, 2000), a tale not of race, nor of class in traditional terms, but of "kinds of people"—those with and without Portfolios, those with small and big Portfolios, Shape-Shifters and non-Shape-Shifters.

It has not been my intention here to make recommendations for the future, but to look into the future the only way I can, through the stories people, especially "enactive" people, have to tell about the present and the future. Nonetheless, it seems to me that, for those who care about disadvantaged children—the poor side of the Tale of Two Millennial Cities—there are two possible courses of action (not necessarily mutually exclusive). One is to give up on public schools, accept their neoliberal function of delivering "the basics" accountably, and work to provide Portfolio-forming activities and experiences, as well as political-critical capacities, for disadvantaged children outside of school and at school at the margins of the neoliberal curriculum. The other is to fight the neoliberal agenda and make

schools sites for creativity, deep thinking, and the formation of whole people—sites in which all children can gain Portfolios suitable for success defined in multiple ways and the ability to critique and transform social formations in the service of creating better worlds for all. I have always favored the latter, but my own bets are now on the former.

Margaret C. Hagood, Lisa Patel Stevens,
and David Reinking

WHAT DO *THEY* HAVE TO TEACH *US*?
TALKIN' 'CROSS GENERATIONS!

> *Well, people try to put us down. Just because we get around.*
>
> *The things they do look awful cold.*
>
> *I hope I die before I get old. Talkin' 'bout my generation.*
>
> —THE WHO (1965)

The Who's (1965) classic lyrics to the song "My Generation" highlight the tensions between generational perspectives and call attention to misunderstandings of adolescence and of youth culture: misunderstanding of what adolescents are like and of who they perceive themselves to be. The adolescent generation that first heralded this song to the top of the billboard charts are the hippies who now work at ad agencies, who have founded organic ice-cream companies, and who became high-tech entrepreneurs that quote Dylan and wear black jeans to work (Brooks, 2001). Though the sentiments expressed in "My Generation" are nearly 40 years old, they haven't been limited to the adolescent Baby Boomers who first heard it. This song has been respun, recreated, and reinvented by contemporary rock bands, holding relevance for youth almost four decades after its creation. Adolescents today, the so-called Millennial Generation born after 1982, continue to use *The Who's* mantra of "My Generation" as it has been repackaged by contemporary adolescent bands such as *Green Day* (1992), *Limp Bizkit* (2000), and *Blink 182* (1999). Actually, although teens of the Millennial Generation are sometimes portrayed as dichotomous to their Baby Boomer counterparts (Gee, this volume), they might easily share with these elders similar pleasures in classic youth culture texts such as those by *Led Zeppelin*, Jimi Hendrix, and *The Doors* produced more than 40 years ago. These kinds of cultural affectations of youth culture can't be expected to be wholly dissimilar across generations. For example, recently, *The Beatles 1* (2000),

a compilation of *The Beatles'* 27 singles that reached the top of the pop charts in the United States and the United Kingdom between 1962 and 1970, was one of the top selling albums among teenagers in the United States in 2000 (Puterbaugh, 2001). Yet in other areas, similar transfers across generations are either rare or decidedly submerged. Most poignant, as we argue in this chapter, shifts in literacy practices have occurred, creating disjunctures between the Millennial Generation and the literacies familiar to older generations such as the Baby Boomers. While some common themes of adolescence and some youth culture texts survive across generations, we believe that the literacies that are embedded in the lives of today's Millennial Generation are substantively and culturally unique. And we argue that they need to be better understood to comprehend and to influence positively literacy development in contemporary society.

In this chapter we explore generational literacies of adolescents in the sense of a separate and identifiable "MY" generation alluded to in *The Who*'s lyrics. We begin by examining how current adolescents of the Millennial Generation are discussed within a rhetoric of generational descriptions of literacy practices. Then we present portrayals of literacies in the lives of several individuals defined as Millennials and as adults. From these individuals' words, we examine how parallels and disjunctures open up and close off conceptualizations about literacies across and between generations. Finally, we use the disjunctures to discuss literacy practices in contemporary society that focus on adolescents.

A key assumption of generational analysis, as outlined by Crispell (1993), is that "each generation has its own perspective because its members were born and grew up during particular eras" (Where generations divide, para. 10). Generational understandings are, therefore, related to economic, political, and social constructions of a particular time in history, and they affect how we view aspects of life and society. We realize that identification of generational categories artificially pigeonholes individuals into a particular group with particular characteristics. Nonetheless, we knowingly use the broad generational characterizations of adolescents as Millennials in order to explore the rhetoric of generational categorizing within historical, political, cultural, and social frames.

Drawing from structural, poststructural, and sociocultural theories, we connect generational characterizations to the work of others who have moved away from a narrow psychological focus and who have embraced social, cultural, and historical explanations for literacy and its practice and influence (e.g., Barton, Hamilton, & Ivanic, 2000; New London Group, 1996). Gee (2000b) explains, "reading and writing only make sense when studied in the context of social and cultural (and we can add historical, political and economic) practices of which they are but a part" (p. 180). Guided by this perspective, we approach generational depictions as socially constructed ways of considering and discussing literacies. We cannot, therefore, separate individuals and their literacy practices from society, but rather we proceed from the idea that "society inhabits each individual" (Sarup, 1993, p. 6). It is from that notion that we explore the construction of people and of literacy as a societal construction of generational differences.

Who Are THEY?

Adolescents today may seem to share similar interests in classic youth culture with adults in their 30s, 40s, and 50s, but they are portrayed as a distinct generation growing up in an era markedly different from the revolutionary 1960s. Luke and Roe (1993), for example, stated that the "universe is substantially different in kind from that accompanied by the print and media narratives with which the last 'modern' generation of the 1950s and 1960s grew up" (p. 118). Noted often in magazines and newspaper articles, today's adolescents were born into a world mediated by digital culture (Gordon, Underwood, Wiengarten, & Figueroa, 1999; Springen, Figueroa, & Joseph-Goteiner, 1999). Television, music videos, movies, the Internet, email, instant messaging, online chats, streaming video, and computer-generated games, for example, entail literacies that permeate the lives of today's Millennial youth, affecting the information they encounter and the texts they read. And, though "the sixties" is often and perhaps erroneously understood as "the decade of the big change" (Frank, 1997, p. 1) that created new culture, fashion, ethos, and a sense of individuality, the technological explosion of the previous ten years has accordingly brought about the newest decade of big change in the literate lives of adolescents.

The Millennial Generation has sometimes been represented in contradictory ways, depending on the context. Like the sentiments relayed in the lyrics of "My Generation," adolescents occupy a precarious position in society—one that can be described as fringelike, irrelevant, and indecisive on one hand; and central, knowledgeable, and powerful in the workings of capitalistic society on the other. Stereotypical descriptions of adolescence in general portray teenagers as indeterminable (Epstein, 1998; Hebdige, 1988), and Millennials are no exception in inheriting that characterization. Millennials, like past generations of adolescents, are often characterized by adults as "bundles of raging hormones" and "unruly" and are thought to be acritical consumers or apathetic citizens based solely upon their age (Finders, 1998; McGregor, 2000).

However, Millennials are positioned and constructed differently in an economic sense. In capitalist societies, Millennials are crucial for economic success. They comprise a market segment valued at $150 billion a year and are the most researched group of people in history (Frontline, 2001). And they drive several industries, such as fashion, entertainment, and technology, defining what's in, what's out, and how products get used (Look-Look.com, 2001). Those in media-related fields are attuned to the fact that Millennials engage in media use for an average of 6.5 hours a day outside of school (Roberts, Foehr, Rideout, & Brodie, 1999). According to Nye, co-founder of the marketing firm U30 Group, Millennial Generation adolescents are indispensable for determining current trends and in shaping the kinds of products made available for them. As he explained,

They are used to choosing and manipulating their experiences—creating their own CDs on the Internet, for example. You can't just take a snapshot of them every six

months. If you aren't inviting them in and including them as collaborators, you're missing the boat. (Gardyn, 2001, para. 20)

Just as Millennials' views influence production and consumption in society, they have also been implicated in influencing the shape and direction of our future. Rushkoff (1996), a cultural theorist, purported, "Kids are our test sample—our advance scouts. They are, already, the thing that we must become" (p. 13).

Clearly, the Millennial Generation has been constructed in society as engrossed in media—sometimes as passive recipients and sometimes as savvy consumers and creators of multimedia texts. Even the field of literacy research has begun to entertain notions of how adolescents might employ literacy beyond the traditional definitions and confines of print-based secondary classrooms. This broadened perspective is notably marked by a shift in terminology from the study of *content area literacy,* which centralizes the curricular content, to *adolescent literacy,* shifting the focus to adolescents and to the culturally defined contexts of their lives (Moore, Bean, Birdyshaw, & Rycik, 1999). Also, in light of increasingly popular and pervasive digital media in adolescents' lives, several writers have called for broader conceptions of literacy, suggesting terms such as *representational literacy* (Cognition and Technology Group at Vanderbilt University, 1994) and *visual literacy* (Flood & Lapp, 1995). As this shift in defining literacy has occurred, the literacy practices studied have accordingly expanded to include literacies used in out-of-school contexts (e.g., Alvermann et al., 2001; Bean, Bean, & Bean, 1999; Moje, Young, Readence, & Moore, 2000) and literacies that extend beyond print-based, alphabetic texts (e.g., Cope, & Kalantzis, 2000; Lankshear, 1997; Reinking, McKenna, & Labbo, 1998; Tierney, 1997). The opening up of the definitions and contexts of literacies in research has contributed to the documentation and portrayal of dynamic literacy practices used by youth as those practices intersect with media other than print-based texts, including film and television viewing and production (Bloustien, 1998; Tobin, 2000), video gaming (Alloway & Gilbert, 1998), online instant messaging (Lewis & Fabos, 2000), telephoning (Gillard, Wale, & Bow, 1998), and musical interests (Alvermann, Hagood, & Williams, 2000; Hagood, 2001). Although broadening perspectives of literacy to include digital media has been clearly acknowledged as an important generational difference, it is important to note that there has been little systematic accommodation of it regarding how literacy instruction including these kinds of literacies plays out in typical school settings (Leu & Kinzer, 2000).

People Try to Put US Down: THEIR Literacies?

The concepts of literacies and their attendant features are requisite aspects of society, and the definitions of the terms *literacy* and *literacies* guide the sorts of texts that are recognized, used, and valued as literacy practices. Rather than provide a list of possible activities that might fall under these amorphous and problematic terms, we draw from two separate studies about adolescents' and adults' literate

lives to ascertain how they define and use literacy. Selected data clips from in-depth interviews with adolescents are drawn from a six-month cross-continental interview and observational study of seven eighth-grade, 12- and 13-year-old adolescents (four living in Australia and three in the United States). This study examined the adolescents' uses of and perceptions of literacy and popular culture in their everyday activities, inside and outside of school (Hagood, 2001). Data clips from in-depth individual interviews with adults are taken from a five-month qualitative study of preservice teachers enrolled in an undergraduate, content-area literacy course in a southwestern city in the United States (Stevens, in press). The latter study used field notes, interview data, and artifacts to document the participants' perceptions of literacy and of adolescents and their literacy activities.

When talking with the adolescents and adults whose voices are represented in this chapter (all names are pseudonyms), we espoused a broad definition of literacy, one that included any type of communicative interaction involving speaking, reading, listening, and writing with text in print or nonprint forms. This broad definition not only gave us a lens that views literacy as reading both the world and the word (Gee, 1996b), it also allowed us to elicit others' conceptualizations of literacy without imposing our own views on them. From the large body of data that comprises our ongoing research, we selected the following data clips as samples to compare and contrast generational views of literacy conceptualized both inside and outside of school. To push against the divisive tendencies of labels and structures that belie daily interactions across generations, we first present the adolescents' and adults' comments in an integrated fashion, and then we discuss the generational parallels and disjunctures among the examples.

> On any day, the best place to find me after 4:00 is in my bedroom talking to my boy-friend [on the phone] and watching music videos, OW! Girl, you learn a lot from them. I know the songs and the dances and all about the people from the *Places in the Crib*. Go on and ask me anything about rap or hiphop and maybe about R&B and I can answer it. (Lil' J, 13-year-old African American)

> I don't really like reading. It's because I can never find a good book. But computers are good because I like to create cards and things on the computers. I don't really like to play [video] games that much. I like to create cards because I can do different things with it. I can write silly stuff or proper stuff and put in different pictures. Oh, and did I tell you that I really like music and dancing? I learn all the words of songs so that I can make up dances to the beat. . . .I am teaching some girls in HPE [Health and Physical Education] this dance I made up to that song "Shackles" by Mary, Mary. Do you know them? (Tee, 13-year-old New Zealand immigrant to Australia)

> It seems like it's the higher the grade level, the fewer opportunities were provided for me to choose reading material. . . . We read from books and wrote on notepaper. I can kinda remember doing some game about Lewis and Clark on a Commodore 64 when I was in eighth-grade, but that's about it. . . . Now, it makes a lot more sense to

me that literacy is reading and writing but also a whole lot more. . . . I feel that literacy is simply a negotiation towards communication. It can take various forms and can mean anything from Shakespeare, email, and even film. If you are deriving a message from it, you are reading it. Adolescents need teachers that use technology in their classrooms and are not afraid to embrace the changing faces of text. But I don't feel very confident about doing that myself. The class I had here went through some programs and software, but not enough to show me how to integrate it using one computer in my classroom, if I'm lucky. . . . I am actually pretty apprehensive about teaching a bunch of kids who know way more than I do about computers and stuff. I wish I knew more, not just because it would be easier to teach it, but it also looks like a lot of fun. (Carminda, 20-year-old Filipino-American in a preservice teacher education program)

Yeah, I love my computer. It's a Compaq Pentium III, 750-megahertz, 20-gigabyte hard drive with 128 meg of ram and 6 USB ports and that's all I can think of off the top of my head. And, um, I just use that mainly for the Internet unless I'm like making a project or I'm typing homework because I really despise writing with my hands. It takes forever and it hurts my hand so I just use that for that kind of stuff, and obviously [it's] what I use to make my web site, which I made a new entrance for it. It's really cool. It took me forever to get the html code because I had to find a page that had that kind of similar thing to actually get the code. That's how I get all of my html stuff . . . I didn't like ever learning anything from people [about computers]. Really, I just did stuff. I just messed around with it until I figured something out. That's all I ever did. And now I know a lot about computers. (Timony, 13-year-old European American)

Becoming a brother site: Okay, this is a damn good deal for you newbie webmasters! What I will do is make you a button, splash pic, and a top banner for your site. I'll also help you with any html problems. And if necessary, I'll get you a layout (although it's a tedious process). What the hell do I have to do, you may ask? Have a site with a lot of content, and . . . Link me. That's right, link me! Just put me under a section entitled "Brother Sites" or "Hosted by." Just e-mail me and I'll start helping ya! (It'd be better if you already had us linked when I look at your site). (Posting on Timony's *Dragonball Z* web site: site name not given to preserve anonymity)

I went to school a while ago, so there definitely wasn't any contact with computers. These days, I use them for typing my papers and projects, and my kids help me to email my sister who lives in Montana. . . . I think that we still need to get the basics down before we get into other kinds of literacy, including the classics and the writing process—the stuff that we know works well and we've been doing for a while. Computers have changed things, but not so much to change what and how we teach. Reading and writing are still being taught the same way that it has been for several decades. But teachers should use computers in classrooms because students will have to deal with them in their working careers. Maybe the younger teachers will do bet-

ter at this because they grew up during the home computer boom. (Diana, 45-year-old European American enrolled in a preservice teacher education program)

As you know, I love art. Japanese cartoons are the best, especially *Dragonball Z*. I really appreciate the pictures that they draw because I know how hard they are, and when they fight [on *Dragonball Z*] the drawing is really, really good. So I like the cartoons because the artists draw on paper, and they use the computer. And I like a good story line. If it doesn't have a good enough story line, I won't watch something. And in *Dragonball Z*, I think it is a really complex storyline. I can't believe how they could actually think of it. So, I learn a lot [about drawing and writing stories] from actually watching cartoons because a lot of them, some of them, have messages and you have to look for them. (Tommy, 12-year-old Australian)

One must know how to use the computer to help them do their homework by searching the Internet for articles and research items, create reports and articles using word processing software, or create items like cards. . . . It is replacing the way work is being done at all levels of life, especially in the workplace, where everyone must know how to use email systems. . . . I don't think teaching computer skills should be done in preadolescents in the schools, I think by the time students get to junior high school and definitely senior high school, they should have curriculum available to learn anywhere from basic computer skills to more intermediate ones, like basic programming skills. . . . I didn't have much exposure to computers until I entered college. . . . Had I been exposed to computers earlier in my life, there is little doubt in my mind I would have worked towards a computer science degree [in college]. (Chris, 30-year-old European American computer programmer who works for a public utility company)

I think of literacy in general in two ways. One way is to have fun with it and enjoy it. The other way is to learn something from it. Like when I saw *The Princess of Egypt*. I first saw it with my dad and my sister. That was just for fun. I wasn't there to learn something. It was just family time. But then I had to watch the cartoon at school. The teacher showed it because she was a substitute, and she didn't have anything else for us to do. So at school we watched it and learned about what kinds of clothes people wore and the kinds of houses they lived in. That time, I watched it to learn something from it. (Amanda, 12-year-old Australian)

Talkin' about MY Generation

The previous data clips suggest distinct contrasts between the literacies of today's adolescents and adults. They might suggest, too, that adolescents' literacies fit the depiction of Millennials as "the Nintendo Generation" (Provenzo, 1991), growing up in a world mediated by digital texts and distinctly different from the adults' ideas about literacies. Some of the statements suggest that adults don't quite

understand the literacies of today's youth. For adolescents, literacy is multimodal, and rather than receive information from static texts, they actively create meaning dynamically across diverse media. For example, Timony creates new ways to learn about computer programming by examining the code on different sites as he surfs the web. And Tommy doesn't just watch cartoons after school; he studies how characters are drawn using both three-dimensional computer graphics and two-dimensional paper sketches so as to improve his knowledge of various visual art forms. In contrast, Carminda, Diana, and Chris, like the adults that Hinchman and Lalik (this volume) describe, are more tentative about literacies that depart from conventional forms. They are seemingly grounded in descriptions of alphabetic, print-based or computed-mediated texts, trying to bring themselves up to speed in dealing with new communication technologies. They seem to worry about how they should teach adolescents about these media that seem so new to themselves as adults. For example, Carminda and Diana worry that they aren't prepared to integrate technology into their teaching, especially with students who are likely to know more than they do about new communication technologies.

Delving further into generational characterizations of Millennials, differences become apparent in the literacies defined and used by adolescents and adults. The adolescents' literacies incorporate diverse media such as computer technology with penciled art, programming codes with photo layout and web design, and music lyrics with dance movements. Absent from the adults' comments is the inclusion of more visual or auditory literacies that seem central to adolescents' lives. For example, none of the adults mention literacies pertaining to music, whereas Lil'J's afternoons are filled with visual and audio literacies developed in the music videos she views, and Tee studies music lyrics and rhythmic beats to compose intricate dances. The adults' perceptions of literacies that adolescents need to use center on curricular, school-based learning and on work-related topics. The adults' perceptions seem disconnected from the literacies the adolescents use independently, especially literacies that encompass interests in popular culture such as music videos, cartoons, and film targeted within current youth culture. As the adults recognize the need to encompass technologically based alphabetic literacies, they typically do so by situating these literacies within the context of traditional school subjects and classes. Conversely, the adolescents make few references to school-based literacies, and those that are mentioned are only given in connection to the literacies they choose to use outside of school. The persistence of viewing literacy in terms of conventional schooling is interesting in light of Barton's (2000) findings that adults, and teachers in particular, have incorporated new technologies into their everyday literacies, often with the help and guidance of the more technologically astute children that they teach.

Carminda and Diana, the preservice teachers, tend to relate their own computer literacy practices to the context of other classes they had taken, while simultaneously grappling with concerns about simply exposing students to technology on a more frequent basis in schools. Even Chris, a businessman whose career is inextricably tied to computer literacies, concentrates on relating his work-associated

computer literacies to school learning. He recommends that adolescents have exposure to digital literacies in school, but only after having established a baseline of conventional writing and reading processes and only as a separate course. Although the adults in our sampling of comments concurred that adolescents need exposure to computer literacies, they frame those literacies primarily in terms of existing school curricula, as opposed to a revolutionary shift in the nature of literacies found both inside and outside of schools. Often, teachers seem to resist applications of technology that are at odds with conventional curricular goals. In fact, they may sometimes benignly undermine the transformative intentions of particular applications to bring them in line with conventional reading and writing. Bruce and Rubin documented an instance of this phenomenon when they introduced teachers to a computer software program designed to integrate authentic reading and writing activities into the language arts curriculum. Despite the program's intent, teachers implemented it in a way that was consistent with their more skills-based orientation.

The adults tend to address computer-mediated literacies as general signs of the times, as supplemental bodies of knowledge for effective pedagogy, or as alternative classroom tools that students need to prepare them for work-related fields. The framing of literacies in terms of globalization, particularly in regard to economic implications, reinforces these views (e.g., Gee, Hull, & Lankshear, 1996). The adolescents, however, seem to live in the moment engaged in the literacies they enjoy. The adults—even Carminda and Chris, who are relatively close to the Millennials' ages and perhaps on the cusp of being labeled Millennials themselves—believe strongly that their own exposure to various literacies, especially those related to computers, has only happened recently, and apart from secondary school contexts and adolescent youth culture. The adolescents' detailed and context-rich references to the diverse media and the literacies they entail do not seem to be part of the adults' perspectives or fully integrated into adults' daily literacies. In contrast to the integrated literacies that the Millennials discussed, the adults' literacy practices seem only superficially affected by newer media.

Talkin' 'Cross Generations

A less dichotomous picture of adolescents and adults becomes clearer when looking at similarities across generational literacies. In other words, rather than trying to determine differences in what texts MEAN between generations, one might instead examine what literacies DO similarly across generations. For example, the desires for knowledge, power, and pleasure may play out differently across generations but they may provide another vantage point for understanding and bridging generational differences.

Literacy in the broadest sense implies knowledge and practice that traverse gener-

ational categorizations. The sampling of comments in this chapter illustrates a wide range of media and literacies—television, computers, telephones, film, and books; activities such as creating web sites, cards, and computer programs; learning from televisual music videos and movies; communicating via email or the phone; and using word processing. These literacy practices provide opportunities to display knowledge about teaching and learning for both adults and adolescents. Lil'J, for example, perceives her afternoon music video watching not as a mindless activity while talking on the phone but as a way to understand particular music genres and cultures, and she excitedly pushes to be quizzed (and to teach others) about her knowledge. Likewise, watching *Dragonball Z* (a popular Japanese animé) facilitates Tommy's learning about animation and plot development within a different culture. Learning song lyrics assists Tee in determining rhythms and beats to choreograph her own dances, which she later teaches to others. Carminda, Timony, and Diana, too, refer to developing computer skills to perform tasks such as writing reports or completing homework assignments. And Amanda considers watching movies to be learning, though she separates such literacy learning from having fun. In fact, she only considers viewing as literacy when she was made to watch a film for a particular purpose at school because the substitute teacher didn't have anything else for the students to do. Both Millennial adolescents and adults clearly use literacy practices to exercise knowledge and expertise, even if their cognitive and sociocultural attributions to media and their use vary (cf., Adoni, 1995; Salomon, 1984).

Practices of creating and acquiring knowledge cannot be separated from the power that one exercises in negotiating learning (Foucault, 1972). One's comfort level with literacies reflects how knowledge and power are intricately bound together with interests in teaching and learning. For instance, Timony explained that he learned html programming on his own by experimenting with the code used on various web sites. Once he was proficient in this new language, he advertised his abilities on his *Dragonball Z* web site so as to assist other "newbie" web masters in their own web site development. His self-created and self-motivated knowledge of new media and his power to communicate with others through online access enabled him to shift fluidly and rapidly from learner to teacher. Timony's desire to share his pleasures in learning by teaching is similar to Lil'J's understanding of hiphop and rap culture as represented in music videos and her interest in challenging the adult who interviewed her to learn from her. In the same way, by assisting others in learning the various dance steps of a dance that Tee choreographed, she exhibits her knowledge and creativity. The power implicit in teaching others in many ways stems from a desire to share knowledge learned from various literacy practices.

The adults' comments also point to issues of power related to their comfort level in using different literacy practices. They address concerns about power between disparities they perceive based upon their own historical conditions formed in academic learning as adolescents and the literacies that are important for adolescents today. With little or no exposure to various literacies—specifically digital literacies—until

adulthood, Carminda, Diana, and Chris are quick to rely heavily upon the impor-
tance of traditional literacies in thinking about curricula for adolescent learners.
Diana and Carminda acknowledge their discomfort with literacies about which
they know little but which they'll be expected to teach. Without the knowledge of
current literacies that are a part of adolescents' lives, they refer back to literacies in
which they feel competent and over which they have control—traditional forms of
reading and writing that, as Diana remarked, "are still being taught the same way
that it has been for several decades." Consistent with views of literacy as enabling us
to read both the word and world, the adults and the adolescents see themselves as
competent users of particular literacies. Capitalizing on their own competencies,
they use their power to share their learning with others.

Regardless of generational differences, literacies always function to assert and
to maintain power. However, new digital technologies disrupt the conventional
mechanisms for doing so within print-based technologies. For example, the
printed office memo on official stationery which is available only to those in posi-
tions of authority has given way to the more open access and dialogue provided by
inter-office email. These differences have not been lost on today's Millennial Gen-
eration. Neilsen (1998) reported that the lines of authority in a secondary school
were readily disrupted by savvy students who took advantage of their access to
digital forms of communication within their school. Schools, managed of course
by the adult population, struggle in dealing with the fallout from the contingen-
cies of new communication technologies and the control they have traditionally
exerted over students' expressions of literacy in school. In both the United States
and Australia, for example, educators struggle with the tensions created by allow-
ing students to freely access the information conveniently available on the Internet
while worrying about them accessing pornography or other socially undesirable
content. That is not to say that there are no mechanisms for exercising power
within the new digital literacies. Adults, however, tend to discover these mecha-
nisms as a matter of necessity in the course of preserving the status quo (e.g., fire-
walls to prevent students from accessing undesirable materials), while adolescents
discover them more spontaneously within an environment that is not at all alien to
them (e.g., Zhao, Tan, & Mishra, 2000/2001).

Aside from desires for agency in power relations, the desires for using literacy as
a means of personal pleasure for enjoyment crosses generational descriptions of
literacy practices, as well. For example, Tee and Carminda noted their own inter-
ests in using various literacies when they were either unable to find or were unin-
terested in finding books that were to their liking. Similarly, Tommy chose to
watch computer-animated cartoons because he enjoyed combining his interests in
drawing and plot development in order to learn about computer animation and
story creation as a form of literacy. Carminda also explained her appreciation of
and desire to participate in pleasurable aspects of various literacies as they relate to
her chosen profession of teaching. Though she found adolescents' digital literacies
daunting, she nevertheless perceived them to be fun. Her intuitive sense that digital
forms are inherently more fun has been argued theoretically by Lanham (1993)

who asserts that the characteristics and uses of digital texts invite writers to take texts and themselves much less seriously and to be more playful.

The literacy practices mentioned by the adolescents and adults also create pleasures in different aspects of work and leisure in their lives. Although Timony's and Chris's computer literacy practices might be more advanced than Carminda's, Tee's, and Diana's skills, they all share pleasures in using computers, whether those pleasures related to computer programming for work, such as in Chris's profession, or for pleasure, as in Timony's programming for his self-created web site. And though Diana's desire to become a teacher propelled her to learn computer literacies involving basic word processing to complete her schoolwork, she also found pleasure in using these literacies to communicate with family over email.

US and THEM: Literacies across Generations

If we consider that terms such as Millennials, adolescents, adults, and literacy have particular and stable meanings grounded in reality, then we will always search for confirmation of *those* meanings. We might become victims of what we've heard described as "hardening of the categories." We argue that understanding literacies within and across generations is not a matter of defining what the term *literacy* means to different generations, but rather what the term implies in various contexts to furthering or undermining the stability of the fixed categorical understandings, such as generational literacies. For example, defining the Millennial Generation as youth who solely spend their time mindlessly and acritically playing with computers, video games, and music, we run the risk of dismissing the highly engaging and increasingly valid literacies they create in their engagement with various media. And, to assume that adults have little or no desire to learn about diverse literacies created in the last ten years shortchanges them as well. By associating certain literacies only with Millennials and not with adults, we restrict the very possibilities of who has access to and can capably use various literacies.

In short, the notion of generational literacies may be an oxymoron, especially today with the rapid infusion of new media into everyday life and to a lesser degree into schools. Although generational literacies are tied to stable depictions of generational categories, the relation between literacy and society is neither stable nor predictable in a strictly generational sense. Thus, literacy practices of one generation are not necessarily particular only to that generation. In fact, to tether definitions and uses of literacy to particular generations may only continue to widen the "generation gap" and to solidify perceived incongruencies between literacy practices of age-defined groups of people. However, the examination of the instability of terms points us in new directions for the future of literacies in contemporary society. In the final section, which follows, we examine disjunctures across generations that open up and close off conceptualizations about adolescents of the Millennial Generation and about literacy practices and discuss the impact of these disjunctures on literacy practices in society.

Disjunctures between Generational Literacies and Contemporary Literacies

In Rushkoff's (1996) description of a postmodern world, he explained, "What we need to adapt to, more than any particular change, is the fact that we are changing so rapidly. We must learn to accept change as a constant. Novelty is the new status quo" (p. 3). Related to literacies, we agree and disagree to some extent. These times of burgeoning worldwide marketplaces that are driven by economies of attention and multimedia text (Lankshear & Knobel, this volume) bring into sharp relief the undeniably larger social context in which adolescents' literacies impinge on all of us. Rather than attribute all new literacies to shifts in current trends and to a new generation, it may be useful to think of literacies not based upon generational differences but as contemporary literacies that are products of contemporary times. In this sense, differences in terms of literacies and literate practices are better understood not as generational differences per se, but as a reflection of larger technological and sociological forces of change.

In describing the literacies of all learners today as contemporary literacies rather than as new literacies, Millennial literacies, or generational literacies, we are arguing for the need to acquire the skills necessary for engaging with literate practices in society. That is, it is incumbent upon everyone to learn these skills, not just adolescents who are coming of age during a technological explosion that invents new forms of literacy. So, rather than categorize which literacies belong to which age group, generation, or social class, thereby allowing people to dismiss one another's literacy practices based on potentially divisive differences, we propose the need to examine contemporary literacies across categories.

de Castell (1996) described the current state of literacy in society as one of "post-literate culture" which "has been fundamentally and irreversibly defined and shaped by literacy, but in which new technologies and practices of representation and communication have largely superseded writing and the written word" (p. 399). Thinking of contemporary literacies in a post-literate culture, we can perhaps address the disjuncture formed between not what literacies mean to users of a particular generation, but what literacies and literacy practices do when conceptualized across generations. Conceiving of contemporary literacies within a "post-literate culture" may provide a means for opening up and moving away from the conceptualization of literacies as print-based texts and toward the inclusion of more visual or auditory literacies embedded in media.

Disjunctures between Who Defines and What Counts as Literacy

In our own and in others' work (e.g., Bruce & Hogan, 1998; Knobel, 1999; Neilsen, 1998; Tierney & Damarin, 1998) it has become obvious to us that for many adolescents characterized as Millennials, their engagements in literacy practices in and out of school are vastly different undertakings in function, form, and purpose.

Like the adolescents whose comments are included in this chapter, we would wager that other adolescents often create, develop, and maintain ownership of literacy practices with little or no formal supervision by or guidance from adults (Lewis & Finders, this volume; Young, Dillon, & Moje, this volume). In many ways, adolescents' proficiencies exceed adults' knowledge and skills of their literacy practices (Barton, 2000; Green, Reid, & Bigum, 1998), and there is a profound disjuncture between the literacies adolescents competently learn and use on their own and the ones adults expose them to and require them to learn in schools (Bigum & Green, 1993; Richards, 1998).

To address this disjuncture between deciding who gets to define literacies and how they are valued is particularly important as adults hold the power to set the curriculum and pedagogy in schools. Whether adults opt for traditional literacies due to convention, to their apprenticeship of observation when they were students as described by Lortie (1975), or to a back-to-basics orientation, the result is a growing dissonance between literacies that take place within schools, and those used in other contexts, by people of all ages. Thus, by stabilizing the term *literacy* as the ability to read and to write print-based, alphabetic texts, other relevant texts, including those visual and auditory, may be discounted.

This rupture between how literacies are defined and valued in schools does not bode well for adolescents who are not given opportunities to develop the literacies of the post-literate world within school, especially among those populations that do not find post-literate literacies clearly embedded in their lives outside of school. For Timony, his computer and accompanying literacies are sources of great pride. We can easily imagine Timony fitting well into worldwide marketplaces that are mediated through digital technologies. However, what of adolescents who are less inclined to engage in such activities for a variety of sociocultural reasons? Without addressing in schools the various literacies within contemporary society and building upon adolescents' post-literate experiences, schools run the risk of becoming anti-educational sites (Buckingham & Sefton-Green, 1998).

On the other hand, we wonder if it is necessary for schools to teach the perhaps intuitive and naturally engaging literacies associated with digital media, or if it is simply a matter of accommodating these literacies within a different framework of teaching and learning. If a new framework for teaching and learning is inevitably needed, the resistance to integrating new technologies into the literacy practices of the school might be better understood as having less to do with preserving conventional literacy and more to do with the inherent threat of contemporary literacies in undermining traditional conceptions of schooling. For example, the International Society for Technology in Education's (1998) standards for using technology in schools reads like a manifesto for progressive education in which the roles of teachers and learners have little in common with the transmission model underlying the structures and practices that can be observed in many U.S. schools.

Disjuncture between Education and Capitalist Society

Disjunctures between educational institutions' and capitalist society's definitions of adolescents and of their literacy practices bring to the forefront differences between how adolescents are constructed in these two contexts. In educational settings, adolescents are understood as a particular student audience, with particular literacy needs and experiences, and the educator's job as Carminda and Diana noted is to address those needs and to teach that audience. But in capitalist society, Millennials are perceived as both an audience and as a market whereby in many ways they take charge of their own literacy lives. The ensuing disjuncture between these contexts conceptualizes an unknowing, naïve youngster on one hand, and a knowledgeable, powerful youngster with influential creative power on the other. Thus, what may happen is that adolescents will continue to have access to various literacies outside of school and to be more knowledgeable about those literacies than their adult counterparts, as illustrated in the quotes previously cited in this chapter. By situating the literacies they enjoy in contexts separate from school, these adolescents highlight literacies that they have the freedom to control and that they could transform for their own purposes. Also, they demonstrate a desire and willingness to share these literacies and to teach others about these literacies.

We believe that implies a need to rethink ways to involve adolescents in both the teaching and learning of contemporary literacies and to acknowledge their knowledge and power of contemporary literacy practices. Giving them space to share those pleasures in relationships with others, whether in relationships as students and teachers or as employers and employees or as older and younger may assist in opening up educational contexts for dialogic interaction where information, skills, and processes are shared and exchanged dynamically (Bakhtin, 1981).

What Do THEY Have to Teach US?

Rushkoff (1996) noted,

Rather than focusing on how we, as adults, should inform our children's activities with educational tidbits for their better development, let's appreciate the natural adaptive skills demonstrated by our kids and look to them for answers to some of our own problems adapting to postmodernity. (p. 13)

Contemporary literacies are more than just an add-on to "real" literacy practices, and they pertain to all generations, not only to adolescents of the Millennial Generation who are growing up surrounded by and engaged in media. Though some contemporary literacies are new in function and form, they nevertheless build on previous literacies (Barton & Hamilton, 2000). Literacies are constantly in motion and continually changing such that new ones are acquired through informal learning and formal training. Because both forms of learning are crucial for

understanding how contemporary literacies are used, achieving literacy in contemporary society implies broad participation and broad interpretation along a full spectrum of media and activities that comprise today's literacy landscape. Like Barton and Hamilton (2000), we believe that we must draw upon users' insight about their own approaches to learning, on their theories about what counts as literacy, and on the strategies they enact for attempting to use contemporary literacies. Recalling that the lyrics of "My Generation" have been significant in the lives of people for almost 40 years, perhaps we'll feel more confident and capable to move beyond the confines of generational literacies and toward conceptualizations across generations of what literacies do, thereby eliminating the need to know where WE stand as US or THEM as members of "MY" generation.

IMAGINING LITERACY TEACHER EDUCATION IN CHANGING TIMES: CONSIDERING THE VIEWS OF ADULT AND ADOLESCENT COLLABORATORS

The purpose of this chapter is to encourage conversation among those with diverse standpoints (Collins, 1991) about how literacy teacher education might address the development of adolescents' literacies at a time when the impact of technological changes on these literacies is constant and pervasive. To begin the conversation, we invited a group of literacy educators to talk with us using a collaborative planning process alternatively called scenario-building (Rowan & Bigum, 1998) and scenariating (Lankshear & Knobel, this volume). We asked them to consider possible contextual issues and outcomes that would result if we were to change adolescent literacy teacher education to better suit our changing times. Then we invited a group of adolescents to respond to their efforts. The discussions that resulted from these initiations helped us to see adolescent literacy teacher education in new ways. We describe our discussions in the sections that follow in the spirit of inviting others to join us in beginning to imagine new directions for our work.

Rationale

The rapid technological advances of the last two decades have brought with them dramatic changes in political and economic relationships, including changes in the organization of capitalism and the ways in which work is conducted and rewarded.

According to Gee, Hull, and Lankshear (1996), who assessed some of these changes as they pertain to global economic arrangements that they call *fast capitalism,* "the emphasis now is on the (active) knowledge and flexible learning needed to design, market, perfect, and vary goods and services as symbols of identity, not on the actual product itself as a material good" (p. 26). In spite of these and other apparent advances, there is concern that new economic arrangements will lead increasingly to an inequitable differentiation in the distribution of rewards and services. Thus, while technological advances are welcome, it remains unclear about what life chances will exist for the growing number of people who find themselves outside elite social groups. Further, there is reason to believe that school literacy teaching may unwittingly contribute to the growing divide (Gee, 2001).

Changes in social, economic, and political arrangements that have ushered in and been transformed by the ongoing technological revolution have important implications for educators. Yet most conversations about adolescent literacy instruction focus on conventional print literacies, particularly textbook-based literacies (Moje, 2000). As Allan Luke (1998) argues, "The 'great debate' over literacy education has taken the form of a near continuous debate over which instructional approach is best able to 'solve' student reading and writing problems" (p. 305), with a focus on young children's literacy. With several notable exceptions (e. g., Alvermann, Moon, & Hagood, 1999; Gee, 1999b; Pailliotet & Mosenthal, 2000), discussions advancing new and multiple literacies among adolescents are muted at best.

When we do see the issue of new literacies and digital technologies addressed in literacy teacher education, the focus is often on the form of regulations meant to insure that teachers know how to use the technologies. For example, teachers may be required to demonstrate particular technological skills, such as those necessary for developing electronic portfolios and web pages (International Society for Technology in Education, 2000). There is little evidence that we literacy teacher educators have examined the complexities of ongoing technological changes as they pertain to adolescent literacy and teacher preparation. Nor do we see evidence that learners are consulted on these matters, even when there is reason to believe that these learners may have lives outside of school in which technological tools and activities are a daily experience and thus a source of ongoing learning. We were motivated to think about our work as literacy teacher educators in ways that account for how we prepare teachers to work with adolescents in a world made increasingly complex by issues surrounding technological change. To explore these issues, we decided to invite both adults and adolescents to scenariate with us.

Scenariating

Scenario-building is a planning process developed, in part, by members of the business community in response to growing dissatisfaction with existing planning models (Wack, 1985). Critics of conventional planning models argued that planners routinely made unquestioned and decontextualized assumptions about the

future, thus limiting the usefulness of resulting plans. Advocates of scenario-building argue that planners are wise to consider possible variations in future environments and make plans that are useful for particular imagined futures. That is, they advise planners to note factors that are at once considerably influential and unpredictable, to imagine the world given various combinations of those factors, and to develop strategies for each of the different worlds they imagine. In theory, given the multifaceted plans that emerge for scenario-building, planners are more likely to be able to act effectively. According to Rowan and Bigum (1998):

> Scenarios . . . are not predictions of the future. They are a means of rehearsing a number of possible futures. Building scenarios is a way of asking important "what if" questions: a means of helping groups of people change the way they think about a problem. In other words, they are a means of learning. (p. 73)

In response to questions we had about scenariating, Chris Bigum (personal correspondence, February 26, 2001) and others advised us to invite to a planning session colleagues who were creative and willing to consider the unconventional. As well, he advised us to invite people with a sense of scenariating as a first step in a larger process, not as an effort to reach some final answer. With these considerations in mind, we invited four colleagues from Syracuse with varying backgrounds and interests.

Scenariators

Owa Brandstein is a graduate student in literacy education. A former eighth-grade reading teacher, he also has taught second language learners from Central and South America in Houston, and language arts to adolescents in grades 6–10 in San Francisco. He is presently involved in a university-school collaboration to develop a literacy-across-the-curriculum course. To this end, he spends much time visiting, facilitating, and collecting digital video from middle school teachers who are helping with the course design.

Kelly Chandler-Olcott is an assistant professor of reading and language arts and a fourth-generation teacher. Although she regularly uses digital technologies such as word processing software, email, and the Internet in both her professional and personal life, she is just now learning to use a digital camera and to develop web sites using pagebuilder software. With co-researcher Donna Mahar, Kelly is conducting a study of early adolescents' personal uses of electronic technologies.

Ted Grace is a literacy educator with deep connections to his African roots. Engagement with various forms of literacy (print as well as oral) occupies both his work and home life. He teaches classes in English language arts, children's literature, and storytelling at Syracuse University. He is also teaching in elementary schools as he conducts research to explore children's comprehension and composition of oral and written stories. He uses digital technologies primarily to write and search for information.

For the past 15 years, Donna Mahar has been a middle school English teacher. She is currently working on her doctoral degree in reading education. Donna's interests in the classroom have focused on student writing and publication in workshop settings. She also has initiated several social action projects in her school and community. Her research focus has grown to include work on students' use of digital technologies for out-of-school literacy. Donna is also exploring the classroom dynamics that occur when students become technology experts who mentor their teachers.

As the authors of this paper and facilitators of the process, we were also participants in the process, although we tried to keep relatively quiet, wanting to foreground the ideas of our collaborators. Rosary is an associate professor of education at Virginia Polytechnic Institute and State University, with interests in critical literacy and literacy teacher education. She uses the computer for word processing, library research, email communication, and various personal transactions such as arranging trips and paying bills. She enjoys the computer immensely. In her spare time she enjoys reading more conventionally formatted novels, memoirs, and biographies.

Kathy is an associate professor of education at Syracuse University who is interested in adolescent literacy and in literacy teacher education. She has some facility with using basic computer functions, including presentation software and Internet applications, and she only sometimes loses patience with experimenting with new uses of technology in her teacher education classes. Internet publishing, digital imaging, and instant messaging are not yet as much a part of her repertoire as are books, magazines, radio, and television.

Planning the Session

To prepare for the scenario-building session, we worked to develop a focal question for our group to consider. After more than a few false starts, we settled on a question that, while not unduly complex, would allow our group to think about adolescents, new literacies, digital technologies, and literacy teacher education:

> What do we do in literacy teacher education to prepare teachers who will be able to make new literacies and digital technologies more significant in secondary school classrooms?

An important consideration was one of time. Should we conduct a single session or several? How much time should we take for each segment of the scenariating process? As novices with this process working with four busy professionals, we decided to hold a single two-hour session. Using that time constraint, we planned an agenda that included six activities: (1) introducing the purpose, question, and process of scenariating; (2) brainstorming driving forces; (3) considering meanings of each identified force; (4) identifying two critical uncertainties and using these to construct a grid; (5) naming and describing possible worlds represented by each

quadrant in our grid; and (6) suggesting appropriate strategies for teacher educa-
tion for each of the four envisioned worlds. We intended to use this agenda as a
guide, making adjustments we deemed appropriate.

To prepare our collaborators for a discussion about our topic, we asked them to
read a draft of Lankshear and Knobel's chapter (this volume). We chose Chapter 2,
"Do We Have Your Attention? New Literacies, Digital Technologies, and the Ed-
ucation of Adolescents," for its concrete examples of new literacies and discus-
sions of how these might play out in adolescents' lives. Our collaborators read this
paper before we met.

Beginning the Session

Getting started. We began the scenariating session with an explanation of our
question, also providing time for brief personal introductions and an explanation
of our reasons for exploring scenariating. We concluded the introduction with an
overview of the agenda. Five of us sat at a table in Kathy's office, and Rosary
joined in via speakerphone. As we worked, we wrote ideas on chart paper, and we
audio-recorded the session.

Brainstorming and considering driving forces. Next, we brainstormed a list of
driving forces, or influences, that were likely to be important to how we might ap-
proach our focal question. To stimulate the conversation, Kathy provided an ex-
ample of something that might be a driving force (e.g., government mandated an-
nual testing). We talked at length about each entry to our list, thus combining
activities two and three on our agenda. Typically, several of us elaborated on one
person's point. For instance, Kelly responded to Kathy's initiation,

> [Government mandated testing] is a two-part thing. . . . The other thing that I think
> would be important . . . is what kinds of emphasis the government puts on different
> kinds of research. For example, if there's lots and lots of grant money to work on
> early literacy and none to work on adolescent literacy, then that will affect what we
> know about what adolescents can do.

We pursued this discussion for about 20 minutes, listing 16 forces on our chart
paper. These varied considerably and included such topics as habits of mind, assess-
ment, and restricted access to computers. Talk during this part of the process ranged
in focus from problems we thought we might encounter to possible solutions to
those problems. At one point Donna even suggested reconceptualizing education as
less discipline-specific so that all teachers would consider print and digital literacies
within the purview of their responsibilities. Once we judged our list to be substan-
tial enough to allow for rich consideration of possible futures, we moved on.

Identifying critical uncertainties. Our collaborators scanned the list of driving
forces, talking about those that struck them as important. As our discussion con-
tinued, we encouraged our group to pick two uncertainties that we would be able
to dimensionalize as the next step in the scenariating process. We forged ahead,

guided by the view that, as explorers of this process, our job was to move through the process to get a sense of its potential. We reminded our group that we were not charged with producing a single best answer to our focal question.

After considering and rejecting several possibilities, we discussed at length the idea of teachers being able to figure out ways to find a bridge between the "old" and "new" literacies and incorporating this bridge into the curriculum. We reasoned that there remained much cultural capital in old literacies, despite the currency, sexiness, and quick changing nature of the new. Thus, we selected this as one of the uncertainties we wished to dimensionalize. Owa noted,

> I really like Ted's idea about finding a bridge between "old" literacies and "new" literacies, incorporating them into the curriculum together. The way that that's going to be done is a big uncertainty but also, I think, a key component of this process . . . What I see it as, is using these new literacies . . . using them as a way to teach these old things . . . that we still believe are keys to success.

We also considered the idea of how comfortable teachers could become with digital technologies, whether they could become both skilled and comfortable enough to weave these technologies into existing or newly designed instructional repertoires. We shared the insight that the best teachers of writing were those who were themselves writers. We theorized that an analogous hypothesis might be constructed for the teacher concerned with digital technologies. We also realized that teachers would have to be comfortable with the likelihood that some students would know more than they about the literacies implied in new technologies. With this thinking, we chose teachers' comfort with digital technologies as the other aspect we wished to dimensionalize.

Consistent with Bigum's recommendations, we developed a two-dimensional grid to represent the intersection of the two selected critical uncertainties. We determined two extreme ends of a continuum of possibilities regarding each critical uncertainty and captured this on the grid. Our purpose in creating the grid was to consider, first, what a future world implied by each quadrant would look like, and, second, how our original question might be answered if the circumstances proscribed by a quadrant's parameters were true.

World Building

Quadrant 1: Teacher has strong bridges between old and new literacies and is comfortable with digital technologies. We named this world "effective literacy instruction" and then discussed what would happen in this world. Donna explained, "Teachers in that world would have to be open to learn from their students because they would have to acknowledge that they were going to have students who know more than they do, at least for the near future." Kelly suggested that classroom structures would allow and invite students to teach each other and their teachers. Owa noted that teachers would orchestrate instruction to serve relevant purposes in the lives of

all their students, not just the students who have computers. They would mediate classroom attention in order that students attend to both traditional literacies (those with high cultural capital) and to multiliteracies that are co-evolving with ever-changing technologies. They would find ways around numerous roadblocks.

Kelly also reasoned that, in this world, teachers and their students would move back and forth across tools, blending old and new literacies more strategically, instead of seeing tools as separate with separate uses. Donna added that teachers would not be driven by packages and by software innovations; instead, they would make thoughtful decisions, inviting students to critique and try different literacies in different contexts. Ted noted,

> The teacher takes the decision to help the students to critique . . . when is it the most appropriate for you to use what kind of literacy . . . because oral literacy might apply to a particular context, and another might need visual technology. . . . Have the kids explore that, critique it. So the questions become a lot of 'whys.' . . .

Teachers in Quadrant 1 represented our ideal, so our group was not initially inclined to discuss teacher education for them. We talked, instead, about celebrating their practices. However, upon reflection, we thought that in an ever-changing technological context, we would want these individuals to continue to attend to their own learning, to work with others to explore the particular literacies of their students, and to extend their pedagogical practices by attending conferences and by engaging in teacher research.

Quadrant 2: Teacher has a weak sense of the bridges between old and new literacies and is uncomfortable with digital technologies. Rosary imagined that teachers in this quadrant would focus on what we called "old," decontextualized literacies. Owa noted that they would not be able to express or model their own new literacies. In this quadrant, students would not be acknowledged for their expertise as teachers, but instead would be viewed as functioning within what Ted called the banking system, where they receive knowledge from the teacher that they store for future exchange. Ted noted that teachers' expectations would delimit students by not acknowledging students' new literacies as strengths, especially if students could not read in a more traditional sense.

Donna imagined that teachers in Quadrant 2 would represent and hold on to standards for learning in a narrow way that does not account for students' existing understandings. They would defend their position by arguing that what they do is measurable, but that the new literacies are not. Kelly noted that such teachers would also get bogged down in issues of equipment and software, seeing obstacles, such as inappropriate software and insufficient access to computer labs, as insurmountable barriers.

Ted observed that a strong, supportive school-based professional development component would be beneficial to Quadrant 2 teachers, including opportunities for working with several persons who have a strong sense of the bridge between old and new literacies and who are comfortable with multiple literacies. We

thought that such field-based instruction could allow for significant mentoring op-portunities, providing a way of supporting people in learning a little at a time about varying aspects of literacy.

Kelly noted that effective teacher education would begin with collecting data from a range of students so teachers might learn more about their students' exist-ing literacies and technology insights. Donna suggested that alternative forms of classroom pedagogy could involve use of learning partners that would allow teachers and their students opportunities for mediated practice of new skills. We imagined use of multimedia case studies or reciprocal clinics as opportunities for such mediated study. Our solutions also included getting access to technology that would map well with what students can do.

Quadrant 3: Teacher has a strong sense of the bridges between old and new literacies but is uncomfortable with digital technologies. We imagined that teachers in this quad-rant would lack experience with the new literacies themselves, but they would be agreeable to having students take over and demonstrate insights and understand-ings. As Ted noted, they would put students in the driver's seat. It is interesting that Kelly and Kathy located themselves in this group as they talked about their discomfort with not being able to model use of new technologies for their stu-dents to their own satisfaction.

In terms of teacher education, our group suggested that teachers could work in teams to help each other develop greater comfort in working with digital technol-ogies. For example, Owa suggested inviting teachers to spend time figuring out what students bring to the table, using the knowledge that they have, and finding ways to activate prior knowledge. This could involve the development of units suited to particular students' expertise (e.g., I'll teach this unit using hypertext be-cause these six students can do it). We recommended finding an easy technological place to start and providing workshops that offer actual models. As well, we sug-gested providing teachers access to experienced teachers who use various new technologies and who also demonstrate a strong sense of the connection between old and new literacies. Along these lines, Kelly noted,

> It also strikes me that those workshops . . . would be more useful if they are contex-tualized within the person's practice. . . . [A] workshop on video editing—that's not going to be as useful as, bring that person in, talk about the possibilities, let that per-son think about where it fits into the curriculum, and then provide targeted staff de-velopment. . . . The teacher would have a lot of control over . . . training or prepara-tion. It wouldn't just be the technology of the month.

Quadrant 4: Teacher has a weak sense of the bridges between old and new literacies but is comfortable with digital technologies. We thought that teachers in this quadrant might go overboard in attending to new literacies—in effect, proverbially throwing the baby (or "old" literacies) out with the bath water. Kelly noted that this group would likely include people who enact digital technology narrowly, as traditional decontextualized media studies. Ted noted that teachers in this group would rely

heavily on traditional methods and teach new literacies in old ways, such as show-
ing students the skills and then standing aside, expecting students to be able to im-
plement them without benefit of teacher mediation of understandings.

Donna observed that there would be little teaching of reading strategies or
being critical of what one sees on the screen or in the textbook. Kelly agreed, not-
ing that Quadrant 4 teachers might fall into the trap of valorizing students' out-of-
school literacies at the expense of teaching them about the codes of power operat-
ing in all texts. Donna saw this quadrant as being the most dangerous one because
teachers working within it would have little evidence that they should change.
There would be little to disrupt a teacher's equilibrium. As Donna explained,
"Your students would love you because it would really be fun, but sadly, you really
would not be giving them the power tools, the strategic applications."

As we imagined teacher education for this group, we wondered how they got to
be this way. We guessed that there may be something about the way schools are set
up that causes teachers to learn the new technologies without having the chance to
think deeply about helping students to build bridges between old and new litera-
cies. To support teachers in this world, we would orchestrate plentiful opportu-
nities for them to reflect on their own educational processes—on how they learned
and developed their own literacy practices. We would invite them to imagine how
they might simultaneously attend to both old and new literacies.

Kelly thought that teacher educators could ask teachers to inquire into ways
that people use literacy beyond the classroom and the ways that students enact
their literacies in various world contexts. Owa suggested that we invite teachers to
reflect on how things have changed since they developed their early literacies. Like
his colleagues, Ted imagined some of the difficulties associated with being a
teacher in Quadrant 4 and having little sense of the bridges between old and new
literacies. In his words: "We're dealing with . . . constantly looking for a silver bul-
let, but there is no silver bullet . . . Are there any jobs out there where you never
have to write . . . never have to talk to each other . . . never listen . . . never read any-
thing?" In acknowledging this tension between old and new literacies, Kelly ob-
served that, so far, we as teacher educators have not done a good job of modeling
how to roam from the known to the new in print literacy, so it will be even harder
to do with a layer of new technology thrown in. Teachers will need to see models
and share ideas from classrooms where the teacher shows students how to do
things that are important to them and where students' knowledge and interests are
used as a bridge to new knowledge.

Seeking the Advice of Adolescents

To structure the session with the adolescents, we reviewed our analysis of the
views and issues that arose as the adults engaged in the scenario-building process.
From this review, we generated 18 questions that paralleled several aspects of that
process. We asked the adolescents to imagine a world in which new literacies and

digital technologies were central to secondary school classrooms, and we asked them for advice relevant to each of the four worlds the adults had envisioned. We also developed an explanation of our project to orient the adolescents to the session and a form that they could use to provide us with information about themselves. When conducting the interviews, Rosary used the orienting information and questions as guides for her comments and questions.

To invite adolescents, Rosary contacted a teacher who was a master's student and mother of adolescents who introduced her to two middle school students, Neetika and Matt. Matt was a 13-year-old male who described himself as "a person who uses technology a lot and who loves to learn new things about technology." He used the Internet on a daily basis at home and in school where he often assisted teachers with technology—an activity that made him feel "useful at school." He did not see himself as being "into" youth culture, or as being popular with other adolescents. His contacts with other adolescents were limited but included chatting with them on the Internet. Neetika was a 12-year-old female who described herself as a hard worker who paid attention and followed directions. Outside of school she read, cooked, and enjoyed puzzles. She also enjoyed new technologies and liked to play games and chat with her friends online. As for youth culture, Neetika said that, like many of her friends, she liked to read, watch TV, and occasionally go to the mall.

Matt's and Neetika's Views on New Technologies and Literacies

Matt and Neetika explained that the computers available to them at school did not always work properly. Typically, the teachers would fix them. If they could not fix "frozen" computers, teachers would get help from the technology teacher, who doubled as the shop teacher, and who had organized a group of students to trouble shoot. This group, known as the "SWAT Team," provided computer assistance around the school as needed. Matt reported proudly that he was a member of the team.

Both students agreed that computers were more often used in English and history than in math and science, where they felt they were less relevant. They reported typing reports in English, looking for information online for history, and viewing PowerPoint presentations that their science teacher had prepared. The students themselves had opportunities to do PowerPoint presentations in English and history.

At home, Matt reported that he played war games on the computer. He chatted with friends using instant messaging (IM). Although he had experienced virus problems with IM, he dealt with them successfully by networking with friends. Neetika reported playing games (e.g., Solitaire), but she also expressed particular pride in having fixed a computer after it had been attacked by a virus. That success led her to other successful attempts to fix "frozen" computers. Like Matt, Neetika expressed high confidence in her ability to use technology. In her words: "I like to . . . see how far I can go . . . with it." For instance, Neetika convinced her cousin in

India to transmit her wedding ceremony via video cam so that she could experience it without traveling to India. Matt, who was also a web cam enthusiast, added that he thought the web tool Microsoft Meeting, which facilitates group meetings, is "a very cool tool!"

The two could imagine a school where new literacies and digital technologies were central in the classroom. Neetika thought that more than a few adolescents would be sending messages to friends, rather than attending to the teachers' agendas. Matt agreed that this would happen. As for the teachers, Neetika thought they would have "a lot of time on their hands" because the adolescents would reason that they could just look information up, rather than ask the teacher about it. She saw this possibility as "a bad thing" because the adolescents might get "off track" with respect to the teacher's plan. She noted that in the end it was the teacher who would be grading the students' work.

Although Neetika was enthused about computers, she pointed to the importance of more traditional literacies, summing up her position this way: "You're going to have a lot of competition for your job because people need to know how to use new technology. Kids should be aware of what they need to be learning, and they should also know about other things because you have to have a diverse background for knowledge." Matt agreed, adding how important it was for people seeking jobs today to be able to use computers. He also spoke of the space and power necessary for supporting a computer-based school, and he wondered about the relevance of the computer for all subjects. In particular, he worried about learning science on the computer. From his perspective, "The best way to get science is hands-on, where you actually do the experiments yourself. . . . That's the one subject, I believe, that you don't really need technology." Neetika agreed, adding that the best way to learn math is with paper and pencil. Matt disagreed, saying, "Once you get the basic things down in math, you don't really need paper and pencil any more. Sure you can practice and everything, but you don't need it."

Both adolescents had definite views on what teachers would need to know and do in schools that supported the use of new technologies. Matt thought they would have to know which programs to use with the various assignments they made. Neetika believed that teachers would have to know how to make the "stuff" they ask adolescents to make, such as *PowerPoint* slide shows, in order to help with any problems that might occur in creating the materials. She went on to explain that teacher educators would have to help teachers be "a little more patient with the kids who don't understand because what if they don't have a computer at home." Imagining that some teachers might not understand as much as they need to know about new technologies, Neetika suggested they ask for help (e.g., training courses). She explained the importance of such courses this way: "If modern technology is going the way it's going, then kids are going to be speeding up. And if the teachers are left behind, that would be a problem!" Matt thought that teachers should also be able to repair computers. In his words: "The teachers should know how to fix . . . general things . . . like if the computer freezes they should

know what to do to fix it." Finally, they agreed that teachers should be required to have basic computer knowledge and skills.

On the topic of old literacies, Neetika explained that paper, pencil, and books were the roots of new literacies, but that now adolescents were avoiding these in favor of online book summaries and so were missing out on things such as "the great classics like the journey of the Odyssey." In her words:

> Because of new literacies, old literacies are being taken for granted and then kids will never be able to comprehend as much. 'Cause you have to think forward now, when you're in like junior year and senior year of high school, you're going to be taking your SATs and when they ask you questions about that . . . you have to be able to comprehend, and you can't comprehend from some of the stuff they give you on Barnes & Noble and Amazon.com.

To promote book literacy, Neetika suggested that teachers bring in "good literature" because some of the things you read at school make "no complete sense." Matt weighed in verbally, exclaiming, "How true!" Both suggested adventure and mystery books, but they added that adolescents should be allowed to pick the books that they read in order to, as Neetika put it, "get more interested readers and less kids going to the internet to find their assignments." Matt was less sure of the importance of old literacies, saying that they were only somewhat important and sometimes useful: "Some new literacies are better than the old ones, but some old ones are still better than the new. For instance, in history, it's sometimes better to use the Internet because you can find information faster."

On the question of student knowledge, both agreed that it didn't matter who knew more, teacher or student. What mattered, they said, was the learning process. Matt explained, "Whoever knows more about computers should try to teach the other one more." He added that the teachers were still "the authority," even when a student knew more, but it was important for teachers to express appreciation when students contribute their knowledge and skill. Both agreed that high knowledge students should be calm, helpful, and modest, while low knowledge adolescents should ask questions and learn. Neither Matt nor Neetika thought teachers needed to be avid users of technologies. Neetika explained that it was more important for teachers to be "learners" who learned things from other teachers and from students.

On the question of students' access to computers outside of school, both responded emphatically that students did not have equal access. Matt attributed many differences in access to cultural differences in which some cultures reject and ignore new technologies while others "love and adore" them. Neetika empathized, explaining that adolescents without access sometimes get aggravated when they see computers and do not know what to do, "especially . . . cool kids because it makes them look not very cool." Both agreed that adolescents without computer access at home were forced to use school and public libraries, while adolescents who "really adore computers are using [them] to their advantage." To illustrate, Neetika alluded to a student who might say to a friend, "Oh, I forgot a

homework assignment at school, can you fax it to me?" She added that success depended on "how you use technology at school and who uses it to their advantage and to their disadvantage." Matt conceded that he could understand how adolescents who did not have access and did not understand might not want anything to do with technology. He said he sometimes did not want to do anything with books because he was not very good at reading. To deal with unequal access to computers and other technologies among students, both agreed that there should be a student-to-student tutoring program because teachers sometimes make things too confusing. Then adolescents could teach their friends. "That way everybody learns," according to Matt. He added that there should be an elective course to teach adolescents how to use computers, as well as a more advanced course for those wishing more knowledge and skill. Both agreed that there would be some problems with students learning from each other in that some learners might not listen to the tutor and that others might get on the tutor's nerves.

Both also agreed that technologies help people develop particular habits of mind. Citing a positive example, Neetika recalled that some friends who used an Internet site that encouraged students to do their homework (funbrain.com) eventually changed their poor homework habits and improved their grades. On the negative side, she recalled receiving some rude email questions and comments before she had learned to block unwanted messages. Matt added that chat rooms could be dangerous places for interaction. Both agreed that it is possible to lose one's privacy when corresponding or chatting on the web.

Matt's and Neetika's Advice to Literacy Teacher Educators

Matt and Neetika made several suggestions for the literacy teacher educator's job within each of the worlds the adult scenariators had imagined. When a teacher knows how to build a bridge between new and old literacies and when he or she is very comfortable using digital technologies, they suggested telling teachers how to use technology at school for particular instructional situations.

For a world in which teachers can neither build a bridge nor use new technologies, Matt suggested that the teacher educator encourage them to be math or science teachers. In his words, "In math you don't need technology. It's helpful and everything, but you don't need it. . . . Science is more of a hands-on subject." Neetika added, "If that person's not good at either of them, they still have a hope because you have to give them hope. Everybody deserves hope. Maybe this person really does know what to do, but doesn't really recognize it themselves." She went on to suggest that teachers have opportunities to take computer-training courses, read books, and play with the computer. To learn to connect old and new literacies Neetika advised, "You have to find a way; just look at something from a different perspective and see how technology helps it." Then she elaborated, giving an example of how one might use PowerPoint to help students learn about literary devices.

For a world in which teachers know how to build a bridge but are uncomfortable using digital technologies, Matt and Neetika suggested offering them a few courses in technology. They suggested helping teachers build on the one thing with which they are comfortable; encouraging them to ask their students for help; showing them how to use technologies; and encouraging them to read about computers—to try out things on the computer and risk making mistakes, instead of not trying.

For the world in which teachers do not know how to build a bridge between new and old literacies but are comfortable with new technologies, Matt and Neetika made several suggestions. Teacher educators might help teachers learn how to connect the two literacies, perhaps by showing them very specific examples of how to do so when working with students. Alternatively, teacher educators might encourage teachers to take school jobs where it is not so important to build a bridge between literacies, such as when working in a computer lab. Teacher educators might also help teachers find jobs in advanced technology (outside of school). Matt explained, "If you get a job in advanced technology, then you really don't need to know how to build that bridge."

As their last words of advice, Matt and Neetika suggested that teacher educators help teachers become more "aware of what is really going on in the students' lives." They explained that such knowledge is vital for making the connections we'd been discussing. As for schools, they suggested that laptop computers be widely available for students, as well as many other devices, such as Palm Pilots for homework assignments. Computers and flat-screen televisions could be used instead of overhead projectors to present information during class, and video cams could be used to communicate with people around the world. Neetika explained a few of the benefits:

> We could be diverse and learn about other countries, and they could learn about our country. Because they have fixed notions about our country, the way we have fixed notions about other countries. . . . But technology is a great thing, and we shouldn't waste it on petty problems, only like using it once or twice for PowerPoint presentations. We could use it . . . more wisely. And you [teacher educators] could help them [teachers] because you could teach them [how to use it more wisely].

Finally, Matt advised teacher educators to consider some of the dynamic and amazing possibilities that technology offers:

> Okay, first of all you, as a teacher [educator], would have to be aware that technology is still climaxing up. . . . Technology is going to keep on growing, whether you know it's here or not. . . . My God, technology has just gotten so good! I'm amazed myself at all the things!

The Value of Scenariating for Literacy Teacher Education

The particular version of scenariating that we enacted with the help of our adult collaborators seemed a fruitful one for considering our work as teacher educators. Within the structure of the scenariating process, they entertained the question we posed, identified and discussed driving forces, selected critical uncertainties, envisioned alternative worlds, and made suggestions for teacher education within those worlds. To facilitate the process, we made two major changes in our agenda. First, we combined brainstorming and considering driving forces. This coupling came naturally to our collaborators and seemed to inspire their conversation. The second change was to resist insisting that collaborators name each of the four worlds they envisioned. At that point in the process, the group was fast approaching the end of our two-hour session; thus, we used the time to envision the worlds and to make relevant suggestions for teacher education.

In our first attempt at scenariating, we made suggestions for literacy teacher education at the end of a two-hour session. In fact, we worked an additional 25 minutes to complete the process. Our sense is that the group could easily have made additional suggestions for teacher education if we had invited them to return for a follow-up session. This is one variation in the process we would like to explore. It would be useful, too, to choose different critical uncertainties with which to carry out the scenariating process to see what possibilities for teacher education they might reveal. Another possibility is to invite scenariators from various fields to participate in this process. People from different fields or different life experiences would likely contribute to our store of possibilities and suggestions.

Given our initial experience, we see scenariating as a way to open up possibilities. Even with a small group of people, all within education, the group was able to develop more than a few ideas about what is important to consider if we wish to make new literacies and digital technologies more central in literacy classrooms in secondary schools. The group's thinking about building bridges between old and new literacies and teachers' level of comfort with digital technologies seems, indeed, an important contribution to our work as literacy teacher educators. Their ideas suggest awareness that even while, in many respects, the world may be changing rapidly and dramatically, vestiges of our history remain that shape and inform what we consider "literacy."

Our adolescent collaborators seemed to be potential scenariators. Although we did not ask Matt and Neetika to follow the scenariating process strictly, we did ask them to engage in similar thinking. For example, we asked them to envision a school in which new literacies and digital technologies were central to classroom learning, to consider several of the issues the adult scenariators raised, and to make suggestions for each of the four possible worlds the adults envisioned. The eager and well-elaborated responses from these adolescents suggest that we might well have asked them to join several other adolescents in a scenariating process along the lines we used with adults. This represents additional next steps we see ourselves taking as we explore the scenario-building process.

Matt and Neetika agreed on many issues, while also expressing unique positions. This pattern made us believe that, at least to some extent, they felt comfortable expressing their views. The enthusiasm and rapidity of their responses contributed to our sense that they were being candid. Besides candor, their particular responses also suggested that they had experienced school and life from widely different perspectives. For Matt, new technologies were an oasis—a collection of possibilities through which he could explore his various interests and express himself as a competent young person—a possibility that had been at least somewhat limited previously, given his struggle with more traditional school-based literacy. For Neetika, new technologies were a bonanza—a set of toys that she could use to further develop her success within and beyond school.

The adolescents agreed with the adults on numerous issues. They saw the importance of new, as well as old, literacies. More enthusiastically than Matt, Neetika reported the influence that some old literacies have in determining one's success, especially success in hurdling conventional school barriers, such as the SATs. She explained the difference between comprehending a complete piece of literature, such as a classic, and comprehending a summary of the work on the Internet. Nevertheless, both were adamant that success in school could be leveraged through the use of the various technologies available to students. In addition, they recognized the importance of technological savvy for work beyond school. Both seemed aware that the world was dynamic and that flexibility would be essential for future success. Neetika seemed focused on developing that flexibility through strengths in both new and traditional literacies. Matt's approach seemed to focus on developing a variety of new literacy skills that he could use to leverage future success. Thus, their conversation supports Gee's (this volume) notion of shape-shifting portfolios.

The adolescents were equivocal in many of their positions with respect to the questions we asked them. Although they saw possibilities for both good and evil in new technologies, difficulties did not dissuade them from grappling with or enjoying new technologies and gaining what they could from their use. They were at once enthusiastic and cautious. In their caution they had developed more than a few strategies to protect themselves, such as using available sites selectively and blocking potentially damaging communicators.

To these youngsters, teachers were not first and foremost experts in technology, nor did they need to be. They explained that their teachers did need to know some basics and be able to perform routine maintenance. One important requirement for them was the stipulation that teachers be able to do what they ask students to do. Matt and Neetika explained that this requirement was necessary because such knowledge would allow teachers to support their students' completion of assignments. To us it also seems eminently fair that when we, as teachers or teacher educators, make a requirement of our students, we first require it of ourselves.

Like our scenariating adult collaborators, many of the suggestions the adolescents made for teacher educators with respect to each of the four envisioned worlds reflected constructivist learning principles. These included making various

learning opportunities available for selection by teacher learners; inviting teacher learners to begin where they are comfortable, knowledgeable, and interested; showing teacher learners how to do what we expect them to do; and encouraging teacher learners to try things out and to feel comfortable making mistakes. We were not surprised that our adult collaborators would favor such principles, but it was noteworthy to find this pattern among adolescents.

Both adolescents left us with a challenge. Neetika offered that technologies were not being used as "wisely" as possible, and she challenged us to work toward improving this situation. To whet our appetites for better use of technology, she suggested Internet conversations among adolescents that could help participants dislodge incorrect yet "fixed notions" about others across the world. Her illustration, as well as her more general suggestion for teacher educators, remains an important agenda item for teacher education. Finally, Matt advised teacher educators to keep in mind the dynamic nature of the current technological revolution, and he ended his comment with an expression of his own awe and wonder at it all. Thus, importantly, at a time when we seem to educate largely through mandate and requirement, even in the dynamic realm that includes technology, Matt left us considering ways to harness the excitement of the possibility he envisioned.

Cynthia Lewis and Margaret Finders

IMPLIED ADOLESCENTS AND IMPLIED TEACHERS: A GENERATION GAP FOR NEW TIMES

On the surface, the emergence of new media and digital technologies seems to accentuate the generation gap between adolescent students and their teachers. This chapter argues, however, that the common meaning of "generation gap"—a gap caused by differences in age and interests—breaks down given that new teachers and their students are often close in age with common interests (especially related to popular culture). Instead, we argue that the "generation gap" that exists between these two groups is shaped by the fact that new teachers and adolescents are compelled to perform particular identities. We use the tropes of "implied adolescent" and "implied teacher" to show that what some may see as a generation gap, a simple case of divide between teachers and the "new media" adolescents they teach, is complicated by constructions of identity that come with material consequences related to access and authority.

The literary concept of the "implied reader" (Iser, 1978) provides a useful lens through which to view conceptions of adolescence in new times. Briefly, an implied reader of a text is the reader that is inscribed through the text's subject and style, the one that is positioned by the text to accept its ideology (McCallum, 1999; Nodelman, 1996). The text's ideological underpinnings are, in turn, constituted in the assumptions of the culture within which it was produced. Perry Nodelman (1996) provides a list of assumptions about children as the implied readers of children's literature that speak to commonplace contemporary constructions of childhood as a time of innocence and egocentricity. Pointing out that such constructions are historical, Nodelman proceeds to argue that one must understand something about views of childhood over time if one is to study and teach

children's literature. Without such understanding, the ideology of the children's text will remain invisible to its readers.

We argue that this concept of the "implied reader/child" as it relates to children's texts maps onto a concept of the "implied adolescent" as it relates to youth culture. In fact, when Cynthia teaches a graduate course on ideology in adolescent fiction, she begins with Nodelman's list of assumptions about children and asks her students to brainstorm a similar list for adolescents. Inevitably, the students list such commonplace assumptions about adolescents as the following: rebellious, independent, peer-influenced, anti-adult, hormonal, and impulsive. Throughout the course, then, Cynthia and her students attend to the ways in which the textual features of particular works of adolescent fiction are inscribed with just such a notion of implied adolescence, thus reifying middle-class, white ideologies of youth culture.

We begin with this notion of "the implied adolescent" because we find it a fruitful trope as it relates to new literacies and adolescent learners. The ways that teachers envision their adolescent learners have everything to do with how they will teach these learners, especially given that most teacher education programs train teachers to focus on the needs of the learner. Interpreting a learner's needs, however, means that one must have a way of constructing the learner, a vision of who that learner is. Traditionally, this vision has come from developmental psychology which, along with cognitive psychology, has been the theoretical linchpin for most of teacher education. However, as the next section of this chapter makes clear, this process of constructing the "psyche" of the learner, and the life stage that we call "adolescence," occurs within a social, cultural, and historical context.

Related to new literacies, then, our conceptions of the "implied adolescent" are very important. Do we see adolescents as savvy users of new literacies (including popular technologies), perhaps savvier than we adults? Do we see them as mesmerized by new literacies and inattentive to more traditional forms of literacy? Are adolescents manipulated by new literacies and, therefore, lacking in analytical skills? And what conditions have led to these constructions of adolescent learners?

As important as it is to examine the "implied adolescent" as a social and historical construction, it is equally important to examine the "implied teacher" as the inscription of what a teacher is or should be. Just as our notion of who we believe adolescents to be is inscribed in our teaching practices, so too is our notion of who we believe a teacher should be in relation to adolescent learners. The latter is particularly important for pre-service and new teachers who often see themselves as barely beyond adolescence and therefore vulnerable about being or acting like the "implied adolescent." This vulnerability is reinforced by the discourse of teacher education with its emphasis on the "management" of children or adolescents. The "implied teacher," then, is one who is positioned by the text of teacher education (shaped, of course, by larger sociohistorical norms) to accept its ideology, an ideology that, as Allan Luke and Carmen Luke argue (2001), normalizes youth as the "uncivil, unruly techno-subject" (p. 8). In fact, engaging in new literacies makes adolescents all the more dangerous, according to Luke and Luke, because their knowledge and skills threaten adults who lack them, leading to the current panic

for the good old days of print literacies. The real crisis, Luke and Luke claim, is "for the postwar trained, baby-boomer teaching, researching, and policy-making workforce entering the final decade of its productive leadership" (p. 12). Yet it is the postwar baby-boomer teacher who remains the "implied teacher" of our teacher education programs and the imagined self of our pre-service teachers.

In this chapter, we first consider historical shifts in conceptions of adolescence (the changing "implied adolescent") in the United States (and other Western nations). Following this discussion, we move to an illustration of particular adolescents' identity performances through digital literacies with a focus on how these performances are circumscribed by notions of implied adolescence. We move next to an example of a particular group of pre-service teachers struggling with normative concepts of what it means to be a teacher of adolescents in new times. Finally, we end by discussing adolescent and teacher identities as they are performed across social and institutional spaces that new media and technology have rendered less clearly demarcated.

Shifting Conceptions of the "Implied Adolescent"

Biological changes often characterize entry into adolescence and these changes have come to signify so much that we tend to describe adolescents in ways that reference their biological changes. We refer to "surging, quivering, quaking, raging hormones" as if to personify these famous biological changes and create a category we can all recognize. Yet the concept of adolescence did not exist before the last two decades of the 19th century (Klein, 1990). Gee (this volume) describes the evolution of generations of adolescents called by many names (Generation Y, Generation XX, Echo Boom, Generation Next, the Bridger Generation, Generation 2K, Millennials) and characterized as shifting from the apolitical, cynical, detached genXers to the economically savvy shape-shifting portfolio adolescents of the fast-capital generation. Although we might tend to regard adolescence as a part of a "natural" life cycle that is biologically determined, adolescence as a life stage depends on the social and economic conditions of any particular historical period. Nancy Lesko (1996) argues that age is for the most part constructed as an orderly progression to a more rational and authoritative state. According to Lesko, adolescents occupy a border zone, a transitional state between "the mythic poles of adult/child, sexual/asexual, rational/emotional, civilized/savage and productive and unproductive" (p. 455).

What we call a "stage," then, must be situated within an ever-evolving complex sociopolitical climate. Klein succinctly describes the creation of adolescence based on social and economic factors:

> Basically, industrialization occurring during the later 1800s created the need for a stage of adolescence; the Depression created the legitimized opportunity for adolescence to become differentiated from childhood and adulthood; and the mass media influence/blitz of the 1950s crystallized this stage by giving it a reality all its own. (p. 456)

Adolescence as a life stage solidified largely due to economic conditions, specifically the Depression. Palladino (1996) explains that up until the 1930s most people in their teens worked for a living on farms, factories, and at home. They weren't teenagers or adolescents; they were adults. Palladino argues that it was this mass coming together in a school setting that solidified adolescence as a distinct age group. Thus, the emergence of adolescence as a life stage had more to do with economic conditions than it did with "raging hormones," the theory popularized by G. Stanley Hall.

In this country, G. Stanley Hall became known as the father of adolescence with the publication of his 1904 two volume-set *Adolescence*. Hall conceptualized the period of adolescence as biologically determined, with little consideration for any social or cultural influences (Santrock, 1993, p. 13). To Hall, adolescence was a period of "storm and stress" characterized as "a turbulent time charged with conflict and mood swings" (Santrock, 1993). According to Hall, hormonal factors account for the marked fluctuations in adolescent behaviors (Brooks-Gunn & Reiter, 1990). Coleman's (1961) landmark study in the 1950s grew out of this storm-and-stress model and led to a construction of adolescence as a subculture sharply distinct from adult culture. Coleman characterized the "adolescent culture" as hedonistic and centered on issues of popularity with peers rather than on academic achievement. Coleman's view of adolescence as a separate culture still persists, but unlike other "cultures," adolescence is denied diversity. Current assumptions about adolescence appear to homogenize the experience. Most often, the historical, economic, social, and cultural complexities that shape the lives of adolescents disappear as we hold tightly to a singular, biological view of the "normal" adolescent, which includes the following assumptions: (1) adolescents sever ties with adults; (2) peer groups become increasingly influential social networks; (3) resistance is a sign of normalcy for the adolescent; and (4) romance and sexual drive govern interests and relations (Finders, 1997, p. 28).

We now understand that class, race, gender, and individual life circumstances influence how one comes of age in this country. In cross-cultural anthropological studies, for example, Schlegel and Barry (1991) note that in middle-class homes where child labor is not needed, adolescents of both sexes are likely to spend a good deal of time with same-age peers. But girls in working-class homes or in families of Hispanic, Middle Eastern, or Asian extraction may be expected to spend their after-school time at home, while boys may be with peers or at work outside the home (p. 43). Likewise, Comer (1993) argues for the necessity of maintaining close ties among children and adults during this period. Similarly, Fine and Macpherson (1993) criticize studies of adolescence because often they do not take into account marked differences in terms of race, class, gender, or sexual orientation. In Cynthia's class on ideology in adolescent fiction, it becomes clear to students that some texts inscribe a different sort of "implied adolescent." Works by African American female authors, for instance, often center on young women who thrive in the midst of strong relationships among generations of women rather than adolescents who seek independence from their families. While recent research problematizes

many commonly held assumptions about adolescence (e.g., Feldman & Elliott, 1990; Lesko, 2001; Takanishi, 1993), many educators and adolescents themselves continue to operate with the assumptions of "implied adolescence" in mind.

Performing the "Implied Adolescent" through Digital Literacy

We turn now to an illustration of particular adolescents' identity performances through digital literacies, intending to illustrate how two girls who engage in this extracurricular literacy practice do so within the boundaries of "implied adolescence." This section, based on research that Cynthia conducted with Bettina Fabos, discusses the social practices surrounding the use of a particular digital literacy, instant messaging (IM), which is short for online, real-time communication with peers. In many ways, the girls' use of IM was regulated by their sense of what it means to be a teenage girl, and they performed this identity very much as though they had invented it. That is, they took up identity stances relative to the normative roles in which they were cast. Nonetheless, the IM format did allow the girls to assume alternative identities that resulted in some movement and recasting of gender positions. Our analysis is informed by Judith Butler's (1993) argument that gender norms are reiterated through performances of identity that are already inscribed.

> [P]erformativity must be understood not as a singular or deliberative 'act,' but, rather, as the reiterative and citational practice by which discourse produces the effect that it names. (p. 2)

However, because this reiterative process is not infallible, "sex is both produced and destabilized in the course of this reiteration" (p. 10). Thus, Butler's argument allows that through the repeated performance of gender, norms might be transgressed or reconfigured.

In previous research on IM interactions, Lewis and Fabos (2000) focused on the girls' creative and sometimes transgressive uses of IM. These two best friends negotiated the technology on three levels: language use, social practice, and surveillance. On the level of language use, the girls manipulated the tone, voice, word choice, and subject matter of their messages, facilitating multiple narratives in the process. On the level of social practice, they negotiated patterns of communication through IM to enhance social relationships and social standings in school. And on the level of surveillance, the girls were able to monitor the IM landscape for their own benefit, combat excessive or unwanted messages, assume alternative identities, and overcome parental restrictions on their online communication.

We think it is important to note these creative uses of digital literacies, particularly from the perspective of observing how youth, as participants in this new digital culture, shape and transform the culture. The girls who participated in this study used literacy for their own social and political purposes, performing multiple

identities moment to moment for multiple audiences (especially when engaged in the common practice of Instant Messaging many buddies at once, and, therefore, negotiating multiple windows). Moreover, the girls' use of IM calls into question the deficit view of online activities that Allan Luke critiques (this volume) in that language choices were self-consciously connected to purpose and audience indicating the girls' rhetorical acumen in peer-driven exchanges.

Despite these creative, and somewhat transgressive, uses of digital literacy, what we want to illustrate here, to advance our argument that the characteristic identity markers associated with the "implied adolescent" are normative, is the way in which the identities the girls perform through IM are already written into the discourses associated with being an adolescent female. To do so, we'll refer to two girls, Sam and Karrie (both age 13) who were the two best friends referred to earlier. Sam was from a working-class family, but she and Karrie interacted with friends across social class boundaries, underscoring Gee's point (this volume) that social class today is often defined in terms of "affiliations with certain sorts of people, objects, technologies, and practices." Karrie makes the point succinctly: "I wouldn't be as cool to some friends if I didn't talk on the Internet."

One example of a scripted performance of identity related to gender roles was Sam's manipulation of attention, which contradicted in interesting ways Lankshear's and Knobel's argument (this volume) that "people withhold attention if they have no interest in the exchange." Whereas several adolescents in the larger study discussed strategies they used to withhold attention from IM buddies who hold little status, Sam strategically withheld attention from boys from another school whom she wanted to get to know, hoping that making them wait longer for a response would attest to her own popularity. She reasoned that withholding attention would lead others to believe she was too busy with her many IM buddies to respond quickly to these high-status boys. One can say that in this case Sam was using the technology with rhetorical sophistication, allowing her to craft a desired identity. Another way to analyze this scenario, however, is to suggest that Sam performed an identity that was already scripted for her by her age and gender. She was cast in the role of "implied adolescent" female, and although she managed to wield some power in this role by withholding attention, she nonetheless enacts the norms expected of adolescent girls—attempting to impress boys and appear popular.

The girls do, indeed, try on other identities when they are online, but the identities they try on are, again, already scripted within normative gender constraints. Sam, for instance, "pretended" on occasion that she was "blond-haired, blue-eyed" because she believed having these particular media markers of beauty would extend conversations with boys she didn't know. As with the previous example, it is possible to view Sam as claiming power. Given a social sphere that excludes the body, she inserts one that will work for her. However, the fact that she does resort to traditional markers of white feminine beauty in the rare social sphere where it need not be central shows that normative gender and race positions are not so easily erased even in a space that is sometimes hailed as a new form of social existence (Jones, 1997) and multiple identities (Turkle, 1995).

Karrie also tried on alternative gender identities, playing the role of a male during occasional forays out of IM and into chat rooms. Her goal was to track her boyfriend into a chat room by assuming the "male" identity of "snowboarder911" because "that's sort of a typical kind of guy screen name," and try to find out what kind of conversations he was having. Since the physical body is not present in Internet interaction, Sam and Karrie did, indeed, have more space for play, parody, and performances that destabilized normative gender roles and gave the girls some control over their gendered positions. Yet, the girls clearly did not use online communication in ways that broke down gendered frames of reference.

The girls wanted to pose in ways that would increase their status as females. With Sam's help, Karrie was able to crack the block her parents had placed on her user profile so that she could include more information about her appearance and make herself sound more interesting and appealing to boys. On the other hand, when Sam and Karrie chose to enter chat rooms that were not age-specific, they made their user profiles more sketchy and lied about their age so as to pursue "adult" conversations with older people. This way, the girls felt they could control the rhetorical contexts of their interactions through careful consideration of issues related to status, age, and gender. These moves were very strategic, as is clear in Sam's comments:

> See if you tell someone you're 18, you sort of have to prepare ahead of time, 'cause they're going to ask what college you go to, what classes you take . . .

Despite this element of control, media attention to the dangers of Internet communication had convinced the girls that their parents had reasonable fears about the Internet and were right to block their access to chat rooms. (Karrie: "We've heard stories about kids where kids can get killed.") Indeed, Sam and Karrie's posing related to gender and age shows that the social and power relations that exist outside the Internet inhere within as well. As Butler suggests, those structures are at once solidified and destabilized in the repeated performances of everyday interaction.

New Literacies in Teacher Education: On Becoming the "Implied Teacher"

In order for adolescents like Sam and Karrie to begin to examine the social and power relations that implicate them, approaches that call for an expanded definition of literacy, which includes the ability to read and critique a wide range of media texts, are essential (Moje, Young, Readence, & Moore, 2000). If we are to support critical media literacy, we must prepare beginning teachers for such tasks. Carmen Luke (2000) notes, "What better site to begin developing new frameworks for knowledge and critical literacy than in teacher education?" (p. 425). What better site, we ask, than a high school English methods course in a conservative

English Department in the rural Midwest? Margaret's English methods class provided just such a site.

While the parameters of the literacy program at Margaret's institution didn't allow for a full course in media and cultural studies, she set out to introduce pre-service teachers to the concept of multiliteracies and popular culture by selecting the text *Popular Culture in the Classroom: Teaching and Researching Critical Media Literacy* (Alvermann, Moon, & Hagood, 1999) as one of the required readings for the course. English education students at Margaret's institution come to this course with a fairly traditional literature background. Students in this program for the most part match the portrait of the typical student enrolled in teacher education:

> She is White and from a suburban or rural home town; monolingual in English; and selected her college for its proximity to home, its affordability and its accessibility. She has traveled little beyond her college's 100 mile or less radius from her home and prefers to teach in a community like the one in which she grew up. She hopes to teach middle-income, average (not handicapped nor gifted) children in traditional classroom settings. (Gomez, 1996, p. 112)

Carmen Luke (2000) notes that those pre-service teachers growing up in a highly technological society may be more receptive to multimedia and multiliteracy approaches to teaching and learning. However, this characterization was contradicted by Margaret's students' resistance to taking new media and digital literacies into their classrooms. While all of these students were between the ages of 21–24 and most were quite savvy with technology and media, they were resistant to sharing what they considered to be their own "private pleasures." Perhaps this can best be understood in terms of the "implied adolescents" they have been and the "implied teachers" they are becoming. In discussing this study, we attempt to illustrate how pre-service teachers embraced the role of the implied teacher. In many ways their struggles with digital literacies were actually struggles with their sense of who they should be as teachers. In other words, their views of the implied teacher prevented them from fully realizing any potential that their own connection to new media may bring to the literacy classroom. Digital technologies did not allow this particular group of future teachers to assume alternative identities that may have resulted in some movement and recasting of their teaching positions. Instead, they clung tightly to their fledgling identities as "teachers," with all that the term implies. Just past adolescence themselves, these pre-service teachers thought of adolescence as a linear life stage that regulated their sense of what it means to be a teacher of adolescents.

Students enrolled in this course were able to examine their views, locate their pleasures, and begin to examine the ways in which social and economic ideologies may have shaped their interactions with particular forms of popular culture. For example, the pre-service teachers brought in CD covers, attempting to analyze how CD jackets get read from multiple perspectives. In attempting to understand the corporate construction of adolescent culture through the production and

distribution of CDs, they examined naturalized conceptions of adolescence as a biological life stage. The students reflected on the pleasures people derive from various media forms and texts in an attempt to move toward an analysis of the politics of location. Margaret's aim was to provide students with the critical analytic tools to understand reader and viewer diversity of reading positions and the sociocultural locations that influence preferences.

During those class periods when the pre-service teachers felt freed from the role of "implied teacher," the conversations were animated and lively. Students laughed and shared and were able to read through and between the lines of the jackets. Ray was a class leader for the first time: For the first nine weeks of the semester, he had sat in the back of the room, often with his head down, never appearing to be engaged. However, when Margaret asked students to bring their favorite CDs to class, he volunteered to bring in his own CD player to ensure "better sound." He asked if there would be any "rules" about what lyrics would be considered out of bounds. After Margaret assured him that there were no such rules in their university classroom, he immediately began his list of what he would bring to class. During that next class period, Ray offered some of his collection to anyone who hadn't "remembered." And as you might guess, he volunteered to be first in leading a discussion of his CD selection. Another student asked if her country music would be booed out of the room before sharing the ways in which this music gave her pleasure. While the music shifted from country to techno to big bands, the class seemed to come together over their lively talk about how music fit into their lives and influenced their views of how to "be" an adolescent. They recognized that they may well have been positioned as a certain kind of target market, but as one student suggested, "When I was in high school, I didn't really care if they were trying to SELL me more than the CD. It's just a way to get into the whole image thing. I wanted to be part of the techno thing." Sure, there were groans and hoots over perceptions of "bad choices" but the atmosphere that day seemed filled with pleasure, respect, and the beginning of trying to understand how one's readings might be constructed by different audiences for different purposes. Ray, in his first attempts to examine notions of pleasure production, noted,

> I guess I always take a boys will be boys view. My music is probably what you might consider very masculine. How do I use it to construct my own notions of masculinity? I have no idea. It is just what I like. But I don't think that just because I watch AND LIKE videos of women in bondage that that makes me some kind of a chauvinist or pervert or something. But there is something that makes women in bondage pleasurable. And that's sort of creepy. And I have never thought about before. Do I need to look at how such images work on me? I guess so. I'm not saying that I think such images will lead to violence, but I guess I do need to think about why I am so comfortable with it. It's really the beat and not the video, I think.

All the while, there remained a sense of tameness to these discussions. The pre-service teachers readily selected CDs over other digital forms, perhaps because

CDs are still perceived as "safer" or more appropriate for classroom discussions. While these pre-service teachers may have actually been much savvier than discussions revealed, the perception of a "generation gap" that exists between teacher and student (between classroom and living room) may have compelled them to hold to particular performances in a university classroom.

While pre-service teachers had worked with Margaret in previous teacher education courses and for the most part had established good working relationships, pre-service teachers may have sensed that this was uncharted territory for Margaret as well. Margaret came to this classroom with years of experience as a teacher educator, a repertoire of pedagogical approaches, and an interest in bringing popular culture into the classroom, but she was indeed a neophyte in terms of working with digital literacies. Yet, for Margaret and the pre-service teachers, interest and engagement with the content was highly animated. They were willing to speculate on how corporate culture shaped views of pleasure, on how they had embraced particular music lyrics and images to influence their adolescent identities.

However, when Margaret nudged the conversations to how these pre-service teachers' high school students might read such texts, conversations became less open, less speculative, more rigid, and more authoritative. Readings suddenly tended to be corrected. Laughter ceased and the pre-service teachers began to take up an authoritative discourse that may be all too familiar. They had willingly wrestled with multiple meanings during their own class discussions, but when asked to consider how a similar conversation might play out in a high school classroom, the students' tone changed. "Just another politically correct move," one said. Another argued, "They'll probably know more than me, I need to be in charge." Yet another insisted, "Parents won't like it."

In short, when pre-service teachers were cast as students of critical media studies, they found the cultural work valuable and engaging, but when they were asked to consider critical media studies from the perspective of a teacher, they found the work filled with controversies, inaccessible, and for the most part inappropriate. Attempts to shift the conversations into the middle or high school context were met with resistance: This material seemed "off limits." "I got my buddies and I've got my students. And I don't think I should mix the two," Ray explained. They saw themselves as holders of knowledge, the gatekeepers who control the "uncivil, unruly techno-subject" (Luke & Luke, 2001, p. 8). Their conversations about teaching made it clear that they operated within the constraints of the "implied teacher" as regulator of the "implied adolescent," despite their own identifications with the pleasures commonly associated with adolescence.

In spite of their resistance, Margaret's students all complied with her directives to infuse media literacies into their literacy lessons. So what did their attempts look like? Where there was any attention to popular culture at all, it was in the form of teaching students to understand how media manipulate audiences, situating the teachers as liberatory guides and students as dupes. But for the most part CDs, Internet sites, and video clips were just more textual objects to be analyzed in a traditional literary manner. In fact, these lessons appeared to be much

more traditional, closed to negotiations, and teacher-centered than those related to literary texts. Ray, who had been so vocal about his own musical pleasures and personal resistance to analyzing these pleasures, wrote the following:

> Use pop culture (specifically music) to define literary terms. My role as a teacher will be to determine the appropriateness of materials. I will choose the music shown for the most part. The students will be able to choose their own music to do outside projects. This gives them choice and choice is good. The unit will show students that some pop culture has merit and is valuable in the classroom. Students will learn definitions and real world applications for literary devices such as allusion, personification, connotation, denotation and various poetic terms.

Others in the course explained that they would tap digital literacies to "reproduce the different elements of narratives," "gain knowledge of different writing styles by examining popular culture," and "learn how to examine the credibility of the author." They envisioned using media in an attempt to make great literary works more accessible. For example, one wrote, "By using the Raiders of the Lost Arc, Beowulf will become more accessible to my students."

While many scholars warn that adolescents may resist teachers' attempts to have them talk about music, films, computer games, and other forms of popular culture in a school setting, these future teachers (just barely past adolescence themselves) were resistant to sharing their own pleasures in a school setting. They felt a need to create firm boundaries between their private pleasure and their professional authority as the "implied teacher" of their imaginations. One undergraduate said, "I want them to see me as their teacher, not just another kid." Another reported, "We shouldn't share our music because then it will make us seem too young. Too much like them. Not like teachers."

"Not like teachers" can perhaps best be understood as not like the implied teacher they were attempting to replicate. They spoke of their direct need as young teachers to widen, not bridge, the experiential and knowledge gap between themselves and their students. To widen the gap, they needed either to declare popular culture off limits or to force fit it into the traditional paradigm of English education. They felt compelled to take up the discourse of teaching with which they were most familiar. In Butler's terms, their teaching identities were already inscribed materially, reiterated through the discourses of schooling and teacher education as well as in the disciplining of their own bodies as students.

Asked to try on the role of teachers, they repeated the performances they knew. Asked to reflect, in journals, on their reasons for doing so, they resorted to the discourses of "implied adolescence" and "implied teacher" that would widen the generation gap that their own youth and interests narrowed. Taking up the position of the implied teacher, pre-service teachers in Margaret's class were primarily concerned with control, authority, and maintaining firm boundaries between their lives and their students. The implied teacher came already equipped with a normalizing discourse that served to regulate adolescent behavior. In their professional

journals they wrote such things as "Kids can get way out of control," "You gotta keep 'em in line," and "I tried it and it didn't work. Kids get out of control." Embedded in the "implied teacher" is a need to be the expert. They feared, as one expressed, "Kids will know more than I do." Their pleasures with popular culture created roadblocks, not avenues. They didn't want to blur the boundaries between their own pleasures and their professional work: "My interests are none of their business."

Caught at the border between teacher and adolescent, young pre-service teachers struggle with knowledge, access, and authority. Boundaries between their teaching selves and their student selves, between their own private pleasures and their professional work, cause students to solidify the borders. Layered on to this struggle, pre-service teachers are faced with a struggle for what will count as official knowledge and competence in the world of school. The linear view of age development as an orderly progression to the more rational and authoritative state of mind creates a generation gap even for young "new media" teachers.

Ambivalent Identities across Social Spaces: Teaching Adolescents in New Times

Common sense suggests that those entering the teaching profession today nearer in age to their students and growing up with music videos, VCRs, and the Internet will perhaps be more receptive to new media and digital culture in their approaches to teaching and learning. Such views do not take into account the generation gap that is built into our conceptions of adolescence. This generation gap is constituted in policies and practices aimed to separate students and teachers: adult/child, civilized/savage, and productive/unproductive. Pre-service teachers seem to be caught at one historic moment between past youth and future teacher, the "implied adolescent" and the "implied teacher." Further complicating this generation gap is the fact that both the adolescents and their young teachers perform identities across social and institutional spaces that are shaped by conceptions of "implied adolescence."

Young people like Sam and Karrie write themselves, figuratively and literally—through digital literacy—within the bounds of the "normal" adolescent, seeking heterosexual affirmation, experimenting with identities that, while slightly transgressive, ultimately conform to normative gender categories. These digital literacies, although not yet part of their school's curriculum, do cross over into the social and institutional space of school. Online conversations are reported and discussed at school and, as Karrie pointed out, using IM is part of what it takes to be cool.

Like Sam and Karrie with their IM buddies, Ray, the pre-service teacher in Margaret's class, was attempting to cross over into a new social and institutional space of school, this time as a beginning teacher. He understood the terrain as two distinct spaces: "I got my buddies and I've got my students. And I don't think I should mix the two." What might happen when beginning teachers like Ray enter

their classrooms filled with savvy adolescents like Sam and Karrie? Some educators see this as a hopeful time, a shrinking of the great divide between teachers now more media savvy and the new media adolescents they teach. However, if they accept the implied positions they are expected to occupy in a school space, Ray, Karrie, and Sam may enact the school's ideology, compliant in their relationships to knowledge, access, authority, and each other. Such ideologies circumscribe the performance of adolescent and teacher identities within a school culture. Left unexamined, these performances of "implied adolescents" and "implied teacher" may change little.

James Gee (this volume) describes "enactive texts" as texts written by powerful people who in their very telling make such texts true. Notions of "the implied adolescent" and "the implied teacher" might be considered enactive texts, taken as true. We argue that one must understand something about the ways in which such identities relate to new literacies and adolescent learners. As we have shown, there are discourses and material conditions in place that compel adolescents and new teachers to perform these identities. Nonetheless, identities are not fixed. Considering identity to be "socially-situated" (Gee, 1999a, p. 13) allows for a way out of the quandary. Stuart Hall's (2000) description of identity is instructive here:

> [Identity] is situational—it shifts from context to context. The identity passionately espoused in one public scenario is more ambiguously and ambivalently "lived" in private. Its contradictions are negotiated, not "resolved." (p. xi)

Pre-service teachers often refer to their ambiguously lived identities when they enter classrooms as teachers, and they discuss as well the ambivalence, or downright discomfort, they feel about their teaching identities when they return to their social worlds outside the classroom. We know, of course, that many adolescents experience similar dissonant identities as they cross social spaces. Yet since new media and technology have begun to blur the social and institutional spaces in which adolescents and their teachers perform their identities, a new discursive space is possible—one where hybrid discourses enable students and teachers to borrow from the culture of classrooms as well as from youth culture, thus using linguistic constructions, textual designs, and interpretive norms appropriate to both spheres. Perhaps what is required of all of us—educators, researchers, and students alike—is to develop a bit more comfort with the ambiguous nature of identity so that more dynamic and multivoiced versions of what it means to be an adolescent and a teacher can flourish, "negotiated but not resolved."

Josephine Peyton Young, Deborah R. Dillon,
and Elizabeth Birr Moje

SHAPE-SHIFTING PORTFOLIOS: MILLENNIAL YOUTH, LITERACIES, AND THE GAME OF LIFE

Millennials, youth born between 1982 and 1998, are beginning to come of age. The oldest of the generation are now in college and are showing signs, as Howe & Strauss (2000) proclaimed, of being "the next great generation." Millennials were born at a time of great wealth and prosperity, soccer moms, "babies on board," family values, and kid-centered politics. Movements such as high-states testing, accountability, and curriculum reform flourished. The rate of youth violent crime offenders and victims peaked in 1993 and steadily dropped thereafter (Howe & Strauss, 2000). Millennials, regardless of their race, ethnicity, or social class, found themselves in families who wanted them badly and viewed them as important resources for the nation and for their own sense of purpose. Many of the parents were Bobos—Boomers who made it (Brooks, 2000; Gee, this volume) and who waged the most focused youth safety movement in history, protecting their children from dangerous strollers and toys, drunk drivers, drugs, and violent or sexual images in the media (Howe & Strauss, 2000). The parents of Millennials resolved to stay involved in their children's lives (unlike some Gen-X parents before them) and provide their children with skills and experiences, and opportunities needed to develop competitive shape-shifting portfolios.

We draw from Gee (this volume) to define shape-shifting portfolios as collections of skills—for example, educational, social, service, and sports experiences and achievements that can be arranged and rearranged in order to define and redefine oneself as a certain kind of competent person. These experiences and opportunities might include attending the right camps, joining the right clubs or teams, volunteering in the community, and taking the right courses in school. The process of building and displaying these portfolios is intended to facilitate present and future

success, and is ongoing. Success, many Millennials believe, is realized through a combination of hard work and being able to shape-shift educational, economic, and familial experiences, advantages, and values so that one can be recognized as successful and as having the potential to become even more successful in new circumstances and social contexts.

When James Gee (this volume) introduced us to Millennials and Bobos, we were immediately interested and intrigued. The generalizations about Millennials outlined by Brooks (2000), Howe and Strauss (2000), and Gee (this volume) resonated with many of our personal experiences. As self-identified Bobos, we could see ourselves, our children and relatives, and some of our research participants or past high school students represented in descriptions of these two groups. We could also name shape-shifting portfolio people who worked hard to create and re-create portfolios of achievements, activities, and experiences. In fact, we see ourselves as portfolio builders and shape shifters.

As researchers and past secondary teachers, however, we believe that such broad claims about a generation should be explored by taking a close look at individual Millennial youth to discern particular and significant differences among individuals and groups. In particular, we fear that the notion of portfolio building and shape shifting could be subsumed by an individualistic achievement ideology (MacLeod, 1987, 1995) that fails to acknowledge how race, class, ethnicity, and gender are always elements of one's portfolio. Thus, we extend Gee's notion that portfolios can be considered experiences and activities by including embodiments, practices, and Discourses (Gee, 1996b) as integral, although not tangible, aspects of portfolios and shape shifting.

With this in mind, we each present portraits of a Millennial youth—Deborah writes about Katie, Josephine writes about Thomas (a pseudonym), and Elizabeth writes about Mario (a pseudonym). These portraits emerge from three different research studies, and we present them as three distinct, individually authored, narratives. In these narratives we describe the youths' portfolios and explore how family income, race and ethnicity, native language, social class, gender, popular culture, digital technologies, globalization, and/or geographic and social space are part of portfolios and influence youths' shape-shifting practices to attain future life goals. We conclude by asking the question: What do their portfolios tell us about Katie, Thomas, and Mario? We also ask what their portfolios suggest about shape-shifting in the new Millennium.

Katie: Stories of Shrines, Portfolios, and Instant Messaging

Katie, my (Deborah) niece, is currently a sophomore at Columbia University double majoring in biology and political science with the desire to go on to law school. Katie graduated from a middle-class home in the central part of the United States. Her mom and dad are both outstanding educators who are aware

of how educational systems work and what it takes to be successful within them. Katie's high school classmates were primarily white, middle-class kids who worked hard in school and for the most part are working or attending college within the state. Several years before graduating, Katie decided that she wanted to leave her home state and attend college at Stanford, Columbia, or a comparable school. She worked to earn admission to these institutions (and was successful at several), secure scholarships and financial aid, and earn extra money for books and expenses. She turned down a full scholarship to an excellent university within her home state to travel to New York City because she wanted a more diverse setting for her college experience—diversity in terms of perspectives as well as people (race, ethnicity, socioeconomic status). She wanted to meet new people with new ideas. After a year and a half at Columbia, Katie noted that there are pros and cons to all the diversity in her life: "It can be very isolating . . . yet to gain this appreciation you have to understand others' lives even if it threatens you—it is important. You don't have an appreciation of who you really are until you understand others even if this is hard. I've learned a lot from this experience."

Using observational data, life history interviews, and document/artifact analysis (Dillon, 2001), I describe and analyze Katie's professional and personal portfolio, and especially the shape-shifting nature of her portfolio as she moved from high school into college. At first glance, Katie epitomizes Brooks's (2001) notion of the organization kid, one of ". . . America's future elite [who] work their laptops to the bone, rarely question authority, and happily accept their positions at the top of the heap as part of the natural order of life" (p. 40). However, my analysis, which begins with Katie's graduation from high school and her Open House event, will complicate characteristics of "typical" Millennial kids.

The "Shrine" Phenomenon

Graduation ceremonies in 2000–2001 are marked by public displays of kids who have succeeded (and by contrast, those who haven't). The school's portfolio of achievements, as well as that of each student, is outlined within the numerous pages of scholarships and awards listed in the graduation program. Likewise, success is marked by the multiple-colored cords worn around the necks of a large number of graduates, and the group photos—taken on stage during the ceremony—of those students who achieved high honors. Graduation celebrations for Millennial kids like Katie include an Open House party. These events are typically held at the young person's home before or after the graduation ceremony, and kids attend friends' parties as well as holding their own party. Each event appears to have common elements: decorations, food, cake and punch, and a display created by the graduate, which I fondly refer to as "the shrine."

As friends enter the Open House they are first routed through the shrine/display. Katie's shrine was set up in the living room (just as one enters the front door) and included five tables, each with a particular theme and matching documentation and with other artifacts such as books and notebooks stacked on the floor

around the tables. For example, one table held several large poster board displays with carefully selected photos of Katie as a little girl through current times. Cute baby pictures capturing funny episodes of Katie as a toddler with food all over her face or dressed up in silly clothes were arranged alongside group photos of high school friends hugging each other and marching band formations on a football field. Another table held papers and stories Katie had written throughout her school years, as well as graded schoolwork. Several of these papers included scoring rubrics filled with high marks and glowing comments from teachers. Yet another table reflected "service" and extracurricular activities in which Katie had engaged, such as a Teddy Bear from an AIDS fund-raising walk; awards earned at music, speech, and drama contests; and 4-H ribbons awarded for projects entered at county and state fairs. A fourth table displayed photos taken during school trips to Washington, D.C. or summer music and leadership camps; posters of school musicals in which Katie participated surrounded these pictures. A fifth table held framed awards, letters detailing acceptance to colleges, scholarship offers, and other honors. In the center of the display was a large Plexiglas container with a professionally taken picture of Katie in her lilac, spaghetti-strapped prom dress. In the picture, Katie has a pensive look on her face coupled with a slight smile. She is standing against a backdrop of a multi-paned window with her arms crossed; this position and body language signify maturity, sophistication, strength, and determination. Stacked near the table were books read in college courses taken at a nearby community college while Katie was still in high school. Notebooks of schoolwork and papers written for these classes were also prominently displayed.

Friends, community, and family members came to the Open House. After being greeted by Katie, they moved through the artifacts, often kneeling in front of tables just to leaf through documents and acknowledge Katie's accomplishments, before moving to the kitchen to partake of food and conversation with Katie's parents and others in attendance. Most of the young people I observed enjoyed seeing the pictures, learning more about their friends, and probably, if truth be told, seeing how they stacked up with their peers in terms of accomplishments as well as cleverness in crafting the display of artifacts.

The "shrines" and Open House events for students like Katie were remarkably the same, indicating, as Gee (this volume) and others have noted, the collaborative nature of Millennials and their desire for sameness. At the same time, there was evidence of what Brooks (2001) described as a sense of individualistic achievement. Yet upon closer scrutiny I noted that the shrine was also a desire to share with others, in a public way, what each kid believes makes her or him a unique person. The photos and items displayed in the shrine seem to say "See, here's what I was like and now here I am today . . . here's what and who I care about . . . here is what is important to me as well as all the other artifacts that I want you to see to know how hard I've worked and how much I've accomplished in my life thus far." Examining kids' shrines provides the personal component often missing from tangible portfolios. Shrines also offer the "evidence" included within or provided in support of the hard copy or electronic portfolio most kids prepare in school.

Shape-Shifting Portfolios

Katie found her high school portfolio—a notebook with multiple paper entries useful during interviews for admission to college and at Columbia, where she still uses items from her portfolio in her coursework. For example, she has used segments of high school history papers in college political science classes. But the portfolio itself is shifting in shape. As she seeks new experiences and summer internships that will position her for her future work in bioethics and law school, Katie has updated the purpose statement (e.g., future goals and current beliefs) in her portfolio. As she noted, "My statement has obviously changed a lot from the one I wrote for high school but I've kept that part of my portfolio and I keep changing it." In fact, Katie noted that evaluators expected to read about her changing goals and philosophies and the rationale behind these changes. Recently, Katie recognized that as she attempts to shape-shift with her portfolio to showcase her talents and efforts, she may actually need two distinct portfolios—one portfolio to display a focus and concentration of effort and another to represent her flexibility and diversity of effort (e.g., various activities under that category of service). In her words,

> Learning how to put together the portfolio and market yourself is the most important thing I learned. It was the process of selecting your most excellent pieces of work. [For example,] in an internship fair I just recently attended I had to go through the process of explaining to people what I've done and how and why I will contribute to their company. This was easier because of completing a portfolio.

Living in a Global World

The last time I interviewed Katie was at midnight during finals week at Columbia (her choice!). She told me that during a semester of long hours of studying and nights with little sleep, her entertainment—even preferable to dating, because there is no time for relationships—is to communicate with her friends all over the country via instant messaging:

> It is the bane of my existence but it is also the greatest thing because I can talk to everyone that I still want to talk to. It eats up my study time (laughs). . . it's on my computer and I'm writing a paper and someone will like instant message me and I'll end up having a half-hour long conversation with them and that's bad (laughs again). I have a buddy list—I have my friends divided by cities like New York, San Francisco, Houston, Cedar Rapids, Princeton, DC—all the places my friends are. I have about 90 people on there . . . you can have like 3 or 4 conversations going at once and you can leave little witty sayings for people."

Katie also spends time surfing the web because she's a self-professed "news site junky—I'm always on the New York Times.com and the CNN.com. But everyone

has their computer vice." The use of the computer allows Katie to be part of a global society while communicating with a community of friends that she may or may not have or be part of in the competitive environment at Columbia.

Goals and Tensions for One Millennial Kid

Like Katie's immediate family members, I am amazed at all that she is and has done. As I talked with Katie I learned that she has a strong desire to work for the good of others, even greater than the desire to make money. As she stated:

> I don't care that much about having the big house in Scarsdale as long as I have a job that keeps me thinking and is intellectually stimulating and is dealing with people. . . . I think I am like kids in Brooks's book. I definitely work the computer to the bone and just accept the role within the elite. I would say that's pretty true of myself and a lot of people I'm going to school with right now—just accepting that we are elite. I think it's fairly true that we rarely question authority. We just kind of try to please as much as we can but in a way—I don't want to make it sound like we're using authority—but in a way we take advantage of it . . . and get as much favor from it . . . and then we turn around and totally reform and change things. . . . You follow the rules imparted by authority figures and try to get as much favor out of them and then after you've done that and gained their respect or fulfilled all that you've needed to fulfill within those structures then people can't question the changes you make. You've done everything and you had all the favor, so then there's no room for them to say, "You didn't do that or you didn't fulfill that.". . . But every person has their own sense of morality or code of ethics . . . their sense of right and wrong is going to supersede power. I would hope mine would or that would be really horrible.

What is clear is that Katie struggles with several issues: wanting to be successful and make money, yet working for the good of others; striving to feel part of a group, yet seeking to be an individual; and working within power and authority structures to meet her goals, yet doing so in morally and ethically respectable ways. Katie's world is filled with tensions. Viewed from her perspective, life among the powerful elites is seemingly not as tranquil as Brooks (2001) and others who write about Millennials would describe it.

Thomas: A Millennial Intellectual

> I don't see myself as a shape-shifting portfolio person . . . I don't know, in some respects I guess it fits [me]. . . . Building up your resumé. . . I don't do that . . . I make a good conscious effort to stay away from [doing that]. . .'Cause you see, you see a lot of people today are, they're intent on finding the most programs and not how can I better myself? [but] how can I make myself look better?

Thomas, a white 18-year-old Millennial, made these comments to me (Josephine) after reading Gee's chapter (this volume). He denied shape-shifting for the sole purpose of being recognized as a certain kind of person. If he shape-shifts, he believes, it is to become a better person. My portrait of Thomas describes the young man he is becoming, a man of strength, integrity, self-control, and self-determination. A man like his father, only different. Thomas wants to enjoy his work (something he assumes his father does not do), and he thinks that several careers over his life may be a good idea, as long as he is happy. Like Katie, happiness and success are more important to Thomas than money. Thomas's portfolio contains remnants of the boy he was and the young man he is becoming. My portrait of his portfolio building and shape-shifting is pieced together from data—transcripts of interviews with him, his mother, and his humanities teacher—collected for a research project on boys and literacy (Young, Hardenbrook, Esch, & Hanson, 2001).

Thomas's Portfolio: Artifacts of Literacy

At the time of this writing, Thomas lived with his parents and 14-year-old brother in a middle- to upper-middle-class neighborhood in Phoenix, Arizona. He planned to attend honors college at Arizona State University in the fall where he expected to be challenged and to use the literacy skills acquired in school. Literacy (especially reading) is life to Thomas; he cannot imagine his world without it. Reading provides him entertainment, knowledge, information, and insights into the social world and the man he will become. His family continues to play an important role in his love for literacy. His mother read to him when he was young, his parents continue to have interesting and stimulating discussions with him about books, and they provide him access to written and digital texts. Thomas has a computer and a hookup to the Internet in his room, and he goes regularly to the local library and bookstores. Thomas's eyes light up when he talks about his favorite books, and he always seems to have one with him. In fact, at the time of one of my interviews with Thomas, he was reading four books—a science fiction book, a horror book, an inspirational book, and a popular non-fiction book. I suppose, if Thomas's portfolio were as tangible as Katie's, it would contain lots of books and other print and electronic texts.

He would also include the television show *Sesame Street* in his portfolio. Thomas credits *Sesame Street* for teaching him to read before he went to kindergarten. He fondly recalls episodes of the "old" *Sesame Street* and admits to occasionally turning on the "new" *Sesame Street*. He believes that *Sesame Street* is still important today because it teaches you the skills you need for reading—skills necessary for access to the plethora of information available. His devotion to *Sesame Street* is in keeping with his love for reading and his belief that his economic well-being is dependent upon education, which in turn is dependent upon intelligence and good literacy skills.

Like other Millennial youth, Thomas values his parents' interests, opinions, and knowledge. For example, he credits his mother for instilling within him an appreciation of live theater performances—something he sees as helping him to develop

an appreciation of drama as a means of making meaning through what he calls "mental and whole brain comprehension." He continues to find discussions with his father an important part of his life. This was especially evident when he gave a copy of the book *Atlas Shrugged* (Rand, 1957/1985) to his father so that he could discuss it with him. Thomas read *Atlas Shrugged* for the first time in 10th grade. Now as a recent high school graduate, he has read it three times, believing that it helps him to understand himself and become a happier, better person. A long-time friend recommended the book to him, and she reread it with Thomas. She, Thomas, and another friend continue to reread sections from *Atlas Shrugged* and to discuss Ayn Rand's theory of objectivism, a theory that considers reality to be objective and supportive of the rational self, self-interest, and capitalism above all else.

Artifacts from School

Thomas entered school as a reader and continues to mature as such. Apart from a few years in a gifted elementary classroom, Thomas found his early schooling to be a waste of time. High school, however, was a bit different. School-related reading and assignments finally began to challenge his thinking and he became interested in the curriculum. He enrolled in all honors courses and received college credit for many of them, thus enabling him to begin college with enough credits to be considered at least a sophomore. In high school, Thomas's tendency to raise his hand or shout out answers in class made him, in his words, "kind of the answer man." It also positioned him as a good student who was rarely wrong. He suspected that this annoyed some of his classmates, but he said he found the courses so interesting that he could not help himself.

In addition to preparing Thomas for an elite college education and positioning as a good student, Thomas's decision to enroll in all honors courses limited his access to male peers and all-male social groups. Following the national trend (Howe & Strauss, 2000), the majority of students in the honors courses Thomas attended were female. This was true in all his classes, including physics and calculus. According to Thomas, it was not considered cool to be male and smart; it was more acceptable for guys to play sports, take weight-lifting classes, and do just what you had to do to get by. Taking honors courses also positioned him as an intellectual among his peers. For instance, a popular male athlete who (unwillingly) was enrolled in Thomas's honors humanities class described Thomas as "a great thinker" and told me he appreciated the way Thomas interacted with the teacher and the other students.

Artifacts of Sports and Shape Shifting

Thomas's portfolio also contains artifacts from his past accomplishments as a competitive swimmer. Around third grade, he practiced swimming everyday year-round. He continued to swim on a club team throughout middle school and saw himself as a "real sports guy." He made good showings at club swim meets during his middle school years, and his coaches began to view him as college scholarship material

and as an Olympic hopeful. He quit the club team after his freshman year of competition as a high school varsity swim team member. Club practice and high school practice took too much time away from reading and studying. He swam one more year on the high school varsity team, ran track, and was awarded a scholar athlete letter, an award given only to those who participated in two varsity sports and maintained at least a 3.8 grade point average. Then he quit sports altogether in his junior year in order to devote more time to preparing himself for college and exploring the nature of reality and life. Several courses—physics, interdisciplinary studies, and humanities—aided his explorations, as did his reading and rereading of *Atlas Shrugged*.

Thomas consciously shape-shifted his identity from scholar-athlete to young intellectual in high school. As school became more important and stimulating to him, participation in team sports was no longer needed or desired. He quit sports and joined the academic decathlon team. He relished the challenge and intellectual stimulation of preparing for the yearly academic competition. Membership on the decathlon team was a visible marker of his intellectual prowess.

Although Thomas did not see himself as a shape-shifting portfolio person, he made decisions and choices that influenced his developing identity and portfolio. For example, he chose to read and engage in many different kinds of texts, most of which provided tools for his quest for knowledge and self-discovery. In his words, he used these texts "to expand my mind, to learn about the world and the kind of decisions I will need to make, ah, to ah, stay sane." Moreover, his decision to take honors courses positioned him as a good student and aligned him with the admission standards of prestigious colleges.

Another decision Thomas made was to read *Atlas Shrugged* (Rand, 1957/1985) with his friends. This book, with its emphasis on objectivism, has had a profound effect on his developing philosophy of life and the choices he is currently making. For example, it influenced his desire to "make Thomas a finished product" and to codify his beliefs. Thomas's experiences with this book and objectivism, in conjunction with the common belief among Millennials that education is the key to success (Gee, this volume), facilitated his acceptance of the twin notions that the broadening gap between rich and poor is natural and that everyone can succeed if they work hard. As a white middle-class male who has never experienced economic hardship, Thomas finds it easy to believe in the ideals of education, literacy, and hard work.

"I'm Not White": The Case of Mario, A Different Kind of Shape-Shifting Portfolio Youth

In this case, I (Elizabeth) represent what I know about the life of a 12-year-old Latino named Mario, a young man whom I view as building a portfolio that allows him to do a number of different things in the world. He is, like many of the Millennial kids described in the works we refer to throughout this chapter, shape-shifting.

However, Mario's portfolio is built around resources different from those described in Gee's chapter (this volume) or in the two previous portraits, primarily because Mario comes from a social and economic space that is vastly different from any of those previously described. What's more, Mario's goals for his shape-shifting seem quite different from the goals ascribed to Millennial kids in the current literature because, as we argued earlier, the descriptions of Millennial kids are either too partial (focused only on youth of the upper middle classes) or too sweeping (generalizing middle- and upper-middle-class value systems to all youth, regardless of social and economic position). And that is precisely the reason that we include Mario's story in this chapter.

I hope to push a bit the portrait of Millennial youth, and in so doing, demand that poor youth of color get paid attention as we think about what it means to live and use literacy and language in a global and digital world. And so, I present the case of Mario, drawn from interview and observational data I collected over the last year and situated in an ongoing ethnography that has been in progress in Mario's predominantly Latino/a community for the last three years (Moje, 2001).

Mario's Existing Portfolio

Mario came to the United States from Mexico when he was 8 years old (at this writing he is 13 years old and is finishing seventh grade). Although Mario *could* call himself Mexicano, he identifies himself as Mexican. He attends a two-way bilingual immersion school of choice that is part of a large urban public school system, and he lives in an area of a large Midwestern city that can be described as both decimated and thriving. As one drives through the community, one sees block after block of abandoned and burned-out buildings; warehouses, train, and truck yards; and heavy industry. The air and water quality in the community is poor.

At the same time, the area can be described as thriving because it includes a popular tourist center called Mexicantown, which is flanked by small businesses, services, and libraries. Young children and older youth play in the streets or speed around the neighborhoods on bikes. Festivals are routinely advertised in local parks or churches. A Catholic church hosts theater, dance, and art courses. People sit on front porches, talk to each other in the streets, and attend quinceaneras (15th birthday celebrations for young women) and first communions.

Mario does not live in poverty, in the sense that he has food to eat, clothes, and books for school, but, unlike a typically described Millennial kid, the money that Mario's family earns comes from working long hours at manual labor. Mario and his friends claim that their parents typically work 60–70 hours per week. Indeed, Mario says that he, too, works at times 70 hours per week, despite child labor laws that restrict work hours to 12 hours per week when in school and 40 hours per week in the summer months. Long hours of construction work are a necessary part of Mario's portfolio, which takes Mario away from the popular culture and digital world portfolio-building that Gee (this volume) and others describe.

Soccer playing is part of Mario's portfolio (his career goal is to be a professional soccer player, a goal that does not include college attendance and is not particularly dependent on the U.S. social or economic system). His goal to play soccer is obviously fed by his love of and prowess with the sport, but it is also interwoven with his love of "things Mexican" and his desire to build a portfolio that identifies him as a Mexican. Following that goal, Mario includes in his portfolio a love of traditional Mexican music, such as mariachi, participation in Mexican festivals and traditions in the community, and the flying or wearing of the Mexican flag on every possible occasion.

At the same time, however, Mario's portfolio also includes elements commonly associated with youth culture in general. For example, like many male youth, Mario is intensely interested in cultivating romantic relationships with young women. He also dresses like a "gangsta" as much as he can in school (where they wear uniforms). He and his friends tell me that "we aren't gangsters, we are good boys." And yet they dress in styles that allow them to affiliate with gangs in the urban neighborhoods around their homes, thus building portfolios that allow them to shape-shift from school to work to street.

Role of Language and Literacy in Mario's Shape-Shifting

Mario's shape-shifting could perhaps more accurately be labeled "shape maintaining." That is, Mario's goal is to shift *back* to a strong Mexican identity. He cares about grades and learning at some level, but he is mainly focused on recapturing and building a Mexican identity. His most explicit and obvious tool for such shape-shifting is his language practice.

Mario is bilingual and biliterate; his dominant language is Spanish, but his reading and writing in English are strong. Thus, in many ways, Mario has a diverse portfolio, one that could take him far in a fast capitalist and global world, where bilingualism can be a resource. However, despite the obvious strengths of a portfolio that displays facility with multiple languages, Mario's emphasis on maintaining his Spanish is less about building a portfolio that will take him far in a global economy, and more about building a portfolio that identifies him as Latino—and Mexican, in particular—and that will allow him to return to Mexico one day.

Although Mario is bilingual and biliterate, he says that he is "losing a lot of his Spanish," and he is actively working to maintain his Spanish because he "wants to go back to Mexico to live someday." In one interview, when assured that he sounded quite fluent, he shook his head and muttered "No, no." He then explained that he speaks Spanish at home with his parents, but feels pressure to speak English in school, where teachers and administrators feel equally pressured to prepare middle school students for the public high schools that do not provide support for second-language speakers. Thus, even in an English-dominant space, Mario works to build a portfolio and to shape an identity that emphasizes Spanish language and things Mexican. On the school's Career Day, for example, a day set aside for helping young people think about the portfolios they should be building,

Mario stopped the first speaker, a Latino clinical psychologist, to say, "You can speak Spanish, can't you?"

Speaker: *Si*.

Mario: Well speak it then!

Such an interaction is not an isolated occurrence in Mario's portfolio-building. In *every* instance I have witnessed of Mario interacting with other Latino/as (nine instances to date), he has requested that the speaker use Spanish, and he always speaks to his Spanish-speaking friends in Spanish. What's more, he and his friends mock other Latino/a students for their inability to speak Spanish (although they do not mock my feeble attempts). Mario's demand for Spanish is not driven by a weakness in English. In fact, Mario seems to thrive on speaking Spanish, perhaps as a tool of identity representation or as a way of building affinity groups (Gee, in press).

Mario is building a portfolio and shape-shifting in ways that stand in sharp contrast to Katie and Thomas. Although Mario does buy into dominant mainstream norms for getting ahead, he does not play by the rules, at least not the rules of the dominant group. Despite his concern with classroom activities that "count" in terms of grades (a concern that echoes that of "typical" Millennials), he does not perform at high academic levels. His low performance stems from challenges in his personal life; his extensive work commitments; his career and life goals; and his resistance to mainstream, Anglo expectations and rules for success. He is courteous, generally kind, and pleasant, much like the Millennial kids described by Howe and Strauss (2000), but his portfolio is built with the goal of maintaining his cultural identity.

To say that Mario's shape-shifting is geared toward protecting and enhancing his Mexican identity does not suggest, however, wearing "bright colors" or singing "upbeat Latin rhythms" (Howe & Strauss, 2000, p. 17). Instead, Mario's focus on Mexican identity routinely emphasizes racism or oppression of Latino/as. In the following excerpt from Mario's language arts class, for example, the teacher has asked students to read a chronology of the African slave trade. The chronology is written simply as a time line, which the teacher uses to start a discussion about exploitation by asking students to explain what's going on in the time line. One student answers that the Africans were unfairly put to work, and then adds, "they didn't do nothing wrong." Mario then responds,

> Because they think just because they are colored, you know, like Black people, and they just think because they're colored different, they start doing bad things to them and they put 'em to work, you know and they . . . [Mario continues to talk but his words are indistinguishable under the teacher's overlapping question].

When the teacher asked what the slave traders valued, Mario (and another student) chorused, "Colors." A bit later, when the teacher asked the class whether the push for equal rights was just for African Americans and whites, Mario called out, "For Hispanics!" He paused, held up his arm, looked at it deliberately and said,

"*I'm* not white." Mario's comments express his interest in how color and ethnicity shape one's experience in this country. He also routinely identified himself as outside the dominant group, which exploits, and within the group that stands to be exploited, as evidenced by repeated comments about the immigration and deportation of Latino/as to the United States.

Mario's practice of interpreting texts in terms of racism is not always supported by his teachers. When Mario remarked, "I'm not white," upon looking at his own skin, his teacher responded, "I don't want to hear any more comments from you today, Mario. Thank you." Mario's resistance to playing by the rules of interpreting texts in school often marks his portfolio—and him—as at the margins of what counts as an academically successful portfolio. Moreover, school-based literacy practices such as the reading and interpretation of novels or textbooks are not as high on Mario's list of important texts and practices as are texts that further develop his understanding of himself as a Mexican (e.g., *Lowrider Magazine*). Thus, while literacy and language are important aspects of Mario's portfolio, they are also aspects that cast his portfolio to the margins in mainstream society.

The Role of Family and Community in Shape-Shifting

Mario's family and community play a critical role in his desire to shape-shift to what he sees as a more Mexican identity, an identity that maintains the practices of his family and larger ethnic community. Mario is not alone in this desire. Although most of his peers are not actively building portfolios that put forward a singular ethnic identity, all whom I've interviewed acknowledge the importance and value of their Latino/a identity as part of their hybrid and fluid sense of selves. They seek to maintain family and cultural values and practices, rather than to dismiss or background such values in the ways often necessary for "shape-shifting."

In addition, the physical and material space of the city plays a role in Mario's shape-shifting and portfolio-building. Maintaining a strong Mexican identity gives him a voice and makes him visible in a vast, impersonal, impoverished and polluted city space where he is not routinely seen, heard, or valued. Such an identity provides a positive sense of belonging for Mario. Whereas elite Millennials might be seen as shape-shifting to belong to and maintain memberships in elite groups—groups that can transcend geographic spaces with the click of a mouse or the swipe of a credit card—poor Millennials might be seen as working to belong to cultural and ethnic affinity groups because the elite group seems so far out of their reach or because the alternative—affiliating around poverty—is not particularly appealing.

The Role of Economies and Globalism in Shape-Shifting

Mario and his peers can be said to have *transnational* lives and identities. Many of them spend significant portions of their year—particularly the summer months—in Mexico, and most of them refer to their "homes" in Mexico. Thus, the youth in Mario's community identify with more than one social and economic space, and

such identifications shape the portfolios they want to build. In many ways, Millennials, such as Katie and Thomas and those described in other writings, appear to be focused on building portfolios that make them different from—perhaps *better than*, in their minds—their parents, families, and peers. In contrast, Mario's peers seem focused on building portfolios that maintain identities as they move back and forth from one community to another.

This focus on maintaining ethnic, cultural, or racialized identities may stem, in part, from the way skin color and ethnicity are viewed in U.S. society. For white Millennials, color and ethnicity are "invisible" aspects of their portfolios; for Millennials of color, their color and ethnicity are always present, providing them opportunities to shape-shift only so far in a context that values whiteness. Thus, their portfolios provide poor Millennials of color access only to certain positionalities in U.S. society, especially as they compete for positions with Millennials like Katie and Thomas. The portfolios of the poor Millennial youth of color whom I describe here, while strong in terms of maintaining cultural, linguistic, and social practices, may serve to limit their abilities to navigate broad social, cultural, political, and economic spaces. But any limitations we observe must be viewed as a function of a sociopolitical and economic context that constrains the shape-shifting possibilities of such youth—because of their color, ethnicity, and social class—even before their portfolios are built.

Concluding Thoughts

In our portraits we described three Millennial youths and their shape-shifting portfolios. In all three cases, the youth made decisions about which practices and experiences they wished to participate in and produced rich, meaningful portfolios, ones that are specific to their goals, values, and resources. Each portfolio is different and each youth shape-shifts for different reasons in different social contexts. What's more, each social context must be understood within the context of new capitalism. In new capitalism, "products and services are created, perfected, and changed at ever faster rates" (Gee, 1999b, p. 46) and networking and collaborating are essential to the financial success of companies. People must be able to shape-shift their portfolios to represent the kind of person needed and desired in the ever-changing, fast-paced workplace of new capitalism. Those who shape-shift become executives and part of a new overclass. Those who do not, become workers and members of the underclass. Within this scenario, class differences are directly related to one's ability to shape-shift, a skill that is linked to one's educational experiences, opportunities, and achievements (Gee, this volume). Those best prepared to shape-shift will probably have attended elite colleges and universities and have had access to technical, educational, and economic resources needed to build competitive portfolios (Brooks, 2000; Howe & Strauss 2000). These portfolios, tangible or intangible, are more than a set of artifacts that represent the credentials of an individual. In new capitalism, they are also symbolic of a person's identities

and represent the culture, beliefs, values and ways of being, thinking, acting, dressing, reading, and writing of that person.

What Do We Know about Katie, Thomas, and Mario?

Our analysis of Katie's portfolio and her responses to Deborah's inquiry lead us to believe that she shape-shifts intentionally. Her shape-shifting is driven by her economic goals as well as her desire to be ethical and moral. Her portfolio reflects the experiences that she values and believes will facilitate her later success. This includes financial as well as moral and ethical success. She sees her portfolio as a tangible, focused, purposeful, ever-changing (shifting) way to showcase her talents and credentials. Moreover, it is a tool for her. For example, Katie was offered a summer internship after sharing the contents of her shape-shifted portfolio with the agency that hired her. She tailored the contents of the portfolio to gain access to this internship, which in the end will give her another experience to add to her portfolio and help her achieve her desired long-term goal—a career in law or bioethics. Katie epitomizes the elite and the future overclass described by Brooks (2000) and Howe and Strauss (2000) and sees herself in entrepreneurial terms. Her parents had the means to help support Katie's endeavors to build her portfolio and achieve the goal of attending Columbia University—financially and emotionally—and she has become quite sophisticated in her shape-shafting skills.

Thomas rejects the notion of shape-shifting for the specific purpose of looking like a certain kind of person and building a resume. He instead shape-shifts to understand an objective reality and to find happiness and his true self. He does not carry his portfolio around. It is not as tangible as Katie's, but it is representative of his strong desire to develop a consistent life philosophy—one that resonates with the man he is becoming. As a white middle-class male, Thomas has access to educational, technological, social, and economic resources necessary to build a competitive portfolio in new capitalism, but he appears to have dropped out of the game, at least temporarily. Oddly, he will continue to accrue resources for his portfolio during his college experience whether he means to or not. The consequences of Thomas's shape-shifting thus far are yet to be determined, but they look like decisions that would make him successful within the old capitalism where individual expertise was valued over collaborative knowledge. Like Katie, Thomas's parents provided him with access to the experiences and opportunities that he needed to build a shape-shifting portfolio. Unlike Katie, Thomas is searching for his single, true identity, one that may be difficult to shape-shift in the fast capitalist society in which he lives.

Mario's shape-shifting portfolio, unlike those of Katie and Thomas, happens within the life of the working poor. His portfolio is not completely tangible, but represents his thoughtful choices and attempts to maintain his cultural identity as a Mexican living in the United States. His shape-shifting is purposefully done to facilitate his success in either the United States or Mexico. He works less to change himself into someone who can compete in a new economy and more to maintain

an identity that he fears losing. Consequently, while he wears a school uniform (adorned as much as possible with gangster codes) and is, for the most part, respectful and polite to adults, he does not play by the rules, at least not the rules of mainstream spaces. In an environment where English is encouraged, he uses as much Spanish as possible. Computers are for Mario a school-based tool—he does not have the time nor the inclination to spend out-of-school hours surfing the web. Mario represents a Millennial youth who is strategic about his portfolio and his identity, but his strategy is not one that fits neatly into the fast capitalistic enterprise. Indeed, his strategy embodies a sense of collective struggle against oppression, racism, and othering, and by engaging in such a struggle, Mario—whether or not conscious of the outcomes of his actions—rejects much of what counts as success in U.S. social, educational, and economic systems.

What Did We Learn about Teaching Literacy from Our Millennial Portraits?

The portraits of Katie, Thomas, and Mario provide us insight into the process of portfolio-building and shifting. They also illustrate the differences among these three youths, differences shaped by race and ethnicity, social class, geographic and social space, and gender. These portraits are important because they challenge journalistic images of youth that are too generalized and too global. They highlight for us the importance of not defining a whole generation simply by the things some middle- to upper-middle-class kids (like Katie) are doing. If we do that, then we exclude the majority of youth that we teach. For example, we exclude students like Katie who share some of the characteristics of the Millennials described by Howe and Strauss (2000), but goes beyond these descriptions in her critique of the actions taken by herself and other elites, and her struggles with moral and social responsibility juxtaposed with economic goals. We also exclude students like Thomas who have taken all the right classes and acquired a collection of experiences and achievements but have decided not to participate in shape-shifting practices for economic gain (although he is prepared to do so). Finally, we exclude Mario, who shape-shifts—but not for the same purposes as kids like Katie. Mario and, we daresay, other poor kids of color, are constructing portfolios and trying to do the "right" things to be accepted in their communities, but what counts as right may be very different (e.g., maintaining cultural heritage, affiliating oneself with street gangs, resisting school practices). Their portfolios, however, will only in rare cases get them into elite colleges where they will acquire the education and experiences needed to be in the overclass.

So what is our responsibility as literacy teachers of "kids these days"—changing kids who live in a changing world? How do we teach kids who are from economically, socially, and educationally diverse backgrounds? Kids who follow rules in school? Kids who resist the rules? Kids who do school because it is good for them? Kids from immigrant, poor, or rich families? Kids who use literacy as a tool? Kids who think of literacy as life? Kids who fight to keep themselves biliterate? Perhaps one of the most striking lessons learned from this account of three

different Millennials is that despite their individual differences and their social contexts, the consequences of their practices are similar when situated in a fast capitalistic, digital, and global world. All three youths are engaged in portfolio-building and shape-shifting (whether to build new identities or regain ones lost). They all use the resources available to them to build their portfolios. They all recognize that rules exist and that mainstream views of success depend on playing by the rules of those in power. But all three youths do not play by those rules. Neither do they share the same resources.

Thus, broad characterizations of how youth make sense of, and succeed in, changing social, economic, and political structures are useful only insofar as we simultaneously examine how different youth interpret those structures and engage in social practices in relation to the communities, families, and economies in which they live. What's more, once we have both global and individual portraits of Millennial youth, it is then important to ask what it means to be successful among these youth. We know that Katie's and Thomas's portfolios will facilitate their movement into the overclass, whereas Mario's portfolio is not likely to do the same for him. By what or whose standard is success measured? What role do literacy, language, and culture play in both supporting and determining success?

These are the questions that we believe teachers of all types of Millennials must grapple with as they think about constructing or choosing from literacy pedagogy and curricula in secondary school settings. What does it mean to be successful in a digital and global world? How far can one's individual definition of success take him or her? How much should we honor those definitions as we engage students in literacy and language education? Should we, for example, help Katie build her shrine? Or should we engage her in critical literacy practices that ask her to challenge the rules a bit? Perhaps we should push Thomas to "play the game" a bit more, and to move beyond his self-expressive portfolio to one that examines how the self is situated in a larger social arena. Or we could demand that Mario focus on improving his English so that he can be successful during his English-only high school years. We could introduce him to more and more digital experiences to make up for the dearth of those experiences in his out-of-school life. In other words, one lesson to learn from individual portraits of Millennial kids is that kids have much to teach us and each other.

In fact, what we have realized from studying these youth closely is that we, too, are shape-shifters and portfolio-builders. Indeed, we would argue that the social and literate practices we have documented here are less about youth themselves and more about the *times* in which we all are living. These new times are times of information density, rapid change, and fragmentation of identities and "shapes." These changes, according to Lankshear and Knobel (this volume), contribute to increased demands for our attention and to our need to keep the attention of others. These are times of high stakes, times when teachers, youth, parents, and researchers must constantly prove themselves. All of us—youths, teachers, parents, and researchers—are building portfolios in new times, and we are using new or reconstituted literacies to craft these portfolios and to shape-shift. Teachers quite

literally are routinely asked to build portfolios that document their prowess in meeting accountability standards, and some of these portfolios require sophisticated digital literacies (e.g., INTASC, 2001; Lehman & O'Brien, 2001). Whether teachers, researchers, or parents, we can analyze our own shape-shifting, as well as the demands placed on each of us to learn new literacy practices in a digital and global world (e.g., learning how to use the tracking feature of word processing programs, rather than using our beloved red pencils as we write collaboratively). Such analyses of our own shape-shifting could represent an important first step in thinking about what we need to teach youth, youth who will continue to move in and through even newer times in this millennium.

By situating the phenomena of shape-shifting and portfolio-building squarely in the high stakes of new times, we are reminded that regardless of individual differences among Millennial youth, economic, social, and political realities play an important part in how youths define who they are and who they want to be. How new times and attention economies are constructed depends on the social, political, and economic spaces to which one has access. Literacy teaching in secondary schools, then, should not only help youth learn how to build portfolios that help them achieve their goals, but also how to examine their goals and navigate the different discursive practices, material conditions, and social spaces of their lives.

Carmen Luke

RE-CRAFTING MEDIA AND
ICT LITERACIES

Media studies or media literacy studies traditionally have been the domain of English and language arts classrooms. Cultural studies has not made significant inroads into school-based media studies although, like media studies, it too is concerned with the politics of image/text representations. Computer studies have focused principally on the teaching of operational "how-to" skills, and communications technology studies are generally absent from the curriculum or else tucked away as a unit of study within the social studies curriculum. Computer education, widely used as an umbrella term, tends to encompass with varying levels of curricular focus the teaching of computer skills and the study of computers as information and communication technologies (ICT). Given the current drift toward media convergence, it is my contention that media studies, cultural studies, and computer and technology studies can no longer be taught independently of each other. Moreover, the fervor with which computer education has been embraced, and the relatively modest incursions media and cultural studies have made into mainstream curricula, suggests that the blending of media/cultural studies with computer, information, and communication technology studies can inject new life, as it were, into both fields of study. Information technologies (IT) education can benefit from the theoretical and critically analytic orientation of media/cultural studies which, in turn, can be "mainstreamed" through broader exposure typical of computer education in schools today.

It has been widely argued that book-based print literacy, and industrial model schooling built around book culture, is no longer adequate in today's changing information, social, and cultural environment. Importantly, in light of the accelerated shift toward electronically mediated communication and social exchange in

almost every facet of everyday life, the need for an expanded form of literacy, one that takes account of today's diversity of information modalities and media, is more crucial than ever. Media studies must contend with new information technologies, and computer education needs the critical analytic tools and cultural framing approach typical of media studies.

Media and Computer Literacy

Media studies focuses on the critical deconstruction of media texts such as print and imagery in popular magazines, TV programs and advertising, movies, billboards, and related forms of media representations. The usual focus is on the study of genre, narrative structures, persuasive appeals, medium-specific production features, and semiotic analyses of imagery . Whereas media studies focuses on text-imagery, cultural studies focuses on the cultural representational context and social uptake of those texts. A less common adjunct to media studies, cultural studies also focuses on the study of youth and/or viewer-reader cultures that form around popular cultural and mass media texts (e.g., music, daytime or prime-time soap fans, Barney or Barbie groupies, or Sesame Street play groups). Cultural studies extends to analysis of childhood and youth subcultural style and taste, the semiotics of identity construction through in-group behaviors, attitudes, style of dress, and so on.

In the 1980s, cultural and media studies focused heavily on "critique"—both of texts and the cultures that form around them. In the 1990s, principally through the work of British media studies scholars this disciplinary focus on students' "self-critique" was abandoned in favor of analysis of the politics of pleasure, and a focus on production (of media texts) rather than a sole focus on deconstruction. Rather than getting students to critique the very texts and images that they like and from which they derive a fair amount of pleasure, this shift toward encouraging students (and teachers) to reflect on what kinds of pleasure people derive from various media forms and texts enabled a move toward problematising the "politics of location": that is, providing students the critical analytic tools with which to understand readers'/viewers' diversity of reading positions and socio-cultural locations and differences that variously influence "affinities" or preferences for (and pleasures derived from) particular kinds of media forms and messages.

This shift was a useful corrective to the sorts of "ideology critique" underpinning 1970s and 1980s media studies, which assumed that students were "duped" consumers of mass culture, unable to read "through" and "between" the lines. Teachers, however, were assumed capable of rescuing students from "naïve readings" by providing them with an analytic tool box that would produce ideologically correct and teacher-preferred text meanings and interpretations. In this model, students ended up providing critical work in line with what "the teacher

wanted" thereby circumventing any engagement with the politics of situated readings, the messy issues of pleasure, or student-authored media productions.

In contrast to media studies or media literacy, computer studies (or what passes as computer literacy) have been implemented rather quickly over the last decade, across the middle and senior years, and with relatively little teacher or parent resistance. If anything, we have witnessed a tidal wave of financial and "in principle" support from federal and state governments for successive initiatives: in the 1980s, to put a computer in every classroom; in the early 1990s, to put a computer on every child's desk; and by the mid-1990s, to have every classroom wired and every computer network capable.

Underscoring this IT push, intense pressure has come from parents who are increasingly vocal in their demands for schools to make students computer literate in light of the heavily promoted millennial visions of the new techno-literate citizen of the 21st century. Schools and communities have jumped on the IT bandwagon in the rush to "teach computers." In efforts to make students functional front-end users, most computer education or literacy instruction focuses on core skills such as the basics of keyboarding, file management, text and spreadsheet processing, CD-ROM and internet navigation, some hardware maintenance and trouble-shooting skills, web page construction, and so on. In short, although calibrated to students' grade/age levels, most computer instruction is about the teaching of operational skills. A critical contextual dimension is by and large absent.

What might such a critical orientation entail? It would require that teachers engage students in critical and thoughtful discussions and analyses of issues of equity and access. Who has access, who doesn't, and why? What are the implications of the emergence of new virtual identities and communities and issues of "authentic" or "masquerade" identity? What issues are involved in web authorship, censorship, or information ownership? What might global electronic communities suggest for intercultural communication? What does connectivity and interactivity of ICTs mean for changes in learning and teaching, changing teacher and student roles, and challenges to industrial model schooling more generally? In the study of web-based information sources, students are generally not directed to ask the "critical" questions: Whose interests are being served through what means and toward what ends? Can we trust this information? Why? Applying the tools of media analysis to internet information, students might consider:

- How are persuasive appeals, promises, or other signifiers of "trustworthiness" used to secure our trust and attention and engagement with a particular site?
- How does this site (or CD) reveal a gender, class, cultural, or age bias?
- How are semiotic features used to construct a particular information environment? Which semiotic devices are used in which kinds of internet "genres"?
- Are there particular web site genres? If so, what are their distinguishing features?
- How are traditional narrative forms re-presented on-screen, or how are they reworked and hybridized with the new net lingo?

- How has email changed the protocol and structure of our communication?
- How has cybertextuality changed our language use?

There are many social, political, and cultural issues at stake in the "information revolution," including changes in language; communication structures and processes; and social relations, consequences of the shift from print to cybertextuality. These are crucial lessons for students—they are about a critical and self-reflexive analysis of the role of ICTs in society, how culture and social subjects shape and are shaped by technological change. And yet computer education is rooted in an operational skills orientation at the expense of what I consider a more critical orientation. By that I mean a metaknowledge of the sociocultural contexts in which ICTs are situated—contexts that already structure big parts of everyday experience, from activating ATMs to using email, from internet shopping or banking to video game playing or using electronic product info-seeks in supermarkets.

What Is Literacy in Media Literacy?

Media studies or "media literacy" have a relatively long history in Britain, Canada, and Australia compared to the United States. In Australia, the 1990s have seen a greater presence of media and cultural studies in the English and language arts classroom. However, Australian teachers' anecdotal reports and curriculum evidence suggest that media studies still tend to be seen as an "add-on" unit to more mainstream literary content, or as a remedial strategy to capture those "reluctant readers" or "at-risk" students for whom traditional literacy instruction has failed. Equally significant is the general failure of media studies to make any substantial inroads *across* the curriculum. For example, media analysis of textbook representations of science, scientists, or scientific discoveries is rare, as are analyses of how science is portrayed in TV news, documentaries, or movies. By extension, classroom study of how math or geometry is packaged for public consumption in, say, advertising, is equally rare. This disciplinary confinement of media literacy in the English/language arts curriculum means that the end product of media analysis commonly remains focused on getting students to produce "proper" written texts or "critiques" or else that staple of 1990s media studies—video production.

A lot of the debate around media literacy in the last 20 years has occurred concomitant with often-heated debate over what counts as literacy more generally. And just as there seems to be some tenuous consensus that literacy is a historically provisional construct, a dynamic and situated social practice, the very core tenets upon which this more critical and pragmatic definition of literacy rests is rattled by a tidal wave of change—the so-called information revolution or information age. I don't want to rehearse the drama of the IT revolution here, nor marshal the pro- and anti-technology scholarship debating "new" and "old" literacies. However, I would argue that in light of current technological change and the situational and

historical contingency of literacy, media literacy can no longer afford its exclusive focus on the study of traditional mass media—whether analysis of text-image systems, viewer ("fandom") communities and uptake, or political economy.

Video production is the common practical and creative component of a media studies syllabus, and while that is still a useful design and communications tool, more kids today probably have access to pre-installed computer proprietary design software than the old video tape recorder. We've all heard the stories or seen TV vignettes of cute four-year-olds building their own web sites. Can media literacy curricula ignore new media such as the world wide web, and can the construct of media literacy sustain itself—theoretically and pedagogically—by maintaining focus on traditional broadcast media and the 'traditional' consumer of those media? I think not.

Underpinning most media literacy debates over the last two decades have been notions of critical and selective viewing skills that would protect the young from unsavory media, principally televisual content. These debates were founded on the historical and technological omnipresence of mass media such as TV, movies, radio, music videos, and so on, which "broad"cast messages and ideologies for which audiences were seen to need critical tools of deconstruction and resistance. Today, however, new media have broken the tyranny of the passive viewer/listener/reader and media engagement has switched from passive receiver to interactive producer and designer. Computers have been in schools—with various levels of dissemination, use, infrastructure, and support—since the late 1980s, and kids have had increasing access to computers at school and at home. Changes in teaching to accommodate computers and connectivity—albeit uneven across and within schools—have exposed teachers and students to "new media," new ways of accessing and exchanging information, new pedagogies, and new problems. The new ICTs *are* media, and today they are no longer accessible only to a minority elite of computer specialists, techno-geeks, or academics.

And yet most media studies or media literacy scholars still seem to be hashing out issues or deliberating "productive" and "critical" practice in a world reminiscent of the early 1980s. With some exceptions, the complexity of all that is said to be "new" in new times—new media, new literacies, new knowledge configurations and workers, new (hyper)textualities, and so on—is not being tackled by media educators or scholars of media literacy. As Tom Callister puts it:

> The field of media literacy runs the risk of becoming a rarely traveled cul-de-sac on that information superhighway everyone keeps talking about. It runs the risk of remaining too narrowly defined, too restricted to the concern of video technologies, and too involved with the process of viewing as opposed to the process of search and communication in cyberspace. . . . [I]f media literacy is to contribute to the promotion of literacy for the "information" it will need to look ahead, developing and formulating the kinds of skills, abilities, and dispositions that will be educationally important for using newer technologies. (p. 417)

Given the rapid developments and dissemination of ICTs, media education

can no longer afford its narrow purview of the old tried and true strategies of text deconstruction based on old (broadcast) media. More importantly however, the future will undoubtedly be far more "determined" and mediated by a total digital data sphere than is currently predicted. Kids use media outside school and are often more "net savvy" than teachers. Indeed, the digital divide is as much about generational differences as it is about social class differences of access and participation (see Hinchman & Lalik, this volume; Lewis & Finders, this volume). Net radio and TV are already here. Media convergence and wireless applications and devices will shortly put all narrowcast and broadcast media in our palms where we select when, where, and what we want to access. Media-related skills are increasingly considered key qualifications for most jobs today. Moreover, media and ICT training is a billion-dollar business aimed at upgrading and updating workers in the spirit of "lifelong learning," which is seen to be so crucial in the "knowledge economy," the "learning society." Media literacy, then, narrowly conceived of as the study of leisure and entertainment media makes no sense at all in a rapidly changing socio-economic and technological context where private and public life is already a multimedia and multimodal information experience for most people in the over-developed and developing worlds.

This is not say that the critical study of linguistic and symbolic systems is obsolete. Quite the contrary; new media require as much if not more critical scrutiny in terms of how meaning is constructed in dramatically changing knowledge and information domains and configurations, who is involved in the production of meaning, how new electronically mediated communities of shared meaning are formed, and how traditional language and symbol systems are being reshaped and by whom. Indeed, reading and writing in both traditional print literacy and new linguistic-semiotic (iconic) symbol systems have increased exponentially in tandem with the mass diffusion of ICTs. If anything, ICTs have generated an explosion of writing—the biggest boom in letter writing since the 18th century. What many social and educational critics of IT repeatedly fail to acknowledge is that reading and writing have taken off in a big way since the advent of online computing, and diverse literacy practices are everywhere in evidence. It seems that there are far more questions to be asked of new ICTs than there are of radio, TV, and movies.

Computer Education

For the most part, the scholarly literature on computer education has done little more than provide a simplistic pedagogy of front-end user skills—a kind of "how-to" navigation license consisting of skill mastery of the most rudimentary keyboarding, text editing "cut and paste" and "save" skills, or the effective use of spreadsheets or web browsers. Where a "critical information literacy" component is present, it is usually no more than a desire for students to be able to recognize and utilize a range of data sources (data searching and collection), to incorporate

a range of multi-modal information sources into an assignment or project (design/production) or at best, to "critically evaluate" hypertext documents (critical literacy). This often means not much more than verifying a web page date of last updating, or noting the number of "hits" a page has received in a specified time frame. The more hits and the more recent the last updating of a web page, the more likely we can trust it to be "authentic," "reliable," and legitimate. Web page design—the strategic use of print, font selection, colors, imagery, sound, and graphics to shape a message system—is usually not addressed in computer literacy instruction. And yet, semiotic and representational decisions, or the central narratives—whether at nasa.com or gap.com—are as much an ideological cultural product governed by medium-specific rules and possibilities as is any TV program, ad, billboard, or movie. A whole new web- and software-based vocabulary has emerged which, in itself, constitutes new literacy practices and requires critical attention, whether one is engaged online or talking over coffee about bits or bytes, bauds or bots, squatters or sigfiles. I will return to issues of language change and changing literacy practices shortly.

Media and culture are inextricable. As the history of technological development and social uptake has taught us, cultural change is tied up with media of communication—from the clay tablet to the printing press to the telephone. Each new medium reshapes social behaviors and organization: for example, crowd management and seating to see the silent pictures; media fandom communities; TV as family time-patterning device; mass consumerism; online virtual communities and social relations. New media also reshape cultural values and, not least, cognitive activity. Learning in oral culture, in book-based culture, or in fully networked digital environments requires very different cognitive mapping and information-processing skills. Media education has been at the forefront of cultural analysis of (mass) media texts, industries, and consumers. Failure to home in on new ICTs with the same kind of critical scrutiny seems politically and pedagogically irresponsible, especially in light of the global, sociocultural, "textual," and representational changes wrought by new ICTs.

Multimedia, Multiliteracies

Media literacy has always meant much more than the ability to engage critically with media texts. It has also, at least since the late 1980s, meant providing students with learning environments within which to create, produce, and display their own media products. In resource-poor schools or districts, media production might mean a student-constructed montage of magazine clippings, photos, or drawings to convey a message targeted at an audience. In more affluent schools, photography, video production, or school magazines and radio stations have been the most popular expressions of production. Multimedia productions might take the form of video, photomontage, print text, in some cases art installations of live performances or tactile experience-based displays, and so forth. Media literacy has

thus gone beyond analysis and critique to include the production of meaning using a range of symbol systems and available media resources. In a multi-media computer based and online environment, however, the possibilities for combining a much greater range of media and modalities far outstrips the technical range and potential of video.

Many media educators have already moved the "production" component of media literacy studies to web-based work. Practical work (or project design) can include still or digital photographs, drawings, print and speech, sound effects, music, animation, movable graphics, video clips or "live" chat among a project's team members, and so on. Unlike video, the creative and design possibilities offered by innumerable authorware programs provide a much richer and denser semiotic environment in which students can combine multiple media and utilize multiple modalities of expression. Branching out into hypertext "production" and analysis of new media is not incompatible with core media literacy skills. However, as some educational scholars have argued for some time now, new media require new analytic and conceptual tools and new literacies. Today, most kids are already expert and literate in the *skills* of hypertext navigation and production, but not necessarily skilled in the tools for critical analysis.

Cultural analysis—from the study of popular culture, fandom, or advertising to political economy or the history of media and communications—can be applied to study the same categories in the cultures of the internet but augmented with new conceptual tools that can help students make sense of emergent cultural and political issues of net culture and new media. Such analyses would investigate hybrid textualities, language change, globalised "mediascapes," and "infoscapes," locally situated but globally connected classrooms or communities, the political economy of "ownership," "censorship," "privacy," and so on. In short, we should be getting students to ask the same questions of dot.com culture and cybertextuality as we have asked of broadcast or static print-based texts.

As a first step, we might begin with analyses of ICT representations in traditional media: How do traditional media representations (e.g., magazines, TV, newspapers) construct images of ICTs? How is age, social class, gender, or cultural diversity represented in association with ICT? What visions are produced of the techno-literate subject in a new wired and global culture? What lifestyle benefits are promised? How is information on technical specifications, peripherals, or costs backgrounded or foregrounded in TV or magazine ads? How do text-image binary oppositions, such as old/new, low tech/high tech, traditional/futuristic, and nature/science shape our understanding of consumer products and culture, but specifically our sense of the "brave new world" of the information revolution?

In one-way, old-style broadcast media, audiences had virtually no input in the design or transmission of content. Interactive media have changed that tyranny of the "dominant text." In that regard, we might ask: How is the social subject involved in the development of new media? That is, although we are all more or less hapless users of existing software protocols (and thereby of certain kinds of literacy and communication practices), the reworking of language-text-image and the

"architectural" and "semiotic" spaces of cyberspace have been ultimately the creative work of front-end users. The "grammar" of emoticons and acronyms is a case in point. Today most young people, as well as most adults, still straddle old and new media: a few hours of network or cable TV a day alongside a few hours on-line. We know the old broadcast genres well but are also familiar with the new genres of the internet. In that regard we are all experiencing a moment of hybridity, caught between the old and new in one of history's most dramatic communication revolutions. And so, students should question to what extent "traditional" categories, features, and genres of old broadcast media have been transposed to "new media"? How are they the same or different? Tracking language change across media is one good instructional example with which to teach concepts of cultural, language, technological, and social change.

We can investigate how quickly and subtly computing discourse has generated language change and infiltrated everyday language use. Acronyms (e.g., ftp, www, http, html, CD, RAM, ROM) have taken on the function of verbs and nouns. New words emerge (e.g., emoticon, hypertext, email, autobot), and old words are imbued with new meanings (e.g., boot, browse, button, flame, virus). Nouns have become verbs (e.g., fax, email); adjectives have become nouns (e.g., floppy from floppy disk); and verb phrases have sprung from nouns (e.g., word process from word processor). New blended terms have emerged (e.g., netiquette, netizen, hardcopy, up/download, cybernaut), not unlike a raft of new words that describe emergent hybrid genres of mass media (e.g., infomercial, docudrama, advertorial, dramedy, edutainment).

A search of internet-related citations in the *New Scientist*, the *Guardian*, and the *Observer* shows a remarkable take-off period from about 1995 that coincides with a decline in "error alerts" for internet-related words in software spell check programs (Shortis, 2000). Initial uses of hyphens (E-mail) and capitalization (World Wide Web, Internet, E-mail) are quickly disappearing alongside the elimination of quotes around words (e.g., "surf," "robots," "gigabyte") enlisted in cyberspeak. Old words used to describe new phenomena such as electronic mail have themselves undergone several linguistic transformations in only a few years. What started as "electronic mail" quickly changed to E-mail, then e-mail, and now email—used as both a noun and a verb. Linguistic hybrids reflect a merging of the language of ICT and the language of book culture: "click" or "scroll" have replaced "turn the page," and "bookmark" means putting an electronic marker where there is no "book." Web sites consist of "documents" or hypertext which consists of paperless "pages." We launch ourselves from our "desktop" with its array of neatly organized "files," "folders," "scissors and paste," and we use "binoculars" to help us find stuff, "trash bins" (or the more environmentally correct "recycle bins") to receive our garbage, and office assistants to sort out our mess.

The iconography of software—from scissors (cut) and wastepaper baskets (trash) to the Eudora email program's pop-up jester (incoming mail) or the file

folder (open/close file)—reflect distinctively Western cultural meanings and literate practices. Electronic reading and writing practices are framed within these meaning systems that suggest not only new symbolic languages (iconic grammars) but also potentially new forms of cultural imperialism. Issues of language change are also issues of cultural change. A critical media literacy goes beyond ideology critique of a text, a TV program, a software program, or web site to attend to these larger metadiscourses of historical change. Investigations into ICT imagery and metaphors, and the patterns of linguistic change linked to new and old media, can be fascinating projects for students that demand interdisciplinary thinking and linking: from history to science, technology to culture, linguistics to media. Such practical work provides insights into how the development and social uptake of ICTs is shaped by history, sociocultural contexts, and residual media of scribal-book culture.

From Production to Design

As I noted earlier, by the 1990s video production was the ultimate product of practical work. "Product," "produce," and "production" were terms loosely connected to "construct" and "construction"—partially influenced by constructivist theories of learning and pedagogy, poststructuralist theories of knowledge as social construct, and notions of collaborative or cooperative learning as befitting group project work. In turn, collaborative and constructivist theories of pedagogy and learning were dovetailing with emerging interest in problem-based learning (PBL). PBL is said to be more responsive to the diverse experiences and background knowledge of students, and thus able to provide "richer" and more "authentic" learning experiences that demand interdisciplinary thinking and learning. Together, collaborative, constructivist, and PBL constitute a powerful conceptual antidote to notions of knowledge as transmission, as *a priori* defined "fact" and "object." Instead, knowledge is seen as a process, as design, as contextual, situational, and contestable. That is to say, the formulation of a solution to a problem is necessarily a design process— a process of harnessing diverse knowledge "bits" into new relations in response to the situated context of a given problem.

That said, if we substitute "construction" for "production," and substitute "knowledge-as-design" for "knowledge-as-transmission" and discrete bits of object-level (and objective) "factoids," then conceptually we come much closer to describing people's actual everyday practices of meaning making and their engagements with knowledge. Knowledge as design implies, and much more adequately describes, the intrinsic relational aspects of knowledge, the mix-and-match characteristics of hybrid, intertextual, and multimodal knowledge and communication exchanges, and the inherent transformative nature of all knowledge as people apprehend, use, contest, or reproduce it in situated contexts. Deconstructing TV text in the classroom, producing the video or photomontage

for the practical media studies assignment, designing the school web page, or using the internet to gather resources for a project on wetland habitat preservation are all meaning making knowledge design activities. They draw on multimodal and multimedia literacy skills, on problem-solving skills, on the social skills necessary for cooperative and collaborative team-work, and on the critical literacy skills required for assessing, selecting, and rejecting information on the basis of group-negotiated criteria relevant to the problem and the situated community of practice-learners. As the New London Group (cited in Cope & Kalantzis) put it:

> In a profound sense, all meaning-making is Multimodal. All written text is also a process of Visual Design. Desktop publishing puts a new premium on Visual Design and spreads responsibility for the visual much more broadly than was the case when writing and page layout were separate trades. So, a school project can and should properly be evaluated on the basis of Visual as well as Linguistic Design, and their Multimodal relationships. To give another example, spoken language is a matter of Audio Design as much as it is a matter of Linguistic Design understood as grammatical relationships. . . .The concept of Design emphasizes the relationship between received modes of meaning (Available Designs); the transformation of these modes of meaning in their hybrid and intertextual use (Designing); and their subsequent to-be-received status (The Redesigned). (p. 29)

A conception of knowledge as design maps into old-style media education practical work and is indispensable to analytic and practical work in new media such as the internet. Moreover, an understanding of knowledge as design, as social construct situated within diverse communities of practice, is at the political and philosophical core of current critical scholarship in literacy education, which is fighting a rear-guard offensive against the backward slide into a uniform and static notion of "Three-Rs" literacy and standardized testing, which represents both a retreat from social justice commitments, and a resurrection of the myth of meritocracy. In other words, it is somewhat ironic and, not least, worrisome that at a time when media literacy is finally making some notable curricular inroads, there is renewed public and governmental energy and support for a return to basics, the elimination of all "frills" or "add-on" content areas such as media literacy or, for that matter, multicultural and anti-racist education. This historical juncture, then, at the level of technological change and educational politics, might well be the right moment to push for the integration of the principles and pedagogies of a reasonably well-established disciplinary and curricular area such as media literacy into or alongside computer literacy education. Reinvigorating media literacy education via the "backdoor" into computer literacy education has a good chance since computer literacy is widely (and blindly) accepted by parents, educators, and politicians as a 'must-have' core skill with which few have a problem of "relevance."

Designing Codes and Cues

Understanding how mass media texts construct meaning through editing and technical production features such as strategic use of camera angles, color, pacing, music, and so forth has been a staple of media education. Editing is meaning making through the manipulation of text-image, and it is fundamentally about design and designing—the intentional and careful crafting of a preferred meaning embedded in a "message system." Editing is a fundamental production skill and analytic component of any media literacy program. We teach students about various forms of framing, closure, and transitions: zooms, fades, dissolves, jump cuts, and so forth. Principles of textual framing apply to print literacy (e.g., opening sentence, transitions, linking ideas through collocations, summaries) as much as they do to hypertext (e.g., home page welcome mats, blue-lined hot links, end-of and top-of screen page icons or links).

In *Literacy Beyond the Book,* Nancy Kaplan makes the case for the limited design and editorial options available to authors of print text in contrast to the multiple design and editing options—indeed requirements—demanded of hypertext authors. She argues that the book, for instance, lends itself to a relatively limited set of design options: cover page and image, font style and size, pictures (color or black and white), page size, paper quality, and so forth, which are almost always decisions made by publishers. The core of meaning in a book resides in the printed, written word—the print-manifest fabrication of an author's imaginary world. Authors construct a preferred meaning logic; a sequential order of ideas, events, plot, or character development that almost always has to fit into the invariant order of the "the book" and a disciplinary genre. An author has virtually no control over the separation of text generated by a book's page-boundary requirements—an arbitrary in-production decision related to page size, typeface, headings, and so on. Yet in practice we know that a title or subtitle at the bottom of a print page is distracting, and we always put a chapter title or a subhead on a new page in order to create visual and conceptual units or chunks of meaning to enhance comprehension.

In Kaplan's view, "The decisions that determine the page boundaries not only affect how a story or an essay looks; they also form constituent parts of the work's design" (p. 221). The end of a printed page signals "turn the page," which Kaplan calls a "node," but it only leads to the next segment in a 'preordained sequence' of words, sentences, paragraphs, and chapters. An author of traditional print text designs and crafts only lexical choice and the sequence of words, sentences, paragraph chunks, and so on. An author of hypertext, however, designs the cues—the nodes and links, the jumping-off points or exits from the main "narrative." The way in which exit cues or links appear (underlined, colored font, icons, etc.), their location on a screen page, and the content of the next node to which a link leads are all knowledge design issues for which the hypertext author is responsible. Ultimately, they are design features that invite readers into a text-imagery zone where

choices other than "turn the page" are offered, and where multiple sequences and multiple knowledge nodes are available. In hypertext, elements of design and editorial framing are seen everywhere, according to Kaplan (2000):

> in the design of the hypertextual space, in the design of the interface, as well as in the designing of the prose style. Craft and artistry emerge in the design of this space, sculpted from the decisions writers make about the boundaries of nodes, the suggestiveness of link cues, and the patterns of links. Just as the negative space of graphic design and page layouts provides the ground for the work's figure, here gaps and fissures allow aspects of the author's invention to be perceived: they define the work of shaping. (pp. 229–230)

A print or video text relies on certain genre- and medium-specific editing codes to metacomment on or frame a text or a chunk of visual or print meaning. Camera angles and lighting, as we know, can set moods and code the same face or person as terrified and scared or happy and content, authoritative or diminutive. We teach students that it is not enough to identify the technical codes of a given print or audiovisual text; instead, it is necessary to identify the semantic cultural referents of technical editing as well as semiotic features. In simple terms: red may mean danger or passion; close-ups may mean intimacy and romance or exaggerate fear or connote authority; white may mean style, purity, or "class" in one cultural context or mourning and sadness in another context. After "decoding" the sociocultural referents suggested by the technical codes, we then expect students to pull the whole thing together by drawing links among the overt and covert meaning systems in order to map patterns, levels of meaning, regularities, and irregularities. Once students understand how orders of meaning are constructed, we can then show how a joke, or a satirical or ironic message is constructed, how stereotyping is encoded, and so on. The same principles, albeit of a different level of semantic and technical complexity, apply to hypertext designing. Discussing the work of the reader, Kaplan (2000) insists that:

> It is not enough to see only the nodes and the links connecting them, not enough to understand reading as merely a sequencing activity. Adding to the language codes we already know, hypertexts occur within and help construct their own semantic codes. Their rules may differ from those formulated by texts in print, but hypertexts also ask readers to dwell within some imaginary rules for a time. (p. 230)

The magazine or newspaper layout, music video or TV program, is self-contained, pre-edited and predetermined, a homogenous object loaded with codes that direct reader-viewers in certain ways (whether they follow preferred reading or interpretive paths is another matter). What is profoundly different and much more challenging for the hypertext author, reader-clicker, or cultural theorist is the "doubleness" of the entire pattern of link cues in a given hypertext document. The technical codes that editorialize print (the book, newspaper, magazine) or audio-

visual text (TV, movie, video clip) are inseparable from the main game—the main text, image, or idea. Hypertext links, on the other hand, are choices readers can either pursue or pass up. A link provides the transition from one element of the text's emerging meanings to another, but it is up to readers to choose which part of the author's design structure to follow or ignore. That is the "doubleness" Kaplan (2000) refers to: "the links taken and those passed by—brings a particular reading into being" (p. 227). I would argue that it brings a particular form of medium-specific literacy into being that is different from, but not that unlike, the 'grammar' and principles of design (re-editorializing through coding) with which we begin in the traditional media studies classroom.

Certainly, computer literacy education has failed to deal critically with these kinds of politics of meaning and politics of knowledge issues. These, I would argue, have profound implications for the reading process, reading positions, and readers' metacognitive or critical framing orientations on the one hand, and, on the other hand, implications for students' authorial, creative, and aesthetic voice and responsibility in the process of designing their "productions" with and in new media.

Ways Forward

The need to move beyond simple operational skills instruction of 1980s style "computer education" and for media literacy studies to move past traditional broadcast media analysis and production should be apparent. Today's generation of students from grade school to graduate school have long outgrown the labels of the Nintendo, TV, and even post-MTV generation. They have grown up with electronic toys, VCRs, first-generation computer games, Gameboy, and now Playstation 2. It is no longer sufficient to contain definitions of media literacy within old-style broadcast media. Instead, media educators ought to break out of the tried and tested certainties of old analytic tool boxes and provide students with the same kinds of critical, self-reflexive, and "productive" analytic tools we expected them to apply to traditional media. Kids and adults are already spending as much and often more time online as watching TV. I suspect that computer education experts will not take charge of providing the kind of critical literacy I have proposed here. I suspect that this is invariably due to their more technical computer science education background—rather than the humanities and social science background from which teacher educators and teachers in computer education come.

What this suggests to me is that now is an opportune historical moment for media literacy education to take charge of "new media" by *using* new media, *teaching* with and about it. We should seize the moment and create the kinds of conceptual links and nodes from the core principles of old-style media studies (e.g., narrative, genre, semiotics, editing, medium-specific design features, audience, political economy) to design a new web-like concept map within which to locate an expanded definition of media literacy that connects across media. This task, in fact,

isn't just about media or ICT literacy. It ought to be part of a much larger project shared among literacy practitioners and theorists who are already engaged in recuperative actions on many fronts to counter the current drift toward skill and drill literacy pedagogy and a largely acritical public and government attitude toward new information technologies. Just at a time when there is some discernable consensus among many teachers and scholars that literacies are situated social practices, government and popular sentiment is on a restorationist mission to reinstate normative definitions of literacy as singular, fixed, immutable, and measurable. Arguing for a reconceptualised critical media and ICT literacy, therefore, is only part of a larger political project founded on commitments to social justice at the core of which are principles of equity and difference, situated communities, learners, and literacies.

USING DIGITAL TOOLS TO FOSTER CRITICAL INQUIRY

Writing in a research paper she produced for a college course, Kathy Simpson (2001) says,

> Being from a small community I found it intriguing to look at the effects of the Internet in small rural communities. Not only did I want to look at how the Internet has enabled people in remote places, but I also wanted to know what motivated them to use the Internet. Therefore, I went back to Collison and asked some questions and got some answers. (p. 1)

As a student at a major research university, Kathy had become aware of the diverse computer activities in which her fellow students had engaged prior to attending the university, and how those experiences differentially prepared students for university learning. She worked from an assumption that rural schools, such as the one she had attended, did not offer the same opportunities for participation in the information age that other schools afforded, especially those in larger areas, such as the wealthy suburbs surrounding major cities.

Kathy decided to conduct a survey of the high school students in her hometown. Although she learned there are only "75 people in its square block," Collison's high school has over 100 students, because it draws from surrounding communities and farm areas. Kathy expected to find "a lot of households without computers, not connected to the Internet, didn't need them for class, and didn't really care if computers were necessary." When she was in the same school, just four years earlier, "technology definitely took a backseat" to farm and sports activities.

She was surprised to find that slightly over half of the students had a computer at home and over three-quarters of those computers were connected to the Internet. Moreover, in contrast to her own experience just a few years earlier, nearly half of the students had access to computers at school. When asked, "How many hours a week do you use the computer?," over half checked "26–35" and six students said "over 35"; that is, four or more hours per day of computer use in a community she had seen recently as bereft of new technologies. This suggests a major shift in access to digital technologies, a likely shift in overall media practices, and at first glance an answer to the problem of the digital divide, at least as it applies to farming communities in the United States.

As she investigated further, Kathy found that things were not as rosy as they first appeared. When asked "Why do you use the computer?," 32% of the high school students said "class work," 23% said "research," 75% said "surf," 83% said "games," and 21% said "other." In particular, 70% said they would not use it to get local information, a fact that provided the impetus for Kathy's own project to create a web site for Collison. Without denying the value of surfing and game-playing, Kathy felt that students in this school did not see the full potential of the Internet.

The major uses her group reported were individualized and receptive, e.g., surfing and game-playing. There was little evidence of active construction of the tools through programming, Internet radio, web page development, or other such activities. Nor did they report any use of computers as a means for constructing social networks, enacting social change, personal empowerment, creative production, or establishing and maintaining personal identity. These activities may have been just emerging, of course, or present, but not salient in a large survey. But on the whole, the digital experience of these students looks quite different from that of many students in wealthy suburbs.

The responses of adolescents in this community remind us that access alone does not imply that young people have the same experiences; the ways in which computers are used mean more than whether someone is "wired" or how long they can stay connected. As Kathy says, "When going into this project I was concerned that most people were not connected and therefore were being left behind in the information age. But from this survey I see that they are being left behind because the technology is not being used in the schools for resources and tools" (p. 23).

What comes through unambiguously in Kathy's study is that computer uses are evolving rapidly. The question that Kathy's study raises, and the question we will examine is, How do adolescents use digital media as tools in ways that go beyond simply extracting information or playing games to engaging in the literacy practices involved in critical inquiry activities?

Participation in Mediascapes

As documented in this book, adolescents are increasingly and actively engaged with media as they participate in chat rooms, digital editing, zine production, interactive computer games, and hypertext/hypermedia productions. Their participation can take several different forms. On the one hand, adolescents take part in "mediascapes" that highlight performance as the "object of spectacle," and treat experiences as part of seeing and being seen or attended to by others (Abercrombie & Longhurst, 1998). Audiences adopt a "possessive gaze" (p. 82) that focuses on surface images, style, and brands associated with markers of identity or status. They attend primarily to the images projected by organizations, products, companies, celebrities, politicians, and so on—images that are often confused with the realities of these worlds or people.

As documented in the PBS Frontline program *The Merchants of Cool,* adolescents are particularly concerned with projecting an image of being "cool," a concern that shapes their consumption of products marketed as associated with being "cool." Abercrombie and Longhurst (1998) argue that this emphasis on spectacle and projecting certain images of self leads to a high level of narcissism, or self-absorption and/or gratification. For Virginia Nightingale (1996), the experiences of the private everyday life have become controlled by a media culture in which those experiences are replaced by public performances and consumption. As a result, the ideal, unified self of the "individual personality" is now dispersed across a range of loosely defined, transitory alliances. In Nightingale's words:

> [M]edia engagement increasingly transposes everyday life to a public "out there."
> Everyday life has become synonymous with what's on television or radio, what's in
> the newspapers or magazines, what's on at the cinema or what's in the shops. All that
> is left is the person finding a way "to be," operating electronically and commercially
> programmed pathways . . . (p. 141)

In perceiving the world as providing them with images of what it means to be "cool" or popular, adolescents are constructing their identities "in terms of the already existing self" (Abercrombie & Longhurst, 1998, p. 91), consistent with a status-quo commodified, consumer culture as opposed to new, alternative versions of the self consistent with visions of new forms of social action and justice. As James Gee (this volume) argues in his chapter on the Millennial Generation, adolescents may be less open to alternative, diverse cultural experiences or values that challenge their sense of self constituted in the mediascape.

While adolescents may continue to use media to construct themselves according to the values of a consumerist, narcissistic world, we would argue that their emerging participation in digital technologies portends the possibilities of alternative ways of constructing identities. Many adolescents are turning away from the represented worlds of much of broadcast media, which "created a world awash in events but largely devoid of shared experiences" (Travis, 1998, p. 114) to participate in shared communal experiences mediated by digital tools.

Characteristics of Digital Tools

In contrast to the case of commercially produced television, radio, or teen maga-zines, adolescents can assume active roles in using new digital tools. These texts often transcend or challenge current hegemonic consumerist notions of self. For example, in instant-chat rooms or "Buddy-chat," one is able to employ stylistic or "double-voice" features that serve to mark oneself as a certain "kind of person" (Hicks, 1996; 2001). In interacting with others, adolescents are continually con-structing their identities through how they interact with both immediate, familiar audiences and distant, unfamiliar audiences. Through sharing their opinions, be-liefs, and ideas with each other online, adolescents are communicating certain ways of valuing that are consistent with being certain kinds of persons in certain types of social worlds (Hicks, 1996; 2001). Valuing certain social practices entails adopting a certain stance toward these practices consistent with one's beliefs and attitudes, a sense of "oughtness" (Hicks, 1996) that guides decisions, plans, and interactions with others.

What is central to Internet-based communication is the experimentation with not only different voices and roles, as documented by Sherry Turkle (1995) and others, but also the adopting of certain stances and beliefs in reaction to others' stances and beliefs. While much of the chat in computer-mediated communication is superficial, it is also the case that these chat environments create contexts that allow participants to share their opinions, beliefs, and ideas relative to others' alter-native opinions, beliefs, and ideas. Through this interaction with others, partici-pants construct identities by performing in ways that position them in relation to these others' alternative positions; thus, "it is in the connection to another's re-sponse that a performance takes shape" (McNamee, 1996, p. 150). As Bakhtin (1981) argues in his concept of "answerability," people's utterances reflect their rela-tionships with other potential, anticipated reactions to their own utterances. Peo-ple are "'addressed' by and 'answering' others and the 'world'. . . answering (which is the stuff of existence), the self 'authors' the world—including itself and others" (Holland, Lachicotte, Skinner, & Cain, 1998, p. 173). They engage in an internal di-alogue between an "I" as self and a "not-I" in ways that differentiate the self from others. For example, in their study of Sam, a 13-year-old female participant on AOL Buddy Chat, Cynthia Lewis and Bettina Fabos (1999) found that Sam experi-mented with a range of voices in order to build social ties with both her friends and with strangers. In talking with her close friend, Sam adopted what she described as a "softer and sweeter" tone, while giving shorter, more pointed answers to peers with whom she did not want to talk. She also mimicked the language of another participant who accidentally got onto her buddy list to maintain the connection:

> *Sam:* This girl, she thinks I'm somebody else. She thinks I'm one of her friends, and she's like "Hey!" and I'm like "Hi!" and I start playing along with her. She thinks that I'm one of her school friends. She doesn't know it's me. She wrote to me twice now.
> *Bettina:* So she's this person that you're lying to almost . . .

Sam: Yeah, you just play along. It's fun sometimes. It's comical. Because she'll say something like "Oh [a boy] did this and we're going to the ski house," or whatever, and I'm like "Oh God!" and like and I'll just reply to her. I'll use the same exclamations where she uses them and I'll try to talk like they do. (Lewis & Fabos, 1999, p. 7)

Sam and her close friend, Karrie, both find that they are less socially awkward on the Internet chat than in face-to-face conversations, particularly with boys:

Sam: You get more stuff out of them. Yeah. They'll tell you a lot more, cause they feel stupid in front of you. They won't just sit there and . . .
Bettina: So it's a different medium and they can test themselves a bit more and . . .
Sam: So they know how we react and they don't feel stupid cause they don't have to think about the next thing to say. I can smile [using an emoticon, which is a visual icon representing an emotion] or I can say something to them. (Lewis & Fabos, 1999, p. 8)

Sam's and Karrie's participation in IM points to the key role of language uses that serve to position or mark relationships with others. Or, as Lankshear and Knobel (this volume) argue, adolescents learn to employ "public media" to "create an *opportunity* to gain attention" in ways that achieve "'immediate effects' (rhetorical, quirky, stunning), but much will likely be predicated on having something to say that is worth hearing, something to sell that is worth buying, and so on." They may use digital tools to engage in "culture jamming"—activities in which they critique, spoof, and otherwise confront elements of mainstream or dominant culture—for example, using hypermedia to morph, alter, or re-create images in order to parody, ridicule, or resist dominant cultural practices.

A second characteristic of digital tools is that they, like any tools, operate within larger institutional or cultural systems. Sociocultural theorists posit that identity is mediated through the uses of tools that are themselves grounded in cultural or historical contexts (Cole, 1996; Glassman, 2001). The uses of various signs or images functioning as class, gender, racial, or ethnic markers on the Internet, for example, derive their meaning from cultural and historical activities. Moreover, these uses of tools are also continually changing as new uses are discovered for a tool that then changes the nature of the tool. The early bamboo poles employed in pole vaults evolved into fiberglass poles that provided pole vaulters with greater spring for clearing the bar. As the system changed—as pole vaulting itself changed within the world of track—new uses for a tool are found. For example, new ways of exploiting the pole to gain a greater spring are discovered (Wertsch, 1998).

Facing the conflicts, contradictions, tensions, and double-binds operating in systems, participants create new tools. For example, a group producing the female zine *riot grrrl* constructs an organizational network designed to promote their music. Marion Leonard (1998) describes the evolution of this social world as part of an expanding network of activities:

Riot grrrl is a feminist network which developed in the underground music commu-
nities of Olympia, Washington, and Washington, D.C. The initiative was promoted
by members of the bands Bratmobile and Bikini Kill who sought to challenge sexism
in the underground music scene and encourage girls and women to assert themselves.
. . . As women and girls began to identify with this idea, riot grrrl networks spread
across the USA and Britain . . . Female audience members began by challenging the
traditional division of the gig environment into gendered spaces, where women were
largely absent from front of stage. Others grrrls formed bands, wrote zines, arranged
meetings and organized events to introduce girls to music making. (pp. 102–103)

In the case of *riot grrrl,* the participants were driven by the object or purpose of
establishing the legitimacy of their own music within the context of a male-
controlled world. Tools are therefore used within an activity to construct new cul-
tural practices that change or transform a system. Vygotsky (1978) argues that the
history of use of a tool is a social activity that mediates social activity through that
history. For example, digital tools are being used to transform or "re-mediate"
more traditional forms of media—television, film, radio, or print texts (Bolter &
Grusin, 2000). A *USA Today* or CNN web page "re-mediates" television news by
constantly updating information, engaging users through polling, and feeding
news to email users. The changes transform how users experience media as a form
of "hypermediacy," which Bolter and Grusin define as a fascination with the media
form itself and the ways that its immediacy of presentation evokes an immediate,
emotional response. Users of hypermedia may then equate this emotional experi-
ence with their lived-world experiences, or, in some cases, as a substitute for or
even preferable to those experiences, a transformation in how users construct their
identities and worldviews (Turkle, 1995).

Similarly, personal digital assistants (PDAs), tools for organizing one's time and
accessing information (something traditionally associated with work), are now
being used to organize both work and home life, breaking down the distinctions
between the systems of work and home life and blurring the lines between work
time and play time (Geisler, 2001). In one study (Darrah, English-Lueck, & Free-
man, 2000), "Participants [saw] themselves as 'doing family' using managerial
strategies and technologies developed at work to manage an increasingly complex
home life" (Geisler, 2001, p. 321). Digital tools such as hypermedia or Internet chat
can also serve to interrogate status quo systems in ways that create new systems be-
cause they have the potential for mobilizing support for change through reaching
large numbers of people, as was evident in the use of the Internet in the post-
communist conflicts in Eastern Europe.

Fostering Inquiry-based Learning through Digital Tools

One of the important objects of education is to help students learn to reflect on
and interrogate their lives through inquiry-learning activity. As others argue in this

book, adolescents can use digital tools to achieve this object. Any definitions of inquiry-based learning are themselves products of inquiry—intellectual tools—as Dewey (1956) would say, for further explorations of how we teach and learn. For the purposes of this chapter, *inquiry-based learning* indicates a broad set of practices in which learners extract meaning from experience as they engage in efforts to address questions meaningful to them.

Dewey (1956) describes four primary interests of the learner: investigation—the child's natural desire to learn; communication—the propensity to enter into social relationships; construction—the pleasure in creating things; and expression, or reflection—the desire to extract meaning from experience. Dewey saw these as the natural resources, the uninvested capital, "upon the exercise of which depends the active growth of the child" (p. 47). But, as Dewey (1956) recognized, schooling is not just about the individual. It is the coming together of the child's interests with those of the society. The disciplines we study in school represent centuries of collective thought as well as the interests of the larger community in maintaining itself by communicating its knowledge and values to the next generation. Moreover, the individual's engagement with social critique and action is central to personal growth.

These ideas were central for progressive educators in their conception of the rapidly changing social fabric as both a challenge and an opportunity for democracy. They understood that democracy means active participation by all citizens in social, political, and economic decisions that affect their lives. Inquiry under this view is not simply the process whereby an individual learns (the development of a romanticized inner child), but rather, the means for a democratic society to continually renew itself. Education of engaged citizens involves supporting individual development based on unique abilities, interests, ideas, needs, and cultural identity, and promoting a critical, socially engaged intelligence. This linking of social critique and action with personal development is why many use the term *critical inquiry* to indicate more than accumulation of inert knowledge.

The Cycle of Critical Inquiry

The cycle of inquiry is a way of thinking about how curricula relate to learning, articulated by Dewey a century ago, but which may be even more relevant today. Rather than thinking of knowledge as static and of the learner as an empty vessel whose function it is to accept as much as possible of that pre-defined material, Dewey saw the learner as an inquirer, who learns through working on problems that are meaningful in the present circumstances. At the same time, the resources—objects, books, web sites, curricular materials—that the learner uses are themselves representative of inquiry. As he did for so many other dichotomies, Dewey argues that books, curricula, disciplines, and technologies should be seen as representations of on-going inquiry, based on collective and historically based understandings, but not fundamentally different from that of the individual

learner. This is known as "psychologizing the curriculum." Aspects of curricula, even the driest textbook, can then be viewed not in opposition to the learner or to inquiry, but rather as another point on a continuum of inquiry (University of Vermont, 2001).

Figure 1 places the primary interests of the learner in the framework of a cycle of inquiry (Bruce & Davidson, 1996). For any question or problem, one may then think of activities of asking, investigating, creating, discussing, and reflecting as the means for furthering the inquiry.

Literacy practices employ basic aspects of the inquiry process: asking and investigating through formulating questions, issues, dilemmas, or "wonderings"; creating through contextualizing social worlds and system; and discussing and reflecting through critiquing and transforming social worlds (Beach & Myers, 2001; Short & Harste, 1996). These inquiry strategies can be mediated through the uses of web-based digital tools that function as a "knowing" rather than "knowledge" (Dewey & Bentley, 1949). Adolescents write these web-based sites, where "write" means to produce text, images, sound, video, and interactive elements in hyperlinked documents. They also read them, where "read" means to observe, study, and interact with them. Through this writing and reading, they are engaged in processes of formulating issues and questions, investigating, creating, discussing, and reflecting—all the elements of the inquiry cycle shown in Figure 1. Learners today can be a part of these collective, collaborative activities, and not merely passive participants destined to do no more than absorb the work of others. The web is not a necessary technology for that shift in roles, but it invites that shift in a way traditional media do not.

We turn now to examples of how digital tools are being used to engage adolescents in literacy practices that are part of the cycle of critical inquiry.

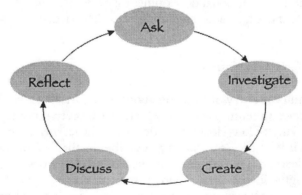

Figure 10–1. The inquiry cycle.

Asking and Investigating to Discover Questions, Issues, or Dilemmas

Inquiry instruction revolves around students' and/or teachers' questions, issues, or dilemmas (Short & Harste, 1996). Framing instruction in this manner mirrors adolescents' attempts to cope with the complex, ill-defined problems, issues, and dilemmas in their everyday lives. Lankshear and Knobel (this volume) point to an example of adopting an interrogative stance through "scenariating" or "coming up with original or fresh ideas of the kind needed to attract and sustain attention [by] asking important 'what if?' questions." For example, adolescents may be caught in a dilemma in which they have to decide whether to continue a relationship their parents don't approve of or seek to please their parents by ending the relationship. Or, in responding to Romeo and Juliet, they may examine reasons for Romeo and Juliet being caught in the same dilemma of competing allegiances (Mosenthal, 1998). Adolescents often have difficulty knowing how to cope with situations that do not lend themselves to simple, easy solutions. Rather than throwing up their hands in despair, they need some strategies for systematically and thoughtfully coping with ill-defined problems, issues, and dilemmas in their everyday lives. They need to learn how to step back and identify reasons why they have certain concerns or why certain solutions may not work.

Adolescents also need to perceive issues as involving multiple, competing perspectives, as opposed to the often simplistic treatment afforded issues in the media or in political rhetoric. In their book, *Learning to Rival: A Literate Practice for Intercultural Inquiry,* Linda Flower, Elenore Long, and Lorraine Higgins (2000), posit the need for students to explore alternative, multiple perspectives or rival hypotheses on social issues. For example, in examining the issue of gangs and gang violence, first-year college students at Carnegie Mellon University met with and interviewed gang members, social service workers, community members, educators, and law-enforcement personnel regarding their perceptions of gang-related issues. They examined the meanings of various conceptions or categories applied to gangs as "dangerous," "crime-ridden," "drug-pushers." In the process, they discovered that there were a range of different perceptions and explanations for gang practices that reflected different beliefs and attitudes about gangs. Contrary to some of their stereotypical notions about gangs, these students discovered that the issue was far more complex than is typically portrayed in the media and that different people representing different community constituencies have different perspectives on the same issue.

Students inductively identify these questions, issues, or dilemmas through immersion in a social world, culture, or text, adopting a dual "participant/observer" ethnographic perspective, in which one is both participating in an experience, world, or text and simultaneously observing and reflecting on that participation as an outsider. Dennis Sumara (1996) argues that, in contrast to superficial "touring" instructional approaches, a "dwelling" mode involves "living in a place with others with an attitude of caring and attention" (1996, p. 160). Adopting an ethnographic perspective involves perceiving phenomena as constituted by certain cultural

norms or discourses. Adolescents, as fish in water, may have difficulty perceiving themselves as being in a particular school, peer group, or community culture.

To recognize the ways in which they are operating in a culture, adolescents may use various digital tools to collect, record, and analyze patterns of social practices that suggest the operation of a culture. They may use digital tools that simulate social worlds such as *Sim City 3000, Populous,* and *Alpha Centauri* to define problems or issues associated with housing, transportation, shopping, business, schooling, waste disposal, and day care. For example, in *Sim City 3000,* if players do not zone for incinerators or landfills, trash piles up in the city (Taylor, 1999). They may also use digital tools to collect data. For example, they may take field notes using a digital recorder or laptop computer, recording observations and reflections on those observations. Or, they may interview participants and then transcribe the interviews themselves by dictating into digital recorders. They may then use qualitative research software to code and analyze these data (e.g., analyzing the uses of certain ways of talking or addressing peers. Or, students may take digital photos or videos of a particular site (Denzin, 1997; Prosser, 1998). Posting these images may then evoke further reflection and questions about the phenomena portrayed.

Students may study issues associated with uses of digital tools themselves and the ways in which these tools function to reshape print or video media. For example, students may examine the relationship between truth or authenticity and "reality" as constituted by "hypermediacy" (Bolter & Grusin, 2000). A case in point is Nick, a State College High School student, who conducted a study of an Internet chat room and found that participants in this virtual community judged each other in a manner different from that in real-world contexts. In Nick's words:

> The Internet has a certain value system that differs from the real world. Online, we choose not to judge people by what age, race, or gender. We choose to judge one another by the way we "act"online, the way we respond and talk to others. In this sense we are all equals, and we show that by giving others a chance to make a good name of themselves. Although there are those who could care less about how others feel and they make the Internet a potentially dangerous place. (Beach & Myers, 2001, pp. 172–173)

As well, students may search the web for information or different perspectives on various issues. Evaluating the validity, legitimacy, and verifiability of this information can lead to further questions and investigations.

Creating to Contextualize Topics or Issues

One of the book's key themes is that the uses of digital tools, as with any literacy practice, are unique to how they are used in specific social contexts and events. From the perspective of activity-theory, the ability to frame or contextualize topics or issues in terms of different components operating in social worlds or systems is

central to inquiry learning (Beach & Myers, 2001; Engestrom, 1987). Students learn by examining how the uses of tools are driven by various components (objects/motives, roles, rules, beliefs, and traditions/history) within a world or system. For example, the female adolescents in Michele Knobel and Colin Lankshear's chapter [this volume] use zines as a tool to achieve the object of challenging sexist norms through adopting the roles of inventive artists or subversives, employing graphic and language features consistent with the norms of the zine genre, conveying anti-sexist beliefs, and operating within a community tradition of zine production. Learning to use digital tools effectively involves the ability to contextualize their use within each of the following components:

Objects/Motives

Social worlds or systems are driven primarily by objects or motives; that is, they are designed to achieve some object or outcome or fulfill some motive (Engestrom, 1987). The various Internet tools described in Colin Lankshear and Michele Knobel's chapter [this volume] are used to attract attention to one's own message or image while at the same time fending off a system cluttered with competing messages or images. In contextualizing uses of tools, students may ask, "What's driving this world or system?" or "What's at stake here?" and "How are tools being used to achieve these things?"

Roles

Within a social world or system, participants adopt roles or identities that are constituted by their uses of tools to achieve certain objects or motives, a central theme of this book. Within an inquiry framework, students use digital tools to study how roles and identities are constituted by participation in the social worlds or systems of peer group, family, school, workplace, community, as well as by participation in the virtual worlds of Internet chat rooms or computer games. For example, ninth graders at State College High School used a range of hypermedia tools to contextualize issues associated with peer relationships (Beach & Myers; (http://www.ed.psu.edu/k-12/socialworlds/) One student, Abby, studied peer groups in the high school by taking digital photos of groups in action during the school day. Using Adobe Photoshop™ she edited these images to grayscale and colorized specific objects that signified group belonging or exclusion. As Abby noted:

> In one of my photographs there are a bunch of bottles sitting on a table in the cafeteria. One bottle is differently shaped and colored than the rest. This is meant to show that there is one girl at my lunch table who doesn't fit with our group. She doesn't drink Snapple like the rest of the girls, which capitalizes on the fact that she doesn't fit in. One of the most striking pictures is one of four girls all wearing the same style of Old Navy Tech Vest in the hallway outside of the bathroom. They are talking and

laughing, and are obviously very comfortable together. . . . My favorite picture is one of a group of girls standing together in the bathroom. This represents something that I call "the bathroom group". The bathroom group is an objective group that consists of pretty much anyone who comes into the bathroom to socialize. Every girl in there is from a different group, and yet the girls all mingle and talk. This is one of the best examples of an objective group because, although I know this sounds odd, no one is judged in the bathroom. (Beach & Myers, 2001, p. 117)

Through her hypermedia project, Abby documented the ways in which female adolescents move in and out of different peer group worlds, adopting identities consistent with the rules or beliefs operating in these worlds.

In their study of their video game playing, Justin and Brett noted that many young players of video games construct future possible identities through play:

[S]ometimes a young child will fantasize about being the basketball player or soccer star that they are controlling in the video game, and they will learn to love and idolize that player for the rest of their life. That is a way that video games shape a person's dreams or identities. (Beach & Myers, 2001, p. 176)

Rules

Students contextualize the uses of tools based on rules or norms for what are considered to be appropriate, significant, or valid practices within a social world or system. For example, Internet chat rooms operate according to their own rules of "netiquette" in constituting appropriate topics, modes of decorum, and civility. Margaret Hamilton (1999) found that the Nancy Drew chat room formulated explicit rules discouraging users from providing full names or using "bad words" as judged in terms of the ideology constituting the world of Nancy Drew. Some of the State College ninth graders used SoundEdit 16™ software to isolate lyrics in popular songs and to represent the various aspects of relationships and identity within the social world of romance. One student contextualized her song clips to examine the norms operating in love relationships based on the expectation that "people care for other people by their words and actions" as well as the fact that "within each relationship some kind of conflict occurs" (Myers & Beach, 2001, p. 541).

Beliefs

Participants contextualize words, objects, and actions in terms of the beliefs or discourses operating in a world constituting objects/motives, roles, rules, and traditions (Gee, 1996; Lankshear, 1997). In a project focusing on the characteristics of effective versus less effective romantic relationships, five ninth-grade State College girls—Alyssa, Audra, Amanda, Kim, and Alissa—created a video drama portraying couples' different beliefs about romance. In her essay about the video, Alyssa explained:

The relationships each portray their own set beliefs and morals . . . The difference is that the good couple communicated with each other. They also had organized places they could go where they could be together outside of school. The bad couple never communicated and they didn't go out with each other that much. (Beach & Myers, 2001, p. 141)

To explore the ways in which the ideologies or discourses of sports define adolescent identities, a State College student, Stephanie, created a quicktime video containing a montage of images from magazines that portrayed how the media represents ways in which participation in sports is shown as marking one's identity in a peer group or community. As Stephanie explained:

For my final project I used the computer and scanned in pictures and added music to it. The social world I was portraying was sports teams while linking it to the social world of friends. In my final project I chose all the images from magazines for a purpose. I went through tons of magazines before I found them . . . When you play on a sports team one thing you should expect is for people to cheer for you and give you team spirit at your games. The very first image of the fans in the crowd was chosen because not only do you become friends with your team but you become friends with the fans as well. Every ones dream and desire is to win their game they are playing. One of my pictures fitted this thought. This picture was of a baseball player sitting on the shoulders of his teammates because he won the game. (Beach & Myers, 2001, p. 99)

Traditions/History

Participants contextualize a world or system in terms of its traditions or past history. As Kathleen McCormick (1999) noted:

This recognition of historical difference helps us in the present to question the apparent naturalness or universality of our own points of view: We come to see that there are changing beliefs and assumptions behind even such everyday activities as wearing jeans to class. Why, for example, does our manner of dress differ so dramatically from the dress of only one hundred years ago? What larger values and beliefs are revealed by the clothing that we wear? (p. 4)

Students may use digital tools to define hypertext links to information about traditions or historical developments, allowing them to contextualize current practices in a world or system based on past developments. For example, middle school students use Storyspace™ (Bolter, Smith, & Joyce, 1990) to construct hypertexts based on research on American history and culture (Patterson, 2000; http://angelfire.com/mi/patter/america.html). In writing a collaborative story about a slave captured in Africa, the students created hypertext narratives with links to information about slavery. In using Storyspace™ as a tool for making these hypertext links, students went beyond just presenting information about

people and events to understanding people and events as shaped by historical and cultural forces (http://www.npatterson.net/mid.html; Patterson, 2000).

Discussing and Reflecting to Critique and Transform Social Worlds or Systems

Digital tools can also be used to foster discussion and reflection on issues or topics in ways that encourage critical analysis and exploration of ways to transform a world or system to address an issue or program. The use of digital tools to construct hypertextual links between media or literary texts and cultural contexts can help students examine how they are positioned to adopt certain roles/stances or beliefs (http://www.ed.psu.edu/k-12/culture; Myers & Beach, 2001; Myers, Hammett & McKillop, 2000). For instance, Ann Margaret McKillop (McKillop & Myers, 1999) taught seventh graders to use StorySpace™ to link original poems, images, and quicktime movies. Although students generally made links designed to simply illustrate ideas in poems through images, in some cases they contrasted texts in ways that created conflicts between different text meanings, resulting in their adopting a critical stance. In one case, a student contrasted her poem originally titled "The Springs" with an excerpt of a nature video of a bear catching and eating fish. She then changed the title of the poem to "The Crying Fish" to challenge the nature video's portrayal of the bear's actions. Students' uses of hypertext production led them to critically examine beliefs and attitudes represented in texts and to resist the texts' implied ideological stances. Moreover, sharing their productions with others led to further discussion and reflection on problematic aspects of these texts.

Teachers' Uses of Digital Tools

Teachers assume an important role in fostering critical discussion and reflection through modeling uses of digital tools and creating activities leading to critical discussion and reflection. They acquire skills involved in using digital tools through using tools that serve their own objects or outcomes—to improve their teaching within the education system.

The Inquiry Page

Web-based sites can serve as a collaborative, community tool to help teachers engage in all aspects of inquiry. One such site, which makes the inquiry cycle more explicit, is the Inquiry Page (http://inquiry.uiuc.edu/). It is designed to help teachers across the curriculum share their successes and collective expertise (Bruce & Davidson, 1996; Bruce & Easley, 2000). A key function of this site is collaborative curriculum development. Teachers inquire through their access to resources on

teaching and learning, which include quotes about inquiry teaching, articles, project links, curriculum units, and content resources. They communicate with other teachers through various online communication media. They construct their own versions of curricula using an online inquiry unit generator. They reflect on their experiences through sharing both literal and textual photos of their classrooms. In a similar way, adolescents use the site to engage in their own inquiries and collaborative activities.

In particular, the site offers both students and teachers a tool for creating online *Inquiry Units*. Each unit starts with a guiding question (or problem) and provides a space for users to describe the resources they find for addressing that question (investigate), the actions they take to answer it (create), the people they collaborate with (discuss), and their own analysis of their activities and progress (reflect). The user does this by filling out a web-based form. When the unit is called up again by the same or another user, it can be used as a guide for their own inquiries. A second user can spin off a copy of the unit, modifying it to fit new circumstances. Students can also do that, thus using the curriculum *Inquiry Unit* as a place for showing their own work. In this way, the site elides the lines between pre-established knowledge and knowledge-in-creation, between curriculum and student work, and between teacher and student, framing all of these as ongoing inquiries. The inquiry unit structure provides a means for articulating some of the important aspects of inquiry, but it can be modified by the user to meet particular needs.

Users of the site may also share videos, photos, graphics, and texts showing people engaged in inquiry in different settings. There are site collections of writings on teaching and learning, links to resources in the Open Directory category on Inquiry Based Learning, and connections to various "inquiry partners"—projects, courses, and schools focusing on inquiry learning.

The Inquiry Page represents a new generation of web design that serves the social needs of classrooms, schools, communities, organizations, or workplaces to engage in critical analysis of problems, issues, or dilemmas. For example, communities are currently developing sites that allow citizens to discuss, debate, and even vote on issues facing a community. This is particularly useful for isolated, rural communities facing mounting social and economic problems (Carter, 1999). Where face-to-face interaction is difficult because of time and geographical barriers, web-based communication fosters increased participation by citizens.

Engaging in collaborative inquiry about a topic or issue, however, requires participants' willingness to adopt tentative, exploratory stances as opposed to rigid or hard-line stances on topics or issues. As part of learning to engage in collaborative inquiry, a group of preservice English teachers participated in a WebCT class bulletin board, addressing various issues associated with education: teachers as role models, vouchers, censorship, testing, motivating students, and so on (Doering & Beach, 2002). In their postings, these teachers framed their ideas or beliefs as hunches or hypotheses—what Donald Davidson (1984) refers to as "passing theories," and Reed Dasenbrook (2001) describes this way:

Everyone enters a communicative situation with a "prior theory," a set of expectations about the words the other uses means. However, because our prior theories never perfectly match one another, the prior theory with which each of us approaches any communication interaction never works perfectly. But this does not mean that understanding is impossible. What happens is that each side develops a "passing theory," a modification of the prior theory to fit the particular usages of the person one is talking to. (p. 73)

This process requires what Dasenbrook (2001) describes as "interpretive charity" (p. 75). Rather than simply reifying or imposing one's prior theories, participants are open to entertaining, analyzing, and integrating others' beliefs into their own beliefs in ways that transform their beliefs.

In treating their beliefs as tentative or exploratory hunches in the bulletin board discussion, the preservice teachers invited others' reactions as a means of verifying or validating their beliefs relative to others' beliefs. For example, in discussing the issue of grading students' writing, one preservice teacher formulated his position on the need to provide feedback during the entire composing process:

So, my two cents: I kind of see grading as a process that begins when the paper is assigned and ends when we hand back that last draft. Plus, it bears great weight (some insist that grading should be done away with in comp classes) in terms of the whole process, their process, of addressing and completing a writing assignment. Does this make sense to anyone? (Doering & Beach, 2002, p. 12)

In his positing, this preservice teacher hedges his comments with words such as "my two cents" and "kind of see." He also notes that others hold different perspectives on grading. And, his final invitation, "Does this make sense to anyone?" implies that he himself is trying to make sense out of his own ideas about evaluating writing. Through participating in the WebCT bulletin board exchange, preservice teachers were learning to use a digital tool to discuss and reflect on issues—an experience they may then provide their own students.

In summary, we argue that digital tools are only as useful as the objects or outcomes they are designed to serve. While digital tools may be used to simply perpetuate consumerism of the "mediascape," they can also be used to foster critical inquiry literacy practices of asking, investigating, creating, discussing, and reflecting. As envisioned by Dewey (1956) long before the advent of these digital tools, teachers still do assume a role in fostering inquiry leading to the development of thoughtful, engaged citizens. Through actively engaging in their own hypermedia or hypertext productions, students learn to investigate, discuss, and reflect on the meanings of texts in their lives.

As we argue, teachers assume an important role in creating contexts such as that illustrated by the Inquiry Page that serve to promote these critical inquiry practices. We close with some implications for teachers related to their uses of digital tools with adolescents in the classroom to foster literacy practices. In using these tools, teachers may want to consider the following questions:

- What objects or outcomes are being served by uses of these digital tools?
- What kinds of literacy practices and inquiry strategies are being fostered through uses of these tools?
- Are students using tools to actively produce texts or hypertexts in ways that lead them to interrogate those texts?
- Are these tools being used to reify or to challenge consumerist values?
- How are students contextualizing uses of tools in terms of objects/outcomes, roles, rules, beliefs, and traditions?
- Are tools being used to foster open, thoughtful exchange of ideas and beliefs in ways that lead to the development of new beliefs?
- Are teachers themselves engaged in uses of tools so that they can demonstrate these uses to students?
- How are tools continually evolving in ways that challenge status-quo systems and create new systems with new objects/outcomes and ways of constructing identities?

CUT, PASTE, PUBLISH: THE PRODUCTION AND CONSUMPTION OF ZINES

Zine culture hit its stride in the mid-'80s with the mushrooming of thousands of tiny-edition photocopied publications distributed by mail, usually to other zine publishers. Many of these small, idiosyncratic hand-crafted publications no longer emphasized the idolized object of "fan action," but rather the zine creators themselves. They were proud amateurs—they loved what they did, even if few other readers (ranging from a couple of dozen to a couple of thousand) would ever appreciate their obsessive devotion to, for example, the respective subjects of *Eraser Carver's Quarterly* or *Thrift Shop News*. —DALY & WICE, 1995, p. 280

Despite their direct relevance to studies of literacy practices, zines (pronounced "zeens") have scarcely featured in the literature of educational research. Zines *have* been taken seriously as a focus of inquiry mainly within studies of popular youth culture (cf., Chu, 1997; Duncombe, 1997; Williamson, 1994). This chapter is intended to provide a modest redress of the silence with respect to zines within literacy studies generally and the new literacy studies in particular. We believe that anyone interested in the nature, role, and significance of literacy practices under contemporary conditions has much of value to learn from zines and, especially, from thinking about them from a sociocultural perspective. Indeed, we think their significance extends beyond a focus on literacy *per se* to pedagogy at large. We begin from the premise that zines are an important but under-researched dimension of adolescent cultural practices and provide fertile ground for extending our understanding of new literacies and digital technologies.

We want to make one point as clear as possible from the outset. In what follows we do *not* want to be seen as advocating any attempt to 'school' zines: to try

and make the production and consumption of zines part of routine language and literacy education in the classroom in the kinds of ways that have befallen so many organic everyday literacy practices. The last thing we would want to see is a zines component within, say, a genre-based English syllabus, or a temporary "zines publication center" in the corner of the classroom. The best of zines are altogether too vital and interesting to be tamed and timetabled. After all, they are a do-it-yourself (DIY) countercultural form systematically opposed to conventional norms and values associated with publishing views of the "establishment" and "schooled" reading and writing. Rather, we think that many learners and teachers might benefit greatly simply from becoming more aware of zine culture. Beyond that, they can participate in zine culture in their own ways and to the extent of their interest (which may be zero), as they would engage with other learning resources and cultural practices in their lives outside school. Our aim here is simply to introduce zines to readers who may not be familiar with them, and to advance a point of view about their significance as literate cultural practice. Our view is that zines exemplify some important dispositions and qualities that young and not-so-young people may find helpful as they negotiate jungle-like social conditions lying foreseeably ahead of us (cf., Friedman, 1999; Gee, this volume; Goldhaber, 1997).

Specifically, zines exemplify in varying degrees diverse forms of spiritedness (gutsiness); a DIY mindset; ability to seek, gain and build attention; alternative (often in-your-face anti-establishment, although not always nice) perspectives; street smarts; originality and being off-beat; acute appreciation of subjectivity; tactical sense; self-belief; enterprise; and a will to build and sustain communities of shared interest and solidarity. These are the kinds of themes that will arise in our account of zines as a characteristically contemporary literacy. In what follows, we will provide a general account of zines as a cultural phenomenon, using brief illustrations of their two main forms: hard copy and electronic zines. After that we will look at some zines we consider exemplary in relation to three main themes relevant to educational work. These concern the ideas of a pedagogy of tactics and a pedagogy of subjectivity.

Zines and Zine-ing

As distinctive forms of publication, zines openly defy longstanding conventions. They often employ handwritten text. They very often subvert the cash nexus: zine purchasing currency is frequently a zine in trade or postage stamps. Among hard copy zines, smudgy photocopied products are common. Zines rarely break even financially on a print run, often running at a permanent loss (sometimes a mark of pride) borne by the self-publisher. Zines are usually accessed via networks of friends, reviews, or other zinesters without recourse to advertising budgets or distributors. It is typical for a zine to be written, illustrated, designed, published, and posted by one person.

Some writers date zines as an identifiable cultural form back to the 1940s (Dun-combe, 1997, 1999). The kinds of zines we are concerned with here—perzines—are more recent, achieving "critical mass" from the mid-1980s. These zines grew out of the 1970s punk rock scene as fans put together "fanzines" about their fa-vourite band—biographical details, appearance dates and venues, album reviews, and the like. These small-run magazines, "zines" for short, were originally typed texts that were cut and pasted by hand into booklet form and photocopied. They were distributed during concerts or via networks of friends and fans. Gradually, these zines evolved into more personalised locations of expression—and their top-ics and themes ranged far beyond the punk rock scene. Nowadays zines come in all shapes and sizes, forms and media:

> Some are just a page or two, others much longer. They can be photocopied or finely printed, done on the backs of discarded office papers or on pricey card stock, hand-written with collages or designed on a computer using different fonts. They can be purchased for anywhere from ten cents to ten dollars; some are free, or just the cost of a stamp. (Block & Carlip, 1998, p. 4)

Increasingly, zines are now being published on the Internet, and conventional paper zine production also often involves computers. Mostly, zinesters retain the DIY ethos and the look and feel of original zines. So today, even when zine pro-ducers key and markup their texts using a computer, they will still cut and paste texts and images onto each page after it has been printed, and then scan or copy these pages as they are.

Young people, who are the majority of zine producers, become involved in zine-ing for all sorts of reasons, and their zines take diverse forms. For example, *Daddy's Girl,* by nine-year-old Veronica (a.k.a. Nikki) grew out of the death of her father when she was six, and was inspired by her older sister's zine making (Taryn Hipp, discussed later in this chapter). Veronica writes about herself, her family, and her friends. The first issue of her zine is 16 pages long and measures 4.5 inches by 5.5 inches (11 cm. by 14 cm.). She includes photos of her family and herself and lists her favourite things and what she would wish for if she had three wishes.

In his first issue of *archáologie francaise,* Caleb (19 at the time) wrote about the death of his grandfather. This issue is a series of photocopied and stapled pages of a size that reminds one of small religious tracts. Inside are copies of the death an-nouncement of his grandfather and images of medicines and surgical tools. The zine is bound down one side with a supermarket "special" label. His second issue contains soul-searching poems apparently inspired by images found in a medical school resource catalogue and included in the zine ("Budget Hands-On Eyeball—give your students an in depth look into the organ of vision"). This issue is cov-ered in thin, flesh-pink cardboard with a hand-printed three-colour caduceus med-ical symbol. The cutout texts and pictures in this zine have been attached to pages by means of old photo corners and then photocopied. His third issue is a set of re-flections on his relationships with girls, his friends, and himself. It comprises a

burgundy cardboard, handsewn envelope containing two small booklets (approximately 2 inches by 2.5 inches, or 4 cm by 5 cm): part one and part two.

Fifteen year-old Athena, a Filipino-Chinese living in Lungsod ng Makati, Manila, produced her online zine *Bombs for Breakfast* from early 2000 until mid-2001 (Athena, 2000). Her white text on a red background was stark and provocative, and her web site included articles from her hardcopy zine, *Framing Historical Theft,* as well as journal entries, a well-used message board, a guest book for visitors to "sign," and a set of pages on the defunct sub-pop band *Hazel.* The web site also included lists of books she's reading for pleasure (e.g., Hannah Arendt's *On Violence*) and for English classes at the international school she attends (e.g., Joseph Conrad's *Heart of Darkness*), and her comments on these books, along with a collection of texts she has published in school magazines and so on. Her hardcopy zine is a vehicle for exploring and discussing "Flipino Chineseness," food, travel, and language. Her writing includes themes such as homophobia, racism, classism, imperialism, student-friendly teaching, the politics of golf, and the like.

Carla De Santis's *ROCKRGRL* began as a disgusted response to the ways her fellow women musicians were portrayed in the rock media. *ROCKRGRL* is a zine about and for women in the rock industry (DeSantis, 1997).

Ciara (20 years old) published a "queer/bisexual" online zine for a number of years—now defunct at the time of writing—and continues to publish in a hardcopy format (Ciara, 2000). The main page of her web site had an aqua-blue background with the text set onto a white inset column studded with pink stars. Her web site was devoted to the personal and political: she critiqued rap music and racist lyrics, wrote about identity and ex-lovers, and posted "confessionals" about her enemies, likes, dislikes, and wrongdoings. Her web site also contained an archive of previous postings, and an interactive message board where Ciara and readers of both the online and offline zines she produced could leave messages and comments. Her web site also linked to a large number of other online zines.

Zines use a range of textual forms, including straight prose, poems (e.g., Paul's *Above Ground Testing*); literary and film narratives (e.g., *Deeply Shallow* edited by Jason Gurley); cartoons and comic strips (e.g., Jeff Kelly's *Temp Slave!*); clipart (e.g., Sean Tejaratchi's *Crap Hound*); collages; and so on. They are thematically diverse. A sample of zines we have surveyed deal with the following kinds of themes: personal tough times and lows (e.g., Steve Gevurtz in *Journal Song #1*); being bisexual or queer (e.g., Ciara, 2000); Abraham Katzman's *Flaming Jewboy* and his *I'm Over Being Dead*); dishwashing in restaurants and diners in the United States (e.g., Dishwasher Pete's *Dishwasher*); fine arts (e.g., *Cyberstudio*); thrift shop shopping (e.g., Al Hoff's *Thrift SCORE*); being fat (e.g., *FAT girl,* Marilyn Wann's *Fat!So?*); paganism (e.g., Madelaine Ray's *The Abyss*); the 1970s (e.g., Candi Strecker's *It's a Wonderful Lifestyle*); collecting things (e.g., Otto van Stroheim's *Tiki News,* Al Hoff's *Thrift SCORE*); being temp workers or work in general (e.g., Jeff Kelly's *Temp Slave,* Julie Peasley's *McJob,* various issues of *Cometbus*); true crimes and murder stories (e.g., John Marr's *Murder Can Be Fun*); feminism (e.g., *Riot Grrrl,* Mimi Nguyen's *Aim Your Dick* and *Slant,* Toad's *I'm Not*

Shy . . . I Just Hate People); music, especially punk music (e.g., *Riot Grrrl*, Digitarts' *Losergurrl*, gutterbunny and others' *Bondage Girl*); popular media images (e.g., Betty Boob and Celina Hex's *Bust*); the "secret history" of wars, global companies, and so on (e.g., Iggy in *Scam*); movies and/or movie making (e.g., Russ Forster's *8-Track Mind*); death (e.g., Caleb, 2000, Kimberley in *the speak easy*); skateboarding/snowboarding; visiting restricted- or no-access areas; UFOs; conspiracy theories; fetishes; and other zines (e.g., Angel, 1999; *Factsheet* 5).

A zine may specialize in a single theme across all its issues, or cover diverse themes within single issues or across issues. In all instances, the writer-producers are passionate—at times to the point of obsession—about their subject matter and desire to share ideas, experiences, values, analyses, comments, and critiques with kindred spirits. Despite widespread claims that contemporary young people are apolitical or apathetically political (e.g., Craig & Bennett, 1997; Halstead, 1999), many zinesters write intensely and with a great deal of caring about the politics of alternative cultures and the politics of the everyday—race/ethnicity, class, sex, gender, work, identity, their bodies, eating, and so on. They voice their opinions loud and clear in their textual productions. According to Stephen Duncombe (1997), zinesters are busy *creating* culture more than consuming readymade "culture," and many are interested in rewriting what counts as 'success.'

> They celebrate the everyperson in a world of celebrity, losers in a society that rewards the best and the brightest. Rejecting the corporate dream of an atomized population broken down into discrete and instrumental target markets, zine writers form networks and forge communities around diverse identities and interests. Employed within the grim new economy of service, temporary, and "flexible" work, they redefine work, setting out their creative labor done on zines as a protest against the drudgery of working for another's profit. And defining themselves against a society predicated on consumption, zinesters privilege the ethic of DIY, do-it-yourself: make your own culture and stop consuming that which is made for you. Refusing to believe the pundits and politicians who assure us that the laws of the market are synonymous with the laws of nature, the zine community is busy creating a culture whose value isn't calculated as profit and loss on ruled ledger pages, but is assembled in the margins, using criteria like control, connection, and authenticity. (p. 2)

To some extent businesses (corporate media) have muscled in on zines, as they have on "alternative cultures" more generally. Occasional television shows or books for young people feature a zinester as the main protagonist (CBC Television, 2000; Wittlinger, 1999). Other approaches include cajoling young people to produce their work as mainstream compilations or how-to-do-it books (e.g., Block & Carlip, 1998; Carlip, 1995), or by posting web sites touted as "online zines" that are really for selling products (e.g., Abbey Records, 2000). Many "faux zines" now exist on the market. *Slant,* produced by the Urban Outfitters clothing chain, includes a "punk rock" issue, and the Body Shop's *Full Voice* praises those who are "rebelling against a system that just won't listen" (Duncombe, 1999).

Most zines and zine-related cultural practices remain steadfastly outside the publishing mainstream. They define themselves against conventional publishing culture and poach off it. As we have seen, corporate publishing culture itself has poached more or less successfully in its own terms off zine culture. So the defining and poaching goes two ways. There is, however, an important difference. Business corporate "faux zine-ing" tends to be highly *strategic,* in the sense developed by Michel de Certeau (1984), in relation to the everyday practices of consumers. By contrast, the operating logic of zines is often highly *tactical*—once more in the sense developed by de Certeau. One of our central concerns in this chapter is to explore zines in terms of a concept of tactics, and to suggest how educators and learners might be able to draw insights from zine culture to develop *pedagogies of tactics.* We are interested in the extent to which pedagogies of tactics might be better adapted to preparing many young people—especially those from non-dominant social groups—for handling the "fast" world (Freidman, 1999) than more conventional pedagogical approaches, which buy more or less exclusively into a strategic logic of producers.

Zines and Pedagogies of Tactics

de Certeau (1997) is a wonderfully subversive and subtle writer. Perhaps it is on account of this that his work has remained relatively marginal within education. Whatever the reason, it is unfortunate because there is enormous potential in his approach to issues of power and subordination for critically informed educational practice. Two common postures within language and literacy education provide useful starting points for considering zines in relation to some of de Certeau's central ideas in ways that help point us toward potentially fruitful pedagogies of tactics.

The first posture might be summarized like this. We are moving into a postindustrial world in which large sections of the "middle" have disappeared and work and rewards have become increasingly polarized. For a few there will be high-skill, high value-added, well-rewarded work that draws on high-order symbolic-analytic knowledge and skills. Even getting lower-level work will require higher levels of literate and symbolic competence than in the past. As (literacy) educators, we must aim to teach higher-order skills to as many as can handle them, and make absolutely sure no learners fall through the basic literacy "net." Indeed, even basic literacy now needs to be seen in terms of problem solving and trouble-shooting abilities that can be transferred to frontline work, as well as in terms of the traditional 3Rs.

The second posture concerns the study of media. According to this, media shape up individuals' understandings of the world: As passive consumers of TV, newspapers, magazines, the Internet, and advertising they absorb worldviews that at best dumb them down and that at worst undermine their own interests to the benefit of powerful groups. Hence, we need to teach (critical) media studies to help learners

decode media messages so they can resist the way that these messages position us. Various techniques and procedures are adopted and adapted from fields like discourse analysis, critical language awareness, semiotics, critical literacy, and so forth, and taught as antidotes to being passive and/or duped. Without in any way wanting to denigrate such postures, not least because we (have) subscribe(d) to them ourselves, we also sense a need to come up with some new pedagogical crafts and orientations, including some that can be thought of as pedagogies of tactics.

In *The Practice of Everyday Life,* de Certeau (1984) develops a conceptual framework based on distinctions between producers and consumers, and strategies, uses, and tactics. Producers (the strong) are those who create, maintain, and impose disciplined spaces. They have the position and power to prescribe social orders and syntactical forms (discourses, timetables, procedures, the organization of space and things within it, etc.). Producers include governments, urban planners, corporations, professional associations, legislators, private utilities companies, scholarly and academic leaders, executives, and so on. Producers, in effect, shape dominant social structures. Consumers, on the other hand, are constrained to operate within these disciplined spaces or structures. (Of course, producers in one context are to some extent consumers in others, albeit typically consumers with greater power to negotiate these spaces than "everyday people".) Thus, for example, inhabitants of government housing consume what has been produced for them—as do users of public transportation and road networks, students, prisoners, and purchasers of diverse goods and services and media available on the market. Consumers are always and inevitably constrained by what producers serve up as disciplined discursive spaces, and the commodities attaching to them.

The distinction between "strategies" and "uses and tactics" parallel that between producers and consumers. Strategy, according to de Certeau, is an art of the powerful—producers. These "subjects of will and power" operate from their own place (a "proper") that they have defined as their base for controlling and managing relations. This place (or "proper") is an enclosed institutional space within which producers regulate distributions and procedures, and which has "an exteriority comprised of targets or threats" (de Certeau, 1984, p. 36). For example, professional scientists define what counts as doing science, build science faculties within universities to police apprenticeships to science, and regulate who can receive qualifications and tickets to practise as scientists. The justice system defines the conditions under which convicted prisoners will live. Education departments regulate what students may and must acquire as formal education and how they must perform in order to be certified as successful, and so on. Strategy operates on a logic of closure and internal administration (Buchanan, 1993). "Strategy equals the institutional," says Ian Buchanan (1993, n.p.), and is the force "institutions must exact in order to remain institutions." Hence, the strategic "can never relax its vigilance; the surveillance of its parameters must be ceaseless. The strong must protect themselves and their institutions from the weak" (Buchanan, 1993, n.p.).

For de Certeau (1984), "uses" and "tactics'" are arts of the weak, by means of which the weak make disciplined spaces "smooth" and "habitable" through forms

KNOBEL & LANKSHEAR | *Cut, Paste, Publish* 171

of occupancy. Through uses and tactics consumers obtain "wins" within their practices of everyday life. de Certeau illustrates "uses" by reference to North African migrants obliged to live in a low-income housing estate in France and to use the French of, say, Paris or Roubaix. They may insinuate into the system imposed on them "the ways of 'dwelling' (in a house or in a language) peculiar to [their] native Kabylia" (de Certeau, 1984, p. 30). This introduces a degree of plurality into the system. Similarly, the indigenous peoples of Latin America often used

> the laws, practices, and representations imposed on them . . . to ends other than those of their conquerors . . . subverting them from within . . . by many different ways of using them in the service of rules, customs or convictions foreign to the colonization which they could not escape. (de Certeau, 1984, p. 32)

"Tactics" involve the art of "pulling tricks" through having a sense of opportunities presented by a particular occasion—possibly only a literal moment—within a repressive context created strategically by the powerful. Through uses and tactics "the place of the dominant is made available to the dominated" (Buchanan, 1993, n.p.). According to de Certeau (1984), a tactic is

> a calculated action determined by the absence of a proper locus. . . . The space of a tactic is the space of the other. Thus it must play on and with a terrain imposed on it and organized by the law of a foreign power. It does not have the means to *keep to itself,* at a distance, in a position of withdrawal, foresight, and self-collection: it is a maneuver "within the enemy's field of vision,". . . and within enemy territory. It does not, therefore, have the option of planning, general strategy. . . . It operates in isolated actions, blow by blow. It takes advantage of opportunities and depends on them, being without any base where it could stockpile its winnings, build up its own position, and plan raids. . . . This nowhere gives a tactic mobility, to be sure, but a mobility that must accept the chance offerings of the moment, and seize on the wing the possibilities that offer themselves at any given moment. It must vigilantly make use of the cracks that particular conjunctions open in the surveillance of proprietary powers. It poaches them. It creates surprises in them. . . . It is a guileful ruse (emphasis in original). (p. 37)

Buchanan (1993) helps clarify what is at stake here by distinguishing between "place" and "space." Buchanan construes "place" as the "proper" of the strategy of the powerful. Place is "dominated space" (Lefevbre) or "disciplined space" (Foucault). Space, on the other hand, is used by Buchanan to refer to *appropriated* space. Tactics, says Buchanan, are means by which consumers convert places into spaces. In this, consumers employ tactics like "bricolage" and "perruque'" to "make do" by "constantly manipulating events in order to turn them into 'opportunities'" (de Certeau, 1984, p. xviii). Very ordinary examples of tactics include stretching one's pay packet to allow for a few "luxuries" every now and then, producing a dinner party out of a few simple and available ingredients, inventing words on the spur of the moment, and so on.

de Certeau (1984) thinks of consumers' everyday creativity in terms of trajectories that can be mapped as a dynamic tracing of temporal events and acts (the precise obverse of passive receiving and absorbing). "In the technocratically constructed, written, and functionalized space in which consumers move about [i.e., the *place* of producers and their productions], their trajectories form unforeseeable sentences, partly unreadable paths across a space" (p. xviii). These trajectories, or transcriptions of everyday ways of operating, "trace out the ruses of other interests and desires that are neither determined nor captured by the systems in which they develop" (p. xviii).

Thinking about zines in terms of trajectories adds a dynamic that can move our analyses beyond zines as merely exotic and static artifacts. We look at them, instead, as vibrant, volatile, thriving social practices that describe deep currents and concerns within youth culture. We can explore zines as enactments of tactics on enemy terrain, and on a number of levels. We may begin this kind of exploration by considering how zines often employ tactical maneuvers of *bricolage* and *la perruque* (de Certeau, 1984). Bricolage refers to the "artisan-like inventiveness" of consumers' everyday practices whereby they use whatever comes to hand in carrying out these practices. de Certeau refers to bricolage as "poetic ways of 'making do'" (pp. xv, 66), and as "mixtures of rituals and makeshifts" (p. xvi). He celebrates the bricolage-like practices of consumers as they go about their everyday lives. Such bricolages are often extraordinarily ordinary, yet underwrite effective modes of living and being on unfriendly terrain. The life of a community, for example, is made from the harvest of miniscule observations, a sum of microinformation being compared, verified, and exchanged in daily conversations among the inhabitants who refer both to the past and to the future of this space. As an old lady who lives in the center of Paris leads her life:

> Every afternoon she goes out for a walk that ends at sunset and that never goes beyond the boundaries of her universe: the Seine in the south, the stock market to the west, the Place de la République to the east. . . . She knows everything about the cafés on the boulevard, the comparative prices, the age of the clients and the time that they spend there, the lives of the waiters, the rhythm and style of people circulating and meeting each other. She knows the price and the quality of the restaurants in which she will never lift a fork.

The daily murmur of this secret creativity furnishes her necessary foundation and is her only chance of success in any state intervention (de Certeau, 1997, p. 96). The "mixtures of rituals and makeshifts" that are bricolages—like those orchestrated in the old lady's walks—are integral to the practice of zines as creative appropriations rather than strategic productions. To use de Certeau's concepts, zines are mostly "miniscule observations" and conglomerations of "microinformation." A good example is provided by Dishwasher Pete and his zine *Dishwasher*. This zine literally traces (documents) a trajectory of poetic ways of making do on a daily basis.

Pete's life goal is to work as a dishwasher in every U.S. state. His zine *Dishwasher* provides accounts of his work in various restaurants and his reflections on life. Pete does not own a car or have a fixed address. He stays with people he meets via his zine—crashing on their lounge room floors until he quits his job and moves on. Much of the detailed commentary in *Dishwasher* focuses on inequities in the food service industry, behind-the-scenes critiques of restaurant owners, work anecdotes from other dishwashers, and so forth. His bricolage is a "critique of class and privilege from a unique viewpoint which preserves [his] personal freedom, self esteem, and well-being" (Vale, 1997, p. 11).

Interestingly, much of de Certeau's (1984, p. 25) work traces the collapse of revolution—overthrowing oppressive regimes by force—as a viable means for transforming "the laws of history" and suggests, instead, that the art of "putting one over" on the established order on its own home ground is a means for undermining these orders from within. One way of doing this is through a tactic identified by de Certeau as *la perruque*—French for "the wig." This is a "[a] worker's own work disguised as work for his [or her] employer" (p. 25).

La perruque differs from stealing or pilfering because nothing of significant material value is actually stolen (the worker uses scraps or leftovers that would ordinarily be thrown out). Likewise, it is not absenteeism because the worker is "officially on the job" (de Certeau, 1984, p. 25). Instead, the worker diverts time to his or her own needs and engages in work that is free and creative and "precisely not directed toward profit" (de Certeau, 1984, p. 25). It may be something as simple as a secretary writing a love letter on company time (and using a company computer and their paper and mailing system) to something much more complex, such as a cabinet maker using a work lathe to create a piece of furniture for his home (using timber offcuts from the for-profit-work, which he picks up from the scrap heap to build his chair). Thus, "[i]n the very place where the machine he [or she] must serve reigns supreme, he [or she] cunningly takes pleasure in finding a way to create gratuitous products whose sole purpose is to signify his own capabilities through his [or her] *work* and to confirm his [or her] solidarity with other workers or his family through *spending* his [or her] time this way" (emphases in original; de Certeau, 1984, pp. 25–26).

La perruque captures the deviousness of tactics and captures ways in which "[e]veryday life invents itself by *poaching* in countless ways on the property of others" (de Certeau, 1984, p. xii). Many hardcopy zines are, in fact, perruques, and would not exist without the possibility of poaching on others' property. To some extent this involves poaching on material resources. A not-for-profit ethos can be sustained, subversively, by means of *la perruque*, as shown in the following example:

> I had a temp job working in the mail room of an insurance company that was promising me full-time employment. I thought, "Hey—this will be good. I can deal with this work; it's easy, I get benefits, I get a regular paycheck . . ." then they reneged and said they were bringing in someone from another department to take over my job.

Anger and access to paper and copiers motivated me to produce the first issue [of the now-famous *Temp Slave*]—everything coalesced at once. (Jeff Kelly in conversation with Vale, 1996, pp. 22–23)

La perruque even can help us understand young people's job choices: "I was showing a zine to a friend and coincidentally its producer was employed in her office mailroom. She'd always thought he was too talented for the job but suddenly realised why he stayed there . . ." (Bail, 1997, p. 44).

Sometimes the material resources that are poached actually become the substance of the zine. R. Collision, for example, worked in a photocopying shop and was amazed at the kinds of images people brought in for copying—everything from mugshots to photos of operation scars to pictures of body parts and pornography. Collision was so fascinated by these windows into the human condition that he made double copies of interesting images and kept one copy for himself. Then, as he describes it, from "the graphics I had accumulated at work, I decided to publish an image compilation book that would say 'Recycle this' on its cover, and began copying as many pages as I could at work [without paying for them]. Eventually I had enough sheets to publish 200 copies of a 300-page book" (R. Collision in conversation with Vale, 1996, p. 43).

In other cases, zinesters' practices of *la perruque* involve poaching on abstract or intellectual "property" in order to appropriate space. Vale speaks of zines as a grassroots response to a crisis in the media landscape: "What was formerly communication has become a fully implemented control process. Corporate-produced advertising, television programming and the PR campaigns dictate the 21st century 'anything goes' consumer lifestyle" (Vale, 1996, p. 6). Numerous zine and zine-like productions poach upon and subvert corporate media productions as exercises in "culture jamming," parody, and exposé.

At one level this is evident in practices as direct and straightforward as literally turning media images in on themselves, or by combining images and tweaking texts to produce bitingly honest social commentaries that everyone everywhere can read and understand—a kind of global literacy. This kind of tactic, wonderfully employed in Adbusters's critique of Benetton's attempt to evoke an "equality" and "global village" ethos in the fashion world (see Lankshear & Knobel, this volume) is widely practised within zine culture.

At another level, strategic productions—or enacted strategies on the part of producers—in the form of "official" versions of how we should be and do are poached, preyed upon, and otherwise made into opportunities to turn place into space by tactical means. For example, Taryn Hipp writes in the first edition of her zine *girl swirl fanzine:* "Being an 'overweight' girl is not easy. When I look around all I see are these pictures of skinny women in revealing clothes standing next to a handsome man" (Hipp, 1999, p. 1). Taryn uses her zine as a personal space: she critiques images of women in the media; candidly discusses her relationship with her boyfriend, Josh; openly describes being a member of a rather unconventional family; and so on. While not a direct "attack" on or resistance to popular media, *girl*

swirl fanzine is the product of Taryn's "making space" in the niches and crevices of institutions such as mainstream magazines and television by thumbing her nose at the formal structures and strategies of these institutions. Her hand-crafted paper zine sits nicely alongside her web site (Hipp, 2001), which in addition to showcasing issues of and excerpts from her zine, also includes a web log (similar in concept to a diary, which can be added to at will) and is often asynchronously interactive, thanks to email and other responses from readers. Her online zine and social commentaries are further supported by an email discussion list. Taryn is not so much out to change the world as to declare her position within it:

> I am happy with the way I am. I am happy with the way I look. I am happy being "overweight." I used to worry about what other people thought of me. I have pretty much gotten over that. It wasn't easy. It never is. (Hipp, 1999, p. 1)

In his inimitable way, Dishwasher Pete also deftly creates his own "space" within the formal world of work and communicates this for a wider audience in *Dishwasher*. Using texts, images, and his own experiences in creating his zine, Pete critiques mainstream mindsets about what young people "should" do and be. For example, he recounts critiquing social assumptions and institutions from a very young age—which in large part he attributes to growing up desperately poor. While he was still in primary school, Pete recalls analysing and 'busting' the myth of upward social mobility through education by means of his observations of the microinformation of everyday life. He recalls:

> No matter how poor you are, you're expected to pretend that someday you'll be a doctor. Every year the nuns at our school would ask, "What are you going to be when you grow up?" Destitute kids would get up and crow about how they were going to be some great lawyer—this is what you were *supposed* to say. I would always say I wanted to be a house painter, because I remembered watching one with a paintbrush in one hand, a sandwich in the other, his transistor radio playing while he sat on a plank brushing away in the sun. I thought, "That's the job for me—I could do that!" The nuns were never happy when they heard this: "A house painter?! Are you sure you don't want to be a doctor?" "No, ma'am." (emphasis in original; Dishwasher Pete in conversation with Vale, 1997, p. 8)

In addition to critiquing social institutions and myths, Pete's zine is not just about dishwashing in countless restaurants across the United States, but is also a deeply thoughtful and thought-provoking critique of work and economic inequality. Indeed, Dishwasher Pete himself actively sidesteps "baby-boomer" work ethics and turns the proliferation of "McJobs" to his own ends (cf., Howe & Strauss, 1993). As he puts it:

> I'm addicted to that feeling of quitting; walking out the door, yelling "Hurrah!" and running through the streets. Maybe I need to have jobs in order to appreciate my

free leisure time or just life in general. . . . Nowadays, I can't believe how *personally* employers take it when I quit. I think, "What did you expect? Did you expect me to grow old and die here in your restaurant?" There seems to be a growing obsession with job security, a feeling that if you have a job you'd better stick with it and "count your blessings." (Dishwasher Pete in conversation with Vale, 1997, p. 6; see also Duncombe, 1997)

By no means do all zines employ tactics in the kinds of ways we have illustrated here. Many zines reflect sophisticated expertise in the use of tactics in the sense that their author-producers "[pinch] the meanings they need from the cultural commodities . . . offered to them" (Underwood, 2000, n.p.). Zinesters are often highly adept at appropriating spaces of dominant culture for their own uses, or of otherwise making these spaces "habitable."

Some important points for educational practice generally and literacy education specifically flow from our attempt to explore zines in the light of de Certeau's (1984) conceptual frame. One fairly obvious implication is that for all the value there is in addressing critical analyses of media texts and other cultural artifacts within curricular learning, it is also important to understand how consumers *take up* these commodities. Doubtless the world will and should be transformed. Meanwhile we need to make it "habitable." There is much to be learned from those whom we classify as learners and/or in need of learning in terms of how they make places habitable, how they borrow meanings to make do, and how having *enough* people making do successfully might *act back* on dominant culture.

Buchanan (1993) makes an important series of points here. He notes that theorists often see strategy and tactics as oppositional terms, and thereby assume that de Certeau's approach belongs to a weaker category of resistance. In other words, it is often thought that tactics are merely "reactive forces, a practice of response" (n.p.). Buchanan notes that, on the contrary, tactics "define the limits of strategy" and force "the strategic to respond to the tactical" (Buchanan, 1993, n.p.). Hence, tactics contain an active as well as a reactive dimension. So, for example, prisoners determine the level of security required in a given prison. Users of non-standard Englishes determine the degree of policing needed on behalf of standard English. Zinesters help to determine the degree of diversity required in establishment publisher lists. In a context where tactics are strong, healthy, many, and pervasive, the fact that the strategic machines are always one step behind when they need to be one step ahead becomes apparent (Buchanan, 1993, n.p.). The situation could become stressful for producers. Could "armies" of tacticians up the ante to the point where strategies pop? Our hunch is that it is worth testing this out.

Perhaps in schools we spend too much time trying to set kids up to perform within *strategically* defined parameters of success. This, paradoxically, often leads to engaging in practices that actually dumb kids down—such as enlisting them in moribund basic literacy remediation programs, or engaging them in painting by numbers activities to familiarise them with dominant genres. This kind of approach can subvert many genuine "*smarts*" that extraordinarily ordinary practitioners of

tactics have—including practitioners who are the so-called literacy disabled—and which could productively be built on in classrooms.

One of our favorite examples here concerns a Year 7 student, Jacques, who told us "I'm not keen on language and that. I hate reading. I'm like my Dad, I'm not a pencil man" (Knobel, 1999, 2001). His teacher concurred, describing Jacques as "having serious difficulties with literacy." Jacques did all he could to avoid reading and writing in class, although he collaborated with family members to engage successfully in a range of challenging literate practices outside school. These included producing fliers to attract customers to his lucrative holiday lawn mowing round, and, as a Jehovah's Witness, participating in Theocratic School each week, where Jacques regularly had to read, explain, and give commentaries on texts from the Bible to groups of up to 100 people.

Jacques's literacy avoidance behavior in class yielded a classic use of tactics with respect to the Writers' Center his teacher had established in one corner of the classroom, where students could work on the narratives they had to produce for their teacher. During a two-week period we observed him spending several hours at this Writers' Center making a tiny book (6 cm by 4 cm, or 2" by 1") containing several stapled pages. On each page he wrote 2 or 3 words which made up a "narrative" of 15 to 20 words (for example: "This is J. P.'s truck. J.P. is going on holiday in his truck. J. P. likes holidays in his truck. The End"). Other students found these hilarious when he read them out loud to them, and he eventually produced a series of six "J. P. Stories."

His teacher's response was negative and highly critical. She was not impressed and saw his activities as "very childish" and as a means of avoiding writing and of not taking too seriously something he could not do. Yet Jacques's tactical approach to making this literacy learning context "habitable" showed precisely the kind of "spark" that could serve him well in all kinds of real-world contexts. It also inchoately contains a critique of much classroom activity (what's the point of it? How is it relevant?) that is consistent with formal research-based critiques of non-efficacious learning (cf., Gee, Hull, & Lankshear, 1996). A teacher who could appreciate and celebrate tactics might have been able to reward the potentially fruitful and genuinely subversive element of Jacques's "trick" and extend it pedagogically.

We want to argue that zines provide the kind of tactical orientation that would help teachers and learners develop pedagogies of tactics to supplement pedagogies that render unto producers. Such pedagogies would identify, reinforce, and celebrate tactics when they occur, and invite other participants to consider alternative possible tactical responses to the same situation. This might take some time out of being on task within formal learning activities, but with the chance of stimulating and enhancing native wit, survival potential, critical thinking, and creative subversion. It may be worth contrasting here the capacity of a Dishwasher Pete to handle the impact of a new work order where many middle-level workers and managers experience their lives and worlds collapsing when their jobs no longer exist. A good tactician always has somewhere to move. Under current and foreseeable conditions of work, teachers as much as their students (will) need well-honed tactical

proficiency in order to obtain the meanings they need. Many of us in education might benefit by refining our capacity to pinch and poach on the property of education producers. In so doing we might contribute something to the tactical prowess of all who are *compelled* to be education consumers. Our argument is that zine culture is a likely place to include in our efforts to understand and develop pedagogies of tactics. This work is greatly assisted by the close study of subjectivity in relation to zining. An individual's sense and enactment of self is tied intimately to his or her ability to celebrate the "everyperson" and the microinformation of everyday life, and to practice poetic ways of "making do."

Zines, Subjectivity, and Pedagogy

The role of education in relation to personal development has been massively complicated during the past two decades. Such phenomena as intensified migration and intercultural exchange, the demise of former longstanding "models" and "pillars" of identity (e.g., well-defined gender norms) and the linear life course, displacement of modernist/structuralist ways of thinking about persons and the world by postmodern/poststructuralist/postcolonialist perspectives, the rise of radically new forms and processes of media, and an emerging new globalization have been prime movers of this complication. They have intersected in ways that generate profound challenges to knowing how and what to be in the world at the level of subjecthood. They have also helped to complicate aspiring, emerging, and established educational reform agendas in areas of equity, gender reform, and the like.

The individual's sense of self, now commonly referred to as subjectivity rather than identity, is shaped at the confluence of diverse sociocultural practices and discourses (Rowan et al., 2001).[1] "Subjectivity" refers to "our ways of knowing (emotionally and intellectually) about ourselves in the world. It describes who we are and how we understand ourselves, consciously and unconsciously" (MacNaughton, cited in Rowan et al., 2001, p. 67). Individuals negotiate cultural understandings about acceptable, proper, or otherwise valued modes of gendered or ethnic *being* in the course of shaping and reshaping their own senses of themselves. Cultures circulate meanings about what it is to be a *valued* kind of girl or boy, or member of a particular ethnic grouping, and so on. Poststructuralist perspectives in particular have re-emphasized the point that while powerful and regulatory social fictions about gender and ethnicity are circulated and endorsed by diverse institutions and discourses, it is also possible for alternative and less restrictive representations to be constructed, circulated, and validated. For example, strands of feminist research have focused on the personal and political significance of alternative representations and images of being a girl or a woman. Donna Haraway (1985) speaks here of new "figurations" (such as her notion of *cyborg*). Such "figurations" are not merely "pretty metaphors [but] politically informed maps [that] aim at redesigning female subjectivity" (Braidotti, 1994, p. 181; Rowan et al., 2001).

From this kind of standpoint, reform agendas within education in areas like gender and ethnicity involve identifying dominant narratives of gender and ethnicity and then working to develop, promote, and validate counternarrratives that recognize there are multiple ways of being, say, a girl or a boy. Moreover, such counternarratives work from the premise that individuals may align themselves with more than one version of being a girl/woman or boy/man in the course of their life or, even, in the course of a day (Rowan et al., 2001, 72.). This is to see "the self" or one's personhood as "continually constituted through multiple and contradictory discourses that one takes up as one's own" (Davies, 1993, p. 57).

The educational implications of this are clear enough. Teachers and learners concerned with moving beyond limitations of dominant cultural fictions of *valued* modes of gendered and ethnic being are necessarily involved in entertaining, discussing, acting out, and producing counternarrative representations. Many zines, especially the burgeoning array of electronic zines, offer fruitful and diverse insights into how different people try to work out or create their subjectivities. Many online zines make available spaces for discussing, critiquing, and reporting different people's experiences of negotiating subjectivity. Two examples are indicative here.

Slant/Slander

Mimi Nguyen is a self-labeled Asian American bi-queer feminist anarchist who has created a range of hardcopy zines (e.g., *Slant, Slander*) and cyberzines (e.g., *Slander, Worse Than Queer*). Nguyen, refugeed from Vietnam when she was one year old, identifies punk rock as the original driving force behind her zines. More recently, however, she has focused on issues and injustices occurring at the interstices of race/ethnicity and sexism. Her zines grew out of her desire to network with people of colour in the punk music scene who—like her—were struggling with identity issues. She uses her online zine, *Worse than Queer,* to deconstruct "Asian-ness" as an anarchist, feminism as a bi-queer, and race in general as a young graduate student at University of California, Berkeley. Her goal is to turn longstanding assumptions about Asian women on their head by refusing to submit to the "Oriental sex secrets" and "Suzy Wong" Asian personae that people foist upon her (cf., Nguyen in conversation with Vale, 1997, p. 54). Nguyen draws herself as a punk rocker complete with piercings, as shaven-headed and toting a gun, and in martial arts poses that are definitely "in your face." Her zine *Slander* is definitely "in your face" as well—no holds are barred, and Nguyen refuses to throw dummy punches:

> In a phone interview over three years ago I was asked, "What do you think of Asian women who bleach or dye their hair; do you think they're trying to be white?". . . . That day my hair was chin-length, a faded green. I said, "No.". . . . It is already suggested by dominant "common sense" that anything we do is hopelessly derivative: we only *mimic* whiteness. This is the smug arrogance underlying the issue—the accusation, the assumption—of assimilation: we would do anything to be a *poor* copy of the

white wo/man. Do *you* buy this? Are you, too, suspicious of "unnatural" Asian hair: permed, dyed, bleached? But if I assert the position that *all* hair-styles are physically *and* socially constructed, even "plain" Asian hair, how do we then imagine hair as politics? Who defines what's "natural"? Does our hair have history? What does my hair say about my power? How does the way you "read" my hair articulate yours?. . . Asian/American women's hair already functions as a fetish object in the colonial Western imaginary, a racial signifier for the "silky" "seductive" "Orient." Our hair, when "natural," is semiotically commodified, a signal that screams "this is exotic/erotic." As figments of the European imperial imagination, Suzie Wong, Madame Butterfly, and Miss Saigon are uniformly racially sexualized *and* sexually racialized by flowing cascades of long, black shiny hair. Is this "natural" hair? Or is hair always already socially-constructed to be "read" a certain way in relation to historical colonial discourse? Is this "natural" hair politically preferable? "Purer," as my interviewer implicitly suggests? (Angel, 1999, p. 91; Nguyen, 1998)

Slander is a bricolage of Mimi's views about race and gender, articles written by friends and colleagues, bold and evocative sketches she has done herself, and in the hardcopy version of the zine, collages and other artwork done by her or by friends, and so on, making *Slander* more than an "amateurish" cut-and-paste production. It qualifies in more than one sense as a "poetic way of making do."

Nguyen's writing and artwork are loud voices of protest, as are her other projects such as "exoticize this!" (http://members.aol.com/critchicks), a virtual Asian American feminist community she founded in the late 1990s, and a 1997 compilation zine entitled *Evolution of a Race Riot*. This zine was and is "for and about people of color in various stages of p[unk]-rock writing about race, 'identity,' and community" (Nguyen, 2000, n.p.).

Nguyen is producing a new literacy in her zine *Slander* (and elsewhere) that is rewriting traditional conceptions of and roles for Asian American women. This literacy concerns finding ways to draw attention to assumptions and stereotypes of Asian and Asian American women that are currently at work in popular media. This includes critiquing texts in 'underground' magazines that profess to

Figure 11–1. Source: http://misterridiculous.com/reviews/non_music/

be anti-establishment and pro-young people (e.g., *Maximumrocknroll,* 1998, issue 198), but which often simply perpetuate images of Asian women as sex toys or as exotica. She also carries her message in the strong, line-drawn images she creates herself for her zine. In these ways, Nguyen is creating a space for herself that grows directly out of the microinformation of her everyday life as a punk, bi-queer, Asian American woman who grew up in Minnesota speaking Vietnamese and who recently has given over her shaved head and combat fatigues for red lip gloss and spiky heels. Mimi does not claim that she is speaking for, or even to, everyone and refuses to make concessions to non-Asian readers of her zine:

> [Mimi] wrote about how someone didn't enjoy her zine because they claimed they "couldn't relate" (being some hip white riot grrl type), but Mimi says "duh, of course you can't relate." (Squeaky n.d.)

Digitarts: Grrrowling

Although numerous reports (e.g., National Science Foundation, 1997; Roper Starch Worldwide, 1998) indicate that boys and young men spend more time on the Internet than girls and young women, the number of online zines created by young women appears to greatly outnumber those created and maintained by young men. Internet searches using advanced search engines and techniques, along with consulting a series of popular online zine web rings and indices,[2] suggest that young women dominate the online zine world, unlike in the offline, meatspace world where young men seem to publish more zines than women.

Digitarts is an online multimedia project space constructed originally by young women for young women, but now also encompasses disadvantaged youth and people with disabilities (Digitarts, 2000). The Digitarts' web site explores different conceptions and constructions of female identity through poems, narratives, journal pages, "how-to-do" texts, and digital images, and presents alternative perspectives on style, food, everyday life and commodities. This Australian-based project is dedicated to providing young women who are emerging artists and/or cultural workers with access to knowledge, expertise, and hardware necessary for the development of their arts and cultural practices in the area of new technologies. It aims to "provide young women and artists with the knowledge and resources to create a world wide web site for the creation, distribution and promotion of their own cultural work and that of their peers" (see http://digitarts.va.com.au/grrrowlr/front.htm). Digitarts provides a venue for emerging multimedia artists to showcase their work, and seeks to attract young women to the field by providing web development courses and beginner and advanced levels, and by publishing a cyberzine called *grrrowl.*

grrrowl (http://digitarts.va.com.au/frames2.htm) is an ongoing, collaborative publishing endeavor, remarkable for its long life (many zines on the Internet only ever reach the 'first issue' stage). Like all authentic (not-for-profit, DIY) zines, *grrrowl's* production is not regular. It follows the beat of projects conducted by Digitarts. Its first issue focused on grrrls and machines. Each contributor con-

structed a page that is either a personal introduction—in the style of a self-introduction at a party—or contains poems or anecdotes about women and technology. Hyperlinks to web sites engaging with a similar theme also define each writer's online self, and her self as connected with other selves.

grrrowl #4 investigates the theme "Simply Lifeless" and documents online (*http://digitarts.va.com.au/grrrowl4*) "the everyday lives of young women in Darwin and Brisbane." Its thesis is: "Our culture informs our everyday activity. Our everyday activity informs our culture." The issue celebrates the "everyperson" and everyday-ness of their lives (cf., de Certeau, 1984; Duncombe, 1997), with eight young women—ranging in age from 12 years to 25 years—broadcasting web page-based "snapshots" of their lives. These snapshots include digital videos of personally important events such as composing music on a much-loved guitar, a daughter feeding a pet chicken and so on, or hypertext journals that span a day or a week and which also include photographic images such as digitised family album snaps, scanned hand-drawn graphics, 3D digital artwork, and so on. For example, 12-year-old Gabriell writes about a typical few days in her life that involve waking early, dressing and going to school, who she plays with at school during lunch and snack breaks and what they do, and what she does after school. She talks a little about what she usually has for dinner, and about going to stay with her father every Saturday night. He lives near her mother and her partner, Stephen (Gabriell, n.d.). In documenting the "banal" and "everyday," this issue of *grrrowl* aims at "increasing the range of criteria by which our cultures are measured and defined" (*grrrowl #4*, n.d.).

grrrowl #5 is subtitled *Circle/Cycle* and focuses on "things that are round and things that go round" (*grrrowl #5*, n.d.). The main menu is a spoof of a woman's diet menu that uses images from a 1960s *Australian Women's Weekly* magazine. The food items listed for various times of day (breakfast, beauty break—morning, lunch, beauty break—afternoon, dinner) are hyperlinked to interviews with interesting women such as comic-strip artists (dubbed "ladies of the black ink"), circus performers, bookstore owners, and so on. Other entries in the zine include a range of summer recipes, a detailed account of how to get rid of cockroaches in the house, recounts of food explorations and adventures, and a zine-within-a-zine link to the *Losergurrl* zine (2000): one young woman's personal offshoot of Digitarts projects.

This fifth issue employs a diverse range of text and image genres. The front page for *Losergurrl*, for example, is a collage of images cut from 1960s and 1970s women's magazines. Each image is hyperlinked to reviews of grrrl punk rock music; interviews with women in the music industry; rants about personal demons, safety issues, and women's comic books; book reviews; online games; treats such as recipes for natural beauty products; DIY files that deal with everything from DIY-Cryonics, to gardening and getting rid of pests in ecologically sound ways.

Items in the *grrrowl* issues are steeped in cultural analyses of everyday life and subjectivity. The zine presents online magazine-type commentaries and is used to establish and nurture interactive networks of relations between like-minded people.

It is used to explore and present cultural membership and self-identity through digital and textual bricolages of writing, images, and hyperlinks. The Digitarts' work is also a keen-edged critique of "mainstream" discourses in Australia and elsewhere. For instance, the editorial in the third issue of *grrrowl* explains how to subvert the default settings on readers' Internet browser software, and encourages young women to over-ride or side-step other socially constructed "default settings" that may be operating in their lives. Digitart projects challenge social scripts that allocate various speaking and acting roles for young women that cast them as passive social objects or as victims (e.g., "This is not about framing women as victims—mass media vehicles already do a pretty good job of that" *Girls in Space*, n.d.), and that write certain types of girls (or grrrls) out of the picture altogether (cf., Cross, 1996; Green & Taormino, 1997).

Indeed, "bricolage" is a key concept in this tactical work: the girls and young women involved in producing the various issues of *grrrowl* experiment with new technological literacy skills that have recently emerged (e.g., Virtual Reality Markup Language, Perl script, and shockwave applications). They use whatever technological equipment they can access at the time, or they poach, scan, and insert images from found texts—often placing mainstream images of women or objects often associated with women beside non-mainstream commentaries or narratives in order to underscore the different worldviews from which the Digitarts are operating. In this way, *grrrowl*—along with the other Digitart projects—offers a coherent alternative to the commodification of youth culture, and the concept of "youth" as a market category is made too complex for corporations to use. *grrrowl* is a cyberspace in which young women can become *producers*, and not merely consumers, of texts and culture (cf., Duncombe, 1997, 1999; Knobel, 1998, 1999).

Just as many zines can provide graphic and hard-hitting insights into everyday uses of tactics in the practice of social critique and commentary and in the enactment of alternative politics, so they provide equally valuable insights into the nature and politics of subjectivity. As will be obvious by now, however, vexed issues converge around the place and roles zines might assume within classrooms in publicly funded schools. We will turn to this and other issues briefly in our concluding section. Meanwhile, it seems clear that teachers and learners who happen one way or another to become familiar with zines and zine culture will be helped in their efforts to negotiate subjectivity and subject positions within classroom pedagogy, as well as to bring a range of perspectives and familiarity with diverse and hybrid text forms to themes and tasks arising within the formal curriculum.

Issues and Possibilities

Zines provide firm ground from which to interrogate literacy education as currently practiced in schools and offer hard evidence that young people are not held necessarily in a "consumer trance" or are without sophisticated critical capacities. Even large corporations recognize that many young people are media smart to a

degree that their parents were not and never will be. For example, the Nike faux zine *U Don't Stop* avoids including the globally famous Nike swoosh logo on any of its pages. It seems that the absence of the logo is an intentional nod to young people's "media savviness." Duncombe (1999) explains:

> When I called Wieden & Kennedy's Jimmy Smith and asked him why the Nike logo was conspicuously absent from *U Don't Stop* he explained that, "The reason [the zine] is done without a swoosh is that kids are very sophisticated. It ain't like back in the day when you could do a commercial that showed a hammer hitting a brain: Pounding Headache. You know, it's gotta be something cool that they can get into." (n.p.)

It may well be that no matter what teachers try to do in bringing young people's literacy practices into the world, it will never be sophisticated enough for their students. Or, as happens all too often with "new" literacies, zine literacy will become domesticated within the classroom so that the zines are produced according to the teacher's vision and purposes, rather than according to the grassroots, personal motivations of authentic zines.

For our own part, we remain unclear about exactly what *direct* implications zine literacy has for *schools*. In optimistic moments we think that the proper literacy business of schools should be to take proper account of any new literacy that is demonstrably efficacious. From this perspective, the role of people involved in studying and interpreting new literacies is to continue politicising literacy education and research. Protesting claims that all young people today are politically apathetic and unmotivated would be another way of approaching zines in education. This would entail reading and discussing meatspace and cyberspace zines in classrooms.

On the other hand, for all their potential for fruitful educational appropriation, zines are often controversial, visually and mentally confronting, and regularly deal with topics taboo to classrooms. If some parents get up in arms about witches in storybooks, imagine how they would react to articles and zines entitled *Murder Can be Fun, Sex and Sexuality, and Why I Jack Off So Much Instead of Talking to Girls, Real Skinheads Take a Stand . . . A Feature on Red, Anarchist, Anti-Fascist and Activist Skinheads,* and so forth (cf., Williamson, 1994, p. 2). One way out of this dilemma might be to focus on the *ethos* of zines—the potent do-it-yourself writing and reading ethic for young people—and acknowledge the manner in which and extent to which new literacy practices evinced in hardcopy and cyberzines engage young people as active and often critically sophisticated participants in and creators of culture.

Alternatively, perhaps a revamped critical literacy that is enacted as "tactics," "clever tricks," a knowledge of how to get away with things, a suspicion of grand narratives, and not simply as critical analysis of media texts as commonly practiced, offers a way of maximising students' media smarts in literacy education. Projects could include a public radio segment conducted by students that critiques some element of media culture each day over a four-week period; a commercially published booklet of interviews with local zinesters about their zines and what

zines enable them to do on a day-to-day basis, and organised into themes that speak to young people; and a Mavis McKenzie-type letter writing campaign (see Bail, 1997) that subtly spoofs large corporations or institutions. For example, students could write to a munitions company asking for their magazine catalogue, to the department of education or large hospital asking for a copy of their recycling policy, to local town councils asking for their youth policy, etc. These letters could then become the basis for a multimedia "position paper" or commentary.

The trick, we believe, is to approach the place and role of zines within school-based (literacy) education *tactically*. Here as well, the medium is the message. Whatever other capacities and dispositions they display, smart teachers and smart learners are tactically adept. Zines present us with a tactical challenge; an ideal learning and implementation problematic for new times. How can we get the kinds of orientations, ethos, perspectives, worldviews, and insights encapsulated in zines into classroom education when to do so necessarily involves maneuvering on enemy terrain? If we cannot work out how to do this and get away with it— with the assistance of endless models of tactics available within the practices of everyday life, of which zines are but one—we probably should not try to incorporate zines and core zine culture values into formal learning. By the same token, if we cannot engage in tactics of this kind it might be time to question our credentials for being educators under current and foreseeable conditions. For it seems likely that in the "fast" world that is now upon us, those who survive well will increasingly be "tactically competent."

Notes

1. With many thanks to Dr. Leonie Rowan, Central Queensland University, Australia, for her generous insights and input into this section.
2. Indices used included:
 - http://www.zinebook.com/
 - http://www.zinos.com/
 - http://www.sleazefest.com/sleaze/
 - http://www.meer.net/~johnl/e-zine-list/
 - http://www.ilovepisces.bigstep.com/businesspartners.html
 - http://altzines.tripod.com/index_t.html
 - http://www.geocities.com/SoHo/Cafe/7423/zineog2.html

WHAT HAPPENS TO LITERACIES OLD AND NEW WHEN THEY'RE TURNED INTO POLICY

While I was preparing this chapter, I was involved in meetings with the Queensland Department of Education over the specification and assessment of "core curriculum" outcomes for the state's 1,300 public schools. This involved discussions on whether and/or how—when we test, moderate, and assess that data—it is to be triangulated, used and reported; to whom; and with what consequences for which communities, student bodies, "equity groups," and so forth. Two things were somewhat apocryphal, utterly predictable and frame this chapter. First, my colleagues in the state government and I were preoccupied with how we would perform on national testing and whether the Federal Education Minister would financially and politically punish us should our test scores show visible decline—despite our intimate knowledge of the limitations of the instrumentation, the problems with public disclosure of the scores themselves, and an array of difficult domain, measurement, and interpretation issues. Second, new literacies, new technologies, and multiliteracies did not even merit a mention, aside from a passing comment that the new technology syllabus had some "good outcomes statements."

As a therapeutic activity and some bizarre form of recreational reading that same evening, I reread the recent exchange between Jim Gee (2000a) and Catherine Snow (2000) in the *Journal of Literacy Research* on the U.S. National Academy's report on literacy. I was particularly interested in Snow's sense of what counted as "political" interference, which assumes that if elected officials aren't intervening directly and overtly in policy analysis and making it themselves or directly on the phone to bureaucrats, it isn't "political" but is rather somehow part of

an empirical, sober, and detached science of the analysis of educational outcomes and the formation of policy. From the perspective of a researcher who has worked in governmental policy formation such a claim appears at best constrained by an extremely narrow definition of what might count as the "political": political apparently read as partisan intervention by elected officials in otherwise neutral educational and policy science. In such a view of the world, the political is not taken as a broader political economy where education systems play one key part in communities' capacities to participate, engage with, exploit, and quite possibly critique flows of capital, information, and bodies.

Aside from this and other curiosities of the rhetoric and the details of the arguments, there is a perlocutionary force to Gee's and Snow's debate. A first observation: Snow's insistent defense of traditional paradigms of reading research and their hegemony over what will count as the research base underlying public policy on print literacy signals that those of us who aren't doing this might indeed be on to something. In some ways, what Gee and colleagues refer to as the "New Literacy" studies has arrived when it is taken as a threat not just to the truth claims of traditional research paradigms, but also when it appears to be a threat to the assumptions underlying the very formation of state educational policy. New—or to avoid the reification into a "camp" or "tribe"—newer literacies studies influencing the formation of state policy would be something unprecedented in current American and British policy formation. But what would such an intervention look like?

A second and related observation: the adamant debate about methodology in the teaching of reading is silent about multiliteracies, with a steadfast onto- and phylogenetic assumption that rudimentary print literacy somehow precedes and is a prerequisite for multiliteracies in individual childhood learning and development, in peoples' everyday lives, in curriculum development, in policy making, in the workforce transition to new economies, and as a strategy in the amelioration of the negative effects of millennial capitalism. Print is seen to come first and last in the queue, despite the increasingly noisy recognition by politicians, bureaucrats, corporate sector, and non-government organization (NGO) leaders that the wealthy nations of the geographic and economic North and West are rapidly moving toward postindustrial economies that require semiotic rather than manual dexterity.

But what shape might a "new literacy" policy take? I am not expert at the epistemological formations of the visual and cyberliteracies that others in this volume explore. For the past two years, I have been involved in something far more mundane and, at times, far more numbing: making government policy on print literacy teaching and assessment, on new curriculum categories, and, where possible, "naming" and engaging with the new literacies. This has been a practice of deliberately "interrupting" the traditions of mainstream policy, which tend to focus almost exclusively on basic print skills acquisition. And it has entailed the introduction of new literacies as nodal points in policy texts and documents to enable and encourage teachers and students to begin "working" new literate practices, examining their possibilities and problems for the remaking of pedagogic practices and the reshaping of life pathways and social futures.

The irony is that given the shared will of governments, transnational non-government organisations (e.g., the OECD, UNESCO, World Bank, and Asia Development Bank) and multinationals towards a reshaping of education systems around the production of skills, laboring subjects, and capital—the imperative to engage with new literacies is not a particularly politically radical or intellectually critical move (though indeed it might be). The debates written about in this volume have powerful implications for pedagogy and identity formation and, of course, for the new distributions of discourse and material resources. The new multiliteracies have become, however unintentionally and undertheorised, the coin of the realm not just in one generation's leisure, but in key sectors of the new economies, with the North and West increasingly moving towards not just information and financial exchange, but also with increasingly significant proportions of national economies committed to culture industries. These include the "creative industries" of entertainment and public pedagogy, media and advertising, fashion and branding, and indeed, export education. These markets of representation provide a flow of texts and signs that act synergistically to enable the flow of material goods, services, and resources. Taken together, we might term these sectors a "semiotic economy"—to explain the centrality of sign and symbol, as against the already quite worn expression of "information economies" (the distinctions between "data" and "information" are among the most shopworn clichés of professional development workshops).

At the same time, the wall between these debates and government and bureaucrat boardroom debates of literacy policy is, well, a wall, and a pretty stolid one at that—buttressed by a generational control over policy by pre-postindustrial bureaucrats. In these circles, one rarely runs into an educational bureaucracy that is in utter collusion with these new industries and the new formations of capital in advancing the interests of the semiotic economy. Quite the contrary: educational leadership internationally generally is and remains focused on perfecting, refining, and reinforcing the pedagogic message systems of our own childhoods. The new literacies constitute an utter blind spot, a black hole, in the bureaucratic imagination of state educational systems where the average age of bureaucrats is 50, the average age of principals is 48, and the average age of teachers is 45—with perhaps a few notable exceptions.

The images in some of our writings about "industrial schooling," therefore, are something more than stereotypes. Even where their documentation proudly boasts that all classrooms are wired, or all teachers are "computer literate," the realities are of creaking print-based curriculum systems, of pedagogies stuck somewhere in a postwar time warp of debates between didactic instruction and progressivism, however dressed up, of curricula whose response to a digitalised universe is to simply add and assess more objectives and outcomes, of a baby-boomer teaching force resistant to engagement with new literacies as they enter the final decade of their time in the educational workforce, and of politicians who mouth clichés of "smart states," "knowledge nations," "intelligent isles," "information economies," and so on but who find electoral and populist solace in de-

fenses of canonical print literacy and basic skills instruction. These are the actual policy and industrial and pedagogical contexts that teachers coming to grips with new technologies, identities, and texts have to live and work in. Colin Lankshear and colleagues' *Digital Rhetorics* (1998) shows this, as do many other recent studies. These are the somewhat anomalous norms in the classrooms and staff rooms of North and West educational systems at the national, regional, state, and local level. Yet while the problem repeatedly is blamed on teachers' Luddite recalcitrance, the problem may indeed sit within a complex generational and intellectual disjunction between policy construction and the new economy.

What is most interesting is not the direct linkage between the interests of the new economies, multinational codes and sign systems, and new globalised capital fields of exchange and the operations of our various national, state, and regional education systems. A quite contrary and contradictory situation exists: an historical moment where there appears to be an apparent delinkage between skill and knowledge production by schools and educational institutions and the emergent appetites for human capital of the new economies. From this perspective, we could ask how the current policy orientations towards basic skills fit into education systems where there are highly inexact correspondences between what schools produce and what elite and non-elite sectors of the new economy demand.

But let's pull back to the challenge of the new literacy studies for a moment. Whatever point we've succeeded in making in the past two decades since the "ethnographic" and qualitative turn in the 1980s, one of the key consequences is the focus on context. All literacies and literacy education are "situated"— that is, "all uses of written language can be seen as located in particular times and places" and can be linked to "broader social structuring" (Barton, Hamilton, & Ivanic, 2000, p. 1). This has several implications for teachers and administrators. First, and most obviously, it means that pedagogy is optimally constructed and implemented in relation to grounded analyses of the new "times and places" where learners acquire and use literacy. Context has become a new methodological mantra, whether old or new left, critical, poststructuralist and new age, or new tech. One of the most interesting theoretical and methodological problems in case-based qualitative research and, indeed, in discourse analysis is the boundaries of, in ethnographic terms, "context" or in Foucault's terms the "local"—of what counts as a case. And a key implication of the compression of space and time, of the emergence of continuous globalised flows of discourse, bodies, and material, is the blurring of the "local," of the "situated," of the "case," of the "community" as problematic both theoretically and practically. The complexity of globalisation makes the relevance of the now-traditional application of the term "community" to lived local context at best unstable and shifting, if not misleading, without broader attention to its relationship to cultural and economic flows (Appadurai, 2000). So the ways in which we translate the "old anthropological" and structural functionalist versions of context into virtual, globalised, hybrid notions of space is a question worth pursuing further.

Second, to say that literacy is "situated" means that these interventions are enabled and disenabled by national, regional, and local politics and by the economics

of our school systems. That is, a missing part of the puzzle of understanding how the new literacies are situated, about understanding the power and the interplay of the "local" with the "global," the "micro" and the "macro," is an engagement with the way that systems, governments, legislation, policy, and the new relations between the state and the non-government and corporate sectors set up enabling and disenabling institutional sites for the realization of multiliteracies. As noted before, they certainly have compelling reasons to do so. But, as I will argue here, they lack the necessary designs, expertise, and generational orientations to do so with any appearance that an embrace of the "new" might be a logical or necessary extension from current neoliberal foci on accountability and surveillance, on reductionism and standardization of knowledge and practice, and on system fiscal and human efficiency in the production of quantifiable outcomes. In other words, the policies and practices of governance being pursued by many Australian, New Zealand, British, and American educational jurisdictions—designed to meet what are perceived to be the key imperatives of both neoliberal and "third way" strategies—may, ironically, be among the strongest impediments to an engagement by educators and their communities with multiliteracies. Ironically, this may act not only to exclude and disenfranchise many of the most endangered communities from the expressive, intellectual, and economic power of the new technologies and economies—as many of the chapters in this book have argued—but it may also act against the will of the new economies to construct and seek out new laboring and consuming subjects.

In focusing here on new multiliteracies as an object of state educational policy, I want to describe briefly a first attempt to create state policy that included multiliteracies, some of the available discourses on both print and new literacies among particular generational cohorts of teachers, and finally, the implications of current patterns of neoliberal educational policy for the appropriation and remediation of new literacies. This chapter has three sections. The first section reviews the Queensland state literacy strategy. The second section attempts to describe what we could call the generational and professional grammar or logic of baby-boomer teachers confronting the new literacies—teachers who are engaging, somewhat confusedly, with the socially and economically deleterious effects of new economies and work orders (Luke & Luke, 2001). The third section describes current policy tenets—amounting to a neoliberal user's guide for how to domesticate new literacies and new literates.

Literate Futures: The Queensland Literacy Strategy

In 2000, Peter Freebody, Ray Land, and I were commissioned to review literacy education in Queensland and to develop a five-year literacy strategy for the 1,300 state-run primary, secondary, and middle schools, which included 30,000 teachers and three-quarters of a million students. Queensland, Australia's third most populous state, is generally considered among its most conservative politically and historically,

with a strong but eroding reliance on primary industries and resources, a relatively small but growing multilingual and multiethnic minority (13% students of non-English-speaking background), and an unresolved and unreconciled relationship with its substantial Aboriginal and Torres Strait Islander communities. In the past three years, it has been the site of a significant right-wing electoral backlash against mainstream parties of the left and right, taken by many as a major political statement by an emergent white underclass. In this historical context, its teachers, teacher education programs, teacher unions, and professional organisations have maintained a strong, stated commitment to social justice, and have undertaken substantial work on critical literacy, "active citizenship," and other curriculum reforms.

The review was the third piece in a series of major policy developments undertaken by the state government—beginning with *Education 2010* (Education Queensland, 1999), the *School Restructuring Longitudinal Study* (Lingard et al., 2001), and the *New Basics* curriculum reform (Luke et al., 1999). The latter reform document actually implemented the New London "multiliteracies" (New London Group, 1996) in 36 trial schools, with about six million dollars in pilot funding over a four-year period. As this book goes to press, the government has expanded these trials to include an additional 20 schools in the "new basics" reform, including some key activist indigenous community schools.

The brief from the government for the literacy strategy was twofold. First, it outlined the conventional task of identifying strengths and weaknesses in classroom curriculum and instruction with an eye to the improvement of student literacy outcomes—similar to the work of Snow (Snow, Burns, & Griffin, 1998) and comparable reviews undertaken elsewhere. What set this review apart was our second brief. Following the state's overarching policy, we set out to develop a durable literacy strategy that considered and addressed the impacts of economic globalisation on Queensland children and youth—both the profound social effects of the unequal spread of capital and declining social infrastructure; the new skill and job demands generated by digital technologies; the shift to service and semiotic, information, and symbol-based economies; and the new forms of textual practice and identity in play on the Internet and with other communication technologies. These are not abstractions, but very real changed material and sociodemographic conditions for Queensland communities—with attendant changes in the "narratives" and grammars of peoples' life pathways. One important point is that we began the formation of a literacy strategy with a social and economic analysis of the changing demography, families, life pathways, and workforce of the state, augmenting this with the largest empirical study of classroom pedagogy in the history of Australian educational research (Lingard et al., 2001).

In addition to the overall shifts in youth culture, identity, and textual practice noted in other chapters in this volume, the emergence of globalised cyberkid culture in the Queensland context entailed the following:

- Highly spatialised poverty: 20% of families living below the "poverty" line, particularly in rural primary economy areas and indigenous areas but also in

low-wage mortgage belts; fringe cities where a white underclass has developed; gradual movement toward more of a binary divide in the distribution of wealth; and youth unemployment in these same areas of 60–80%.

- Changing job market: with casualisation, deunionisation, flexibilisation, out-sourcing, and subcontracting of the workforce; a proliferation of service and information work, both high and low paying; a shift from traditional male-dominated jobs requiring physical dexterity to semiotic, data, and social inter-actional skills; and a clear income and status divide between those professional jobs involving knowledge and discourse production and a service industry of low-paid information "end-users."

- Most specifically in relation to this chapter: a "de-linearisation" of life pathways from school to work and further education, employment, underemployment, and unemployment. That is, there are recursive, non-linear and somewhat less predictable life "trajectories" that indicate both the volatility of employment conditions, but as well the degree to which careers have become (for some) "de-signer portfolios" with switches, retrainings, re-entries, and withdrawals. Con-ventional government data are unable to account for where dropouts and grad-uates go, from what "streams" into what areas, when, how they return to education, with what capital and consequences. "Lifelong education" has be-come the normative cliché to explain something that researchers and govern-ments haven't fully documented and don't fully understand yet.

While schools continue to operate on an academic-vocational streaming system, assuming a postwar stability and predictable patterning of students' life trajectories into the workforce, a radical destabilisation, unpredictability, recur-sive, and non-linear set of life trajectories has emerged, driven by phenomena such as the advent of postfordist work in both the public and private sector; deteriora-tion of state-funded social infrastructure and capital within communities; and, however unintentionally, the opening, marketisation, and proletarianisation of higher education that attracts students to training and retraining which may or may not articulate to new economies and cultures.

So, this was what "new times" looked like in the context of Queensland—at the edge of empire and a willing but not major player in the push and pull effects of economic globalisation. There are two other not coincidental pieces of the puzzle:

- A highly spatialised "systematic underperformance" (Freebody & LoBianco, 1997) in literacy, with poverty and location being the strongest predictors of low test scores, high dropout rates, and poor overall achievement.

- A state system with falling "market share" embattled by a federal government seemingly bent on the steady and ongoing expansion of state funding, both legal and defacto, to Catholic and elite private schools.

To echo Gee's (2000a) response to Snow (2000), thinking of the improvement

of literacy outcomes principally in terms of pedagogy, instruction, and method, and not in terms of significant changes in the spatialised contexts of capital where literacy is acquired and used, is a way of "desituating" literacy. It also sets out a literacy policy as a short-term technocratic, readily manageable "fix" to what is a more medium term, embedded, and complex sociocultural matter. In sum, we wanted the Queensland strategy to have a strong social-justice orientation for dealing with the economic consequences of new conditions, and for preparing students for new economies, technologies, and cultures. But we also knew that it must stand as a means for that putatively democratic state educational system to revive and realign itself in relation to the "market threat" secured by expanding state support for private education.

Our four-month work program involved an analysis of student performance data from Queensland schools; a review of various other state, national, and regional approaches to literacy policy; and a statewide public and professional consultation that involved stakeholder consultation (with relevant professional organizations, universities, and others), public meetings and school visits across the state, and written submissions. As much as this could be taken as a "scientific" study of literacy standards, then, it was equally an exercise in public policy discourse formation and consensus building among the state's key educational constituencies and stakeholders. From the consultation, we collected and coded over 2,000 statements and slightly over 250 written positions for a discourse analysis of key words and themes. The report, *Literate Futures* (Luke, Freebody, & Land, 2000), was endorsed by the state Labor government in October 2000 and is currently under implementation. It focuses on the following four core strategies:

1. A statewide focus on "balanced approaches" to the teaching of reading based on the "four resources" model (Freebody & Luke, 1990; Luke & Freebody, 1997). This requires that teachers make principled decisions based on analyses of their students on the program balances between "coding," "semantic," "pragmatic," and "critical" practices of literacy. While it acknowledges the continued and urgent need for a coherent common vocabulary on reading instruction, the report does not assume that there is a universally effective or valid "method" or curricular commodity that will be relevant or worthwhile for all student communities.

2. A statewide focus on the development of whole school plans that includes analyses of local community linguistic and cultural resources, audits of teacher expertise, and community involvement. This requires that all schools develop whole school programs by the end of 2001. It also involves the setting of "distance-traveled" performance targets benchmarked against "like-schools" of similar community demographic and socioeconomic backgrounds. It encourages schools to discuss and negotiate progress with stakeholders and the school communities, but it opposes public publication of "league tables" that compare schools with incommensurate socioeconomic and demographic contexts.

3. A statewide focus on the introduction of "multiliteracies" blending information technologies and traditional print literacies (New London Group, 1996). This requires that teachers, schools, and the state system begin engaging with how the four resources model might also be adapted to deal with blended literacies required by online communications, mass media, and digital cultures.

4. A statewide focus on the regeneration of professional development to rebuild teachers' social networks and capital and facilitate intergenerational change between "baby boomers" and young teachers. This requires that the state system and schools rebuild and refocus their professional development resources and networks to achieve 1, 2, and 3, above.

Literate Futures thus sets out a different educational approach from that underway in many systems: in its refusal to get "sucked into" the reading wars debate, in its focus on school/community analyses and linkages, and in its focus on the capitalization on and development of teacher expertise. It is an attempt to reframe the professional development capacity of educational systems as teachers' "social capital" (Luke, Freebody, & Land, 2000). The strategy contrasts sharply with a "compliance approach" that targets short- and medium-term improvement of test scores via the standardization, surveillance, and control of teacher classroom behaviour and methods, such as that undertaken in the U.K. Literacy Hour and by several states in the United States. It is based on the premise that teacher learning and professionalisation, rather than deskilling and centralized control, have the potential for more flexible and sustainable approaches to these problems. Finally, its futures orientation is based on the assumption that an overly zealous focus on short-term surface performance gains may fail to engage with the educational challenges facing schools and systems, governments, and economies: across-the-board educational effects of new and persistent configurations of poverty; new textual and semiotic economies; blends of oral, print, and technologically mediated language and multiliteracies; and the large-scale generational shift in teacher population, expertise, and technological competence as school systems are handed over to Generations X and Y between 2005 and 2010.

Teachers' Views on New Times

Literate Futures begins from a sociological analysis of teachers' work and community contexts where student literacy is situated rather than a psychological analysis of the efficacy of methods. But it is also based on a broad thematic and content-based analysis of the statements of thousands of teachers. Taken as a group, the teachers we spoke to were perplexed by the new community, cultural, and economic conditions; yet they reproduced with great fluidity verbal, intellectual, and social deficit explanations of student failure. Comments such as the following were typical:

Many students can't string a sentence together so how do we then expect them to read or write one? The decrease in student ability is widespread and needs to be initially addressed by schools with a review of their place and function in the community. (Urban principal)

The upskilling of parents is needed. Many kids are not hearing adult language and are interacting primarily with other kids. When they cannot negotiate on an oral level, getting them to do so on the written level is vexing. (Urban teacher)

What we took away from the consultation was not a sense that the dominant explanation for failure was "wrong," but that the teachers and principals were struggling to come to grips with the effects of the very changes we described earlier, mining the available discourses from their staff rooms and teacher education experiences. We viewed their statements as evidence of the tenacity of particular species of deficit theory. In a telling presentation, a group of Queensland principals put it succinctly:

The sociocultural circumstances of modern families and childhood are not well enough understood by personnel working in schools. Pedagogy has not been altered sufficiently to meet the needs of a rapidly changing and diverse clientele.

In Australia, the United States, and the United Kingdom, the principal public debates over education have been over declining standards of traditional print literacy. These are broadly connected with a perception of declining student ability and confounded by new family and community configurations; purported deficits in preschool print experience and mainstream spoken language experience; and, indeed, by a multiplication of children ascertained as having learning disabilities, behavioral disorders, and/or other special education typification. Many teachers named the concomitants of failure to be single-parent homes, parental neglect, poor oral language development and early developmental lapses, and, interestingly, the deleterious effects of "electronic child minding," television, and videogames. We encountered many statements of what Carmen Luke in this volume describes as a classical "displacement hypothesis" from the media effects literature. For example:

Children don't receive enough social interaction. Computers, games and TV encourage passive interaction. (Urban teacher)

Our content and discourse analyses of interview and survey data searched for statements about new literacies and multiliteracies. Here we found a widespread support for print "critical literacy" and a few sympathetic comments for multiliteracies, but little articulation of what this might look like or how to go about making such a shift. Our public and statewide meetings did not draw one information technology or computer teacher.

Interactive communication skills need to be improved. A definition of literacy beyond print literacy is needed. (Teacher)

Exposure to different literacies is needed. What the community can offer students needs to be defined. The school does not have a mandate on literacy culture. There is a need for someone at the school level to monitor different types of literacy—those of the year 2000 will not be adequately responsive in the near future. It is the school's responsibility to monitor other world types of delivery, and to then integrate the best into their local setting. (Principal)

Strategies for change need to be forward thinking and progressive—the place of technology is pertinent and we will have to be flexible in order to evolve with society and not try to change it, or ignore technological advances. There has not been nearly enough discussion on what spelling will mean in the next ten years, and the place of spellcheckers in learning. Same for reading and viewing—viewing is not being focused on enough by teachers. A futures focus for curriculum is needed. (Principal)

And this was among the converted. Most of the teachers we spoke to, and the written and online briefs submitted to us, reflected no engagement with information and communication technologies (ICTs) or multiliteracies. In fact, quite the contrary: engagement with the new technologies was viewed as the cause of print deficit. We took this to be evidence that teachers are struggling with new conditions but lack new vocabularies for talking about community and workplace change and the pedagogical and educational possibilities of ICTs. There were signs of an educational will but a lack of available discourses.

As a result, many teachers are engaged in a misrepresentation and misrecognition of competence, where competence and engagement with new technologies is read off as individual deficit in old technologies—to be restored through a return to old cultures, pedagogies, and textual practices. When we tracked the overall patterns of teachers' claims through a discourse analysis of the data, the following story grammar emerged:

That adolescent behavioral and delinquency problems (social and educational problem) → [had their basis in] early literacy failure (pedagogical/curriculum problem) → [attributable to] deficit oral language competence on entry to school (community-based educational problem) → [caused by] deficit parenting (root soci-moral cause) → [which requires] early intervention (solution).

In this way, the new deficit models largely rely upon a particular species of twisted dialectical logic: that the new identities and material conditions, including changing life pathways of new times, are the negative product of individual deficits wrought by the moral neglect of parents, family, and community, and, to close the loop, new ICTs. In this way, too, the stress of print literacy-based policies (because they assume that a universal fix or instructional method is the optimal

approach) has the effect not only of sublimating or delaying an educational and curricular engagement with fandom, critical media literacies, cyberidentities, and connectivities, but also blames these things for the apparent erosion of traditional print literacy.

Hence, among Queensland teachers there is a powerful logic of deficit: that the failure at print literacy is caused by participation in popular culture, engagement with non-canonical text forms. This sits alongside a traditional "displacement hypothesis" that time spent online or playing videogames is time not spent on reading and writing. Faced with such patterns of teacher belief in a kind of technological causation of print literacy problems, the strategy of choice in state policies internationally is an early inoculation model in print literacy and its accompanying forms of moral discipline, with a particular focus on those who show the most symptomatic psychometric evidence of deficit. Not surprisingly, this tends to be the bottom quartile of children living at or below the poverty line, those children whose families and life pathways have been most adversely affected or neglected by the expansion of the new economies.

Given these socioeconomic conditions, we could ask humbly what chances any new strategy has of actually making a difference—particularly given the dearth of actual materials, strategies, and actual classroom techniques for teaching new literacies. Much of this depends on the capacity of groups such as the authors in this volume to generate possible pedagogical directions, and new, practicable vocabulary. In another Queensland observational study of 1,000 classrooms, we found that those teachers who were actually ready to engage with various forms of online identity and texts appear to be doing so through an almost chaotic educational bricolage (Lingard et al., 2001). There is a beginning vocabulary for talking about the media, but no conceptual or practical frameworks for guiding the mix or blending of print and nonprint, visual, and non-visual engagements. We were likely to see kids answering questions on worksheets using the web as a library resource, or confused and mixed multimedia projects, such as one that involved looking up different multicultural costumes on the web, making puppets out of pipe cleaners, and then presenting them as a developmental drama exercise to the class. Even among the 36 schools designated last year to implement "multiliteracies," we have found a lack of resources. There is simply a vacuum in professional development resources and materials for dealing with the new literacies, beyond the button-pushing introductions to instructional technology (IT).

I have argued that in addition to the pedagogic events in classrooms, literacies are situated within two overlapping contexts: first, within the overall economic and cultural changes within local and regional communities; and second, within the enabling and disabling contexts of state educational policies. I then described the attempt we made to engage with new literacies in the Queensland state strategy and the extent to which teachers who were struggling to explain the consequential effects of new and old literacies reverted to discourses of print deficit.

The last section of this chapter deals with neoliberal educational policy. Here I want to make the case that the problem is not just teacher generational resistance.

Instead, it would appear that current policy settings act both to sublimate and cancel multiliteracies, while maintaining a significant potential to appropriate and domesticate them into the familiar pedagogical forms and practices of technocratic print literacies.

New Literacies and New Liberalism

First, a quick primer on educational policy. Educational policy-making itself consists of the mediation, regulation, and surveillance of flows of discourse, materials, and bodies across systems towards identifiable normative ends. The way that we regulate, block, and enable these flows sets up rules of conversion for capital by students in the fields of schools, civic institutions, and workplaces. Curriculum and assessment policy enables particular blends of positioning, self-positioning, and disposition in the social fields of schools, which may be isomorphic or have some relation to other social fields. One of the lessons of the previous section is that there may be little direct correspondence between curriculum and other social fields: the instruction in some Queensland schools shows signs of relative autonomy and complete obliviousness to changes in the social fields of workplaces and governmentality. In this way, policy and curriculum reform are both classic cases of the unruliness of local sites of discourse, with the curriculum-in-use as constructed interactionally by teachers and students in classrooms and lessons both the subject and at times obstinately resistant and idiosyncratic object of policy generated from the "centers" of state parliaments and bureaucracies.

The term "neoliberal" refers to the free-market and "trickle-down" economics, and deregulation of state enterprises of conservative U.K. and U.S. governments in the 1980s—moves that have been subjected to two decades of critique. But what is interesting is the degree to which the term is still treated as emergent by many educators. Quite the contrary, many state and local governments are confronting the issue of what to do "after the marketplace." Consider the conditions in Queensland that I described earlier, including growth and high-employment economies with fundamental losses in real wage growth, evidence of increased binarisation of wealth, and the significant differentiation of a high-income "high-tech" sector from a low-income service, entry-level information sector. Managing these in an environment where publicly funded and supported social capital—including the education system—has been stripped, is difficult.

But if the cliché of the 1980s was that there is no space outside of multinational capitalism, the cliché of 2000 should be that there is no form of governance outside of new liberal corporatism. The patterns of "millennial capitalism" (Comaroff & Comaroff, 2000) are no longer disorganized and chaotic (if they ever were), but have reformed in some clearly identifiable ways. Across educational systems, there are two basic goals that work in various mixes to frame the flows of resources. Almost all nation states, and NGOs like the World Bank and Asia Development

Bank, have mandated "structural adjustment programs" for the production of human capital and the attraction and expansion of multinational corporate capital. At the same time, social democratic and left-leaning governments and NGOs also run ameliorative educational programs whose purpose is to mop up the deleterious social, ecological, and cultural effects of the same capital that they are vying to attract. In this way, the attraction and amelioration functions drive current government dispositions towards capital.

Corporate managerialism has had parallel impacts on public-sector bureaucracies and traditionally state-run and state-sponsored enterprises; and on work in historically feminised "helping professions" such as social welfare, nursing, and child-care. It has extended to school-based management, to higher education administration and teaching, and to teacher education. Among its well-documented characteristics are:

- *Cultures of performativity:* that is, accountability for state and corporate expenditure is reported via multilevel performance and feedback systems using simplified assessment data ("performance indicators"); adjudication is done through discourses of "quality assurance."
- *Steering from a distance:* that is, regulative, labor-intensive bureaucracies yield to "lean" local management structures with accountability to the "centre" established through data-driven surveillance, as above.
- *Output-based funding:* that is, increasingly scarce public funding is provided not on the basis of traditional input measures (e.g., student numbers, community demography and geography, staffing entitlements, institutional profile, and mission) but through quantifiable outcomes (e.g., test scores, graduates, exit-survey data, and client satisfaction).
- *Marketisation:* the construction of educational systems of (consumer/client/student) "choice" within differentiated institutional fields of traditional and alternative state-subsidised and corporate providers selling commodified knowledge and credentials.

The first wave of 1980s neoliberal reforms argued that "deregulation" and "decentralization" would free up management to develop differentiated, locally responsive, and entrepreneurial institutions. There is a persistent argument that market "choice" will yield more equitable levels of access, participation, and achievement than traditional state systems (Soucek, 1999), despite evidence to the contrary that marketisation is as effective a mechanism for the production of unequal educational effects as previous models ever might have been. Nineteen eighties reforms purported that these were attempts to move systems "beyond ideology." Two decades later it is apparent that this strategy is in and of itself a political and social ideology, building particular institutional ethos and cultures that permeate down to the experiences of students and teachers in classrooms and staff rooms. Although many of these reforms have been taken over by "third way" governments with ostensive commitments to

social justice, the behavioural effects of such systems are simple: to run educators and educational systems around in pursuit of stronger output indicators and improved competitive rankings.

This said, I want to make two points about the implications of these approaches for ICTs and new literacies. First, the expansion and rationalization of new management and marketisation have relied upon the construction and documentation of crisis in traditional competences such as print literacy and numeracy. The market is actually conceived of as an immanent construction without any natural steady state—continually becoming and expanding, continually engaged in a narrative of cleaning up the incompetence and inflexibility of pre-market systems. In this way, current strategies of marketisation are contingent upon a "crisis" requiring a curiously parasitic mix of direct government intervention (often highly regulatory and centrally directive, despite supposed neoliberal opposition to regulatory regimes) that often spurs the desire and demand for new pedagogic products. This inherent instability of market-based reform driven, without a trace of irony, from the governmental centre and visible in the continual discourses of risk, is another manifestation of what Comaroff and Comaroff (2000) refer to as "casino capitalism."

By contrast, the mid-20th century Deweyian model of democratic state education was premised on the stability and knowability of common curriculum, of shared competence, and of identifiable parameters of practical citizenship. Markets place us in a continual state of "lack" and becoming. It shouldn't be surprising, then, that one of the key policy moves is to ferret out the non-performers (both individuals and schools) in the production and reproduction of traditional print literacies. As I noted at the beginning of this chapter, to date, most neoliberal policies have neglected multiliteracies. The strong orientations toward "countability" and efficiency—shared by both traditional technocratic approaches to education and neoliberal approaches to educational governance and management—set in place a systemic proclivity toward print literacy, which, following a century of technical instrumentation and curricular commodification, is ostensibly "countable" and "accountable" in ways that newer repertoires of practice have yet to become.

The second point, then, is that we need to theoretically and institutionally model and critique the emergent relationships among the new literacies, the textual practices and discourses of the new information technologies, and neoliberal governance. If we return to Barton, Hamilton, and Ivanic's (2000, p. 1) definition of situated literacies, the question is how the new textual practices described in the other chapters in this volume connect with what Barton called "broader social structuring." One approach is to engage in an analysis of the texts and interactions that kids produce with ICTs and attempt to "read off" broader implications for economy, habitus, and social position. My point is that we also need to assess and anticipate how the intermediary political economy of schooling and educational policy remediates the new literacies into official knowledge.

A key analytic strategy is to take neoliberal governance not simply as a political economic strategy but more as a Discourse in Gee's (1996b) sense—a form of life

with particular ritual statements, practices, and regularities. This move enables us to ask whether there is in fact a much more clear correspondence emerging not between curriculum content and new work orders, but between the structuring and management of educational systems—and, indeed, the experience of being and becoming a performance indicator or surveilled "output" in any such system—new work orders where service and information workers do their daily business.

Certainly, there is no doubt that technological compression of space and time, the instantaneous archive, and the globalisation of the flow of information have enabled the reorganisation of labor. An increasing number of people in the North and West economies are learning to work within corporate, civic, and governmental systems that operate according to the same principles as the new educational systems. That is, more and more of us are active participants in systems of governmentality; and experts in quality assurance, in ISO 2002 checks, in the flow of information and surveillance, and in outsourced small, loosely coupled organisations, busily entering our data so that we might be "steered from a distance," or rather steer ourselves. The question here is whether the overall reproductive function of education has been turned into the reproduction of forms of neoliberal forms of life—with accountancy, learning organizations, and MBAs at the fore, and e-edubusiness taking its place of privilege. The further question, an anomaly that has perhaps been understated in the extensive humanist and radical educational critiques of neoliberalism, is whether this particular approach to educational governance in the postindustrial nation state is in fact doing even an adequate job of serving the interests of emergent capital in the new economies.

The issues become even more complex if we draw from the treatment of print literacies patterns for the "domestication" and management of the definition and implementation of multiliteracies. These patterns would suggest that the new literacies are likely to be:

- *Commodified and marketised:* through syllabus documents, print/online CD-ROM, e-educational businesses as traditional print publishers move quickly into the new markets opened up by new pedagogies and technologies.
- *Privatized:* where teachers will increasingly source materials from the very private sector information multinationals whose semiotic products dominate workplaces, work practices, and governmentality.
- *Performance managed:* where the new literacies will be coded into standardised performance measures for centralised compilation, analysis, and monitoring.
- *Steered from a distance:* where schools, districts, and teachers will be funded (or perhaps unfounded) by their capacity to produce quantifiable outcomes with the new literacies.

To return to the Gee (2000a) and Snow (2000) debate, this scenario implies that particular research paradigms for defining and researching new literacies and

ICTs are probably better adapted to generate the avalanche of numbers (that is, "evidence") that will be required to domesticate these new literacies; that we can expect governmental selection of those approaches that "desituate" literacies and reduce them to replicable pedagogies and methods. Yet the policy contexts I have described are not without significant silences, contradictions, and open spaces. Not surprisingly, the fully privatized and marketised sectors of the education system tend to respond with greater speed, flexibility, and capital to new technologies, while state systems typically latch new competences into long-wave Tylerian curriculum development and implementation cycles.

I have made the case here that the problem of failure to engage with the new technologies and new literacies may not be simply a matter of teacher resistance, backwardness, and unpreparedness. Certainly, there needs to be a strong professional and pedagogic focus on engagement with new literacies and their potentials, as many in this volume argue. But the blockage is in part the result of the complementarity between neoliberal governance and the teaching, monitoring, and reproduction of print literacy. The highly sophisticated and historically evolved practices for teaching and assessing print literacy—the product of a century of reading research and based on the neutral sciences invoked by Snow—have a tightly coordinated set of historical convections with neoliberal governance and systems reforms. There are sophisticated technologies for making print literacy countable and accountable, and to a significant extent, educational systems will not make the jump into new technologies until they can be fully integrated into such administrative regimes.

This explanation calls into question a range of the stated and implied strategies that we have been pursuing. I have already begun second-guessing the problems we will have created in Queensland by "mandating" multiliteracies: Will they lead to an appropriation, a repressive tolerance of multiliteracies and a capturing of the unruly, unpredictable, and potentially critical possibilities described throughout this volume? Will we next encounter the appearance of the "zines" described by Knobel and Lankshear as forms of official knowledge? These and other emergent genres have already been appropriated and commercialized by entertainment multinationals. Would educational publishers and state governments be far behind?

Silence and neglect in policy can create huge spaces for local curricular development. For example, the key developments in critical literacy and media literacy in Queensland were enabled precisely because of a loosely enforced curriculum and low-stakes assessment environment in literacy. This result is hardly ideal. But it does suggest that attempts at high definition, tightly coupled educational governance may actually preclude innovation and development.

A powerful scenario to consider, then, is to continue to neglect the new technologies and new literacies as curricular domains, to allow industrialist, creaking print systems to wind down and out; not to colonize the space of chaotic and unequal development of IT competence; and to await the year 2005 and beyond, when a generation of teachers' primary discourses will include engagement with new technologies. In this scenario, we would maintain a focus on multiliteracies

for pedagogic and textual design and seed it with trainee teachers and through professional development—but avoid defining them as forms of official knowledge precisely to preclude atomization, marketisation, and assessment as part of state and capital performativity. At the same time, we would need to continue theoretically to explore the relationships between media and discipline and empirically to explore students' situated blendings of different literacies in practice in classrooms and communities. But we would halt our attempts to 'gain an official space' for multiliteracies.

In his analysis of the emergence of "choice, charter, and market," Soucek provides an overview of what he calls the "strategic manipulative action" of neoliberal capitalism. Its principal stated goals are to "democratize and liberate education from the shackles of state bureaucracies, to encourage innovation, promote effectiveness and efficiency, empower consumers of education" (Soucek, 1999, p. 223). So this approach to educational governance begins from an egalitarian appeal, when in fact the evidence suggests to us that it is generating a more "dramatic correspondence between spatialised poverty and class, credentials and labour markets." One of the failures of educational theorists and researchers has been our incapacity to come up with an alternative to neoliberal governance—that is, to refurbish and renew and exemplify what a neo-democratic state educational system serving a divided but not fully determined semiotic democracy might look like.

When the New London Group (1996) was debating the initial formulation of multiliteracies in New London, one of the very deliberate strategies was to come up with a vocabulary that would be both enabling to capital and the new work orders—that is, for the enfranchisement of marginalised communities—while retaining the centrality of critique, social analysis, and community transformation. Until we situate our vision of the ICTs and multiliteracies within a much more rigorous theorisation of the undoing of the school, of public education as manageable and managed institution in relation to new economies and new identities and new communities, we risk engaging in a designer activity. Without such a vision, it is more likely that the new texts, practices, and identities that we describe in this volume will simply be appropriated, however meekly or aggressively, by the forms of governance that have led schools and educational systems to their present retro state. And the next thing we know, educational systems will awaken from their generational slumber and begin the serious task of domesticating the new literacies, of developing standardised measures on multiliteracies to ensure and verify their inequitable production through the deployment of the first generation of IT-based multinational curriculum packages.

REFERENCES

Abercrombie, N., & Longhurst, B. (1998). *Audiences: A sociological theory of performance and imagination*. Thousand Oaks, CA: Sage.

Abbey Records. (2000). MusicEzine. Downloaded December 26, 2000. Available: http://www.musicezine.com

Adler, R. (1997). *The future of advertising: New approaches to the attention economy*. Washington, DC: The Aspen Institute.

Adoni, H. (1995). Literacy and reading in a multimedia environment. *Journal of Communication, 45*(2), 152–174.

Allington, R. (1994). What's special about special programs for children who find learning to read difficult? *Journal of Reading Behavior, 26*, 95–115.

Alloway, N., & Gilbert, P. (1998). Video game culture: Playing with masculinity, violence and pleasure. In S. Howard (Ed.), *Wired up: Young people and the electronic media* (pp. 95–114). London: UCL Press.

Alvermann, D. E. (1998). Imagining the possibilities. In D. E. Alvermann, K. A. Hinchman, D. W. Moore, S. F. Phelps, & D. R. Waff (Eds.), *Reconceptualizing the literacies in adolescents' lives* (pp. 353–372). Mahwah, NJ: Erlbaum.

Alvermann, D. E., Hagood, M. C., Heron, A. H., Hughes, P., Williams, K., & Yoon, J. (2001). *After-school media clubs for struggling adolescent readers: A study of youths' critical awareness*. Unpublished manuscript, University of Georgia, Athens.

Alvermann, D. E., Hagood, M.C. & Williams, K. B. (2001, June). Image, language, and sound: Making meaning with popular culture texts. *Reading Online, 4*(11). Available: www.readingonline.org/newliteracies/lit_index.asp.html

Alvermann, D. E., Moon, J. S., & Hagood, M.C. (1999). *Popular culture in the classroom: Teaching and researching critical media literacy*. Newark, DE: International Reading Association.

Anderson, J. (1988). *The education of blacks in the south, 1860–1935*. Chapel Hill: University of North Carolina Press.

Angel, J. (1999). *The zine yearbook: Vol. 3*. Mentor, OH: Become the Media.

Appadurai, A. (1990). Disjuncture and difference in the global cultural economy. In M. Featherstone (Ed.), *Global culture* (pp. 295–310). London: Sage.

Appadurai, A. (2000). Grassroots globalisation and the research imagination. *Public Culture 12*(2), 1–20.

Apple, M. W. (1988). *Teachers & texts: A political economy of class & gender relations in education*. New York: Routledge.

Apple, M. W. (1996). *Cultural politics and education*. New York: Teachers College Press.

Apple, M. W. (1998). The culture and commerce of the textbook. In L. E. Beyer & M. W. Apple (Eds.), *The curriculum: Problems, politics, and possibilities* (2nd ed., pp. 157–176). Albany: State University of New York Press.

Applebee, A. (1996). *Curriculum as conversation: Transforming traditions of teaching and learning*. Chicago: University of Chicago Press.

Athena. (2000). *Bombs for breakfast*. Downloaded November 19, 2000. Available: http://www.bombsforbreakfast.com/

Bail, K. (1997, May). Deskbottom publishing. *The Australian Magazine*, 3–4, 44.

Bakhtin, M. (1981). *The dialogic imagination: Four essays*. (C. Emerson & M. Holquist, Trans.). Austin: University of Texas Press.

Barksdale, M., & King, J. (2000). *At risk in early intervention: The construction of error and accuracy in shared writing*. Unpublished manuscript, University of South Florida, Tampa.

Barna, G. (1997). *Generation next: What you need to know about today's youth*. Ventura, CA: Regal Books.

Barrett, E. (Ed.). (1989). *The society of text: Hypertext, hypermedia, and the social construction of information*. Cambridge: MIT Press.

Barthes, R. (1985). *From speech to writing: The grain of the voice*. New York: Hill and Wang.

Barton, D. (1994). *Literacy: An introduction to the ecology of written language*. Cambridge, MA: Blackwell.

Barton, D. (2000). Researching literacy practices. In D. Barton, M. Hamilton, & R. Ivanic (Eds.), *Situated literacies: Reading and writing in context* (pp. 167–179). New York: Routledge.

Barton, D., & Hamilton, M. (2000). Literacy practices. In D. Barton, M. Hamilton, & R. Ivanic (Eds.), *Situated literacies: Reading and writing in context* (pp. 7–15). New York: Routledge.

Barton, D., Hamilton, M., & Ivanic, R. (Eds.). (2000). *Situated literacies: Reading and writing in context*. London: Routledge.

Beach, R., & Myers, J. (2001). *Inquiry-based English instruction: Engaging students in life and literature*. New York: Teachers College Press.

Bean, T. W., Bean, S. K., & Bean, K. F. (1999). Intergenerational conversations and two adolescents' multiple literacies: Implications for redefining content area literacy. *Journal of Adolescent & Adult Literacy, 42*, 438–448.

The Beatles. (2000). *The Beatles 1* [CD]. New York: Capitol Records.

Berliner, D. C., & Biddle, B. J. (1996). *The manufactured crisis: Myths, fraud, and the attack on America's public schools*. Reading, MA: Addison-Wesley.

Bigum, B., & Green, C. (1993). Aliens in the classroom. *Australian Journal of Education, 37*, 119–141.

Bishop, A. P., Bazzell, I., Mehra, B., & Smith C. (2001, April). Afya: Social and digital technologies that reach across the digital divide. *First Monday, 6*(4). Available: http://www.firstmonday.dk/issues/issue6_4/bishop/

Bishop, A. P., Mehra, B., Bazzell, I., & Smith, C. (in press). Participatory action research and digital libraries: Reconsidering evaluation. In A. P. Bishop, N. Van House, & B. Buttenfield (Eds.), *Digital library use: Social practice in design and evaluation*. Cambridge: MIT Press.

Blink 182 (1999). *Enemy of the state* [CD]. New York: MCA Records.

Block, F., & Carlip, H. (1998). *Zine scene: The do it yourself guide to zines*. Los Angeles: Girl Press.

Bloustien, G. (1998). "It's different to a mirror 'cos it talks to you": Teenage girls, video cameras, and identity. In S. Howard (Ed.), *Wired up: Young people and the electronic media* (pp. 115–134). London: UCL Press.

Bolter, J., & Grusin, R. (2000). *Re-mediation: Understanding new media*. Boston: MIT Press.

Bolter, J., Smith, J., & Joyce, M. (1990). *StorySpace*. Cambridge: Eastgate.

Bowles, S., & Gintis, H. (1976). *Schooling in capitalist America: Educational reform and the contradictions of economic life*. New York: Basic Books.

Braidotti, R. (1994). *Nomadic subjects: Embodiment and sexual difference in contemporary feminist theory*. New York: Columbia University Press.

Brand, S. (1999). *The clock of the long now*. New York: Basic Books.

Brooks, D. (2000). *Bobos in paradise: The new upper class and how they got there*. New York: Simon and Schuster.

Brooks, D. (2001, April). The organization kid. *The Atlantic Monthly*, 40–54.

Brooks-Gunn, J., & Reiter, E. O. (1990). The role of pubertal processes. In S. S. Feldman & G. R. Elliott (Eds.), *At the threshold: The developing adolescent* (pp. 16–53). Cambridge: Harvard University Press.

Brown, A. L. (1994). The advancement of learning. *Educational Researcher 23*, 4–12.

Bruce, B. C. (1997). Literacy technologies: What stance should we take? *Journal of Literacy Research, 29*(2), 289–309.

Bruce, B. C. (1998). New literacies. *Journal of Adolescent and Adult Literacy, 42*(1), 46–49. Available: http://www.readingonline.org/electronic/jaal/author.html

Bruce, B. C. (in press). New technologies and social change: Learning in the global cyberage. In L. Bresler & A. Ardichvili (Eds.), *Research in international education*. New York: Peter Lang.

Bruce, B. C., & Davidson, J. (1996). An inquiry model for literacy across the curriculum. *Journal of Curriculum Studies, 28*, 281–300.

Bruce, B. C., & Easley, J. A., Jr. (2000). Emerging communities of practice: Collaboration and communication in action research. *Educational Action Research, 8*(2), 243–259. Available: http://www.lis.uiuc.edu/~chip/pubs/easley/

Bruce, B. C., & Hogan, M. P. (1998). The disappearance of technology: Toward an ecological model of literacy. In D. Reinking, M. C. McKenna, L. D. Labbo, & R. D. Kieffer (Eds.), *Handbook of literacy and technology: Transformations in a post-typographic world* (pp. 253–268). Mahwah, NJ: Erlbaum.

Bruce, B. C., & Rubin, A. (1993). *Electronic quills: A situated evaluation of using computers for writing in classrooms*. Hillsdale, NJ: Erlbaum.

Bruer, J. T. (1993). *Schools for thought: A science of learning in the classroom*. Cambridge: MIT Press.

Bruner, J. (1990). *Acts of meaning*. Cambridge: Harvard University Press.

Buchanan, I. (1993) Extraordinary spaces in ordinary places: de Certeau and the space of post-colonialism. *SPAN, 36*. Downloaded December 4, 2000. Available: http://wwwmcc.murdoch.edu.au/ReadingRoom/litserv/SPAN/36/Jabba.html

Buckingham, D. (Ed.). (1998). *Teaching popular culture*. London: University College London Press.

Buckingham, D., & Sefton-Green, J. (Eds.). (1994). *Cultural studies goes to school*. London: Taylor & Francis.

Buckingham, D., & Sefton-Green, J. (1998). Introduction. In S. Howard (Ed.), *Wired up: Young people and the electronic media* (pp. vii–ix). London: UCL Press.

Burbules, N. C. (1998). Digital texts and the future of scholarly writing and publication. *Journal of Curriculum Studies, 30*(1), 105–124.

Burbules, N. C., & Bruce, B. C. (1995, November) This is not a paper. *Educational Researcher, 24*(8), 12–18.

Burbules, N., & Callister, T. (2000). *Watch IT: The risky promises and promising risks of new information technologies in education*. Boulder, CO: Westview Press.

Butler, J. (1993). *Bodies that matter*. New York: Routledge.

Caleb. (2000). *archáologie francaise*. (Issue 1). (zine; no publication source given)

Callister, T. (2000). Media literacy: on-ramp to the literacy of the 21st century or cul-de-sac on the information superhighway? In A. W. Pailliotet & P. Mosenthal (Eds.), *Reconceptualizing literacy in the media age* (pp. 403–420). Stamford, CT: JAI Press.

Carlip, H. (1995). *Girl power: Young women speak out*. New York: Warner Books.

Carter, C. S. (1999, December). *Education and development in poor rural communities: An interdisciplinary research agenda*. Report No. EDO-RC-99-9. (Available: http://www.ael.org/eric/digests/edorc999.htm)

CBC Television (2000). *Our hero*. Downloaded 22 November, 2000. Available:http://www.ourherotv.com/home.shtml

Chu, J. (1997). Navigating the media environment: How youth claim a place through zines. *Social Justice, 24*(3), 71–85.

Ciara. (2000). *A renegade's handbook to love and sabotage*. (Issue 1). Portland, OR: Ciara.

Cognition and Technology Group at Vanderbilt University. (1994). Multimedia environments for developing literacy in at-risk students. In B. Means (Ed.), *Technology and education reform: The reality behind the promise* (pp. 23–56). San Francisco, CA: Jossey-Bass.

Cole, M. (1996). *Cultural psychology*. Cambridge: Harvard University Press.

Coleman, J. S. (1961). *The adolescent society*. New York: Free Press.

Collins, J. (1998). *Strategies for struggling writers*. New York: Guilford Press.

Collins, P. H. (1991). *Black feminist thought: Knowledge, consciousness, and the politics of empowerment*. New York: Routledge.

Comaroff, J., & Comaroff, J. F. (2000). Millennial capitalism: First thoughts on a second coming. *Public Culture 12*(2), 291–343.

Comer, J. P. (1993). The potential effects of community organizations on the future of our youth. In R. Takanishi (Ed.), *Adolescence in the 1990s* (pp. 203–206). New York: Teachers College Press.

Conroy, P. (1987). *The water is wide*. New York: Bantam.

Considine, A. (2000). Media literacy as evolution and revolution: In the culture, climate, and context of American education. In A. W. Pailliotet & P. Mosenthal (Eds.), *Reconceptualizing literacy in the media age* (pp. 299–327). Stamford, CT: JAI Press.

Contractor, N. S., & Seibold, D. R. (1993). Theoretical frameworks for the study of structuring processes in group decision support systems: Adaptive structuration theory and self-organizing systems theory. *Human Communication Research, 19*, 528–563.

Cope, B., & Kalantzis, M. (Eds.). (2000). *Multiliteracies: Literacy learning and the design of social futures*. London: Routledge.

Coupland, D. (1991). *Generation X: Tales for an accelerated culture*. New York: St. Martin's Press.

Coupland, D. (1995). *Microserfs*. New York: Regan Books.

Craig, S. C., & Bennett, S. E. (Eds.). (1997). *After the boom: The politics of Generation X*. Lanham, MD: Rowman and Littlefield.

Crispell, D. (1993, May 1). Where generations divide: A guide. *American Demographics*. Retrieved May 8, 2001. Available: http://www.demographics.com

Cross, R. (1996). Geekgirl: Why grrrls need modems. In K. Bail (Ed.), *DIY feminism* (pp. 77–86). Sydney: Allen & Unwin.

Cuban, L. (1993). *How teachers taught: Constancy and change in American classrooms 1890–1990*. New York: Teachers College Press.

Daly, S., & Wice, N. (1995). *alt.culture: An A-to-Z guide to the '90s—underground, online, and over-the-counter*. New York: HarperCollins.

Darrah, C., English-Lueck, J. & Freeman, J. (2000). *Living in the eye of the storm: Controlling the maelstrom in Silicon* Valley. (Available: http://www.sjsu.edu/depts/anthropology/svcp/SVCPmail.html)

Dasenbrook, R. W. (2001). *Truth and consequences: Intentions, conventions, and the new thematics*. University Park: Pennsylvania State University Press.

Davidson, D. (1984). *Inquiries into truth and interpretation*. Oxford: Clarendon Press.

Davies, B. (1993). *Shards of glass: Children reading and writing beyond gendered identities*. Sydney: Allen & Unwin.

de Castell, S. (1996). On finding one's place in the text: Literacy as a technology of self-formation. In W. F. Pinar (Ed.), *Contemporary curriculum discourses: Twenty years of JCT* (pp. 398–411). New York: Peter Lang.

de Certeau, M. (1984). *The practice of everyday life*. (Vol. 1). Berkeley: University of California Press.

de Certeau, M. (1997). *The capture of speech and other political writings*. (Trans. Tom Conley). Minneapolis: University of Minnesota Press.

de Certeau, M., Giard, L., y Mayol, P. (1999). *La Invención de lo Cotidiano. 2. Habitar, Cocinar*. (Trans. Alejandro Pescador). (2nd ed.). (*The practice of everyday life: Living and cooking*). México, D.F.: Universidad Iberoamericana.

Dembeck, C. (2000, June 2). Internet boosts overall book sales. *E-Commerce Times*. Available: http://www.ecommercetimes.com/

Denzin, N. (1997). *Interpretive ethnography: Ethnographic practices for the 21st century*. Thousand Oaks, CA: Sage.

de Pourbaix, R. (2000). Emergent literacy practices in an electronic community. In D. Barton, M. Hamilton, & R. Ivanic (Eds.), *Situated literacies: Reading and writing in context* (pp. 125–148). New York and London: Routledge.

DeSantis, C. (1997). Foreword. In V. Kalmar, *Start your own zine*. New York: Hyperion.

Dewey, J. (1938). *Experience and education*. New York: Collier Books.

Dewey, J. (1956). *The child and the curriculum/The school and society*. Chicago: University of Chicago Press. (Original work published 1902 and 1915.)

Dewey, J. (1966). *Democracy and education*. New York: Macmillan. (Original work published 1916.)

Dewey, J., & Bentley, A. (1949). *Knowing and the known*. Boston: Beacon Press.

Digitarts. (2000). Front page. Downloaded January 1, 2000. Available: http://digitarts.va.com.au

Dillon, D. R. (2001). *Katie: A case study on one millennial*. Research in progress.

Doering, A., & Beach, R. (2001). *Preservice English teachers acquiring literacy practices*. Paper presented at the annual meeting of the American Educational Research Association, New Orleans.

Drucker, P. F. (1994, November). The age of social transformation. *The Atlantic Monthly*, 53–80.

Drucker, P. F. (1999). *Management challenges for the 21st century*. New York: Harper Business.

D'Souza, D. (2000). *The virtue of prosperity: Finding values in an age of techno-affluence*. New York: Free Press.

Duncombe, S. (1997). *Notes from the underground: Zines and the politics of alternative culture*. New York: Verso.

Duncombe, S. (1999, December). DIY Nike style: Zines and the corporate world. *Z Magazine*. Downloaded January 4, 2001. Available: http://www.lol.shareworld.com/Zmag/articles/dec1999duncombe.htm

Education Queensland. (1999). *Education 2010*. Brisbane: Education Queensland. Available: http://www.qed.qld.gov.au

Ellul, J. (1973). *The technological society*. [Trans. J. Wilkinson]. New York: Knopf (Orig. English, 1964; French, 1954.)

Ellul, J. (1980). *The technological system* (Trans. J. Neugroschel). New York: Continuum. (Orig. French, 1977.)

Emode. Available: http://www.emode.com

Engestrom, Y. (1987). *Learning by expanding: An activity theoretical approach to developmental research*. Helsinki: Orienta-Konsultit.

Epstein, J. S. (Ed.). (1998). *Youth culture: Identity in a postmodern world*. Malden, MA: Blackwell.

Ethnologue. (2001). Available: http://www.ethnologue.com/

Farkas, S. (1997). Kids these days: What Americans really think about the next generation. New York: Public Agenda.

Feldman, S., & Elliott, G. (1990). *At the threshold: The developing adolescent*. Cambridge: Harvard University Press.

Finders, M. (1997). *Just girls: Hidden literacies and life in junior high*. New York: Teachers College Press.

Finders, M. (1998). Raging hormones. *Journal of Adolescent & Adult Literacy, 42*, 252–263.

Fine, M., Macpherson, K. (1993). Over dinner: Feminism and adolescent female bodies. In S. Biklen & D. Pollard (Eds.), *Gender and education: Ninety-second yearbook of the National Society for the Study of Education* (pp. 126–154). Chicago: University of Chicago Press.

Flood, J., & Lapp, D. (1995). Broadening the lens: Toward an expanded conceptualization of literacy. In K. A. Hinchman, D. J. Leu, & C. K. Kinzer (Eds.), *Perspectives on literacy research and practices* (pp. 1–16). Chicago: National Reading Conference.

Flower, L., Long, E., & Higgins, L. (2000). *Learning to rival: A literate practice for intercultural inquiry*. Mahwah, NJ: Erlbaum.

Foucault, M. (1980). *Power/knowledge: Selected interviews and other writings 1972–1977*. New York: Pantheon Books.

Frank, R. H., & Cook, P. J. 1995. *The winner-take-all society: How more and more Americans compete for ever fewer and bigger prizes, encouraging economic waste, income inequality, and an impoverished cultural life*. New York: Free Press.

Frank, T. (1997). *The conquest of cool: Business culture, counterculture, and the rise of hip consumerism*. Chicago: University of Chicago Press.

Freebody, P., & LoBianco, J. (1997). *Australian literacies*. Canberra: National Languages and Literacy Institute of Australia.

Freebody, P., & Luke, A. (1990). Literacies programs: Debates and demands in cultural context. *Prospect: Australian Journal of TESOL 5*(7), 7–16.

Friedman, T. (1999). *The lexus and the olive tree: Understanding globalization*. New York: Anchor Books.

Frontline. *Merchants of cool: A report on the creators and marketers of popular culture for teenagers*. (n.d.). Retrieved February 4, 2001. Available:http://www.pbs.org/wgbh/pages/frontline/shows/cool/

Fukuyama, F. (1999). *The great disruption: Human nature and the reconstruction of social order*. New York: Free Press.

Gabriell. (n.d.). typically. . . .*grrowl*. (Issue 3). Downloaded January 1, 2001. Available: http://digitarts.va.com.au/grrrowl4/gabriell/typicalday.html

Gardyn, R. (2001, April 1). Granddaughters of feminism. *American Demographics*. Retrieved May 8, 2001. Available: http://www.demographics.com

Garner, R., & Gillingham, M. (1996). *Internet communication in six classrooms: Communication across time, space, and culture*. Mahwah, NJ: Erlbaum.

Garner, R., Zhao, Y., & Gillingham, M. (Eds.). (in press). *Hanging out: After-school child care in different communities*. Westport, CT: Greenwood.

Gee, J. P. (1996a). On robots and classrooms: The converging languages of the new capitalism and schooling. *Organization, 3*(3), 385–407.

Gee, J. P. (1996b). *Social linguistics and literacies: Ideology in discourses* (2nd ed.). Bristol, PA: Taylor & Francis.

Gee, J. P. (1999a). *An introduction to discourse analysis: Theory and method*. New York: Routledge.

Gee, J. P. (1999b). New people in new worlds: Networks, the new capitalism and schools. In B. Cope & M. Kalantzis (Eds.), *Multiliteracies: Literacy learning and the design of social futures* (pp. 43–68). London: Routledge.

Gee, J. P. (2000a). The limits of reframing: A response to Professor Snow. *Journal of Literacy Research 32*, 121–128.

Gee, J. P. (2000b). The new literacy studies: From 'socially situated' to the work of the social. In D. Barton, M. Hamilton, & R. Ivanic (Eds.), *Situated literacies: Reading and writing in context* (pp. 180–196). New York: Routledge.

Gee, J. P. (2000c). Teenagers in new times: A new literacy studies perspective. *Journal of Adolescent & Adult Literacy, 43*, 412–420.

Gee, J. P. (2001). Reading as situated language: A sociocognitive perspective. *Journal of Adolescent & Adult Literacy, 44*, 714–725.

Gee, J. P. (2001). Identity as an analytic lens for research in education. *Review of Research in Education, 25*, 99–125.

Gee, J. P., Allen, A-R., & Clinton, K. (2001). Language, class, and identity: Teenagers fashioning themselves through language. *Linguistics and Education, 12*(2), 175–194.

Gee, J. P., & Crawford, V. (1998). Two kinds of teenagers: Language, identity, and social class. In D. E. Alvermann, K. A. Hinchman, D. W. Moore, S. F. Phelps, & D. R. Waff (Eds.), *Reconceptualizing the literacies in adolescents' lives* (pp. 353–372). Mahwah, NJ: Erlbaum.

Gee, J. P., Hull, G., & Lankshear, C. (1996). *The new work order: Behind the language of the new capitalism*. Boulder, CO: Westview Press.

Geisler, C. (2001). Textual objects: Accounting for the role of texts in the everyday life of complex organizations. *Written Communication, 18*(3), 296–325.

Gibson, W. (1984). *Neuromancer*. New York: Ace Books.

Gilbert, R., & Gilbert, P. (1998). *Masculinity goes to school*. London: Routledge.

Gillard, P., Wale, K., & Bow, A. (1998). The friendly phone. In S. Howard (Ed.), *Wired up: Young people and the electronic media* (pp. 135–152). London: UCL Press.

Girls in Space. (n.d.). Downloaded January 2, 1999. Available: http://digitarts.va.com.au/gis/

Gladwell, M. (2000). *The tipping point: How little things can make a big difference*. Boston: Little, Brown.

Glassman, M. (2001). Dewey and Vygotsky: Society, experience, and inquiry in educational practice. *Educational Researcher, 30*(4), 3–14.

Goldhaber, M. (1997). The attention economy and the net. *First Monday*. http://firstmon day.dk/ issues/ issue2_4/goldhaber/

Goldhaber, M. (1998a). The attention economy will change everything. *Telepolis* (Archive 1998) http://www.heise.de/tp/english/inhalt/te/1419/1.html

Goldhaber, M. (1998b). M. H. Goldhaber's principles of the new economy. http:// www.well.com/ user/mgoldh/principles.html

Gomez, M. L. (1996). Prospective teachers' perspectives on teaching "other people's children." In K. Zeichner (Ed.), *Currents of reform in preservice teacher education*. New York: Teachers College Press.

Goodlad, J. (1990). *Teachers for our nation's schools*. San Francisco: Jossey-Bass.

Gordon, D., Underwood, A., Wiengarten, T., & Figueroa, A. (1999, May 10). The secret life of teens. *Newsweek*, 45–50.

Grabe, M., & Grabe, C. (1998a). *Integrating technology for meaningful learning*. Boston: Houghton Mifflin.

Grabe, M., & Grabe, C. (1998b). *Learning with internet tools: A primer*. Boston: Houghton Mifflin.

Green, B., Reid, J-A., & Bigum, C. (1998). Teaching the Nintendo generation? Children, computer culture, and popular technologies. In S. Howard (Ed.), *Wired up: Young people and the electronic media* (pp. 19–42). London: UCL Press.

Green Day. (1992). *Kerplunk* [CD]. New York: Lookout Records.

Green, K., & Taormino, T. (Eds.). (1997). *A girl's guide to taking over the world: Writings from the girls zine revolution*. New York: St. Martin's Press.

Greider, W. (1997). *One world, ready or not: The manic logic of global capitalism*. New York: Simon & Schuster.

Gromov, G. (1995–2000). History of Internet and WWW: The roads and crossroads of Internet history. Downloaded 13 July 2001. Available: http://www.netvalley.com/int-val.html

grrrowl #4. (n.d.). (Issue 4). Downloaded January 1, 2000. Available: http://digitarts.va.com.au/ grrrowl4/

grrrowl #5. (n. d.). Shortcrust. (Issue 5). Downloaded January 1, 2000. Available: http:// digitarts.va.com.au/grrrowl5/quote.html

Hagood, M. C. (2001). *Troubling identity and literacy: Young adolescents, literacies, and subjectivities*. Unpublished manuscript, University of Georgia, Athens.

Hagood, M. C. (2001). Media literacies: Varied but distinguishable. In J. Hoffman, C. Malcolm, & J. Worthy (Eds.), *Fiftieth Yearbook of the National Reading Conference*. (pp.248–261). Chicago: National Reading Conference.

Hall, S. (2000). Foreword. In D. A. Yon, *Elusive culture: Schooling, race, and identity in global times*. Albany: State University of New York Press.

Halstead, T. (1999). A politics for Generation X. *The Atlantic Monthly*. August. Downloaded November 23, 2000. Available: http://www.theatlantic.com/issues/99aug/9908genx.htm

Hamilton, M. (1999). *Deciphering the rhetoric of Nancy Drew*. Unpublished paper. University of Minnesota, Minneapolis.

Haraway, D. (1985). Manifesto for cyborgs: Science, technology, and socialist feminism in the 1980s. *Socialist Review, 80,* 65–108.

Hart, D. (1991). *Understanding the media: A practical guide*. London and New York: Routledge.

Hawisher, G., & Seife, C. (Eds.). (2000). *Global literacies and the world wide web*. New York: Routledge.

Hayek, F. A. (1996). *Individualism and economic order*. (Reissue Edition). Chicago: University of Chicago Press.

Hebdige, D. (1988). *Hiding in the light: On images and things*. London: Comedia.

Heilbroner, R. L. (1994). *21st century capitalism*. New York: W. W. Norton.

Hicks, D. (1996). Learning as a prosaic act. *Mind, Culture, and Activity, 3,* 102–118.

Hicks, D. (2001). Literacies and masculinities in the life of a young working-class boy. *Language Arts, 78,* 217–226.

Hickman, L. A. (1990). *John Dewey's pragmatic technology*. Bloomington: Indiana University Press.

Hipp, T. (1999). Editorial. *girl swirl fanzine*. (Issue *1*).

Hipp, T. (2001). *girl swirl*. Downloaded July, 27, 2001. Available: http://www.girlswirl.net

Holland, D., Lachicotte, W., Skinner, D., & Cain, C. (1998). *Identity and agency in cultural worlds*. Cambridge: Harvard University Press.

Holtz, G. T. (1995). *Welcome to the jungle: The why behind "Generation X."* New York: St. Martin's Press.

Howe, N., & Strauss, R. (1993). *13th gen: Abort, retry, ignore, fail?* New York: Vintage Books.

Howe, N., & Strauss, W. (2000). *Millennials rising: The next great generation*. New York: Vintage Books.

International Society for Technology in Education. (1998). *National educational technology standards for students: Essential conditions to make it happen*. Available: http://www.cnets.iste.org/condition.htm

International Society for Technology in Education. (2000). *National educational technology standards for teachers*. Eugene, OR: Author.

Interstate New Teacher Assessment and Support Consortium (INTASC). (2001). Available: http://www.ccsso.org/intasc.html

Iser, W. (1978). *The act of reading: A theory of aesthetic response*. Baltimore: Johns Hopkins University Press.

Jackson, P. W. (1986). *The practice of teaching*. New York: Teachers College Press.

Jones, S. (1997). *Virtual culture: Identity and communication in cybersociety*. London: Sage.

Kahney, L. (2000). Video clothes: 'Brand' new idea. *Wired Online*. June 7.

Kaplan, N. (2000). Literacy beyond books. In A. Herman & T. Swiss (Eds.), *The world wide web and contemporary cultural theory* (pp. 207–234). New York: Routledge.

Kaplan, R. D. (1997, December). Was democracy just a moment? *The Atlantic Monthly,* 55–80.

Kaplan, R. D. (2000). *Eastward to Tartary: Travels in the Balkans, the Middle East, and the Caucasus*. New York: Random House.

Kearsley, G. (2000). *Online education: Learning and teaching in cyberspace*. Belmont, CA: Wadsworth Thomson Learning.

Kennedy, D. (1993). *Sexy dressing etc*. Cambridge: Harvard University Press.

King, J. (1993). The social construction of "AT-RISK" readers and writers: Stories, texts, and contexts. *Review of Education, 15,* 251–260.

Klein, H. (1990). Adolescence, youth and young adulthood: Rethinking current conceptualizations of life stage. *Youth and Society, 21,* 446–471.

Knobel, M. (1998). Paulo Freire e a juventude digital em espacos marginais. (Paulo Freire and digital youth in marginal spaces). In M. Gadotti (Ed.), *Poder e desejo: Paulo Freire a as memorias perigosas de libertacao. (Power and desire: Paulo Freire and dangerous memories of liberation)*. Porto Allegre, Brazil: Artes Medicos.

Knobel, M. (1999). *Everyday literacies: Students, discourse and social practice*. New York: Peter Lang.

Knobel, M. (2001). "I'm not a pencil man": How one student challenges our notions of literacy "failure" in school. *Journal of Adolescent & Adult Literacy, 44,* 404–419.

Kouzes, R. T., Myers, J. D., & Wulf, W. A. (1996, August). Collaboratories: Doing science on the Internet. *IEEE Computer,* 40–46.

Kramarae, C. (1995). A backstage critique of virtual reality. In S. Jones (Ed.), *Cybersociety* (pp. 36–56). Thousand Oaks, CA: Sage.

Kutz, E., & Roskelly, H. (1991). *An unquiet pedagogy: Transforming practice in the English classroom.* Portsmouth, NH: Boynton/Cook.

Lam, W. S. E. (2000). L2 literacy and the design of the self: A case study of a teenager writing on the Internet. *TESOL Quarterly, 34*(3), 457–482.

Lanham, R. A. (1993). *The electronic word: Democracy, technology, and the arts.* Chicago: University of Chicago Press.

Lanham, R. (1994). The economics of attention. Proceedings of 124th annual meeting of the Association of Research Libraries.http://sunsite.berkeley.edu/ARL/Proceedings/124/ps2econ.html

Lankshear, C. (1987). *Literacy, schooling and revolution.* New York: Falmer Press.

Lankshear, C. (1997). *Changing literacies.* Buckingham, UK: Open University Press.

Lankshear, C., Bigum, C., Durrant, C., Green, W., Honan, E., Murray, J., Morgan, W., Snyder, I., & Wild, M. (1998). *Digital rhetorics.* Canberra, Australia: Department of Employment, Education and Training.

Lankshear, C., & Knobel, M. (2001). Mapping postmodern literacies: A preliminary chart. In M. Ylä-Kotola, J. Suoranta, & M. Kangas (Eds.), *The integrated media machine* (Vol. 2). Hämeenlinna, Finland: Edita.

Lankshear, C., Snyder, I., & Green, B. (2000). *Teachers and technoliteracy.* Sydney: Allen & Unwin.

Latour, B. (1998). Drawing things together. In M. Lynch & S. Woolgar (Eds.), *Representation in scientific practice* (pp. 19–68). Cambridge: MIT Press.

Lehman J., & O'Brien, D. (2001, March). *P3T3: Purdue program for preparing tomorrow's teachers to use technology.* Paper presented at the Twelfth International Conference, Society for Information Technology and Teacher Education, Orlando, FL.

Lemke, J. (1998). Metamedia literacy: Transforming meanings and media. In D. Reinking, M. C. McKenna, L. D. Labbo, & R. D. Kieffer (Eds.), *Handbook of literacy and technology: Transformations in a post-typographic age* (pp. 283–301). Mahwah, NJ: Erlbaum.

Lenhart, A., Simon, M., & Graziano, M. (2001, September 1). *The Internet and education: Findings of the Pew Internet & American Life Project.* Available: http://www.pewinternet.org

Leonard, M. (1998). Paper planes: Traveling the new grrrl geographies. In T. Skelton & G. Valentine (Eds.), *Cool places: Geographies of youth cultures* (pp. 101–120). New York: Routledge.

Lesko, N. (1996). Past, present, and future conceptions of adolescence. *Educational Theory, 46,* 453–472.

Lesko, N. (2001). *Act your age! A cultural construction of adolescence.* New York: Routledge.

Leslie, J. (1994, October). Goodbye, Gutenberg: Pixilating peer review is revolutionizing scholarly journals. *Wired, 3*(10), 5–8.

Leu, D. J., & Kinzer, C. K. (2000). The convergence of literacy instruction with networked technologies for information and communication. *Reading Research Quarterly, 35,* 108–127.

Lewis, C., & Fabos, B. (1999, December). *Chatting on-line: Uses of instant message communication among adolescent girls.* Paper presented at the National Reading Conference, Orlando, FL.

Lewis, C., & Fabos, B. (2000). But will it work in the heartland? A response to new multi-literacies. *Journal of Adolescent & Adult Literacy, 43,* 462–469.

Lewis, M. (1999). *The new new thing: A Silicon Valley story.* New York: Norton.

Lewis, M. & G. Brooks (Eds.), *Language and literacy in action.* London: Routledge.

Limp Bizkit (2000). *Chocolate starfish and the hotdog flavoured water* [CD]. New York: Uni/Interscope.

Lincoln, B. (1989). *Discourse and the construction of society: Comparative studies of myth, ritual, and classification.* New York: Oxford University Press.

Lingard, R., Mills, M., Ladwig, J., Bahr, M., Christie, P., Hayes, D., Luke, A., & Gore, J. (2001). *School restructuring longitudinal study report.* Brisbane: Education Queensland.

Live365. Available: http://www.live365.com/

Look-look.com. (2001). Retrieved April 13, 2001. Available: http://www.looklook.com/looklook/html/Test_Drive_Who_We_Are.html

Lortie, D. C. (1975). *Schoolteacher: A sociological study.* Chicago: University of Chicago Press.

Losergurrl. (2000). Downloaded January 1, 2001. Available: http://digitarts.va.com.au/losergurrl/main.htm

Luke, A. (1993). Social construction of literacy. In L. Unsworth (Ed.), *Literacy learning and teaching language as social practice in the primary school.* Melbourne: Macmillan Education Australia.

Luke, A. (1998). Getting over method: Literacy teaching as work in "new times." *Language Arts, 75,* 305–313.

Luke, A. & Carrington, V. (in press). Globalisation, literacy, curriculum practice. In R. Fisher, M. Lewis, & G. Brooks (Eds.), *Language and literacy in action.* London: Routledge.

Luke, A., & Freebody, P. (1997). The social practices of reading. In S. Muspratt, A. Luke, & P. Freebody (Eds.), *Constructing critical literacies* (pp. 185–225). Cresskill, NJ: Hampton Press.

Luke, A., Freebody, P., & Land, R. (2000). *Literate futures: The Queensland state literacy strategy.* Brisbane: Education Queensland. Available: http://www.qed.qld.gov.au

Luke, A., Matters, G., Land, R., Herschell, P., Luxton, P., & Barrett, R. (1999). *The New Basics technical paper.* Brisbane: Education Queensland. Available: http://www.qed.qld.gov.au

Luke, A., & Luke, C. (2001). Adolescence lost/childhood regained: On early intervention and the emergence of the techno-subject. *Journal of Early Childhood Literacy, 1*(2), 91–120.

Luke, C. (1996). ekstasis@cyberia. *Discourse, 17*(2), 187–208.

Luke, C. (1997a). Media literacy and cultural studies. In S. Muspratt, A. Luke, & P. Freebody (Eds.), *Constructing critical literacies* (pp. 19–50). New York: Hampton Press.

Luke, C. (1997b). *Technological literacy.* Canberra: Language Australia Publications.

Luke, C. (1999a). Media and cultural studies in Australia. *Journal of Adolescent & Adult Literacy, 42*(8), 622–626.

Luke, C. (1999b). What next? Toddler netizens, playstation thumb, techno-literacies. *Contemporary Issues in Early Childhood, 1*(1), 95–100. Available: http://www.triangle.co.uk/ciec

Luke, C. (2000a). Cyber-schooling and technological change: Multiliteracies for new times. In B. Cope & M. Kalantzis (Eds.), *Multiliteracies: Literacy learning and the design of social futures* (pp. 69–91). Melbourne: Macmillan.

Luke, C. (2000b). New literacies in teacher education. *Journal of Adolescent & Adult Literacy, 43,* 424–435.

Luke, C. (2001). Dot.com culture: Buzzing down the on-ramps of the superhighway. *Social Alternatives, 20,* 8–13.

Luke, C., & Roe, J. (1993). Introduction to special issue: Media and popular cultural studies in the classroom. *Australian Journal of Education, 37*(2), 115–118.

Lunsford, K. J., & Bruce, B. C. (2001, September). Collaboratories: Working together on the web. *Journal of Adolescent and Adult Literacy, 45*(1), 52–58.

Lusted, D. (1991). *The media studies book: A guide for teachers.* New York: Routledge.

MacLeod, J. (1987). *Ain't no makin' it: Leveled aspirations in a low-income neighborhood.* Boulder, CO: Westview Press.

MacLeod, J. (1995). *Ain't no makin' it: Aspirations and attainment in a low-income neighborhood.* Boulder, CO: Westview Press.

MacLeod, R. (2000, September). Attention marketing in the network economy. Paper presented at The Impact of Networking: Marketing Relationships in the New Economy, Vienna, Austria. http://www.esomar.nl/congress2000/congress2000_programme.htm

McAllister, D., & Springle, P. (1999). *Saving the Millennial Generation: New ways to reach kids you care about in these uncertain times.* Nashville: Thomas Nelson.

McCallum, R. (1999). *Ideologies of identity in adolescent fiction: The dialogic construction of subjectivity.* New York: Garland.

McCormick, K. (1999). *Reading our histories, understanding our cultures: A sequenced approach to thinking, reading, and writing.* Boston: Allyn & Bacon.

McGregor, G. (2000). Kids who "talk back"—Critically literate or disruptive youth? *Journal of Adolescent & Adult Literacy, 44,* 220–228.

McKibben, B. (1993). *The age of missing information.* New York: Penguin.

McKillop, A. M., & Myers, J. (1999). The pedagogical and electronic contexts of composing in hypermedia. In S. DeWitt & K. Strasma (Eds.), *Contexts, intertexts, and hypertexts* (pp. 65–116). Cresskill, NJ: Hampton Press.

McLuhan, M., & Powers, B. (1989). *The global village: Transformations in world life and media in the 21st century.* New York: Oxford University Press.

McNamee, S. (1996). Therapy and identity construction in a postmodern world. In D. Grodin & T. Lindlof (Eds.), *Constructing the self in a mediated world* (pp. 141–155). Thousand Oaks, CA: Sage.

McNeil, L. M. (2000). *Contradictions of school reform: Educational costs of standardized testing.* New York: Routledge.

Malone, T. W., & Crowston, K. (1994, March). The interdisciplinary study of coordination *ACM Computing Surveys, 26*(1), 87–119.

Manovich, L. (1996, May 22). The aesthetics of virtual worlds: Report from Los Angeles. *CTheory, 1.03.* Available: http://www.ctheory.com/

Marable, M. (1993). Beyond racial identity politics: Towards a liberation theory for multicultural democracy. *Race and Class, 35,* 113–130.

Millennial Surveys. Available: http://millennialsrising.com/survey.shtml

Minow, M (1997, December 1). Filters and the public library: A legal and policy analysis. *Firstmonday,* 2(12). Available: http://www.firstmonday.dk/issues/issue2_12/minow/

Mitchell, L. S. (1961). *Young geographers: How they explore the world and how they map the world.* New York: Basic.

Moje, E. B. (2000). "To be part of the story": The literacy practices of gangsta adolescents. *Teachers College Record, 102,* 651–690.

Moje, E. B. (2001, April). *Space matters: Examining the intersections of literacies, identities, and physical and social spaces.* Paper presented at the annual meeting of the American Educational Research Association, Seattle, WA.

Moje, E. B., Young, J. P., Readence, J. E, & Moore, D. W. (2000). Reinventing adolescent literacy for new times: Perennial and millennial issues. *Journal of Adolescent & Adult Literacy, 43,* 398–410.

Moore, D. W., Bean, T. W., Birdyshaw, D., & Rycik, J. A. (1999). Adolescent literacy: A position statement. *Journal of Adolescent and Adult Literacy, 43,* 97–112.

Mosenthal, P. (1998). Reframing the problems of adolescence and adolescent literacy: A dilemma-management perspectives. In D. E. Alvermann, K. A. Hinchman, D. W. Moore, S. F. Phelps, & D. R. Waff (Eds.), *Reconceptualizing the literacies in adolescents' lives* (pp. 325–352). Mahwah, NJ: Erlbaum.

Murnane, R. J., & Levy, F. (1996). *Teaching the new basic skills: Principles for educating children to thrive in a changing economy.* New York: Martin Kessler.

Myers, J., Hammett, R., & McKillop, A. M. (2000). Connecting, exploring, and exposing the self in hypermedia projects. In M. Gallego & S. Hollingsworth (Eds.), *What counts as literacy: Challenging the school standard* (pp 85–105). New York: Teachers College Press.

Myers, J., & Beach, R. (2001). Hypermedia authoring as critical literacy. *Journal of Adolescent & Adult Literacy, 44,* 538–546.

Nardi, B. A., & O'Day, V. L. (1999). *Information ecologies: Using technology with heart.* Cambridge: MIT Press.

National Academy of Engineering (2000). *Greatest engineering achievements of the 20th century.* Available: http://www.greatachievements.org/

National Commission on Excellence in Education (1983). *A nation at risk: The imperative for educational reform.* Washington, DC: U.S. Department of Education.

National Science Foundation. (1997). *U.S. teens and technology: Gallup Poll executive summary.* Downloaded July 13, 2000. Available: http://www.nsf.gov/od/lpa/nstw/teenov.htm

Neilsen, L. (1998). Coding the light: Rethinking generational authority. In D. Reinking, M. C. McKenna, L. D. Labbo, & R. D. Kieffer (Eds.), *Handbook of literacy and technology: Transformations in a post-typographic world* (pp.129–144). Mahwah, NJ: Erlbaum.

Neilsen, L. (1998). Playing for real: Performative texts and adolescent identities. In D. E. Alvermann, K. A. Hinchman, D. W. Moore, S. F. Phelps, & D. R. Waff (Eds.), *Reconceptualizing the literacies in adolescents' lives* (pp. 3–26). Mahwah, NJ: Erlbaum.

Nelson, M. (1991). *At the point of need: Teaching basic and ESL writers.* Portsmouth, NH: Boynton/Cook.

New London Group. (1996). A pedagogy of multiliteracies: Designing social futures. *Harvard Educational Review 66,* 60–92.

Newman, S. B. (1991). *Literacy in the television age: The myth of the TV effect.* Norwood, NJ: Ablex.

Nguyen, M. (1998). Me and my hair trauma. *Slander.* Downloaded January 4, 2001. Available: http://worsethanqueer.com/slander/hair.html

Nguyen, M. (2000). Zine. Downloaded January 4, 2001. Available: http://worsethanqueer.com/slander/zine.html

Nightingale, V. (1996). *Studying audiences: The shock of the real.* New York: Routledge.

Nodelman, P. (1996). *The pleasures of children's literature* (2nd ed.) New York: Longman.

O'Brien, D. G. (1998). Multiple literacies in a high-school program for "at-risk" adolescents. In D. E. Alvermann, K. A. Hinchman, D. W. Moore, S. F. Phelps, & D. R. Waff (Eds.), *Reconceptualizing the literacies in adolescents' lives* (pp. 27–50). Mahwah, NJ: Erlbaum.

O'Brien, D. G. (2001). "At-risk" adolescents: Redefining competence through the multili-teracies of intermediality, visual arts, and representation. *Reading Online,* 4(11). Avail-able: http://www.readingonline.org/newliteracies/lit_index.asp?HREF=/newliteracies/obrien/index.html

O'Brien, D. G., Springs, R., & Stith, D. R. (2001). Engaging "at-risk" high school students: Literacy learning in a high school literacy lab. In E. B. Moje & D. G. O'Brien (Eds.), *Constructions of literacy: Studies of teaching and learning in and out of secondary schools* (pp. 105–123). Mahwah, NJ: Erlbaum.

O'Reilly, B. (2000, July 24). Meet the future—it's your kids. *Fortune,* 144–168.

Padgham, H., and Sting (Producers). (1995). *Ten summoner's tales* [CD]. Hollywood, CA: A & M Records.

Pailliotet, A. W., & Mosenthal, P. (Ed.). (2000). *Reconceptualizing literacy in the media age.* Stamford, CT: JAI Press.

Palladino, G. (1996). *Teenagers: An American history.* New York: Basic Books.

Patterson, N. (2000). Weaving a narrative: From teens to string to hypertext. *Voices from the Middle,* 7(3), 41–47.

Perkins, D. (1992). *Smart schools: From training memories to educating minds.* New York: Free Press.

Probst, R. (1998). Reader response theory in the middle school. In K. Beers & B. Samuels (Eds.), *Into focus: Understanding and creating middle school readers* (pp. 125–138). Nor-wood, MA: Christopher Gordon.

Prosser, J. (Ed.). (1998). *Image-based research: A sourcebook for qualitative researchers.* Bristol, PA: Falmer.

Provenzo, E. (1991). *Video kids: Making sense of Nintendo.* Cambridge: Harvard University Press.

Public Broadcasting System: Frontline (1995, October 31). *High stakes in cyberspace.* Avail-able: http://www.pbs.org/wgbh/pages/frontline/cyberspace/saffo.html

Puterbaugh, P. (2001, March 1). The Beatles—Inside the hit factory: The stories behind the making of 27 number one songs. *Rolling Stone,* 863, 30–60.

Putnam, R. D. (1995). *Bowling alone: The collapse and revival of American community.* New York: Simon & Schuster.

Rainer, T. (1997). *The bridger generation: America's second largest generation, what they believe, how to reach them.* Nashville, TN: Broadman & Holman.

Rand, A. (1957/1985). *Atlas shrugged.* New York: Penguin Books.

Reich, R. (1991). *The wealth of nations: Preparing ourselves for 21st century capitalism.* New York: Knopf.

Reinking, D., McKenna, M. C., Labbo, L. D., & Kieffer, R. D. (Eds.). (1998). *Handbook of lit-eracy and technology: Transformations in a post-typographic world.* Mahwah, NJ: Erlbaum.

Richards, C. (1998). Beyond classroom culture. In D. Buckingham (Ed.), *Teaching popular culture: Beyond radical pedagogy* (pp. 132–152). London: UCL Press.

Rifkin, J. (2000). *The age of access: The new culture of hypercapitalism where all of life is a paid-for experience.* New York: Jeremy Tarcher/Putnam.

Roberts, D. F., Foehr, U. G., Rideout, V. J., & Brodie, M. (1999). *Kids & media @ the new millennium.* Menlo Park, CA. Retrieved May 5, 2001. Available: http://www.kff.org/content/1999/1535/KidsReport%20FINAL.pdf

Roper Starch Worldwide. (1998). *Roper youth report.* Princeton, NJ: Roper Starch Worldwide.

Rosenblatt, L. (1995). *Literature as exploration* (5th ed.). New York: Modern Language Association.

Rowan, L., & Bigum, C. (1998). The future of technology and literacy teaching in primary

learning situations and contexts. In C. Lankshear, C. Bigum, C. Durrant, W. Green, E. Honan, J. Murray, W. Morgan, I. Snyder, & M. Wild, *Digital rhetorics: Literacies and technologies in education—Current practices and future directions*. (pp. 73–93). Canberra, Australia: Department of Employment, Education, Training and Youth Affairs.

Rowan, L., Knobel, M., Bigum, C., & Lankshear, C. (2001). *Boys, literacies and schooling: The dangerous territories of gender based literacy reform*. Buckingham, England: Open University Press.

Rushkoff, D. (1996). *Playing the future: How kids' culture can teach us to survive in an age of chaos*. New York: HarperCollins.

Rushkoff, D. (1996). *Media virus*. New York: Ballantine.

Sacks, P. (2000). *Standardized minds: The high price of America's testing culture and what we can do to change it*. Cambridge: Perseus.

Saffo, P. (1996). *Sensors: The next wave of infotech innovation*. Available http://www.iftf.org/sensors/sensors.html

Salomon, G. (1984). Television is "easy" and print is "tough": The differential investment of mental effort in learning as a function of perceptions and attributions. *Journal of Educational Psychology, 76*, 647–658.

Santrock, J. W. (1993). *Adolescence*. Dubuque, IA: Wm. C. Brown.

Sarup, M. (1993). *An introductory guide to post-structuralism and postmodernism* (2nd ed.). Athens: University of Georgia Press.

Savin-Baden, M. (2000). *Problem-based learning in higher education: Untold stories*. Buckingham, England: Open University Press.

Schlegel, A., & Barry, H. III. (1991). *Adolescence: An anthropological inquiry*. New York: Free Press.

Selfe, C., & Selfe, R. J. (1994). The politics of the interface. *College Composition and Communication, 45*, 480–504.

Semali, L., & Pailliotet, A. W. (Eds.). (1999). *Intermediality: The teachers' handbook of critical media literacy*. Boulder, CO: Westview.

Sharan, S. (1994). *Handbook of cooperative learning methods*. Westport, CT: Greenwood.

Shaughnessy, M. (1977). *Errors and expectations: A guide for teachers of basic writing*. New York: Oxford University Press.

Short, K., & Harste, J. (1996). *Creating classrooms for authors and inquirers* (2nd ed.). Portsmouth, NH: Heinemann.

Shortis, T. (2001). *The language of ICT: Information and communication technology*. New York: Routledge.

Simon, H. (1971). Designing organizations for an information-rich world. In M. Greenberger (Ed.), *Computers, communications and the public interest*. Baltimore: Johns Hopkins University Press.

Simpson, K. (2001). *Rural internet and the digital divide*. Unpublished manuscript, University of Illinois, Champaign.

Smith, R. A. (1989). Special issue: Arts education in China. *The Journal of Aesthetic Education, 23*(1), 1–158.

Smoler, F. (1998, February/March). Paradise lost? An interview with Michael Elliott. *American Heritage, 49*(1), 58–60, 62–67.

Snow, C. E. (2000). On the limits of reframing: Rereading the National Academy of Sciences report on reading. *Journal of Literacy Research, 32*, 113–121.

Snow, C. E., Burns, S. M., & Griffin, P. (Eds.). (1998). *Preventing reading difficulties in young children*. Washington, DC: National Academy Press.

Snyder, I. (1998). *Page to screen—Taking literacy into the electronic era*. London: Routledge.

Soucek, V. (1999). Educating in global times: choice, charter and the market. *Discourse, 20,* 219–234.

Sowell, T. (1996). *The vision of the anointed: Self-congratulation as a basis for social policy.* New York: Basic Books.

Springen, K., Figueroa, A., & Joseph-Goteiner, N. (1999, Oct. 18). The truth about tweens. *Newsweek,* 62–71.

Spindler, G., & Spindler, L. (1982). Roger Harker and Schonhausen: From the familiar to the strange and back again. In G. Spindler (Ed.), *Doing the ethnography of schooling: Educational anthropology in action* (pp. 20–46). New York: Holt, Rinehart and Winston.

Squeaky, J. (n.d.). Non-music Reviews. Downloaded January 5, 2001. Available: http://misterridiculous.com/reviews/

Star, S. L. (1989). The structure of ill-structured solutions: Boundary objects and heterogeneous distributed problem solving. In M. Huhs & L. Gasser (Eds.), *Readings in distributed artificial intelligence 3* (pp. 37–54). Menlo Park, CA: Morgan Kaufmann.

Statistics Canada. (2001, July 26). Household Internet use survey. *The Daily.* Available: http://www.statcan.ca/Daily/

Stevens, L. P. (in press). Making the road by walking: The transition from content area literacy to adolescent literacy. *Reading Research and Instruction.*

Stuckey, J. E. (1991). *The violence of literacy.* Portsmouth, NH: Boynton/Cook.

Sumara, D. (1996). *Private readings in public: Schooling the literary imagination.* New York: Peter Lang.

Takanishi, R. (1993). Changing views of adolescence in contemporary society. In R. Takanishi (Ed.), *Adolescence in the 1990s* (pp. 1–7). New York: Teachers College Press.

Taylor, C. (1999, March). Playing God. *Time, 153*(8), 52.

Terralingua. (2001). Available: http://www.terralingua.org/

Thau, R. D., & Heflin, J. S. (1997). *Generations apart: Xers vs. boomers vs. the elderly.* New York: Prometheus Books.

Thurow, L. C. (1999). *Building wealth: The new rules for individuals, companies, and nations in a knowledge-based economy.* New York: HarperCollins.

Tierney, R. J. (1997). Learning with multiple symbol systems: Possibilities, realities, paradigm shifts and developmental considerations. In J. Flood, S. B. Heath, & D. Lapp (Eds.), *Handbook of research on teaching literacy through the communicative and visual arts* (pp. 286–298). Newark, DE: International Reading Association.

Tierney, R., & Damarin, S. (1998). Technology as enfranchisement and cultural development: Crisscrossing symbol systems, paradigm shifts, and social-cultural considerations. In D. Reinking, M. C. McKenna, L. D. Labbo, & R. D. Kieffer (Eds.), *Handbook of literacy and technology: Transformations in a post-typographic world* (pp. 253–268). Mahwah, NJ: Erlbaum.

Tobin, J. J. (2000). *Good guys don't wear hats: Children's talk about the media.* New York: Teachers College Press.

Travis, M. (1998). *Reading cultures: The construction of readers in the twentieth century.* Carbondale: Southern Illinois University Press.

Tunbridge, N. (1995, September). The cyberspace cowboy. *Australian Personal Computer,* pp. 2–4.

Turkle, S. (1995). *Life on the screen: Identity in the age of the Internet.* New York: Simon and Schuster.

Underwood, M. (2000). Semiotic guerrilla tactics—Michel de Certeau. Downloaded December 4, 2000. Available: http://www.cultsock.ndirect.co.uk/MUHome/cshtml/index.html

University of Vermont. (2001). John Dewey Project on Progressive Education. Available: http://www.uvm.edu/~dewey/

U. S. Census Bureau. (2000, March). *Educational attainment in the United States*. Available: http://www.census.gov/

Vale, V. (Ed.). (1996). *Zines*. Vol. 1. San Francisco: V/Search.

Vale, V. (Ed.). (1997). *Zines*. Vol. 2. San Francisco: V/Search.

von Mises, L. (1997). *Human action: A treatise on economics*. (4th rev. ed.). San Francisco: Fox and Wilkes.

Vygotsky, L. S. (1978). *Mind in society: The development of higher psychological processes*. Cambridge: Harvard University Press.

Wack, P. (1985, November–December). Scenarios: Shooting the rapids. *Harvard Business Review*, 139–150.

Waldrop, M. (1992). *Complexity: The emerging science at the edge of chaos and order*. London: Viking.

Walker, C. (1998). Short attention spans on the web. Reprinted with permission. Available: http://wondermill.com/sitelaunch/attention.htm

Walkerdine, V. (1996). Subject to change without notice: Psychology, postmodernity, and the popular. In V. Curran, D. Morley, & V. Walkerdine (Eds.), *Cultural studies and communication* (pp. 96–118). London: Arnold.

Waxman, H. C. (1992). Introduction: Reversing the cycle of educational failure for students in at-risk school environments. In H. C. Waxman, J. W. de Felix, J. E. Anderson, & H. P. Baptiste, Jr. (Eds.), *Students at risk in at-risk schools* (pp. 1–9). Newbury Park, CA: Sage.

Waxman, H. C., de Felix, J. W., Anderson, J. E., & Baptiste Jr., H. P. (Eds.). (1992). *Students at risk in at-risk schools: Improving environments for learning*. Newbury Park, CA: Sage.

Wenglinsky, H. (1998). *Does it compute? The relationship between educational technology and student achievement in mathematics*. Policy Information Center, Educational Testing Service. Available: http://www.ets.org/research/pic

Wertsch, J. (1998). *Mind as action*. New York: Oxford University Press.

White, M. (1987). *The Japanese educational challenge: A commitment to children*. New York: Free Press.

The Who. (1965). *The Who sings My Generation*. London: MCA Records.

Williamson, J. (1994, October). Engaging resistant writers through zines in the classroom. *Rhetnet: A Cyberjournal for Rhetoric and Writing*. Downloaded January 1, 2001. Available: http://showme.missouri.edu/~rhetnet/judyw_zines.html

Willinsky, J. (1991). *The triumph of literature/the fate of literacy: English in the secondary curriculum*. New York: Teachers College Press.

Wittlinger, E. (1999). *Hard love*. New York: Simon and Schuster.

Wriston, W. (1997). *The twilight of sovereignty: How the information revolution is transforming our world*. Bridgewater, NJ: Replica Books.

Young, J. P., Hardenbrook, M., Esch, M., & Hanson, K. (2001). *What's happening with/to the boys in adolescent literacy classrooms*. Research in progress.

Zhao, Y., Tan, S. H., & Mishra, P. (2000/2001). Teaching and learning: Whose computer is it? *Journal of Adolescent & Adult Literacy, 44,* 348–353.

Zoba, W. M. (1999). *Generation 2K: What parents & others need to know about the Millennials*. Downers Grove, IL: Intervarsity Press.

Zuboff, S. (1988). *In the age of the smart machine: The future of work and power*. New York: Basic Books.

CONTRIBUTORS

Donna E. Alvermann is Distinguished Research Professor of Reading Education at the University of Georgia, USA. She is an editor of *Reading Research Quarterly* and co-editor of *Reconceptualizing the Literacies in Adolescents' Lives.* Her research focuses on adolescents' literacy practices in and out of school, particularly in the realm of media culture.

Richard Beach is Wallace Professor of English Education at the University of Minnesota, USA. He is co-author of *Inquiry-Based English Instruction: Engaging Students in Life and Literature.* He conducts research on adolescents' response to literature and the media.

Bertram (Chip) Bruce is a Professor of Library and Information Science at the University of Illinois at Urbana-Champaign, USA. He is co-author of *Network-Based Classrooms: Promises and Realities and Electronic Quills: A Situated Evaluation of Using Computers for Writing in Classrooms* and writes the Technology Department in the *Journal of Adolescent and Adult Literacy.* His research and teaching focus on inquiry-based learning, emphasizing communities of inquiry, new literacies, learning technologies, and social justice issues.

Deborah R. Dillon is a Professor of Literacy and Chair of the Curriculum and Instruction Department at the University of Minnesota, Minneapolis, USA. Her research focuses on examining adolescents' literacies and shifting identities in school and out-of-school settings, and how adolescents' interactions with peers and teachers shape who they are as learners and people.

Margaret Finders is Director of Teacher Education and Associate Professor at Washington University in St. Louis, USA. Author of *Just Girls: Hidden Literacies and Life in Junior High,* her current research focuses on teacher preparation, specifically in regard to preparing teachers for diverse contexts.

James Paul Gee is the Tashia Morgridge Professor of Reading at the University

of Wisconsin-Madison. He is the author of *Social Linguistics and Literacies, The Social Mind,* and *An Introduction to Discourse Analysis,* among other books. His current research is focused on the implications of digital literacies for learning in and out of schools.

Margaret Hagood is a doctoral candidate in Reading Education at the University of Georgia, USA. Her research and teaching examine young adolescents' uses of traditional print-based and contemporary popular culture texts to construct identities for themselves across school and out-of-school contexts and in media influenced local and global environments.

Kathleen A. Hinchman is Associate Professor and Chair in the Reading and Language Arts Center at Syracuse University. She is interested in adolescents' perspectives toward literacy in various contexts and critical literacy teacher education.

James R. King is a professor of literacy education at the University of South Florida, where he is co-director of the Accelerated Literacy Learning program. He is the author of *Uncommon Caring: Learning from Men Who Teach Young Children.* His current research focuses on the construction of error and accuracy in teaching literacy.

Michele Knobel is an Adjunct Associate Professor for Central Queensland University in Australia, currently working as an Associate Research Specialist at the University of California, Irvine. Her research interests center on students' in-school and out-of-school literacy practices, and on new literacies and technologies. Her recent books include: *Everyday Literacies: Students, Discourse and Social Practice,* and *Maneras de Ver* (with Colin Lankshear).

Rosary Lalik is an Associate Professor of Education at Virginia Tech where she is a member of the Literacy Studies Faculty. With Kimberly Oliver, she is co-author of *Bodily Knowledge: Learning about Equity and Justice with Adolescent Girls.* Dr. Lalik's current research explores the use of inquiry processes among adolescents, teachers, and teacher educators.

Colin Lankshear is a free lance educational researcher and writer living in Mexico and a professorial research fellow at the University of Ballarat, Australia. Co-author of *Teachers and Technoliteracy* and *Boys, Literacies and Schooling,* his current research and writing interests include new forms of literacy, social practices employing new technologies, and teacher research.

Cynthia Lewis is Associate Professor in the Language, Literacy, and Culture Program at the University of Iowa. She is interested in how literacy is shaped by the social politics of classrooms and communities. Her current research focuses on response to literature among early adolescents and their teachers, and on the uses of

Instant Messaging among teens. She is author of *Literary Practices as Social Acts: Power, Status, and Cultural Norms in the Classroom.*

Allan Luke teaches literacy education, sociology and discourse analysis at the University of Queensland. He is currently completing work on a sociolinguistic taxonomy and language-in-education plan for Aboriginal and Torres Strait Islander students in Queensland schools.

Carmen Luke is Associate Professor at the University of Queensland. Her most recent book is *Globalization and Women in Academia: North/west—East/south* (Lawrence Erlbaum, 2001), and her current research focuses on globalization and higher education, and identity politics and literacy practices in digital information environments.

Elizabeth Birr Moje is an Associate Professor of Literacy, Language, and Culture, in the Educational Studies Program at the University of Michigan. Moje studies the literacy practices and identity representations of youth in one Detroit community, and works with youth and other community members to carve out productive school and social spaces for youth.

David O'Brien is a professor of literacy education at the University of Minnesota. His research focuses on the literacies of "at-risk" adolescent learners. Most recently he is studying how digital media fosters the literacy engagement of struggling adolescents while reshaping their perceptions of what it means to be competent.

David Reinking is a Professor of Education and Head of the Department of Reading Education at the University of Georgia. He is an editor of *Reading Research Quarterly* and previously served as editor of the *Journal of Literacy Research*. His main research interest is in the relation between digital technologies and literacy.

Lisa Stevens is the Reading Specialist for the Hawaii Department of Education. Her research interests include adolescent literacy from the perspectives of research, practice, and policy discourses. Beginning in July 2002, she will be affiliated with the University of Queensland in Brisbane, Australia.

Josephine Peyton Young is an assistant professor of Language and Literacy at Arizona State University, USA. Her research study, *Critical Literacy: Young Adolescent Boys Talk about Masculinities within a Homeschooling Context,* won the 1998 National Reading Conference's Student Outstanding Research Award. Her research continues to focus on adolescent boys, masculinities, and literacies.

INDEX

A Nation at Risk, 52, 65
Abbey Records, 168
Abercrombie, N., 149
Adbusters, 35, 174
Adler, R., 20, 26
adolescence
 and adult discourses, viii
 definition of, vii,
 diversity of roles, 1
 research statistics, 3
and social constructionalism, vii
studies of, 104
Adolescence (Hall), 104
adolescents
 engaging in new literacies, 102–3
 generational literacies of, 69
 literacy, 71
 contrasted with adults, 74–75
 multiliteracies, 40
 and print literacy, 41–42
 and school work, 4
 and student knowledge, 95
Adoni, H., 77
adult-directed subtext, 57
advertising, 26
 and the Internet, 26–27
Affinity Groups, 51, 65
Age of Transition, 52
Allen, A. R., 59, 63
Allington, R., 44, 45
Alloway, N., 71
Alpha Centauri, 156
Alvermann, D., 47, 71, 85
Anderson, J., 11, 44
Angel, J., 180
Appadurai, A., 189

Apple, M., 42, 54
Applebee, A., 46
appropriated space, 171
archáologie francaise, 166
Arizona State University, 120
Asia Development Bank, 188
Aspen Institute, 20, 26–29, 30
Atlas Shrugged (Rand), 122
at-risk adolescents, viii, 135
 reconceptualizing definition of, 43–45
attention economy, 19
 advertising and, 26
 definition of, 20
 Michael Goldhaber on, 20–23
 and new literacies, 32–37
 Richard Lanham on, 23–26
attention transacting, 35
Australian Women's Weekly, 182

Baby Boomers, 51, 52, 53
 versus Millennials, 59–61
Bahktin, M., 82, 150
Bail, K., 174, 185
Baptiste, H. P. Jr., 44
Barksdale, M., 48
Barlow, J. P., 24
Barna, G., 54
Barney & Friends, 51, 55–59
Barrett, E., 7
Barry, H., 104
Barthes, R., 6
Barton, D., 48, 69, 75, 81, 82, 83, 200
Bazzell, I., 15
Beach, R., xi, 154, 157, 158, 160, 161
Beach, S., xiii, 3
Bean, K. F., 71

Bean, S. K., 71
Bean, T. W., 71
Benetton, 35, 174
Bennahum, D., 33
Bennett, S. E., 53, 168
Bentley, A., 154
Berliner, D. C., 11, 12
Biddle, B. J., 11, 12
Bigum, C., 34, 81, 84, 86
Bikini Kill, 152
Birdyshaw, D., 71
Bishop, A. P., 15
Blink 182, 68
Block, F., 166, 168
Bloustein, G., 71
Blue's Clues, 51, 55–59
Bobos, 51, 53
Body Shop, 168
Bolter, J., 152, 156, 159
Bombs for Breakfast, 167
book literacy, 95
Boomlet, 54
boundary objects, 3
Bowe, A., 71
Bowles, S., 11
Braidotti, R., 178
Brand, S., 33
Brandstein, O., 86
Bratmobile, 152
bricolage, 172, 183, 197
Bronowski, J., 48
Brooks, D., 53, 62, 68, 114, 116, 127, 128
Brooks-Gunn, J., 104
Brown, A. L., 65
Bruce, B. (Chip), ix, xi, 3, 4, 7, 9, 12, 14, 15, 76, 80, 154, 160
Bruce, E., ix
Bruce, S., ix
Bruce, T., 5
Bruer, J. T., 65
Buchanan, I., 170, 171, 176
Buckingham, D., 81
Burbules, N., 5
Burns, S. M., 191
Butler, J., 105

Cain, C., 150
Callister, T., 136
Carlip, H., 166, 168
Carnegie Mellon University, 155

Carr, M., xiii
Carter, C. S., 161
casino capitalism, 200
CBC Television, 168
Center for Children's Books (University of Illinois), ix
Centre for the Easily Amused, 38
Chandler-Olcott, K., 86
Children of the Restoration, 51
Christo, 24
Chu, J., 164
class-based customized standardization, 62, 63
Clinton, K., 59, 63
CNN, 152
Cognition and Technology Group, 71
cognitive psychology, 102
cognitive science, 65
Cole, M., 151
Coleman, J. S., 104
Collins, J., 49, 50, 84
Collision, R., 174
Columbia University, 115, 128
Comaroff, J., 198, 200
Comaroff, J. F., 198, 200
Comer, J. P., 104
computer education, 137–38
computer literacy
 and media literacy, 16
computer use in small communities, 147–48
computers and gender divide, 2
contact displaying, 32–33
contemporary literacies and generational literacies, 80–82
content area literacy, 71
Cook, P. J., 60
Cope, B., 71, 142
Coupland, D., 33
Craig, S. C., 53, 167
Crawford, V., 47, 59
Crispell, D., 69
critical contextual dimension of computer studies, 134
critical inquiry, cycle of, 153–54
critical literacy, 195
critical uncertainties, 88
Cross, R., 183
Cuban, L., 17
cultural analysis of the Internet, 139
culture jamming, 35–36, 49
Curriculum as Conversation (Applebee), 46

Daddy's Girl, 166
Daly, S., 164
Damarin, S., 80
Darrah, C., 152
Dasenbrook, R., 161, 162
datasphere, 40
Davidson, D., 161
Davidson, J., 154, 160
Davies, B., 179
D/discourse, 33, 200
de Castell, S., 80
de Certeau, M., 35, 169, 171, 172, 182
 and literacy education, 176
de Felix, J. W., 44
Dembeck, C., 11
Denzin, N., 156
De Santis, C., 167
developmental psychology, 102
Dewey, J., 10, 11, 14, 15, 16, 17, 154, 162
 four primary interests of the learner, 153
digital divide, 137
Digital Rhetorics (Lankshear et al.), 189
digital technologies, ix
 and the economics of attention, 30–32
 and M. Goldhaber, 31
 and new literacies, ix
digital texts, 4–6
digital tools, 160
characteristics of, 150–52
inquiry-based learning through, 152–53
teachers' uses of, 160–63
Digitarts, 181–83
Dillon, D., x, 81, 116
Dillon, L., xiii
"disciplined space," 171
Dishwasher, 172, 175
Dishwasher Pete, 175, 176
"displacement hypothesis," 195, 197
Doering, A., 161
"dominated space," 171
Dragonball Z, 77
Drucker, P. F., 58
D'Souza, D., 59
Duncombe, S., 164, 166, 168, 175, 182, 183, 184

Easley, J. A. Jr., 14, 160
e-books, 11
Economics of Attention, The (Lanham), 23
E-Cowboys, 53
e-edubusiness, 201

Education 2010, 191
Education Queensland, 191
effective literacy instruction, 89
Elliott, G., 105
Ellul, J., 16, 18
Emode, 2, 7
enactive texts, 51, 113
encapsulating, 37
Engestrom, Y., 157
English-Lueck, J., 152
E. O. Muncie Elementary School, 7
Epstein, J. S., 70
Ethnologue, 9
Evolution of a Race Riot, 180
"exoticize this!" 180
expository texts, 45, 46
extracurricular digital literacy, x

Fabos, B., 71, 105, 150
fanzines, 166
Farkas, S., 60
fast capitalism, 85
faux zine-ing, 169
Feldman, S., 105
Figueroa, A., 70
Finders, M., x, 70, 81, 104, 137
Fine, M., 104
Fitch, S., 31
Flood, J., 71
Flower, L., 155
Forehand, R., xiii
forkinthehead.com, 38
Foucault, M., 6, 77, 189
framing, 37
Framing Historical Theft, 167
Frank, R. H., 60, 70
Freebody, P., 190, 192, 193, 194
Freeman, J., 152
Friedman, T., 165
Frontline, 70, 149
Fukuyama, F., 52
Full Voice, 168
Fulmer, J., xiii
funbrain.com, 96

Gardyn, R., 71
Garner, R., 4
Gary, S., xiii
Gee, J. P., x, 8, 33, 43, 44, 47, 51, 58, 59, 63, 65,
 66, 69, 72, 76, 85, 99, 103, 106, 113, 114,

Gee, J. P. *(continued)*
117, 120, 122, 123, 127, 158, 165, 177, 185, 186, 192, 200, 201
Geisler, C., 152
Generation Y, 54
generational analysis, 69
generational literacies and contemporary literacies, 80–82
Gen-Xers, 51, 53
Geocities, 64
Gibson, W., 33
Gilbert, P., 61, 71
Gilbert, R., 61
Gillard, P., 71
Gillingham, M., 4
Gintis, H., 11
girl swirl fanzine, 174
Girls in Space, 183
Gladwell, M., 55, 57
Glassman, 151
global personalities, 8
Goldhaber, M., 19, 20, 30, 165
 and digital technologies, 31
Gomez, M. L., 108
Goodlad, J., 17
Google, 5
Gordon, D., 70
Gore, A., 33
Grace, T., 86
Graves, D., 6
Graziano, M., 3
Great Disruption, 51, 52
Green, B., 81, 183
Green Day, 68
Greider, W., 60
Griffin, P., 191
Gromov, G., 33
groupware, 7
grrrowl, 181
Grusin, R., 152, 156
Guardian, 140

Hagood, M., x, 71, 72, 85
Hall, G. S., 104, 113
Halstead, T., 168
Hamilton, M., 48, 69, 82, 83, 158, 200
Hammett, R., 160
Haraway, D., 33, 178
Hardwear International, 32
Harste, J., 154, 155

Hayek, F. A., 66
Hazel, 167
Hebdige, D., 70
Heflin, J. S., 52
Heilbroner, R. L., 62
Hickman, L., 14
Hicks, D., 150
Higgins, L., 155
"higher-order thinking," 65
Hinchman, K. A., 75, 137
Hipp, T., 166, 174
Hogan, M.P., 15, 80
Holland, D., 150
Holtz, G. T., 53
Howe, N., 52, 54, 59, 61, 64, 66, 114, 127, 128, 129, 175
Hruby, G., xiii
Hull, G., 8, 51, 58, 66, 76, 85, 177
Hynd, G., xiii
"hypermediacy," 152, 156
Hyperstudio, viii
hypertext, 7
 and design, 143–44
hypertext production, 139

illusory attention, 22
"implied adolescent," x
 and digital literacy, 105–7
 shifting conceptions of, 103–5
"implied reader," 101
"implied teacher," x
 and classroom control, 111
 definition of, 102
 new literacies in teacher education, 107–12
inappropriate literacy, 44
information and communication technologies (ICT), 132, 196, 200, 202
information economies, 188
information technologies (IT) education, 132, 197
inquiry cycle, 160
inquiry instruction, 155–56
Inquiry Page, 160, 162
Inquiry Units, 161
instant messaging, 105, 151
INTASC, 131
intermediality, 42
International Society for Technology in Education, 81, 85
Internet

cultural analysis of, 139
 student writing on the, 7
"interpretive charity," 162
Irwin, R., 24
Iser, W., 101
Ivanic, R., 69, 200

Jackson, P. W., 17
Jefferson High School Literacy Lab, 42, 46
Jones, S., 106
Joseph-Goteiner, N., 70
Journal of Literacy Research, 185
Joyce, M., 159

Kahney, L., 22, 31
Kairos, 5
Kalantzis, M., 71, 142
Kaplan, N., 8, 144, 145
Kelly, J., 174
Kennedy, D., 6
Kieffer, R.D., 4
kinderpolitics, 52
King, J., ix, 45, 48
Kinzer, C. K., 71
Klein, H., 103
Knobel, M., ix, xi, 2, 40, 49, 66, 80, 88, 106,
 130, 151, 155, 157, 174, 177, 183, 202
knowledge workers, 7
Kouzes, R. T., 7
Kutz, E., 46, 47, 48

Labbo, L.D., 4, 71
Lachicotte, W., 150
Lalik, R., x, 75, 137
Lam, W. S. E., 64, 65
Land, R., 190, 193, 194
languages, change in, 9
Lanham, R., 19, 20, 23, 30, 37, 78
Lankshear, C., ix, xi, 2, 8, 40, 44, 49, 51, 58,
 66, 71, 76, 80, 85, 88, 106, 130, 151, 155, 157,
 158, 174, 177, 202
la perruque, 172
 definition of, 173
 and intellectual property, 174
Lapp, D., 71
La Technique, 16
Latour, B., 6
*Learning to Rival: A Literate Practice for Inter-
 cultural Inquiry* (Flower et al.), 155
Lehman, J., 131

Lenhart, A., 3
Leonard, M., 151
Lesko, N., 103, 105
Leslie, J., 11
Leu, D. J., 71
Levy, F., 18
Lewis, C., x, 71, 81, 105, 137, 150
libraries and librarians, role of in attention
 economy, 25
Lichtenstein, R., 24
Limp Bizkit, 68
Lincoln, B., 6
Lingard, R., 191
literacies, viii
 across generations, 79
 assessing change, 12
 definition of, viii
 and the digital world, viii
 globalization and, 76
 and new technologies, viii
 textbook-based, 85
 where they are 'situated," 189
literacy
 adolescent versus adult, 74–75
 classroom practices that limit, 48
 as a material activity, 12–14
 assessing change, 12
 history of, 9–10
 multimodal, 75
 as a societal construction of generational
 differences, 69
 technology and, 10
Literacy Beyond the Book (Kaplan), 143
Literacy Lab (Jefferson High School), viii
literacy practices
 and texts, 3
literacy teacher education, x, 84, 96–97
 value of scenariating for, 98–100
Literate Futures (Luke et al.), 193, 194
Live365, 6
LoBianco, J., 192
Long, E., 155
Longhurst, B., 149
Look-Look.com, 70
Lortie, D. C., 81
Losergurrl, 182
Lowrider Magazine, 126
Luke, A., xi, 14, 41, 85, 102, 106, 110
Luke, C., x, 6, 16, 40, 70, 102, 107, 108, 110,
 193, 194, 195

Lunsford, K. J., 7

Macleod, J., 20, 28, 29, 32, 35, 115
Macpherson, K., 104
macro-myopia, 5
Mahar, D., 86, 87
manipulation of attention, 106
Marable, M., 12
Martin, D., xiii
McCallum, R., 101
McCormick, K., 159
McGregor, G., 70
McKenna, M.C., 4, 71
McKibben, B., 8
McKillop, A. M., 160
McLuhan, M., 33
McNamee, S., 150
McNeil, L. M., 66
Media Lab (MIT), 31
media literacy, 132, 133–35
 and computer literacy, 16
 development of, 145
mediascapes, participation in, 149
 and adolescent identities, 149
media studies, x
mediasphere, 40, 41, 46, 48, 50
Mehra, B., 15
meme, 33, 49
millennial capitalism, 198
Millennial Surveys, 59
Millennials, 51, 54–55, 70, 114
 collaborative nature of, 117
 description of, 69–71
 and diversity, 61
 girls and consumer behavior, 62
 versus Baby Boomers, 59–61
Millenials Rising: The Next Great Generation, 54
Minow, M., 10
Mishra, P., 78
Mitchell, L. S., 17
Moje, E., x, 71, 81, 85, 107, 123
Montero, K., xiii
Moon, J. S., 85
Moore, D. W., 71, 107
Mosenthal, P., 85, 155
multiliteracies, 196, 197
and "play," 42
and state educational policy, xi
Multimedia Director, viii

multinational capitalism, 198
multiple identities, 106
Murnane, R. J., 18
Myers, J. D., 7, 154, 157, 158, 160

Nardi, B. A., 15
narrowcast strategies, 27
National Academy of Engineering, 9
National Commission on Excellence in Education, 52
National Science Foundation, 181
NCR Knowledge Lab, 20, 26–29, 30
Neilsen, L., 46, 78, 80
Nelson, M., 49
netiquette, 158
Network Economy, 29
New Baby Boom, 51
New Basics, 191
New Capitalism, x, 51, 52, 58, 60
New Civil Order, 52
New Critics, 46
new economy, 24
new literacies, 187, 200, 201
 challenge for schools, 37–39
 designing policy for, 187–88, 188–89
 factors affecting, 191–92
 and digital technologies, ix
 and the economics of attention, 32–37
 attention transacting, 35
 contact displaying, 32–33
 culture jamming, 35, 49
 framing and encapsulating, 37
 meme-ing, 33, 49
 scenariating, 34, 49
 transferring (trickle across), 36–37, 49
 historical perspective, ix, 3
 implications for schooling, 10–11
 and mentoring, 91
 and new liberalism, 198–203
 in teacher education, 107–12
New Literacy Studies, xi
new literate communities, 6–8
New London Group, 69, 142, 191, 203
new media, 145
New Scientist, 140
new technologies
 challenges to educational system, 3
 contracted with print-based technologies, 78
Newman, S. B., 11

Nguyen, M., 179, 180
Nick Jr.com, 56
Nightingale, V., 149
Nintendo Generation, 74
Nodelman, P., 101, 102

objectivism, 122
O'Brien, D., viii, ix, 40, 42, 44, 45, 46, 131
Observer, 140
O'Day, V. L., 15
OECD, 188
Old Capitalism, 51, 52
online manipulation of identities, 106
O'Reilly, B., 54, 59
organization kids, 116
Overclass, 51, 130

Pailliotet, A. W., 40, 42, 85
Palladino, G., 104
Patterson, N., 159, 160
pedagogies of tactics and zines, 169–78
Perkins, D., 65, 66
personal digital assistants (PDAs), 152
perzines, 166
Plato, 31
"play"and multiliteracy efforts, 42
*Popular Culture in the Classroom: Teaching and
 Researching Critical Media Literacy* (Alver-
 mann et al.), 108
Populous, 156
post-literate culture, 80
Powers, B., 33
Practice of Everyday Life, The (de Certeau), 170
pragmatic technology, 14
pre-service teachers as gatekeepers, 110
print literacy, 41–42, 95, 103
problem-based learning (PBL), 141
Probst, R., 45
Prosser, J., 156
Provenzo, E., 74
psychologizing the curriculum, 154
Public Broadcasting System: Frontline, 5
publishing statistics, 11–12
Puterbaugh, P., 69
Putnam, R. D., 53

Queensland Department of Education, 186
 and literacy education, 190–94

Rainer, T., 54
Rand, A., 122
Readence, J. E., 71, 107
Reagan, R., 53
real attention, 22
Reid, J.-A., 81
Reinking, D., 4, 71
Reiter, E. O., 104
representational literacy, 71
response pedagogies, 46
Restoration, 51
Richards, C., 81
Rifkin, J., 52, 62
riot grrrl, 151, 152
ROCKRGRL, 167
Roe, J., 70
Roper Starch Worldwide, 181
Rosenblatt, L., 45, 46
Roskelly, H., 46, 47, 48, 49
Rowan, L., 34, 84, 86, 178, 179
Rubin, A., 4, 14, 76
Rushkoff, D., 33, 38, 40, 71, 82
Rycik, J. A., 71

Saffo, P., 4, 5, 7, 15
Salomon, G., 77
Salon, 31
Santa Fe Group, 33
Santrock, J. W., 104
Sarup, M., 69
Schlegel, A., 104
schooled literacy, 48
scenariating, 34, 49, 84, 85–92, 155
scenario-building, x, 84
School Restructuring Longitudinal Study, 191
Sefton-Green, J., 81
Semali, L., 40, 42
semiotic economy, 188
Sesame Street, 51, 55–59, 120
Sesameworkshop, 55
shape shifting portfolios, 44, 99, 118
 role of economics and globalism in, 126–27
 role of family and community in, 126
 role of language and literacy, 124–26
Shape-Shifting Portfolio People, x, 51, 61–64,
 103
 class differences and, 127
shared artifacts, 3
Short, K., 154, 155
Shortis, T., 140

"shrine phenomenon," 116
Sim City 3000, 156
Simon, M., 3, 19
Simpson, K., 147
Skinner, D., 150
Slackers, 53
Slander, 180
Slant, 168
Smith, C., 15, 16, 159
Smith, J., 184
Smoler, F., 10
Snow, C., 185, 186, 191, 192, 201
social constructionism, vii
social literacy, 15–16
"society of text," 7
sociohistorically informed practices, vii
soft skills, 18
Soucek, V., 199, 203
Sowell, T., 66
Spindler, G., 49
Spindler, L., 49
Springen, K., 70
Springs, R., 44
Squeaky, J., 181
stars and fans, 21–22
Statistics Canada, 4
Stevens, L. P., 72
Stith, D. R., 44
Strauss, W., 52, 54, 59, 61, 64, 66, 114, 127, 128,
 129, 175
Stuckey, J. E., 47
student knowledge, 95
subjectivity, 178
Suck, 31
Sumara, D., 155
symbolic analysts, 7
Syracuse University, 86, 87

Takanishi, R., 105
Tale of Two Millennial Cities, 51
Tan, S. H., 78
Taormino, T., 183
Taylor, C., 156
technology
 as knowledge, 14–15
 as "play," x
 reading, writing and, 14
technology-mediated social interaction, 3
Temp Slave, 174
Terralingua, 9

textbook-based literacy, 85
texts in digital form, 5
Thatcher, M., 53
Thau, R. D., 52
theory of technology (Dewey), 14
"three-way attention transaction," 22
Thurow, L. C., 52, 60
Tierney, R., 80
Tobin, J. J., 71
transferring, 36–37, 49
Transition, 51
Travis, M., 149
trickle across, 36–37
Tunbridge, N., 24
Turkle, S., 106, 150, 152

U Don't Stop, 184
U30 Group, 70
umbrella cultures, 8
Underwood, A., 70, 176
UNESCO, 188
University of California, Berkeley, 179
University of Georgia, xiii
University of Illinois, ix
University of Vermont, 154
Urban Outfitters, 168
U.S. Census Bureau, 12
U. S. National Academy, 185
USA Today, 152

Vale, V., 173, 174, 175, 176
Vanderbilt University, 71
video production, 141
violence of literacy, 47
Virginia Polytechnic Institute and State Uni-
 versity, 87
visual literacy, 71
vocational education, 44
von Mises, L., 66
Vygotskian tenets of learning, 48
Vygotsky, L. S., 152

Wack, P., 85
Waldrop, M., 33
Wale, K., 71
Walker, C., 38
Walkerdine, V., 42
Warhol, A., 24
Waxman, H. C., 44, 45
wearable advertising, 31–32

WebCT, 161, 162
Weingarten, T., 70
Wertsch, J., 151
White, M., 12
Who, The, 68
Wice, N., 164
Williams, K. B., 71
Williamson, J., 164, 184
Willinsky, J., 45, 46
Winner-Take-All, 51
Wittlinger, E., 168
World Bank, 188
Worse than Queer, 179
Wriston, W., 24

writing as assemblage, 6
Wulf, W. A., 7

Young, J., x, 71, 81, 107

Zhao, Y., 4, 78
zines, 164–65, 165–69
 implications for schools, 184
 and literary studies, 164, 183–85
 and pedagogies of tactics, 169–78
 subjectivity and pedagogy, 178–83
 trajectories of, 172
Zoba, W. M., 54
Zuboff, S., 14, 15

Colin Lankshear, Michele Knobel,
Chris Bigum, & Michael Peters
General Editors

New literacies and new knowledges are being invented "in the streets"
as people from all walks of life wrestle with new technologies, shift-
ing values, changing institutions, and new structures of personality
and temperament emerging in a global informational age. These new lit-
eracies and ways of knowing remain absent from classrooms. Many educa-
tion administrators, teachers, teacher educators, and academics seem
largely unaware of them. Others actively oppose them. Yet, they in-
creasingly shape the engagements and worlds of young people in socie-
ties like our own. The *New Literacies and Digital Epistemologies* series
will explore this terrain with a view to informing educational theory
and practice in constructively critical ways.

For further information about the series and submitting manu
scripts, please contact:

Dr. Colin Lankshear
"Papeleria Garabatos"
Av Universidad #1894, Local 1
Col. Oxtopulco Universidad
Mexico City, CP 04310 MEXICO
Fax 1-508-267 1287
c.lankshear@yahoo.com

To order other books in this series, please contact our Customer
Service Department at:

(800) 770-LANG (within the U.S.)
(212) 647-7706 (outside the U.S.)
(212) 647-7707 FAX

Or browse online by series at:

www.peterlangusa.com